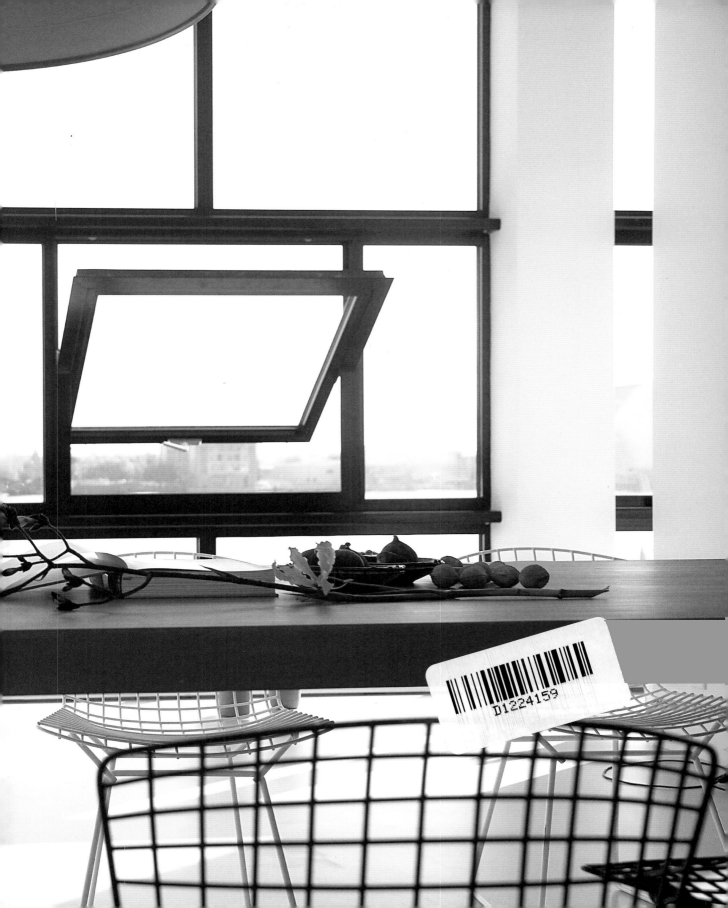

INTERIORS
NOW!

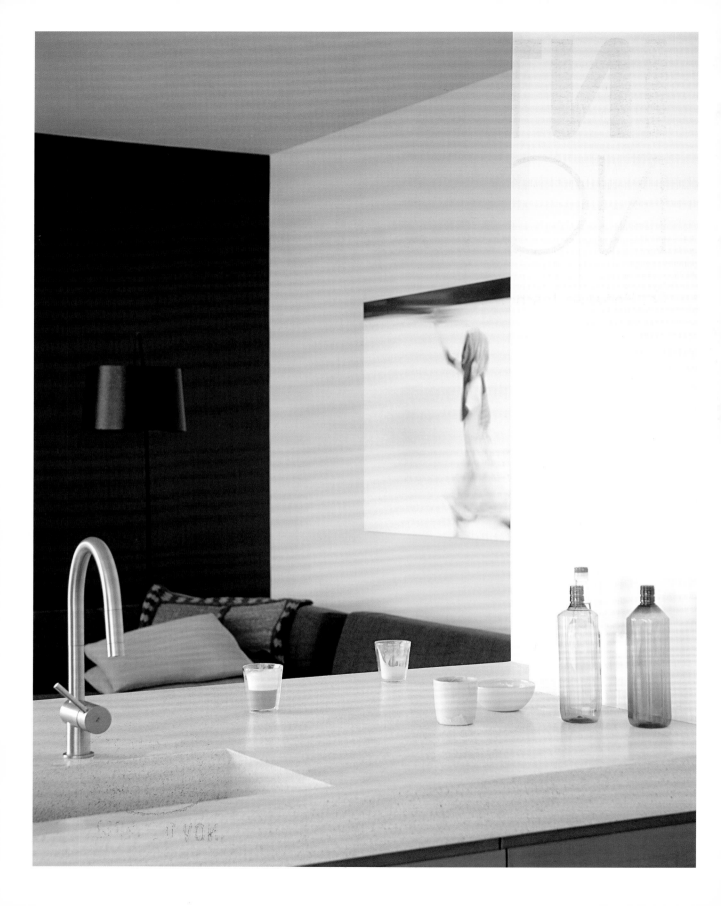

INTERIORS NOW!

Ed. Angelika Taschen

1

TASCHEN

CONTENTS

INHALT SOMMAIRE

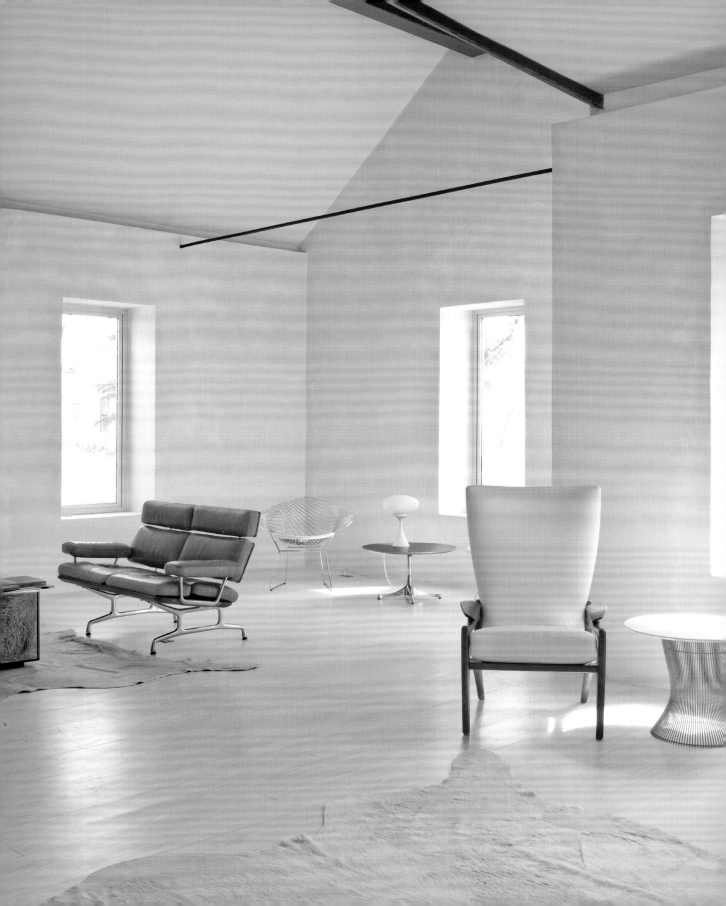

FOREWORD

by Angelika Taschen

Just as no one snowflake resembles another, when it comes to interiors we all have our own particular taste. There may be defining international trends in style – chrome, glass, and black leather Bauhaus classics were dominant in the 1980s, while one decade later everything was bathed in mud and cream tones – yet today such interiors usually seem dated.

The new millennium is characterised by an interest in vintage furniture from the period between 1950 and 1980. Luckily for us, new editions of the great, timeless classics of yore – like the immortal Lounge Chair by Charles and Ray Eames, found today in living rooms from Berlin to Bogota – can be acquired at affordable prices. If vintage furniture is mixed and matched with antiques and contemporary design items, what emerges is an ambience that is altogether up-to-the minute.

One of the best developments of recent years is, in my view, that more and more people are taking the time and energy to cultivate their very own style of interior and not just relying on those ready-made living room wall units complete with sofa and armchairs.

This book hopes to promote that development. After all, one's own four walls are supposed not just to be presentable, but also to create a sense of warmth and cosiness. Fortunately, this has nothing to do with a big bank account. Ideas are what really counts. Just take a simple wooden table, a white candle from a supermarket, a good bottle of red wine and surround the whole with an adept combination of discarded pub chairs of various shapes and woods – and you have a harmonious, authentic, attractive look.

The first volume of "Interiors Now" aims to reflect the diversity of living styles from Antwerp to Chiang Mai, from Copenhagen to Mumbai. These houses, residences, apartments and studios are destined to astonish and inspire you, irrespective of your personal taste. Be it casual, cast-off chic, glittering gilt splendour, space-age design, expert minimalism or luxuriant neo-baroque, you will find hundreds of ideas on these pages that you can adapt for your own home.

Among the highlights here are the country home designed by John Pawson for the legendary style guru Fabien Baron, the refuge of the Thai artist Rirkrit Tiravanija, Fabrizio Plessi's unique finca on Mallorca (artists always have the most beautiful homes!), the Milan apartment of fashion star Roberto Cavalli as a perfect reflection of his extravagant ego, and last but by no means least, the penthouse of art collector Christian Boros situated on the roof of a Berlin bunker, where his collection of contemporary art is also on display. This absolutely unique synthesis of war bunker and penthouse is a successful example of how bad karma can be transformed into good karma, the terrible into the beautiful – a dream and reality at one and the same time.

VORWORT

von Angelika Taschen

So wie kein Schneekristall dem anderen gleicht, hat jeder von uns seinen einzigartigen Einrichtungsgeschmack. Es gibt zwar prägende internationale Stiltendenzen – in den 1980er Jahren dominierten Chrom, Glas und Bauhaus-Klassiker aus schwarzem Leder, ein Jahrzehnt später wurde alles in Schlamm- und Cremetöne getaucht –, aber für unseren heutigen Geschmack sehen diese Interieurs meist »dated« aus.

Kennzeichnend für das neue Jahrtausend ist das Interesse an Vintage-Möbeln aus der Zeit zwischen 1950 und 1980. Zu unserem Glück gibt es die großen, zeitlosen Klassiker von einst inzwischen als bezahlbare Neuauflagen zu kaufen – wie den zeitlosen Lounge Chair von Charles und Ray Eames, der heute in Wohnzimmern zwischen Berlin und Bogota steht. Kombiniert man Vintage-Möbel individuell mit Antiquitäten und zeitgenössischen Design-Stücken, entsteht eine Atmosphäre, die ganz up to date ist.

Für mich zählt es zu den schönsten Entwicklungen der letzten Jahre, dass immer mehr Menschen Zeit, Liebe und Gedankenkraft investieren, um ihren ganz persönlichen Einrichtungsstil zu entwickeln und weniger häufig einfach nur vorgefertigte Wohnzimmerschrankwände mit dazugehöriger Sofagarnitur zu kaufen.

Dieses Buch soll diese Entwicklung weiterfördern, denn die eigenen vier Wände sollen nicht nur repräsentabel sein, sondern zugleich ein Gefühl von Wärme und Geborgenheit schaffen. Das hat, zum Glück, nichts mit einem dicken Bankkonto zu tun, denn was wirklich zählt, sind Ideen. Man nehme einen schlichten Holztisch, eine weiße Kerze aus dem Supermarkt, eine schöne Flasche Rotwein und umgebe das Ganze mit einem gekonnten Mix aus ausrangierten Kneipenstühlen in unterschied-

lichen Formen und Hölzern, schon entsteht eine stimmige, authentische, schön anzusehende Szenerie.

Der erste Band von »Interiors Now« möchte die Vielfalt der Wohnstile von Antwerpen bis Chiang Mai, von Kopenhagen bis Mumbai widerspiegeln. Die gezeigten Häuser, Residenzen, Apartments und Studios sollen Sie, unabhängig von Ihrem persönlichen Geschmack, zum Staunen bringen und anregen. Ob lässiger Sperrmüllschick, goldglänzende Pracht, Space-Age-Design, gekonnter Minimalismus oder schwelgerischer Neo-Barock: Auf den folgenden Seiten finden Sie Hunderte Ideen, die Sie für Ihr Zuhause adaptieren können.

Zu den Highlights dieses Buches gehören das von John Pawson entworfene Landhaus des legendären Stilgurus Fabien Baron, das Refugium des thailändischen Künstlers Rirkrit Tiravanija, die einzigartige Finca von Fabrizio Plessi auf Mallorca (Künstler wohnen immer am schönsten!), das Mailänder Apartment von Modezar Roberto Cavalli als perfektes Spiegelbild seines extravaganten Egos und last but not least das Penthouse des Kunstsammlers Christian Boros auf dem Dach eines Berliner Bunkers, in dem er seine Sammlung zeitgenössischer Kunst zur Schau stellt. Die weltweit einzigartige Synthese aus Kriegsbunker und Wohnhaus ist ein gelungenes Beispiel dafür, wie man schlechtes in gutes Karma verwandeln kann, wie man Schreckliches in Schönes verzaubern kann – ein Traum und Wirklichkeit zugleich.

PREFACE

par Angelika Taschen

Nous avons tous nos préférences en matière d'aménagement. Il existe, c'est vrai, des tendances stylistiques internationales qui font autorité – les années 1980 ont été sous l'emprise du chrome, du verre et des classiques du Bauhaus en cuir noir ; une décennie plus tard, l'heure était aux teintes mastic et crème – mais nous ne les apprécions plus aujourd'hui et trouvons le plus souvent que ces intérieurs « datent » un peu.

Ce qui distingue l'homme du nouveau millénaire, c'est son goût pour le mobilier fabriqué entre 1950 et 1980. Par bonheur, on peut acheter aujourd'hui à un prix abordable des rééditions de grands classiques – par exemple l'immortelle Lounge Chair de Charles et Ray Eames que l'on trouve de nos jours dans de nombreux séjours entre Berlin et Bogota. Le mariage de meubles vintage avec des antiquités et des pièces design contemporaines génère une atmosphère tout à fait up-to-date.

Une des évolutions les plus positives de ces dernières années, selon moi, est que nous sommes de plus en plus nombreux à investir du temps, de l'amour et de la réflexion pour trouver notre style personnel et à acheter moins souvent des éléments muraux préfabriqués avec le canapé assorti.

Le présent livre doit faire progresser encore cet état de choses car notre intérieur n'est pas seulement là pour être montré, nous devons y trouver chaleur et réconfort, nous y sentir en sécurité dans un bel environnement. Ce n'est heureusement pas une question d'argent – ce qui compte vraiment, ce sont les idées. Une table de bois toute simple, une bougie blanche achetée au supermarché, une belle bouteille de vin rouge, tout autour un mélange savant de chaises de bistrot de formes et de bois différents et voilà

que naît sous nos yeux un décor harmonieux, authentique et agréable à regarder.

Le premier volume d'« Interiors Now » se propose de refléter la diversité des styles déco, d'Anvers à Chiang Mai et de Copenhague à Mumbai. Quels que soient vos goûts personnels, les maisons, résidences, appartements et studios présentés doivent vous étonner et vous inspirer. Chic nonchalant des meubles récupérés, magnificence scintillante de l'or, design futuriste, minimalisme assumé ou néobaroque opulent : vous trouverez sur les pages suivantes des centaines d'idées susceptibles d'être adaptées à votre intérieur.

Font partie des clous du présent ouvrage : la maison de campagne du designer mythique Fabien Baron, créée par John Pawson, le refuge de l'artiste thaïlandais Rirkrit Tiravanija, l'extraordinaire finca de Fabrizio Plessi à Majorque (les artistes ont vraiment toujours les plus beaux logements !), l'appartement milanais du tzar de la mode Roberto Cavalli qui reflète à merveille son caractère extravagant, sans oublier bien sûr le penthouse du collectionneur Christian Boros, édifié sur le toit d'un bunker berlinois dans lequel il expose sa collection d'art contemporain.

Unique en son genre, la synthèse de bunker antiaérien et penthouse montre que l'on peut parfaitement corriger son karma, métamorphoser comme par magie quelque chose d'horrible en quelque chose de beau – être à la fois dans le rêve et la réalité.

AMMERSEE
Riederau, Upper Bavaria, Germany

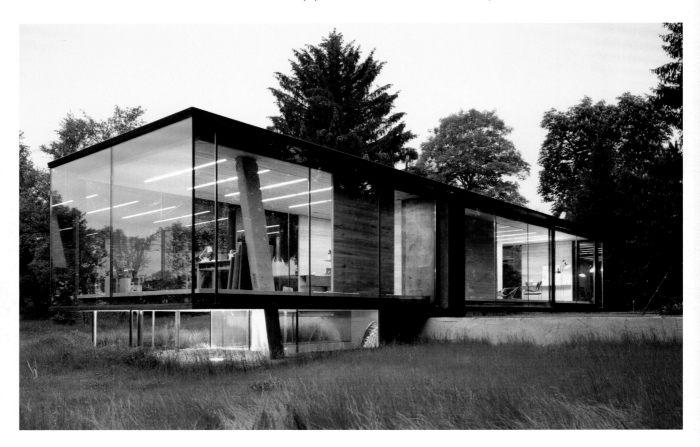

OWNER
Marion Bembé

OCCUPATION
Artist

PROPERTY
Atelier / Studio
160 sqm / 1,720 sq ft
2 floors; 4 rooms; 1 bathroom

YEAR
Building: 2002

ARCHITECTS & INTERIOR DESIGNER
Bembé Dellinger Architekten, Greifenberg
www.bembe-dellinger.de

ART
All paintings by Marion Bembé

FURNITURE
Pierre Paulin "Butterfly" chair; William
Katavolos "T" chair; Charles & Ray
Eames "Surfboard" table; all built-in
furniture, such as kitchen, shelves, sleeping
den, by Bembé Dellinger Architekten

PHOTOGRAPHER
Stefan Müller-Naumann, Munich
www.mueller-naumann.de

PRODUCTION & STYLING
Christine Bauer, Munich
www.christinebauer.com

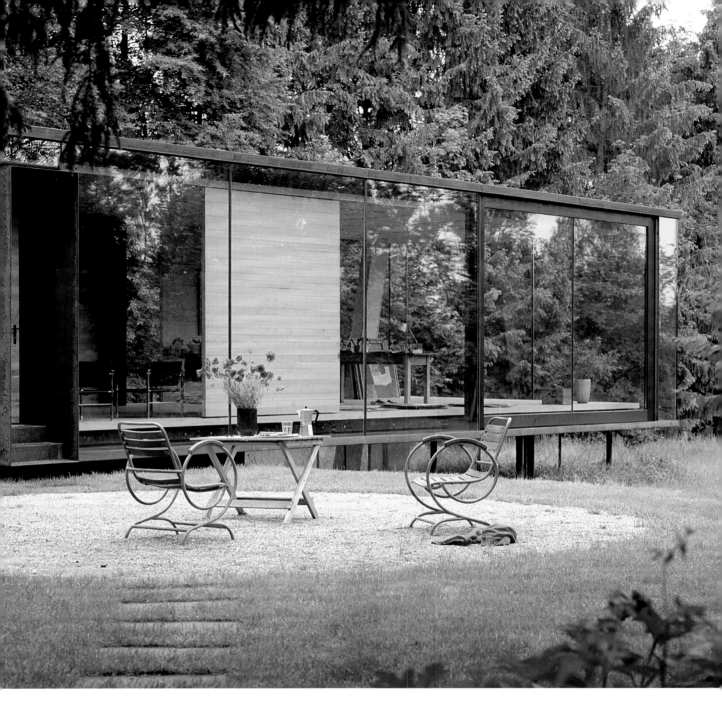

STYLE

Conceptual architecture with decorative details: on the ground floor, the local oak planks on the ceiling and the floors are visibly nailed. The wooden partitions can be shifted and stacked. On the slope level, round cavities, ceiling, walls and floor have been lined with crinkle-look PVC and the concrete is visible.

Konzeptionelle Architektur mit handwerklichen Details: Im Erdgeschoss sind Boden und Decke mit heimischen Eichendielen sichtbar vernagelt. Die Holzwände sind verschieb- und stapelbar. Im Hanggeschoss wurden runde Höhlen, Decke, Wände und Boden mit PVC-Folie im Knitterlook geschalt und auf Sicht betoniert.

Une architecture conceptuelle avec des détails décoratifs : au rez-de-chaussée, les planches du plafond et du sol, en chêne local, sont clouées de manière apparente. Les cloisons en bois peuvent être déplacées et rangées. À l'étage inférieur, les cavités rondes, les plafonds, les sols et les murs ont été tapissés en PVC à l'effet « froissé » et le béton laissé visible.

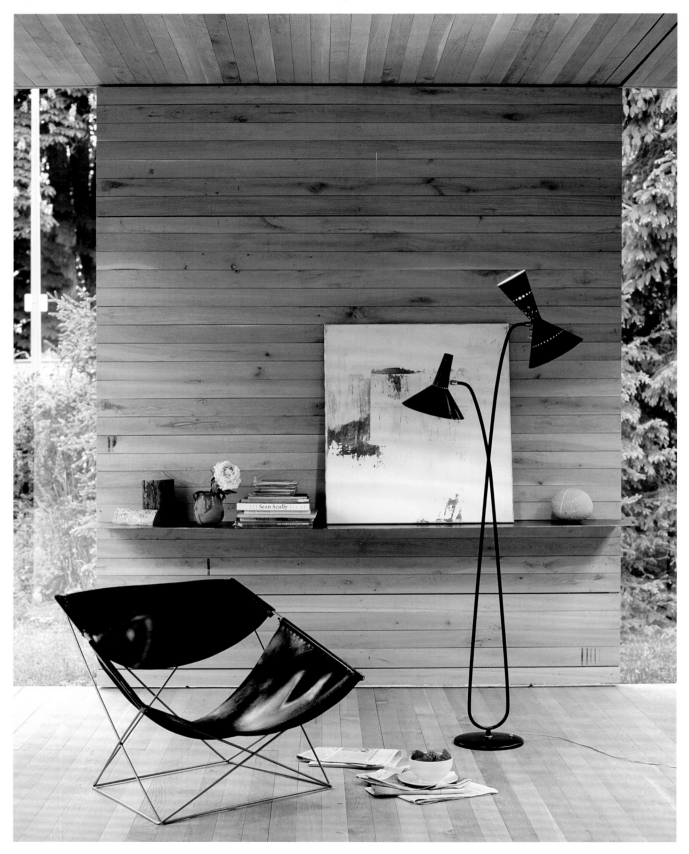

"The architects were allowed to do what they wanted. Because artists don't like people interfering with their paintings either."

»Die Architekten durften machen, was sie wollten. Maler wollen sich ja auch nicht in ihre Bilder reinmalen lassen.«

« Les architectes ont eu carte blanche. Les artistes aussi n'aiment pas qu'on se mêle de leurs tableaux ».

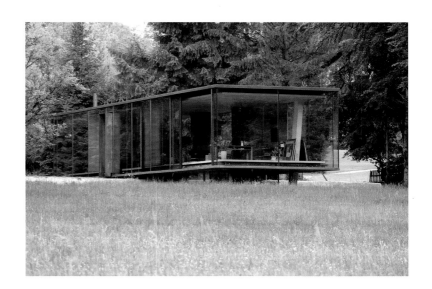

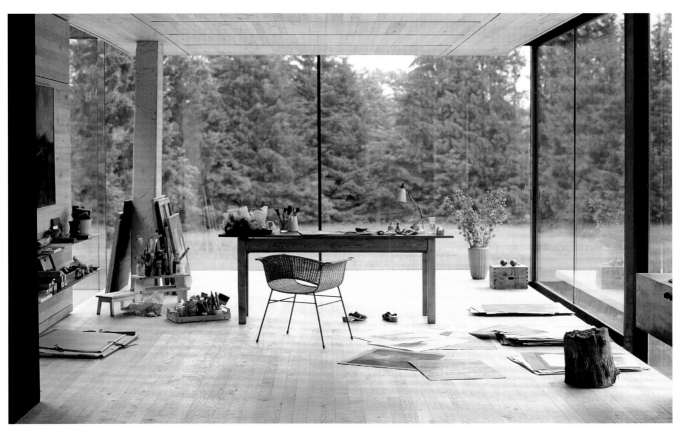

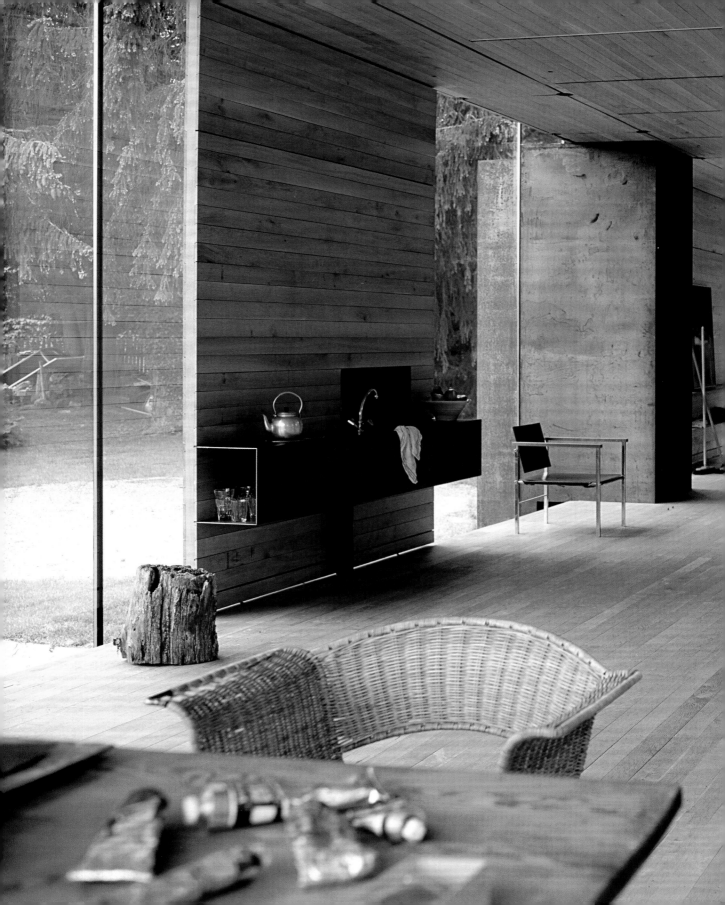

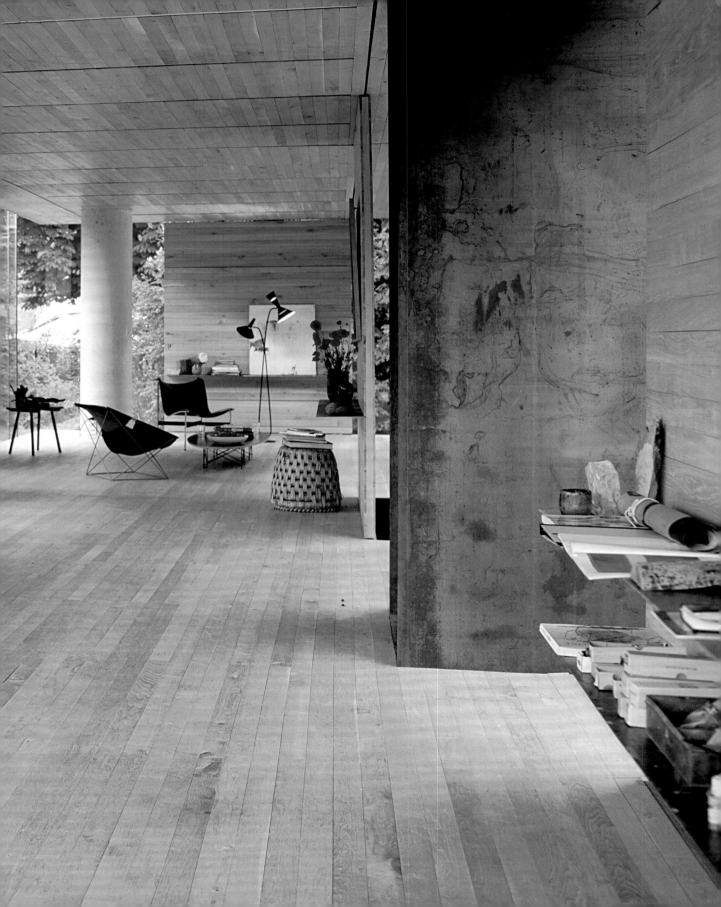

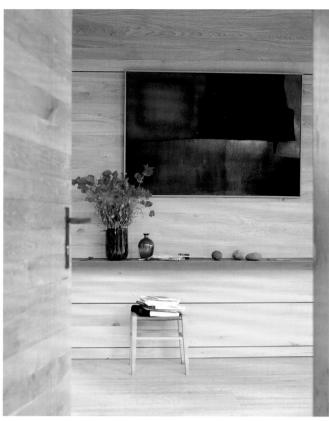

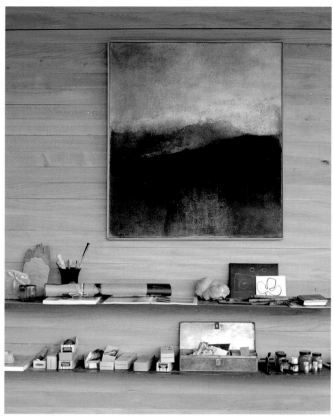

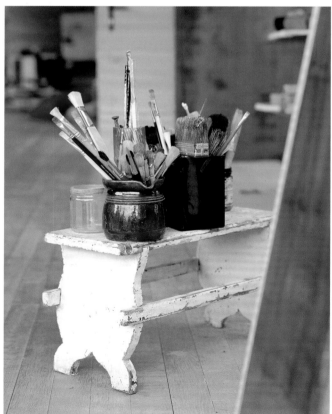

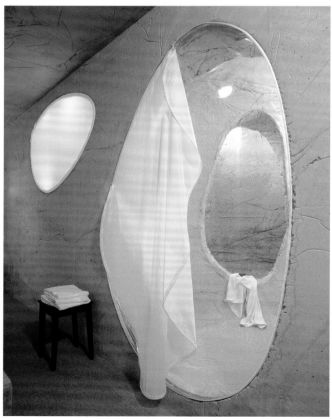

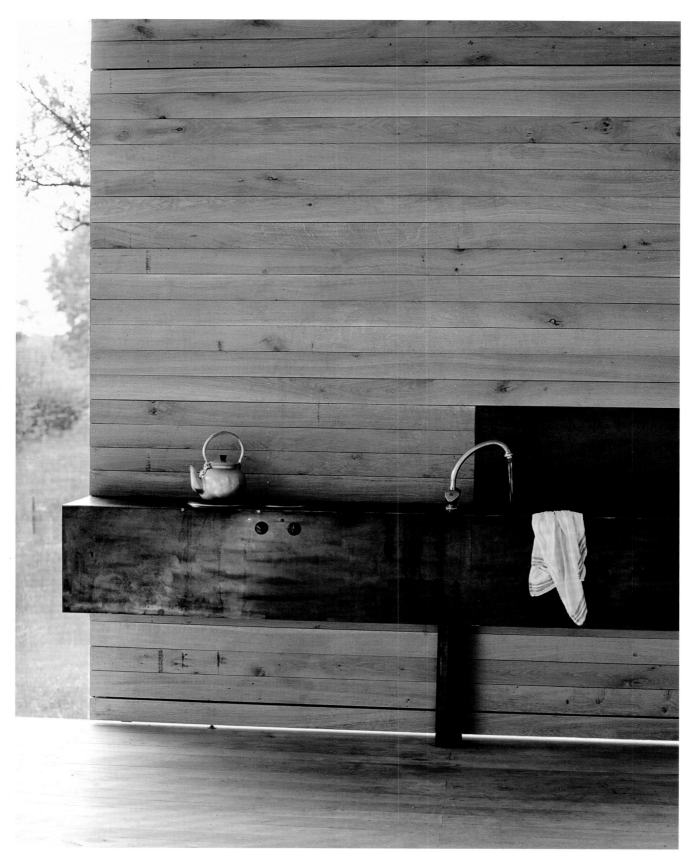

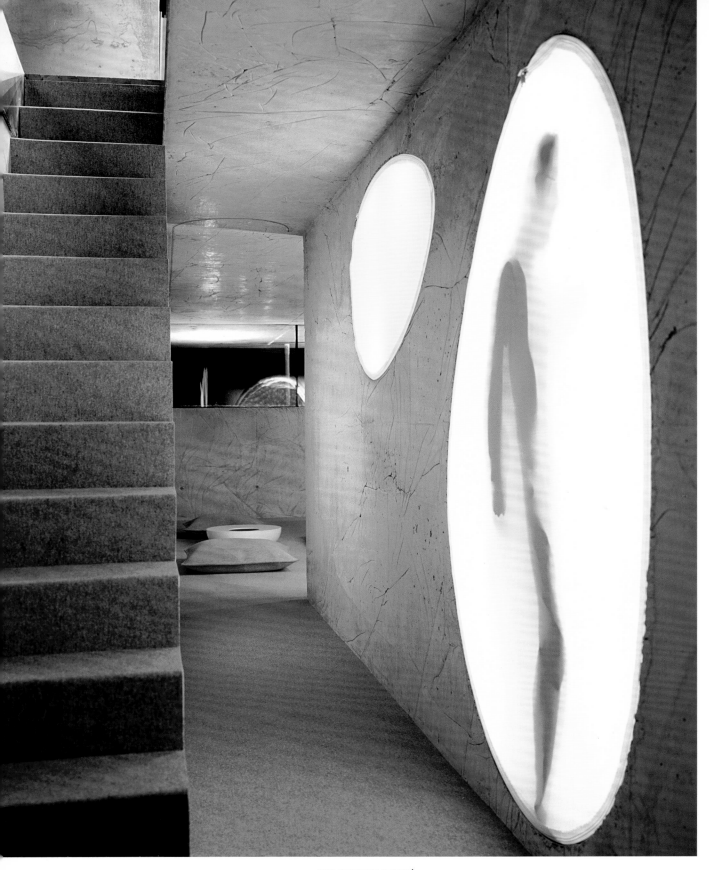

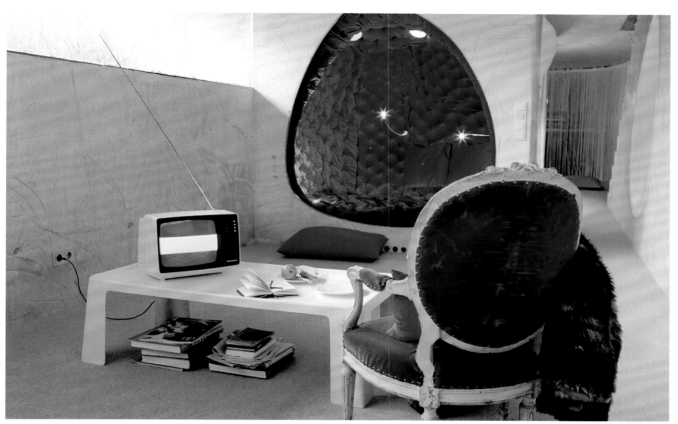

AMSTERDAM

Holland, The Netherlands

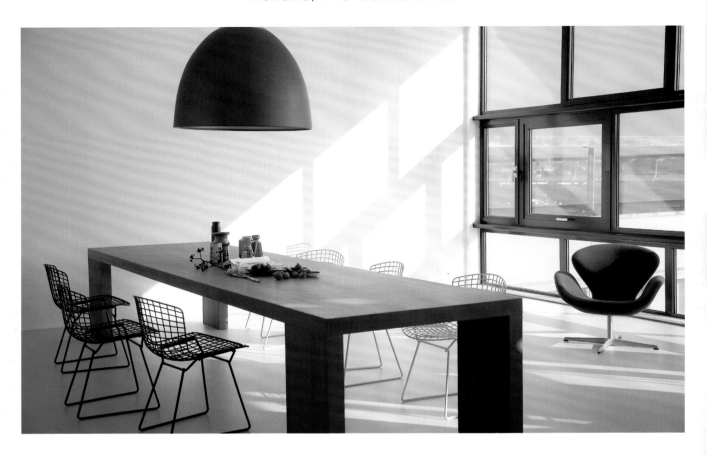

OWNERS
Sylvia Avontuur & Arie-Jan Laan

OCCUPATION
Director of Press Only PR agency
Director of Heritage Travel, India specialist

PROPERTY
Loft / Apartment
250 sqm / 2,700 sq ft
2 floors; 5 rooms; 2 bathrooms

YEAR
Building: 2002
Remodelling: 2008

ARCHITECTS
MVRDV, Rotterdam
www.mvrdv.nl

INTERIOR DESIGNER
Marius Haverkamp, Flow, Amsterdam
www.flow.nu

KITCHEN
Piet-Jan van den Kommer
www.vandenkommer.nl

ART
Mirjam Bleeker photo from
"Hidden Beauty" series

FURNITURE
Harry Bertoia black and white chairs
around the table; "Nur" lamp above table,
Artemide; Arne Jacobsen grey "Swan" chair;
Alexander Begge white "Casalino" chairs;
"Twiggy" lamp in the lounge area, Foscarini;
Pierre Paulin "560" dark red chair & ottoman

PHOTOGRAPHER
Mirjam Bleeker, Amsterdam
www.mirjambleeker.nl

PHOTO STYLIST
Frank Visser, ijm, Amsterdam
www.ijm.nl

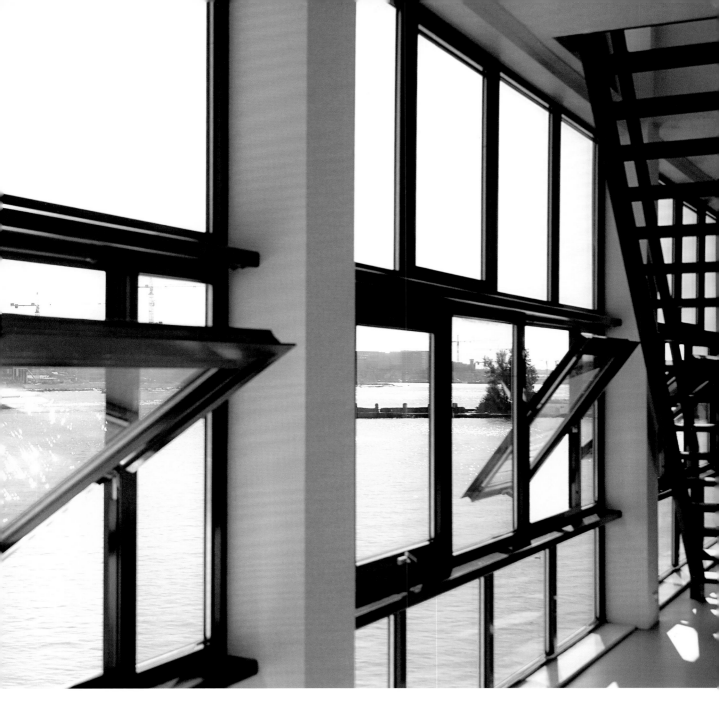

STYLE

High ceilings and large windows create a bright space. To add a warm and personal touch to the minimal atmosphere mahagony and dark oak wood were used, combined with nomad carpets and vintage furniture. The kitchen is the heart of the house, because the owners love to organise dinner parties.

Durch die hohen Decken und großen Fenster entsteht ein heller Raum. Um der minimalistischen Atmosphäre etwas Warmes und Persönliches zu verleihen, wurden Mahagoni und dunkles Eichenholz eingesetzt und mit Nomadenteppichen und Vintage-Möbeln kombiniert. Die Küche ist das Herzstück des Hauses, denn die Besitzer richten gerne Dinnerpartys aus.

Les hauts plafonds et les grandes fenêtres créent un espace de lumière. L'acajou et le chêne sombre, associés aux tapis nomades et au mobilier vintage, apportent une touche personnelle et chaleureuse à l'atmosphère minimaliste. La cuisine est le cœur de la maison, car les propriétaires adorent recevoir leurs amis à dîner.

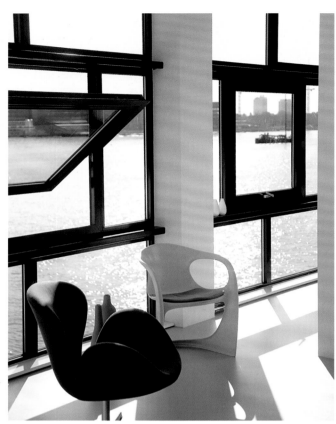
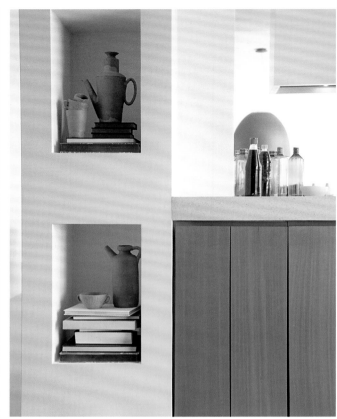
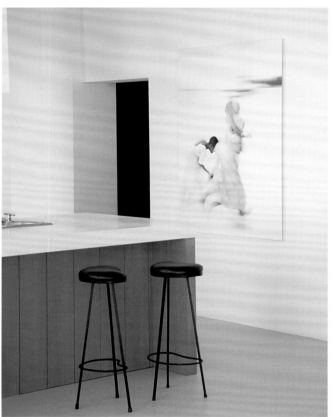

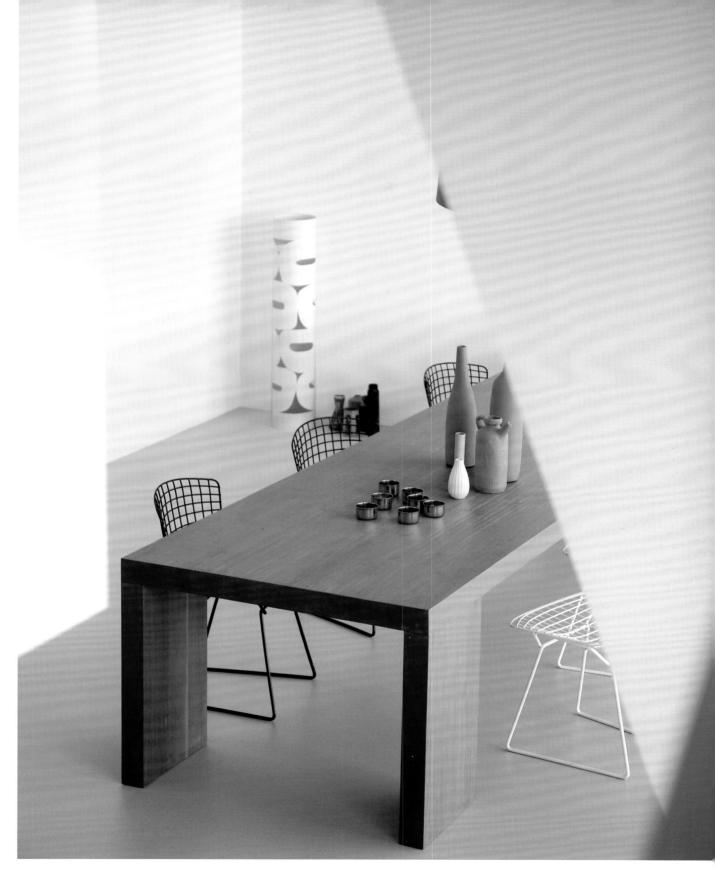

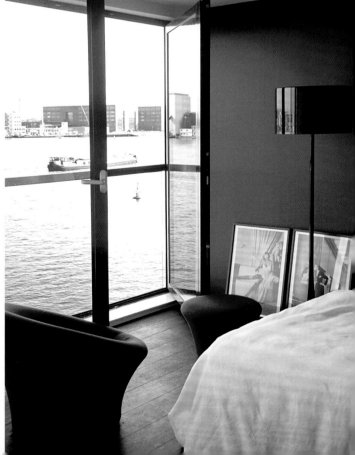

"Living on the waterfront is very special. It is extremely stimulating and calming at the same time."

»Das Wohnen am Wasser hat etwas ganz Besonderes: Es ist beruhigend und gleichzeitig äußerst aufregend.«

« Vivre au bord de l'eau est magique ; c'est à la fois plein de vie et paisible. »

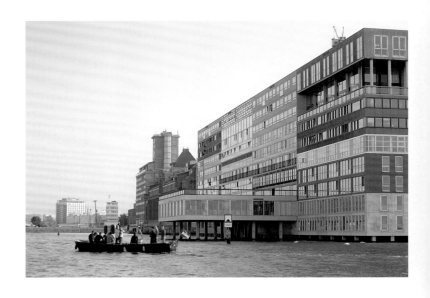

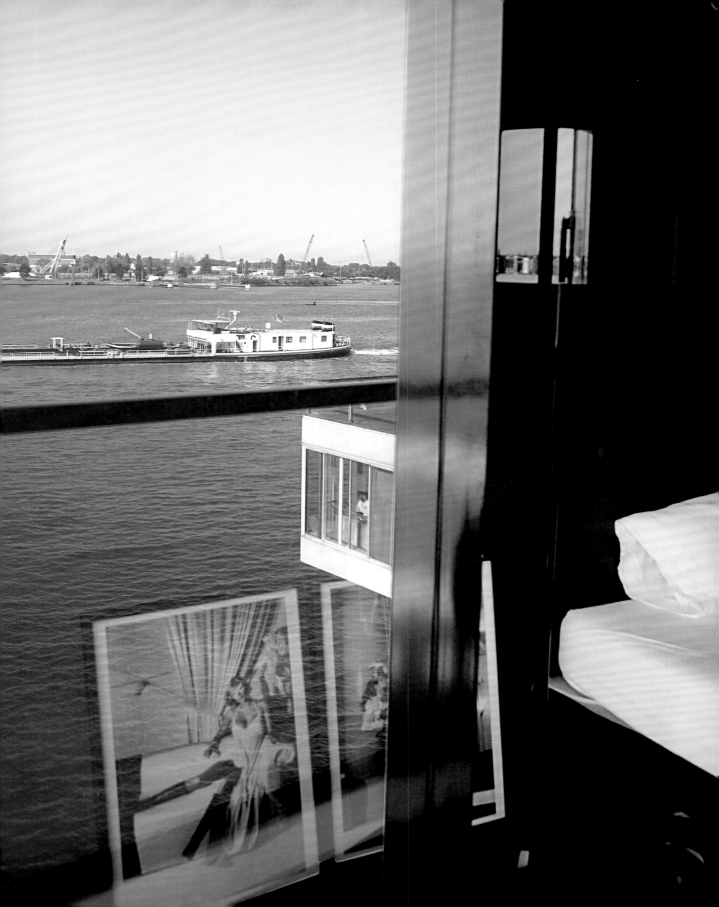

ANTWERP

's-Gravenwezel & Wijnegem, Belgium

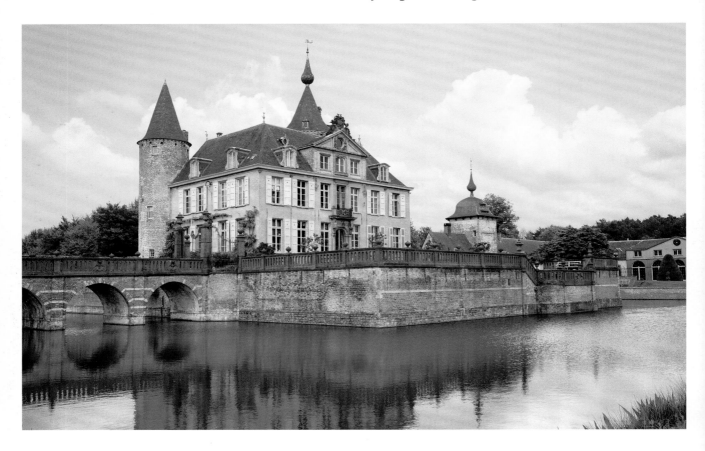

OWNERS
May & Axel Vervoordt

OCCUPATION
Interior designer, collector, art dealer

PROPERTY
Castle & Kanaal
Castle: 5 floors + outbuildings;
50 rooms; 8 bathrooms
Kanaal: 5 buildings: main building,
warehouse, office building,
"Escher" building, circular room with a
permanent installation by Anish Kapoor

YEAR
Building: 12th century
Remodelling: 1745 (van Bamshit)
and 1984 (Axel Vervoordt)

INTERIOR DESIGNER
Axel Vervoordt
www.axel-vervoordt.com

ART
Kazuo Shiraga "Taijima", 1989; Victor
Vasarely "Erebus", 1957; Lucio Fontana
"Concetto Spaziale, Attese", 1959; Inuit
coat made of intestines, Alaska, ca. 1860;
Otto Piene "Sun Soot", 1975; Jef Verheyen
"Concorde", 1979; Koh Ker Buddha
Khmer, sandstone, 10th century; large
Syro-Palestinian pillar idol, Golan Heights,
Chalcolithic, 4th millennium BC

FURNITURE
Mannerist sculpted mirror, Antwerp, late
16th century; Japanese screen by Tanyu
Kano, 16th century; Italian marble table
(Roman model from Pompeii), ca. 1800

PHOTOGRAPHER
François Halard, New York
for Monopol Magazine
www.trunkarchive.com

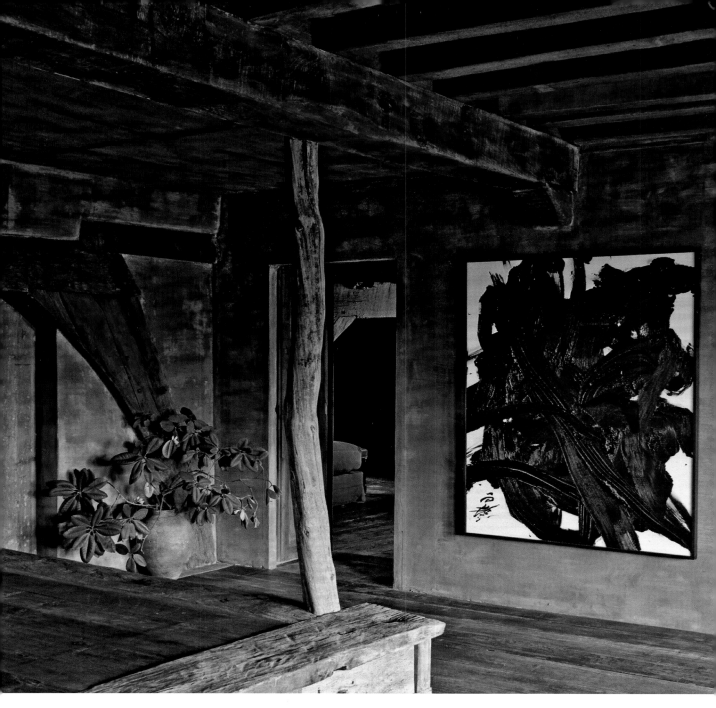

STYLE

A sense of proportion dominates my taste. We try as much as possible to avoid the purely decorative but we do want to achieve an effect of harmony between the architectural environment, the furnishings and the works of art and antique objects that we have installed in the houses.

Mein Geschmack wird von einem Gefühl der Ausgewogenheit bestimmt. Wir versuchen, das rein Dekorative so gut wie möglich zu vermeiden, und möchten eine harmonische Wirkung im Zusammenspiel der architektonischen Umgebung, der Einrichtung, der Kunstwerke und der antiken Objekte im Haus erzielen.

Mon goût est dominé par un sens des proportions. Nous essayons le plus possible d'éviter le purement décoratif tout en cherchant à créer une harmonie entre l'environnement architectural, le mobilier, les œuvres d'art et les antiquités que nous plaçons dans les maisons.

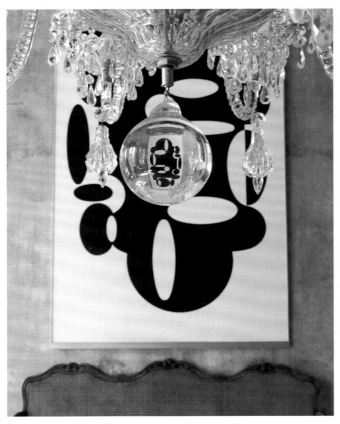

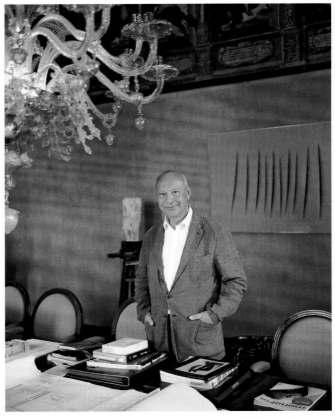

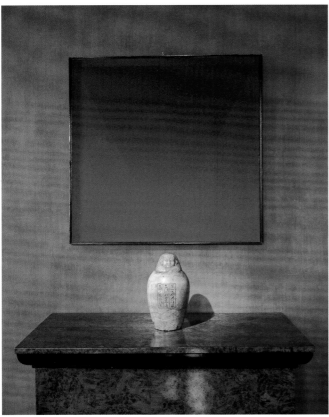

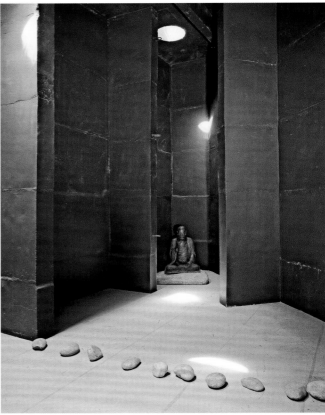

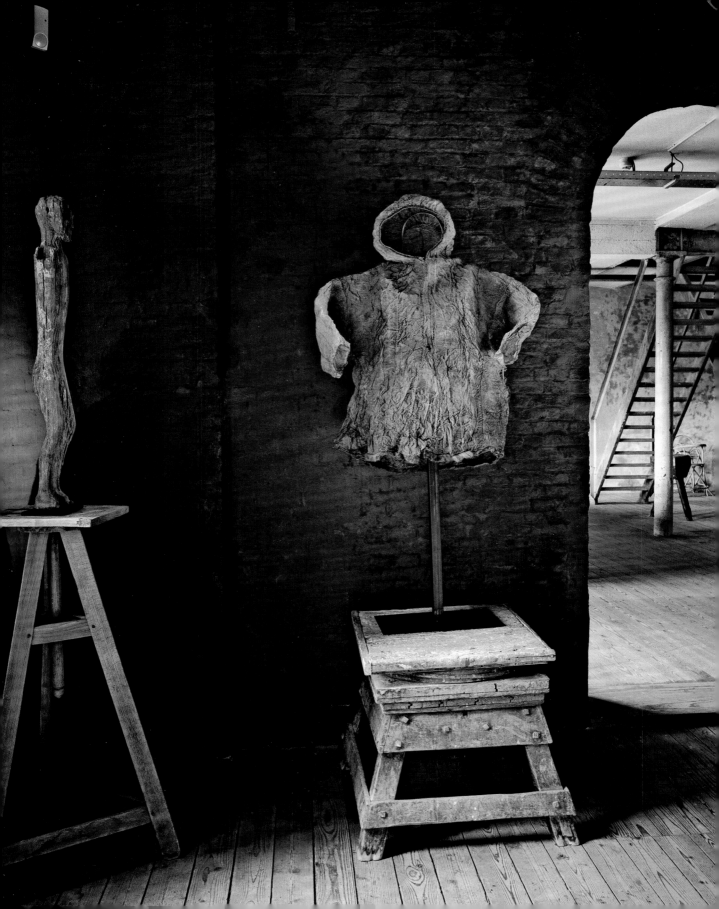

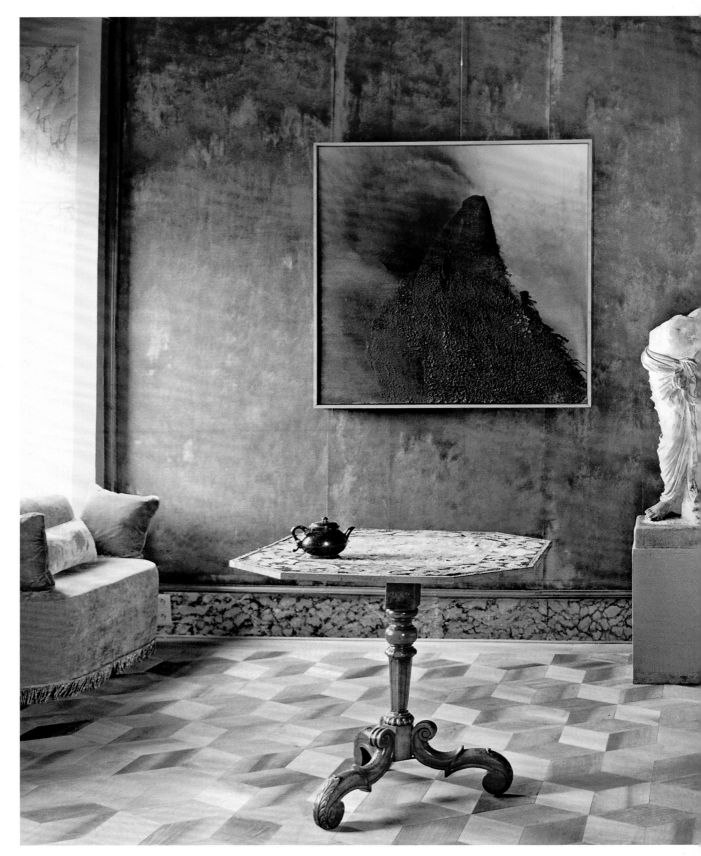

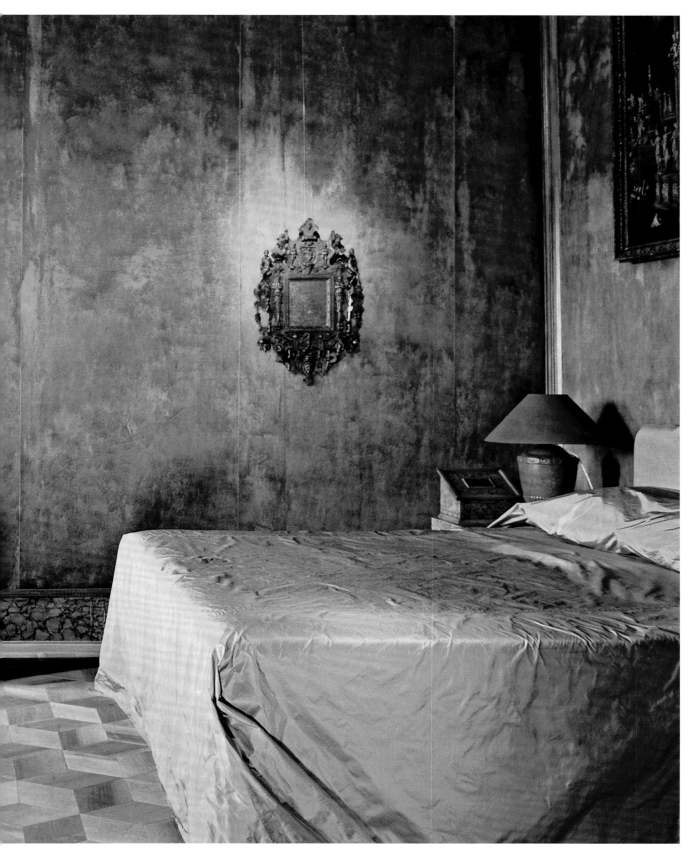

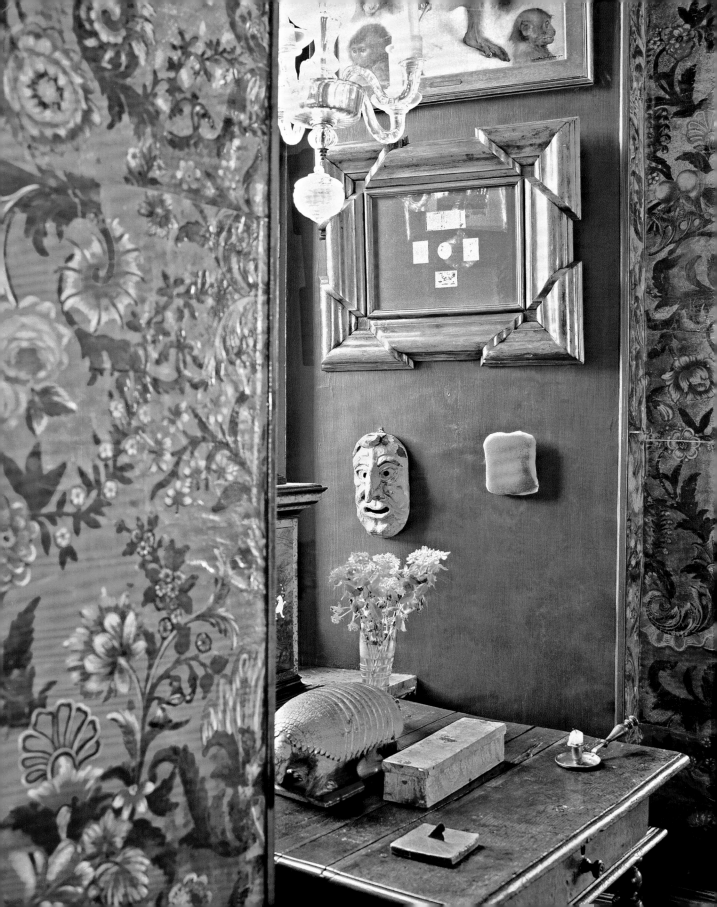

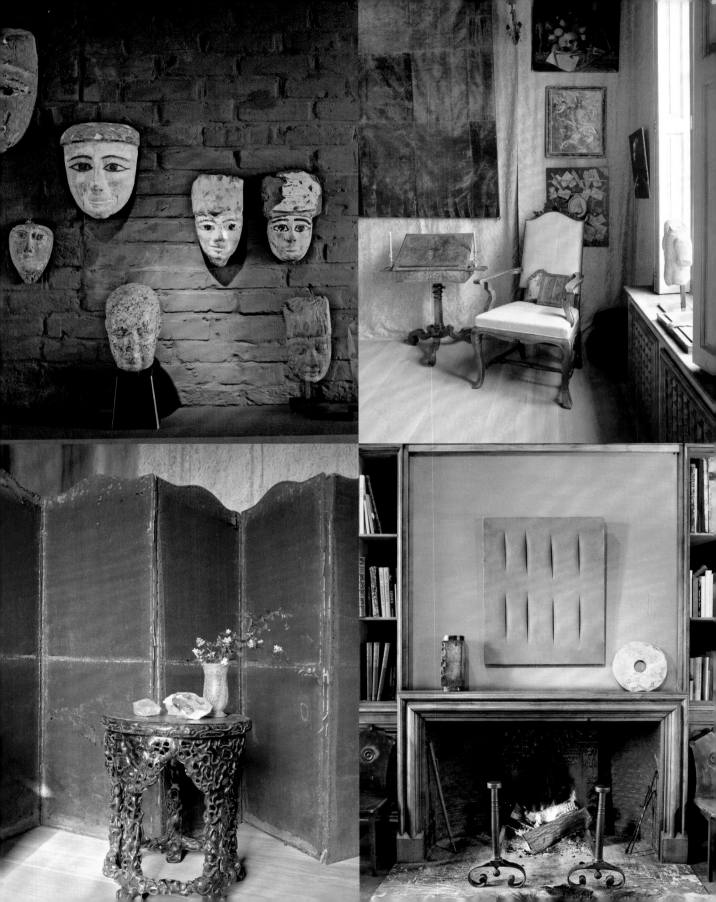

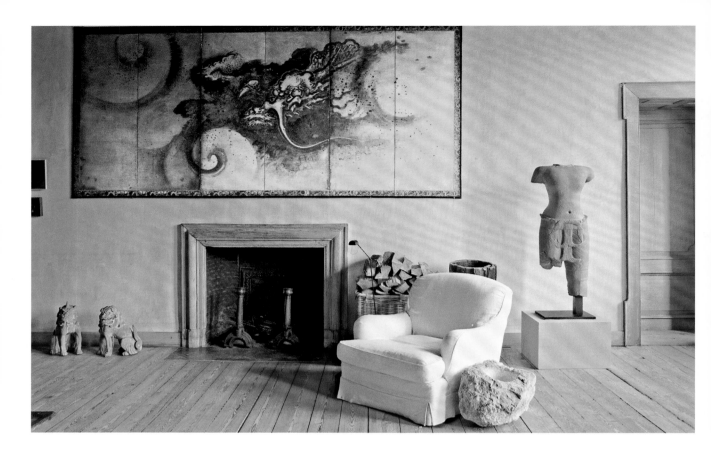

"The idea behind decoration is not decorating.
I like art from all genres, from all parts of the world and from all sorts of periods. I like everything that is honest and real."

»Das Konzept hinter jeder Dekoration besteht darin, nicht zu dekorieren. Ich mag Kunst aller Genres, aus allen Teilen der Welt und aus allen möglichen Perioden. Ich mag alles, was ehrlich und real ist.«

« L'idée derrière la décoration est de ne pas décorer. J'aime l'art sous toutes ses formes, de tous les pays et de toutes les époques. J'aime tout ce qui est honnête et vrai. »

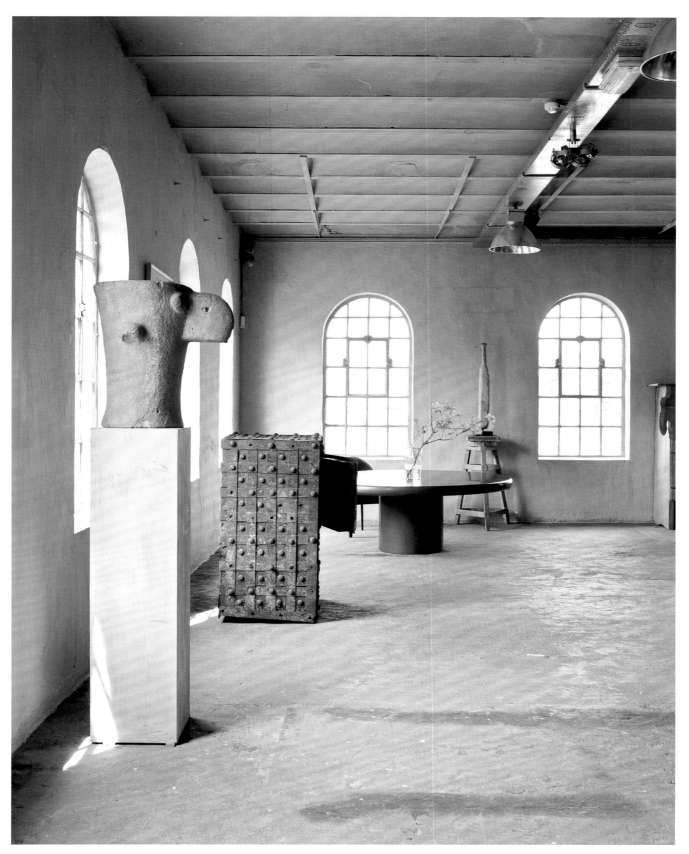

ATHENS
Greece

OWNER
A businessman

PROPERTY
Penthouse
400 sqm / 4,300 sq ft
2 floors; 5 rooms; 2 bathrooms

YEAR
Building: 2004

INTERIOR DESIGNER
Angelos Angelopoulos Associates, Athens
www.angelosangelopoulos.com

ART
Victor Vasarely

FURNITURE
Harry Bertoia "Bird" lounge chair & ottoman;
Mies van der Rohe "Barcelona" stools;
Eero Saarinen black "Tulip" chairs & table;
Gino Sarfatti chandelier; Eero Aarnio;
Arne Jacobsen; Andrew Martin; bathroom
tiles by Mosaico

PHOTOGRAPHER
Vangelis Paterakis, Zapaimages
www.studiopaterakis.com
www.zapaimages.com

STYLE
A mixture of 1960s elements and just a few
touches of rock'n'roll, such as the Andrew
Martin armchairs with a parrot-green Rubelli
fabric. There is also an ethnic touch in the
master bedroom.

Eine Mischung aus Elementen der 1960er
Jahre und wenigen hervorstechenden
Akzenten wie den Andrew-Martin-Sesseln
mit dem papageigrünen Stoff von Rubelli.
Das Schlafzimmer des Eigentümers hat
außerdem einen Ethno-Touch.

Un mélange d'éléments des années 1960
avec quelques touches rock n' roll, comme
les fauteuils d'Andrew Martin tapissés
d'un tissu vert perroquet de Rubelli. Il y a
également une connotation ethnique dans
la chambre principale.

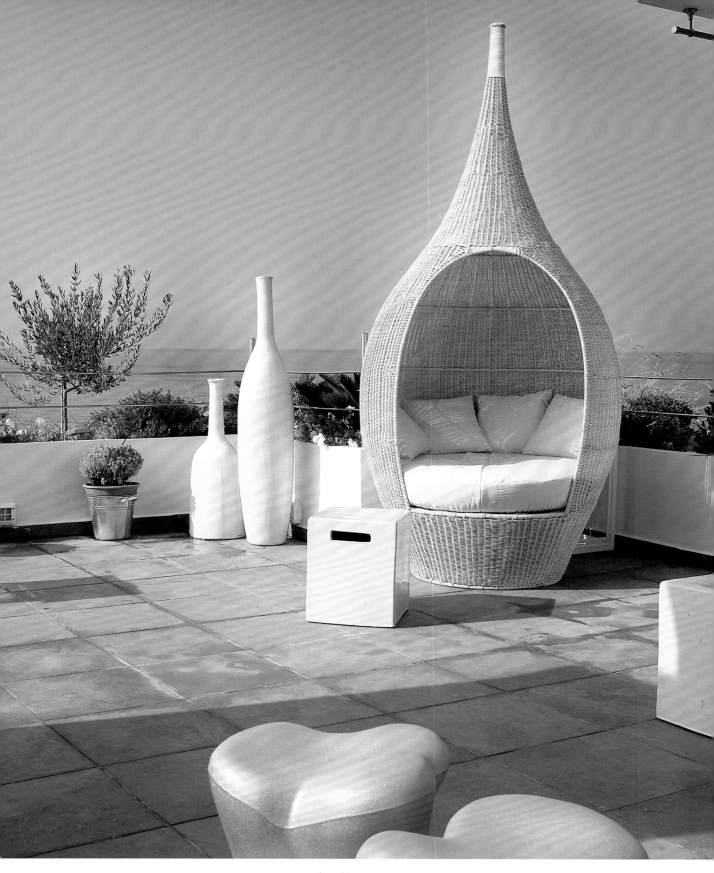

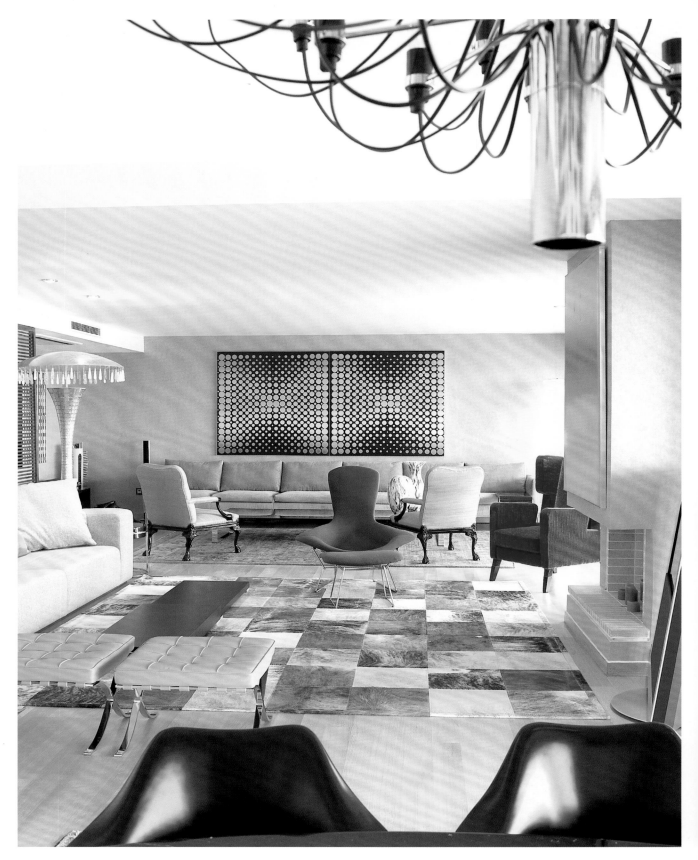

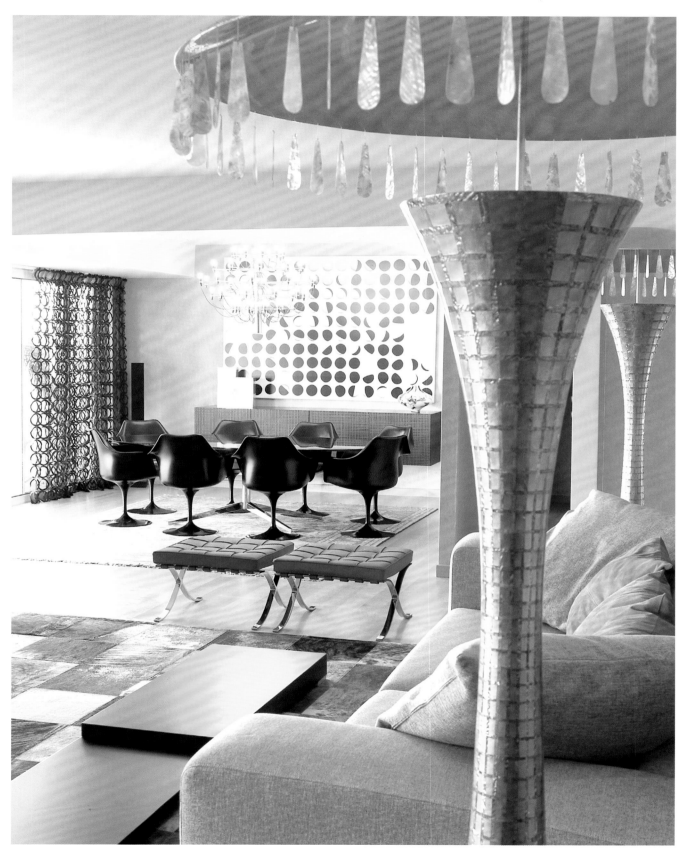

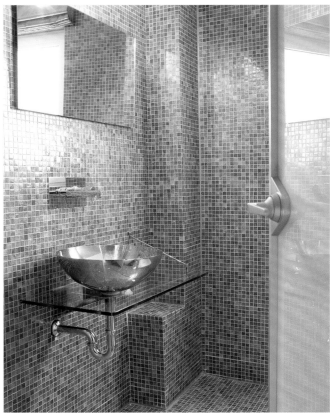
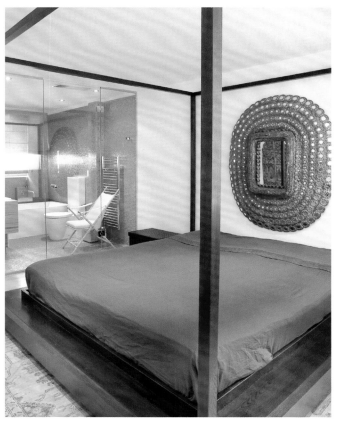

BADEN NEAR VIENNA

Lower Austria, Austria

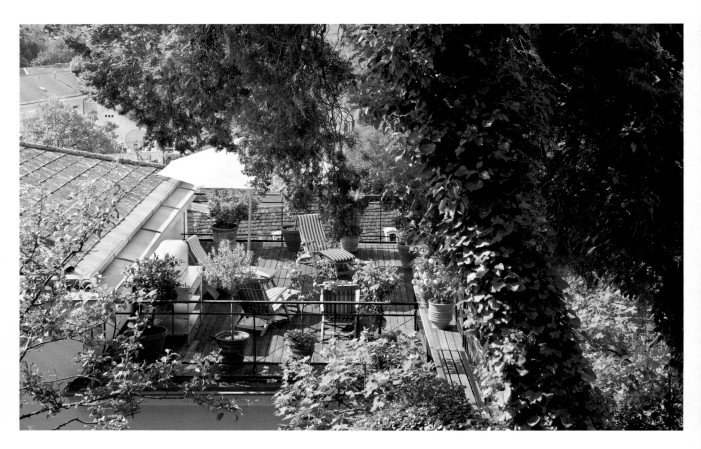

OWNERS
Renate Kainer & Christian Meyer

OCCUPATION
Gallerists

PROPERTY
Villa
450 sqm / 4,850 sq ft
3 floors; 14 rooms; 4 bathrooms

YEAR
Building: 1871
Remodelling: 1996

ARCHITECT
Werner Molaschek (1871)

INTERIOR
Heimo Zobernig, Vienna (artist)

ART
Franz West; Wolfgang Tillmans;
Marcin Maciejowski; Dan Graham;
Raymond Pettibon; Sue Williams;
Heimo Zobernig in cooperation with
Herbert Brandl; T. J. Wilcox;
Yoshitomo Nara

FURNITURE
Franz West; Biedermeier furniture
& chandelier

PHOTOGRAPHER
Heiner Orth, Marschacht
www.heiner-orth.com

PHOTO PRODUCER
Ruth Wegerer, Vienna

STYLE
The interior is a collaboration with artists
connected to the Viennese linguism of
Adolf Loos and Karl Kraus. The aesthetic,
determined by terminology, creates thought
spaces for contemporary art.

Raumgestaltung und Mobiliar sind in
Zusammenarbeit mit Künstlern entstan-
den, die im Zusammenhang des Wiener
Linguismus eines Adolf Loos und Karl Kraus
stehen. Begrifflichkeit determiniert das
Ästhetische. Dies schafft Denkräume für
zeitgenössische Kunst.

Les intérieurs et l'ameublement ont été
réalisés en collaboration avec des artistes
associés au langage viennois d'Adolf Loos et
de Karl Kraus. L'esthétique est déterminée
par la terminologie, créant des espaces de
pensée pour l'art contemporain.

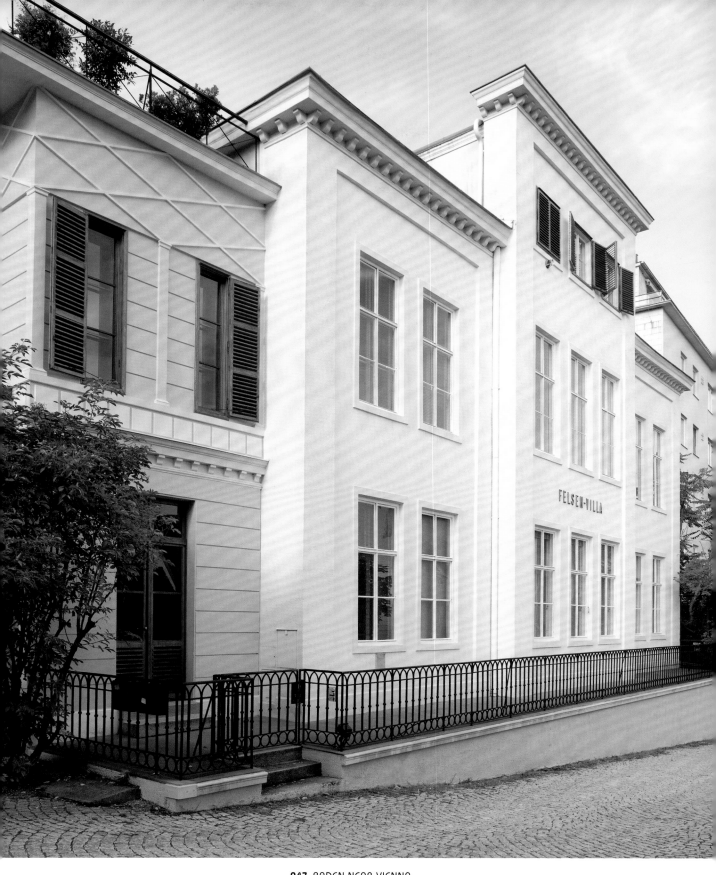

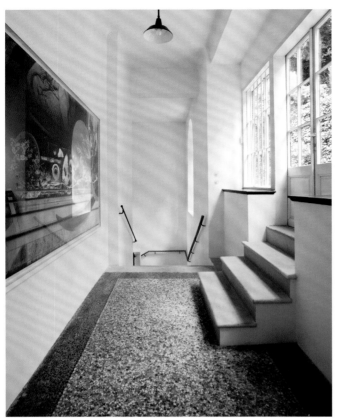

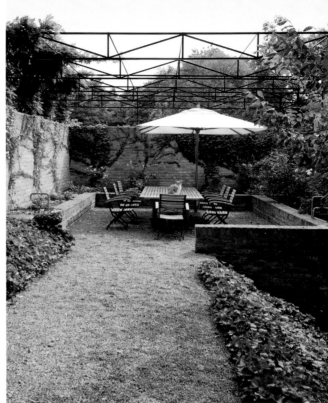

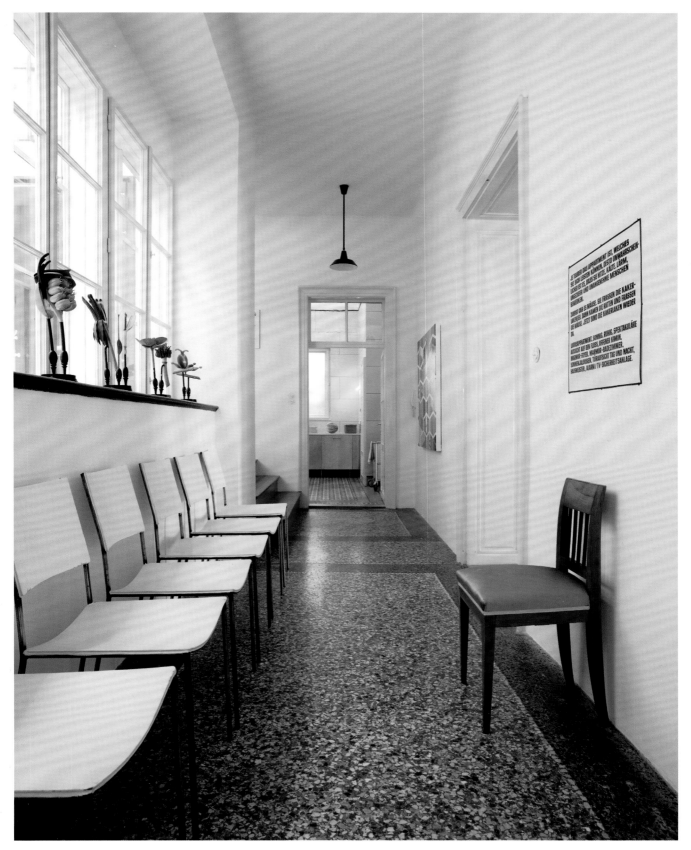

JE TEURER DAS APPARTMENT IST, WELCHES
SIE SICH LEISTEN KÖNNEN, DESTO UNWAHRSCHEIN-
LICHER IST ES, DASS SIE HITZE, KÄLTE, LÄRM,
UNGEZIEFER UND UNANGENEHME MENSCHEN
BEMERKEN.

ZUERST GAB ES MÄUSE. SIE FRASSEN DIE KAKER-
LAKEN. DANN KAMEN DIE RATTEN UND FRASSEN
DIE MÄUSE. JETZT SIND DIE KAKERLAKEN WIEDER
DA.

LUXUSAPPARTMENT, SONNIG, RUHIG, SPEKTAKULÄRE
AUSSICHT AUF DEN FLUSS, OFFENER KAMIN,
MARMOR-FOYER, MARMOR-BADEZIMMER,
SONNENJALOUSIEN, TRAUMSICHT TAG UND NACHT,
HASMUSTER, ALARM / TV-SICHERHEITSANLAGE.

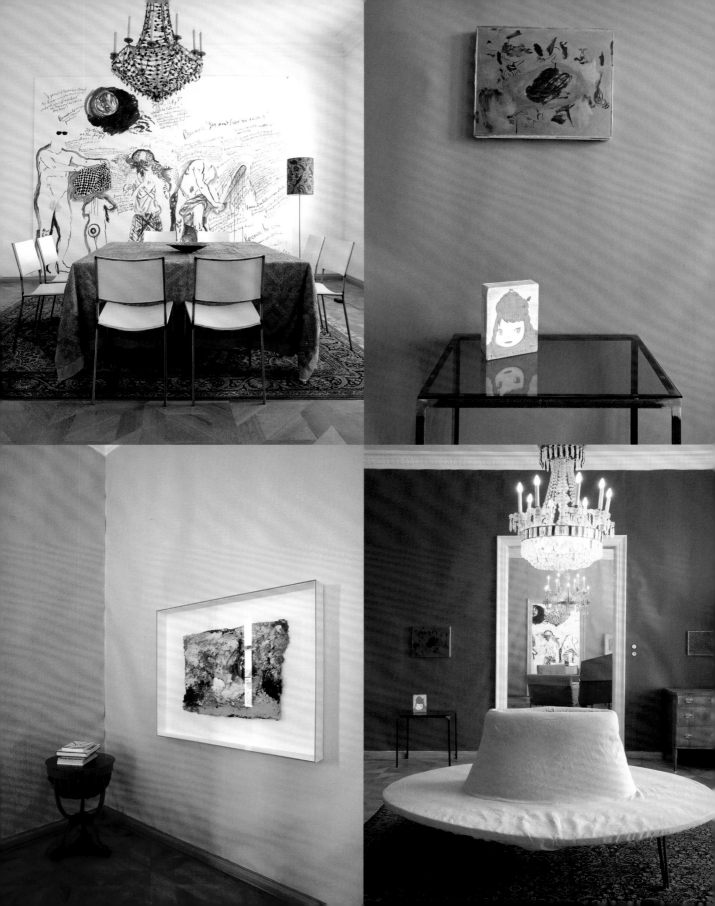

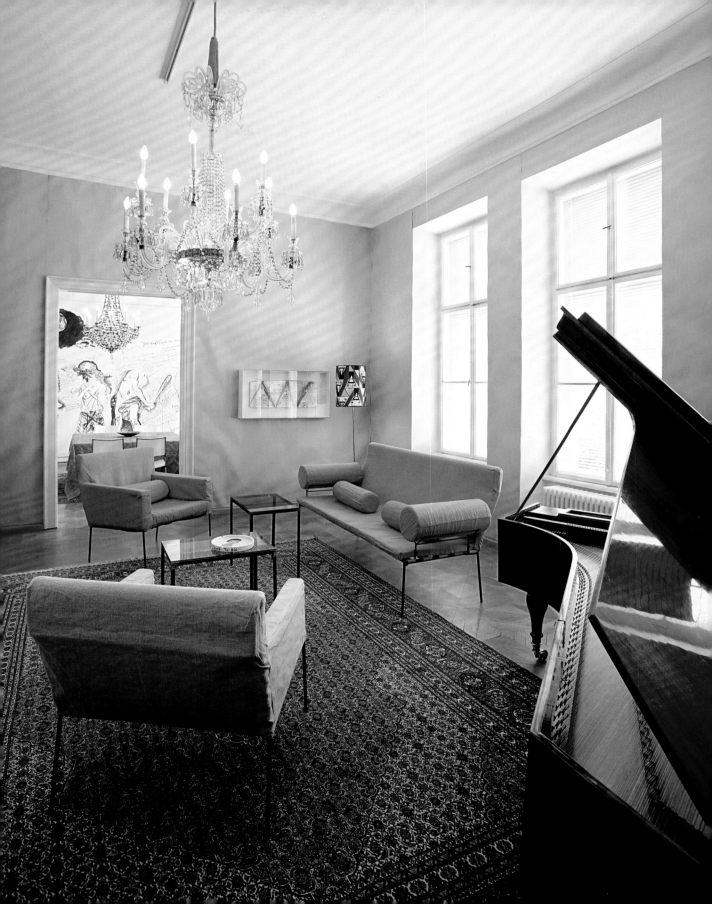

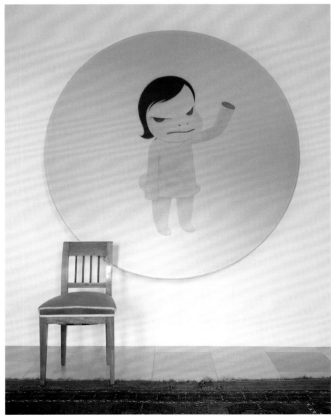

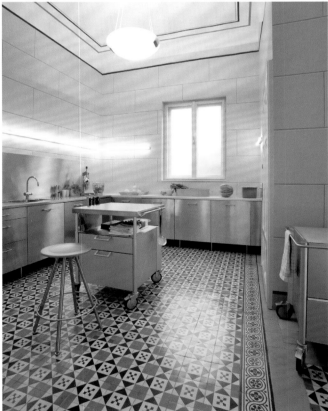

BAD WALDSEE

Baden-Württemberg, Germany

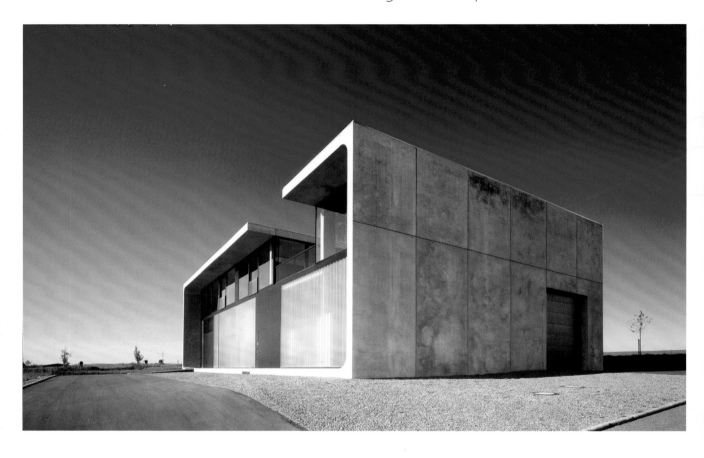

OWNER
Max Bold

OCCUPATION
Administrative sciences

PROPERTY
Loft + workshop + small apartment
2 floors
245 sqm loft + 395 sqm workshop
2,640 sq ft loft + 4,250 sq ft workshop
70 sqm apartment + 62 sqm office
750 sq ft apartment + 670 sq ft office

YEAR
Building: 2004

ARCHITECT & INTERIOR DESIGNER
Thomas Bendel, Berlin
www.thomasbendel.de

FURNITURE
Alexander Begge white "Casalino"
chairs & table; anonymous 1960s
and 1970s vintage pieces

PHOTOGRAPHER
Ludger Paffrath, Berlin
www.ludger-paffrath.de

PHOTO PRODUCER
Andreas Tölke, Berlin
www.andreastoelke.de

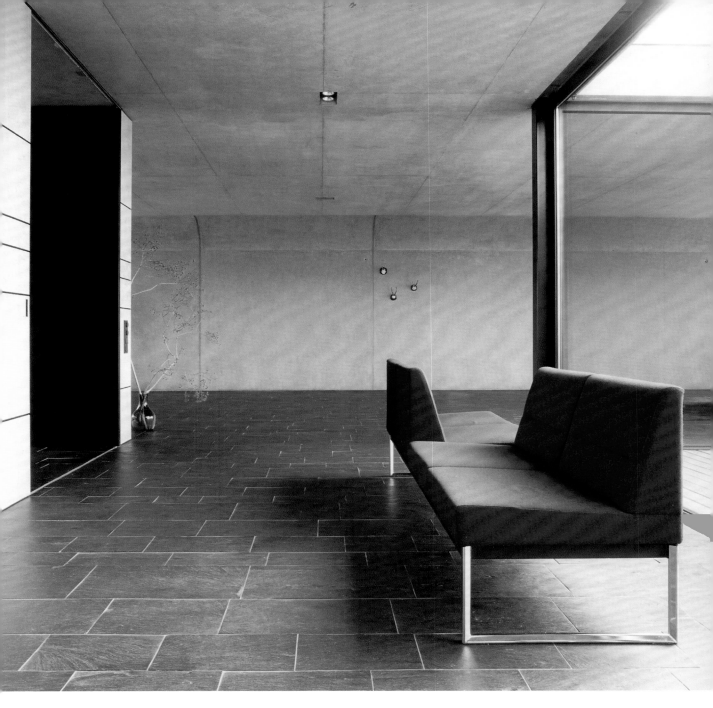

STYLE

This homogeneous building harmonises with its surroundings thanks to the unified concrete surfaces. The contrast between the built-in maple veneer parts and the concrete surfaces gives the room a unique feel. When you open the folding doors to the kitchen you see a room lined completely in black, like the inside of a casket.

Durch die einheitlichen Betonoberflächen entsteht ein homogener Baukörper im Einklang mit der Umgebung. Die Einbauten aus Ahornfurnier im Kontrast zu den Betonoberflächen machen den Raum einzigartig. Öffnet man die Falttüren zur Küche, so zeigt sich ein komplett in Schwarz ausgekleideter Raum, der wie das Innere einer Schatulle wirkt.

Ce bâtiment homogène s'harmonise avec son environnement grâce aux surfaces unifiées en béton. Le contraste entre les placards encastrés plaqués en érable et le béton confère à cette pièce une atmosphère. Quand on ouvre les portes pliantes de la cuisine on découvre un espace entièrement tapissé de noir, comme l'intérieur d'un cercueil.

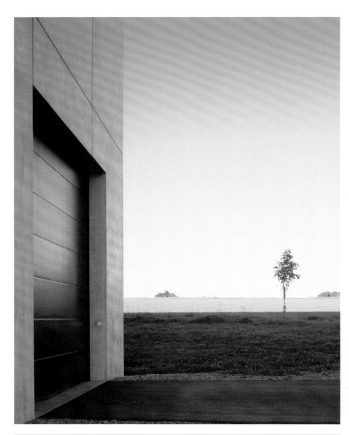
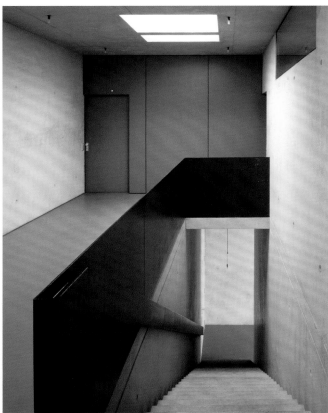
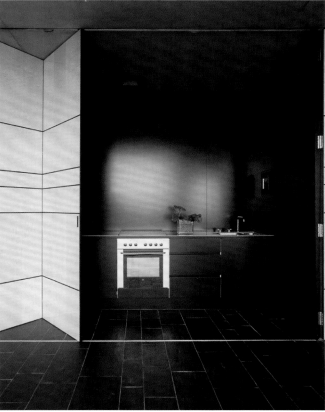

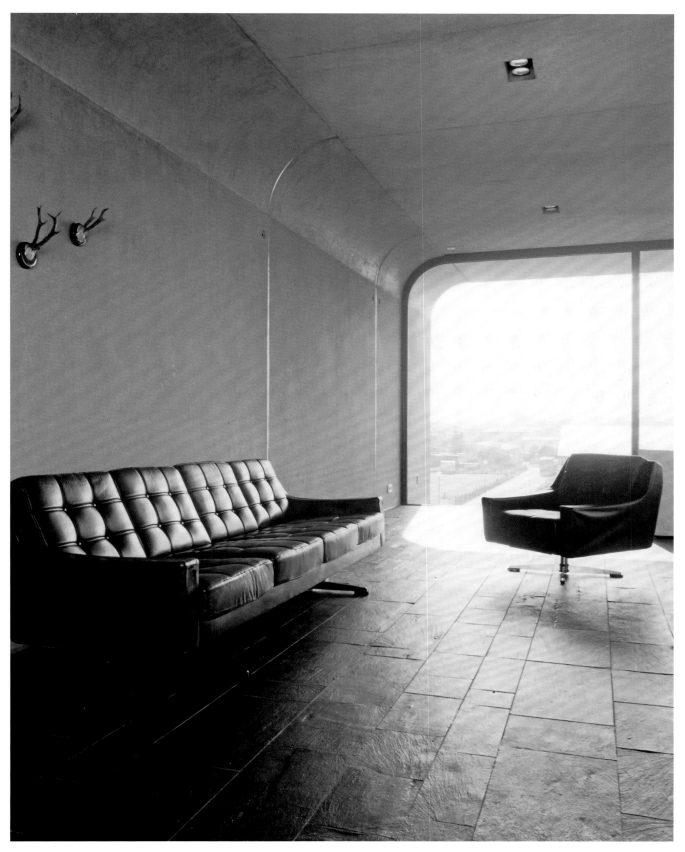

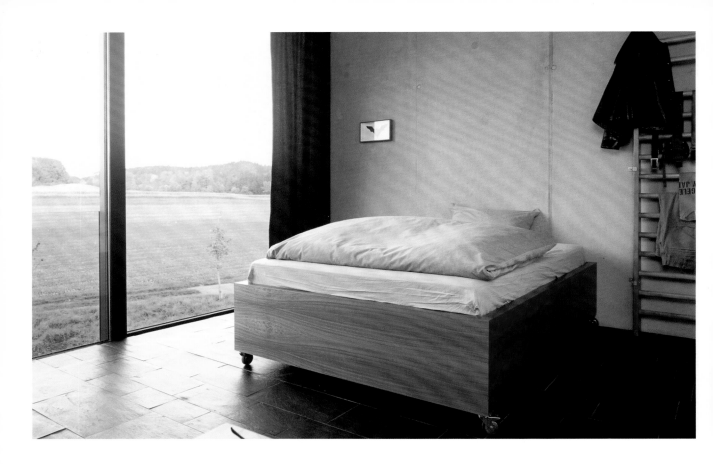

"In the 1970s, people
still had time and
a liking for high-class
and timeless design."

»In den 1970er Jahren hatte man
noch die Zeit und Liebe für qualitativ
hochwertiges und zeitloses Design.«

«Dans les années 1970, les gens
avaient encore du temps et le goût
du design de qualité et intemporel. »

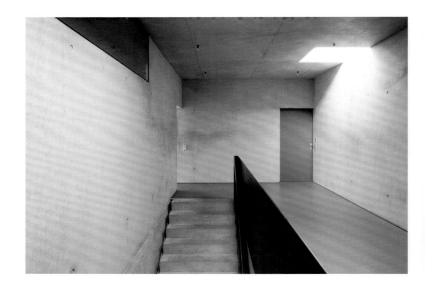

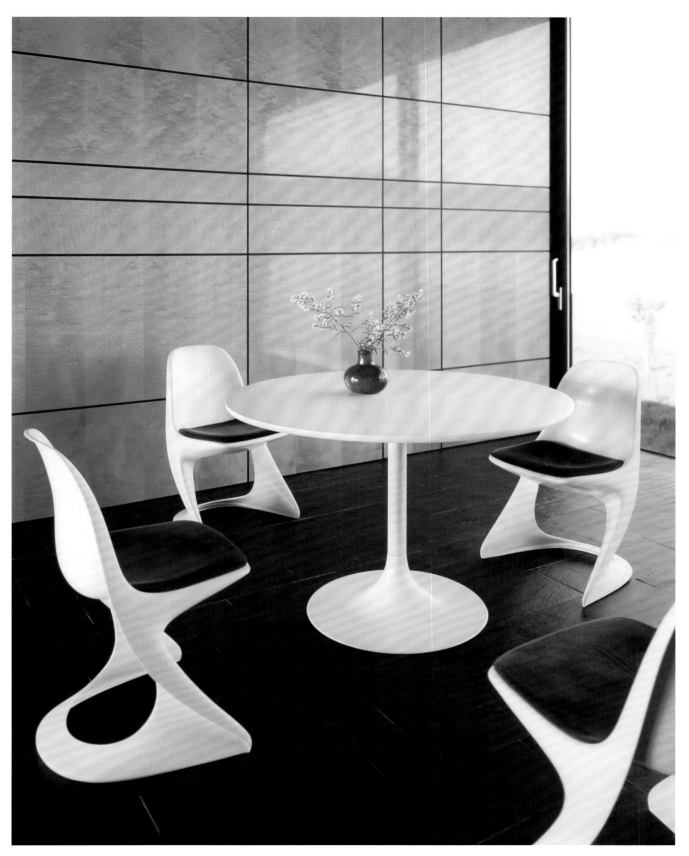

BARCELONA
Sant Just Desvern, Spain

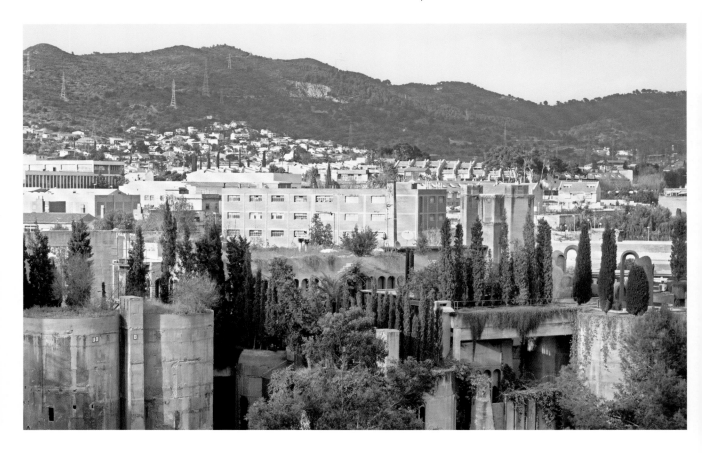

OWNER
Ricardo Bofill

OCCUPATION
Architect

PROPERTY
House
500 sqm / 5,400 sq ft
4 floors; 8 rooms; 4 bathrooms

YEAR
Building: 1975

ARCHITECT & INTERIOR DESIGNER
Ricardo Bofill & Marta de Vilallonga
Taller de Arquitectura, Barcelona
www.ricardobofill.com

ART
Architectural drawings by Xavier
Llistosella, Fernando Trueba,
Jean-Pierre Carniaux, Patrick Dillon

FURNITURE
Le Corbusier "LC4" chaise longue;
Jack L. Iams chairs; Vico Magistretti
sofas; Ricardo Bofill & Marta de Vilallonga
sofas & tables; Antoni Gaudí chairs
(re-edition); Charles Rennie Mackintosh
chairs (re-edition)

PHOTOGRAPHER
Verne Photography, Ghent
www.verne.be

PHOTO PRODUCER
Hilde Bouchez, OWI, Ghent
www.owi.bz

STYLE
Ricardo Bofill and Marta de Vilallonga provide
complete solutions for their buildings: archi-
tecture, design, furniture and products. Thus
they can create a harmonious relationship
between the interior and exterior.

Ricardo Bofill und Marta de Vilallonga
liefern Komplettlösungen für ihre Häuser:
von Architektur und Design über Möbel bis
hin zu Gebrauchsgegenständen. So schaffen
sie eine harmonische Beziehung zwischen
Innen- und Außenbereich.

Ricardo Bofill et Marta de Vilallonga
apportent à leurs bâtiments des solutions
complètes : architecture, design, mobilier et
produits. Ils peuvent ainsi créer une relation
harmonieuse entre l'intérieur et l'extérieur.

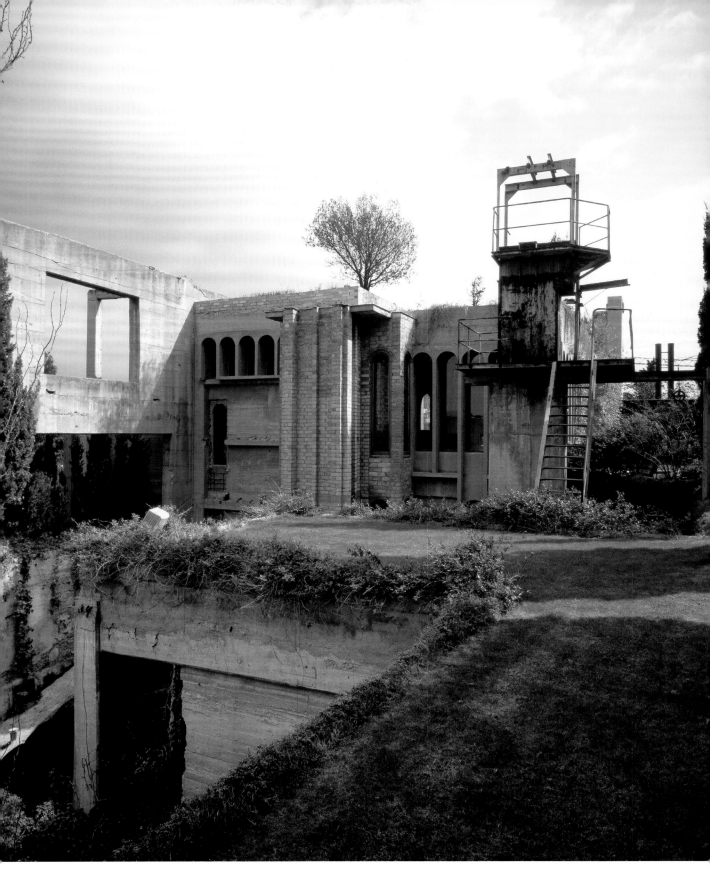

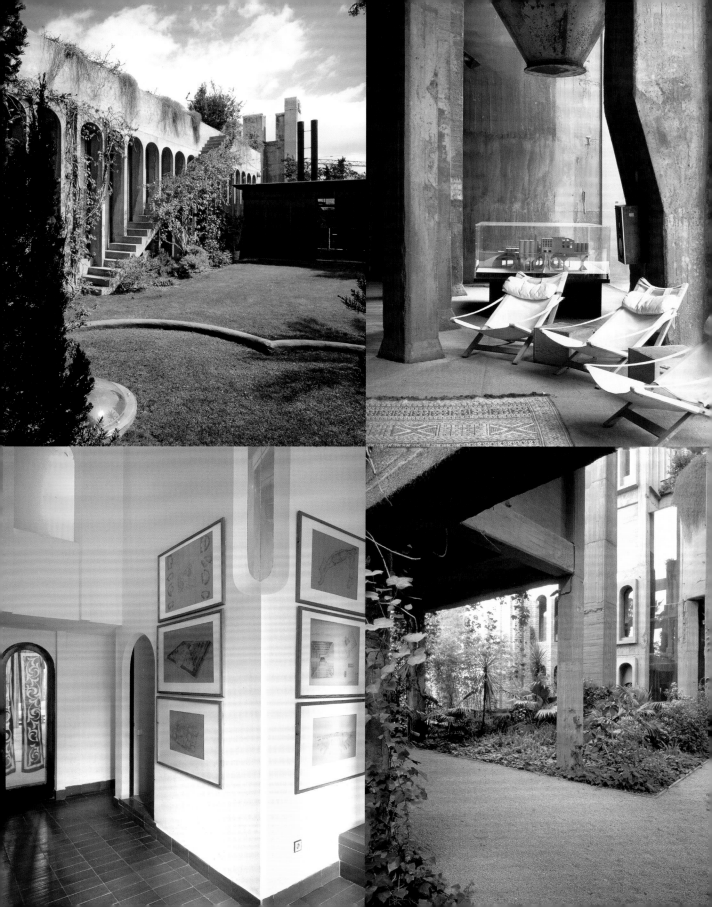

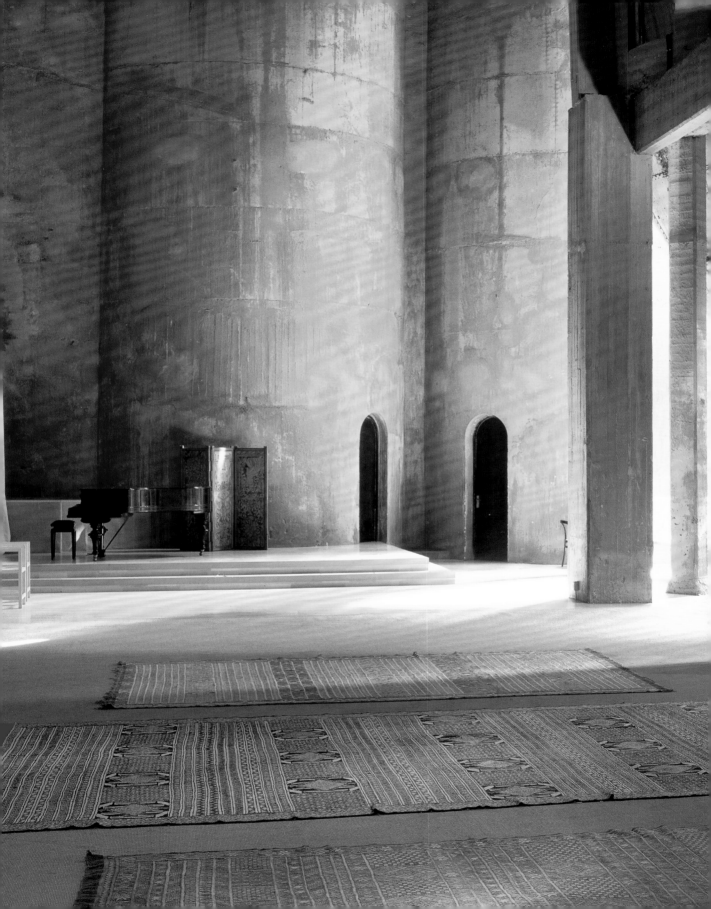

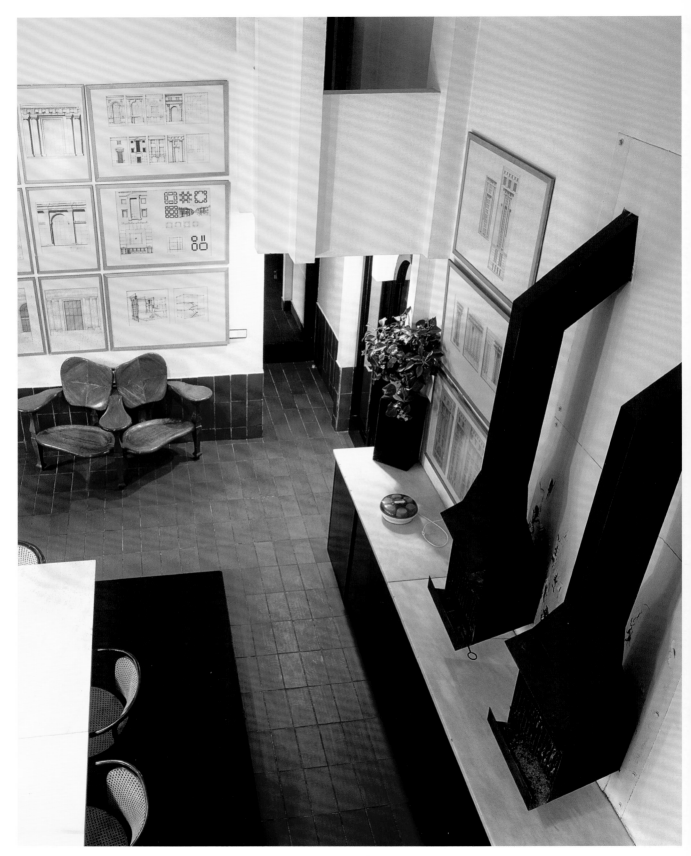

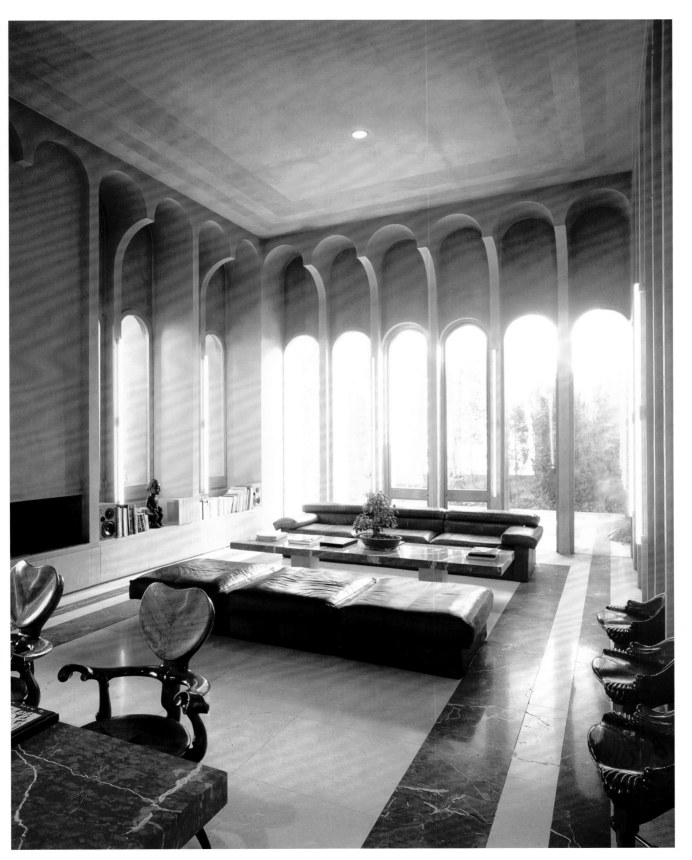

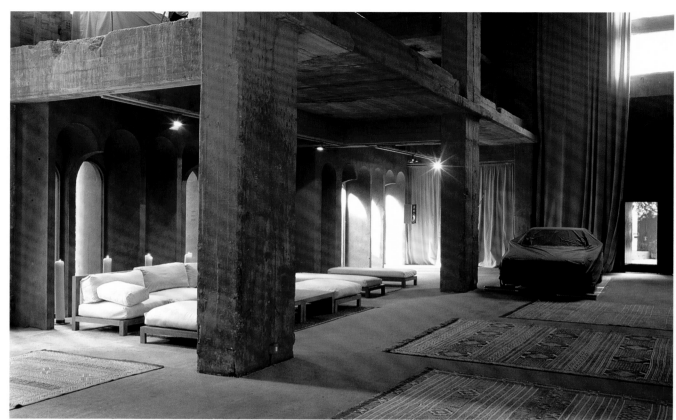

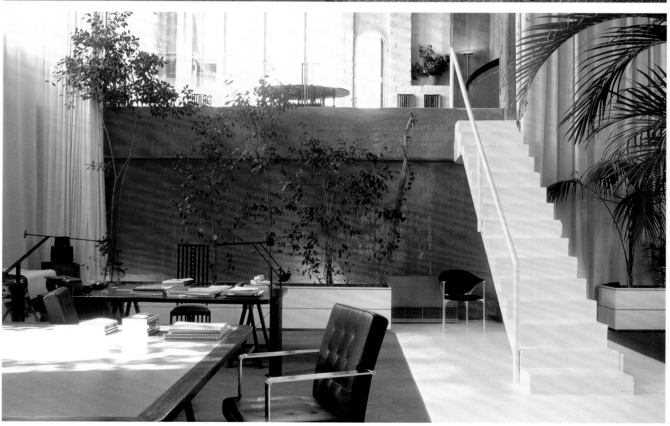

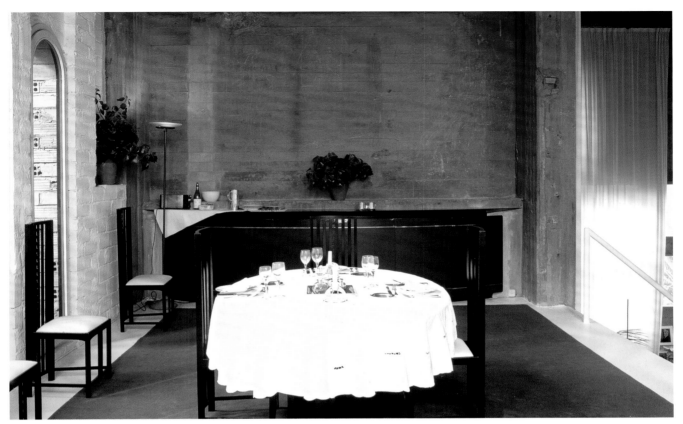

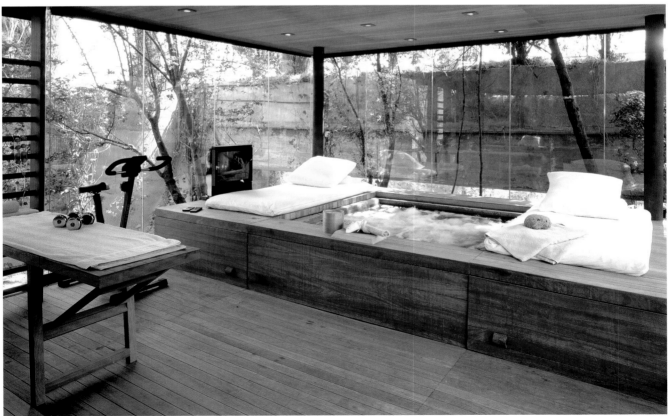

BASEL
Switzerland

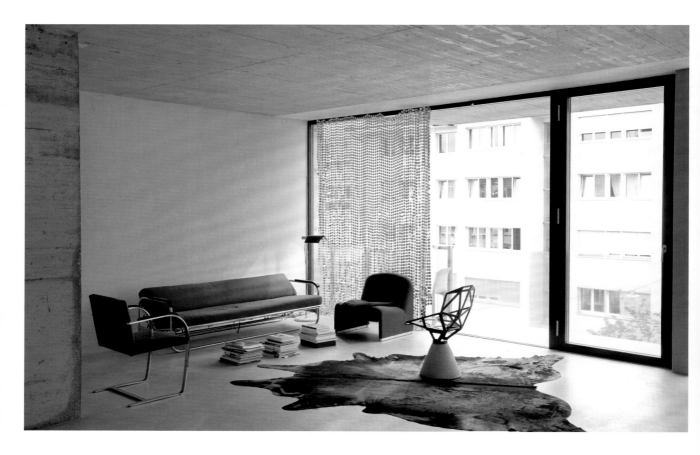

OWNERS
Daniel Buchner
Andreas Bründler

OCCUPATION
Architects

PROPERTY
Lofthouse
6 floors + 1 basement;
160 sqm / 1,720 sq ft per floor
1 room per floor; 1 bathroom per floor

YEAR
Building: 2002

ARCHITECTS & INTERIOR DESIGNERS
Buchner Bründler Architekten, Basel
www.bbarc.ch

ART
Takahiro Inamori; Luigi Moretti
"Villa La Saracena"; Bruno Rousseau

FURNITURE
Alvar Aalto red sofa; Giancarlo Piretti
"Alky" chair; Konstantin Grcic "One" chair;
Mies van der Rohe "Brno" chair; Alexander
Begge "Casalino" chair; Daniel Buchner
table & lamp; Charles & Ray Eames,
Eero Saarinen vintage chairs; Eero Aarnio
"Bubble" chair; 1950s vintage sofa; Charles
& Ray Eames "Soft Pad" chair; Patrick
Lindon "T71 Modular Furniture"; "itbed"
folding bed, It Design; Max Bill chairs

PHOTOGRAPHER
Giorgio Possenti, Vega MG, Milan

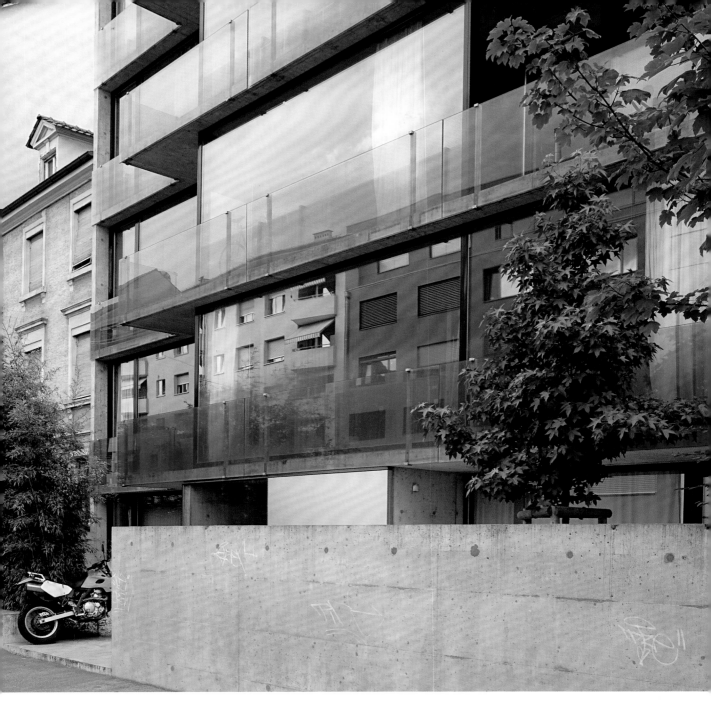

STYLE

The ceiling-high glazing contrasts with the rough concrete surfaces giving the apartment the aura of a loft. The sparse interior consists of vintage furniture, inherited items and the owners' designs, each piece linked with a story, a journey or an experience.

Raumhohe Verglasungen stehen im Kontrast zu rohen Beton-Oberflächen und verleihen der Wohnung Loftcharakter. Die reduzierte Einrichtung besteht aus Vintage-Möbeln, Erbstücken und eigenen Entwürfen. Jedes Stück ist mit einer Geschichte, einer Reise oder einem Erlebnis verbunden.

Les vitres montant jusqu'au plafond contrastent avec les surfaces en béton, donnant à l'appartement une atmosphère de loft. Le décor dépouillé est constitué de meubles vintage, d'objets de famille et de créations des propriétaires, chaque élément étant associé à une histoire, un voyage ou une expérience.

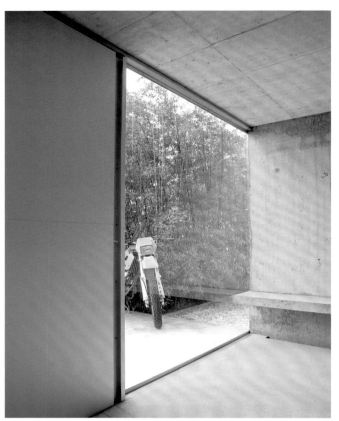

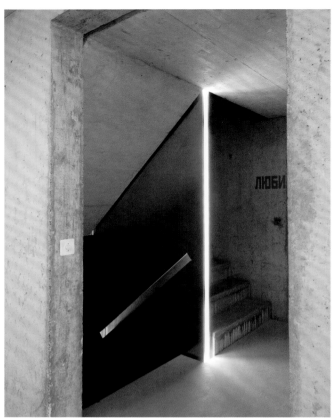

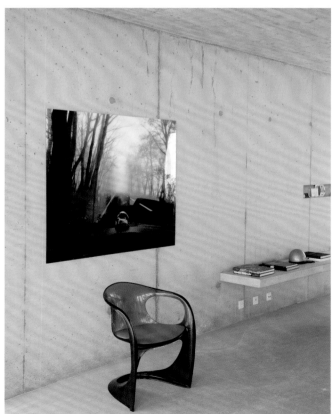

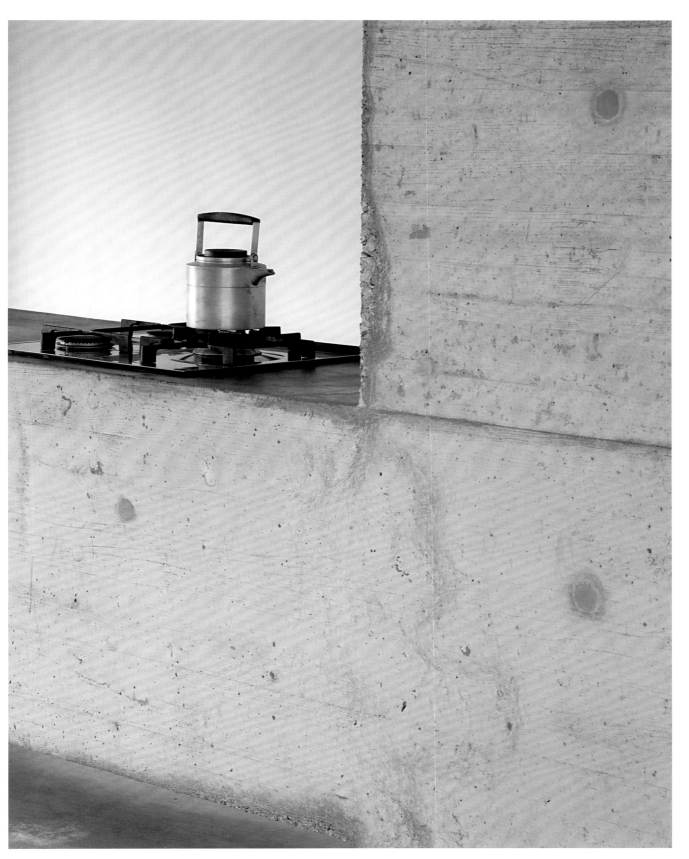

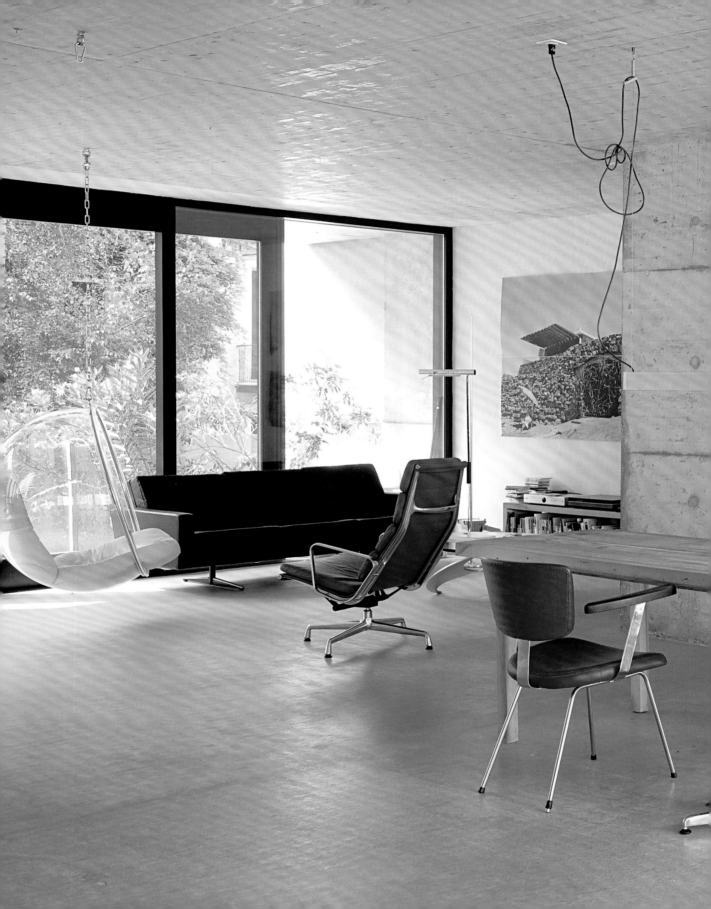

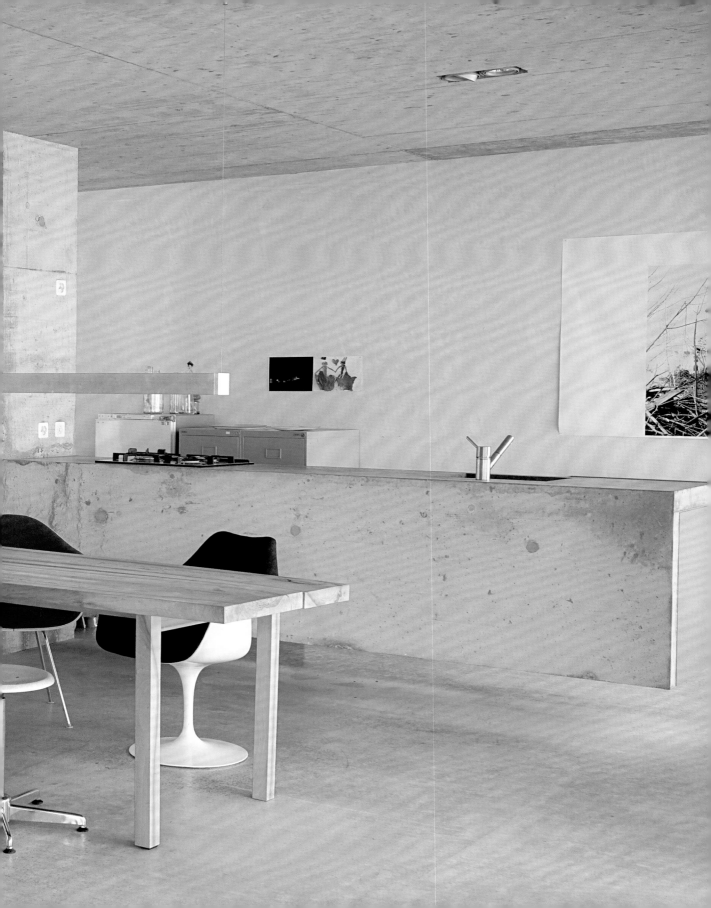

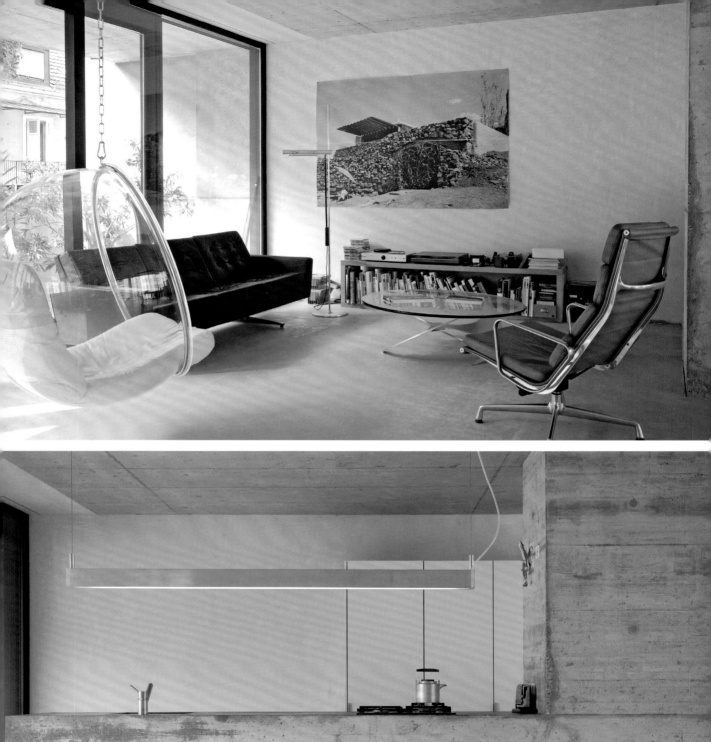

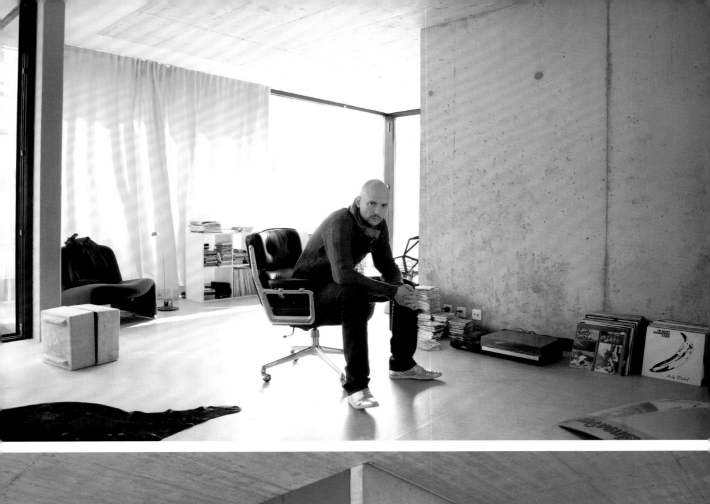
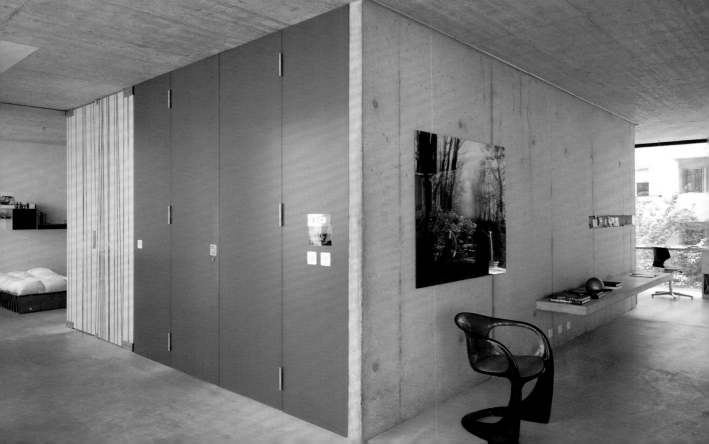

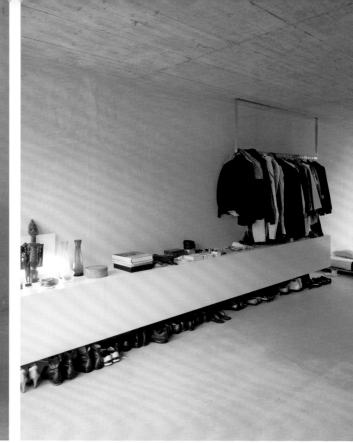
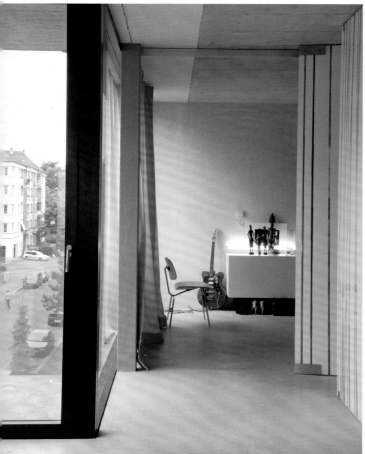
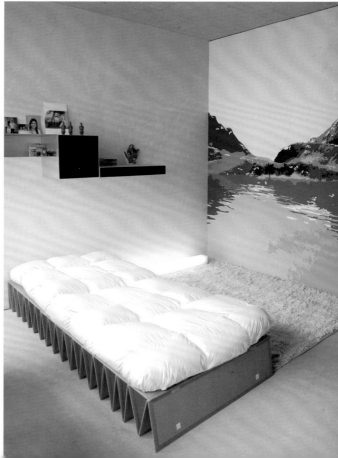

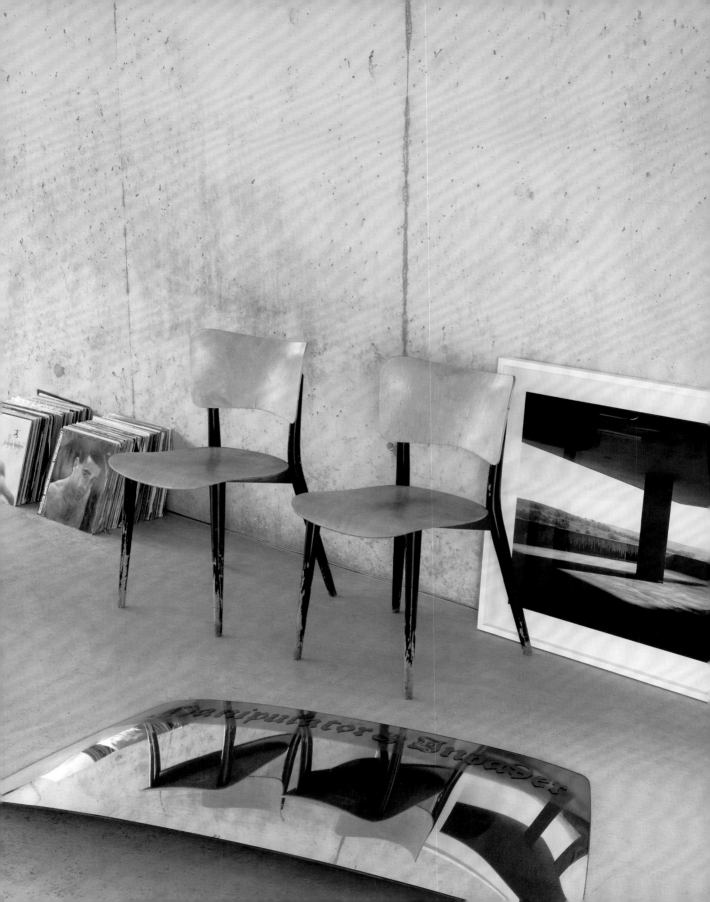

BEIJING
Shunyi District, China

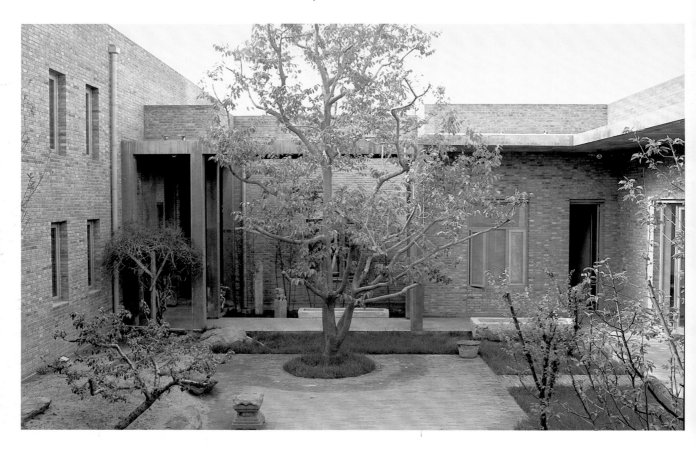

OWNERS
Anna Liu Li & Shao Fan

OCCUPATION
Artist

PROPERTY
Courtyard house
1,600 sqm / 17,200 sq ft
1 floor; 21 rooms; 8 bathrooms

YEAR
Building: 2003

ARCHITECT
Shao Fan, Shao Fan Studio, Beijing
www.shaofanart.com

INTERIOR & LANDSCAPE DESIGNERS
Anna Liu Li & Shao Fan
Shao Fan Studio, Beijing

ART
Shao Fan paintings & sculptures

FURNITURE
Shao Fan "deconstructed" furniture;
Chinese & Tibetan antique furniture;
Qing Dynasty Buddha sculptures

PHOTOGRAPHER
Reto Guntli / TASCHEN GmbH
www.zapaimages.com

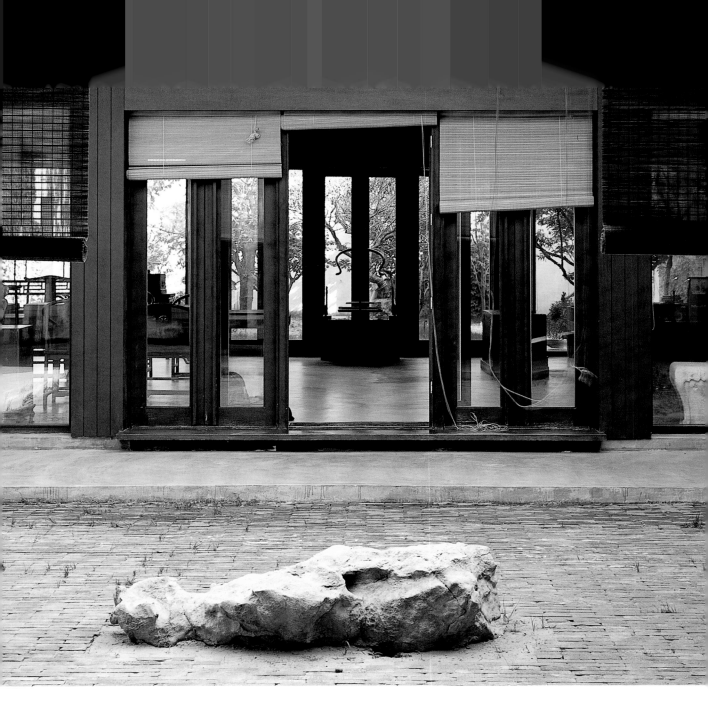

STYLE

The style of the building is about extending the habits and the ways in which traditional Chinese people live. Shao Fan calls his building style contemporary courtyard living. Only a small range of low-key materials were used so that the interiors and the outdoor courtyards form a coherent whole.

Stilistisch versucht das Haus, die Gewohnheiten und die traditionelle Lebensweise der Chinesen zu erweitern. Shao Fan bezeichnet seinen Gebäudestil als »zeitgenössisches Innenhofleben«. Es wurde nur eine kleine Auswahl schlichter Materialien verwendet, sodass die Innenräume und der Hofbereich konsistent sind.

Le concept de cette demeure est d'élargir les coutumes et le mode de vie traditionnels chinois. Shao Fan appelle ce style « vie moderne ouverte sur l'extérieur ». Les matériaux ont été choisis sobres et peu variés pour assurer une cohérence entre les intérieurs et les cours.

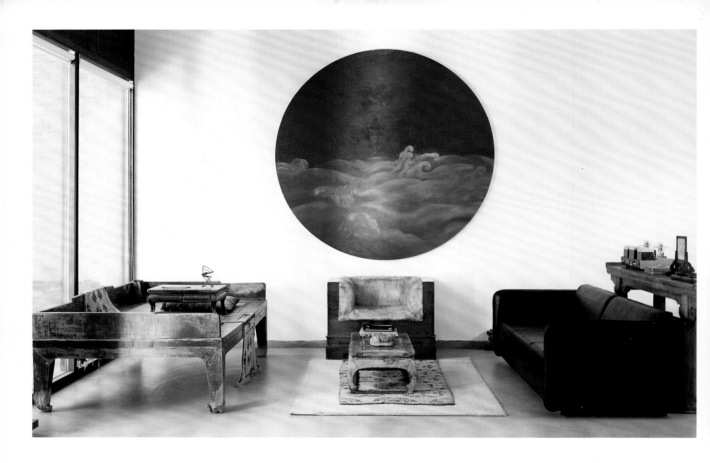

"Different interior designs represent the different aesthetics and views a person has of the world."

»Die jeweilige Einrichtung repräsentiert die Ästhetik und die Weltsicht eines Menschen.«

«Les différents styles de décoration reflètent les différents sens esthétiques et visions qu'une personne a du monde.»

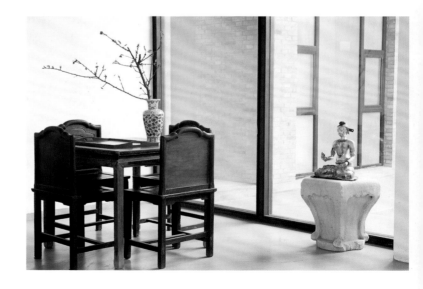

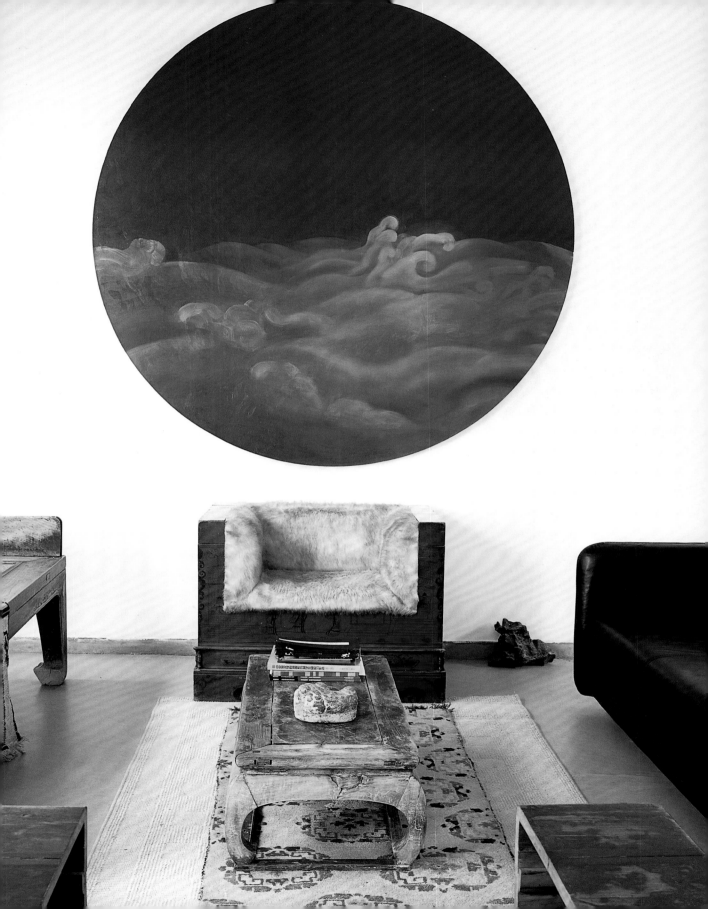

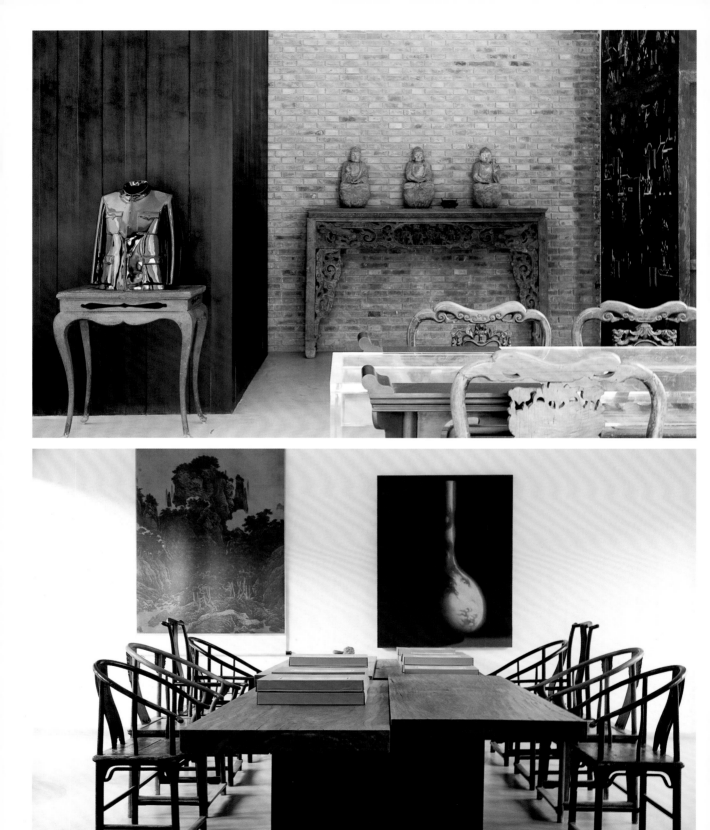

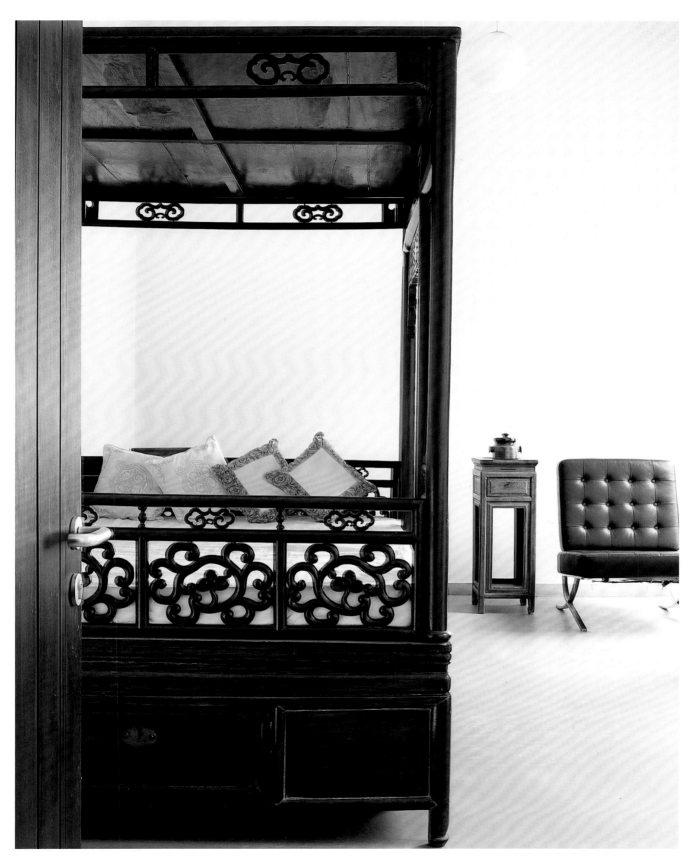

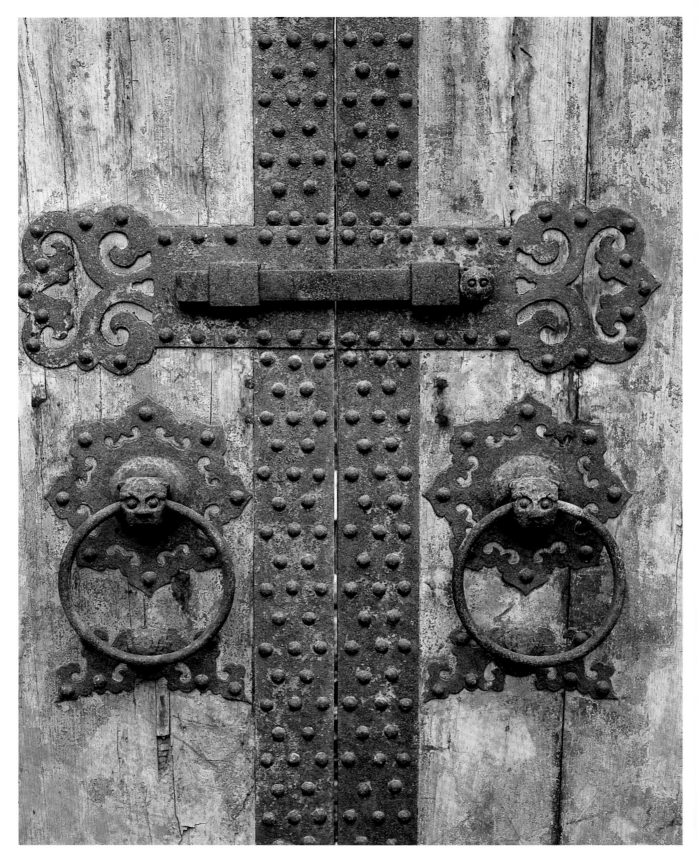

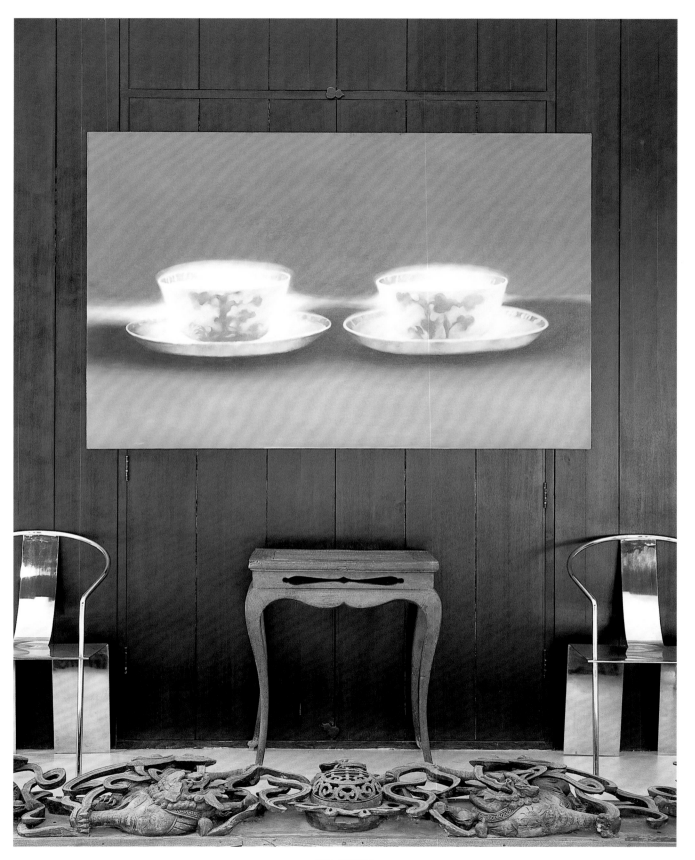

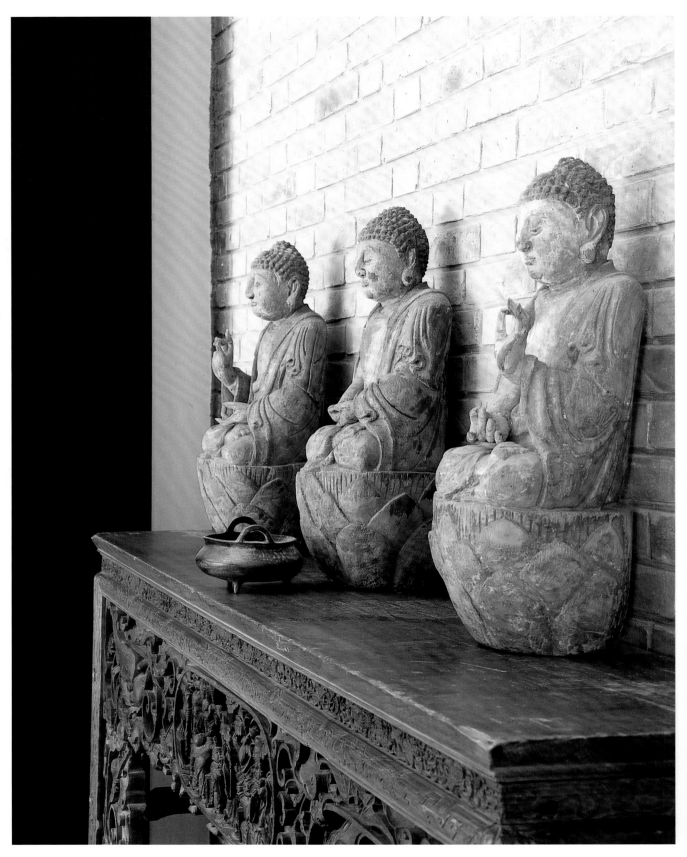

"I believe design is split into two directions: the first is heightening people's desire for material goods, the second is reducing people's desire for material goods."

»Ich glaube, Design spaltet sich in zwei Richtungen auf. Die eine verstärkt das Verlangen nach materiellen Dingen, die andere vermindert das Verlangen nach materiellen Gütern.«

« Je pense que le design est tiraillé entre deux directions : la première cherche à accroître le désir de biens matériels, la seconde à le réduire. »

BERLIN

Germany

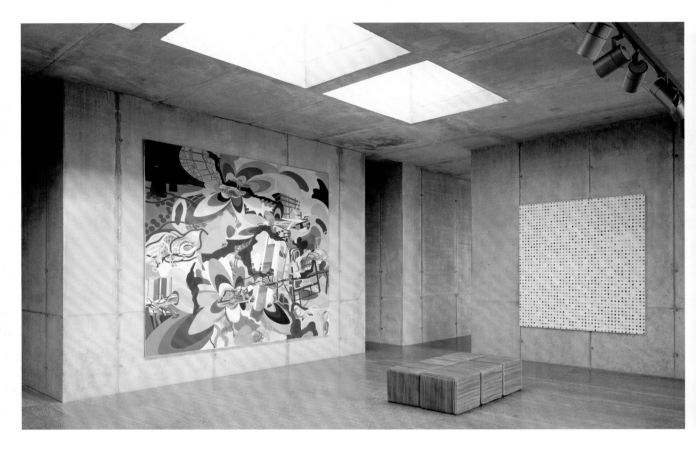

OWNERS
Karen Lohmann & Christian Boros

OCCUPATION
Art historian / Media entrepreneur,
art collectors

PROPERTY
Penthouse
1,000 sqm / 10,750 sq ft
1 floor; 9 rooms; 2 bathrooms

YEAR
Air-raid bunker: 1942 (Karl Bonatz)
Remodelling + penthouse: 2004–2008

ARCHITECT & INTERIOR DESIGNER
Jens Casper, Realarchitektur, Berlin
www.jenscasper.com

LANDSCAPE DESIGNER
Timo Herrmann, bbz, Berlin
www.bbz.la

ART
Franz Ackermann; Damien Hirst; Elizabeth
Peyton; Terence Koh; Wolfgang Tillmans;
Thomas Scheibitz; Olivia Berckemeyer;
Olafur Eliasson; Friedrich Kunath; Katja
Strunz; Enrico David; et al.

FURNITURE
Warren Platner; Oscar Niemeyer; Florence
Knoll; Hans J. Wegner; Mies van der
Rohe; Martin Eisler; Charles & Ray Eames;
Tommaso Barbi; Georg Hornemann; Venini
chandeliers; Chinese & Japanese antique
furniture; old German cottage bed

PHOTOGRAPHER
Noshe / TASCHEN GmbH
www.noshe.com

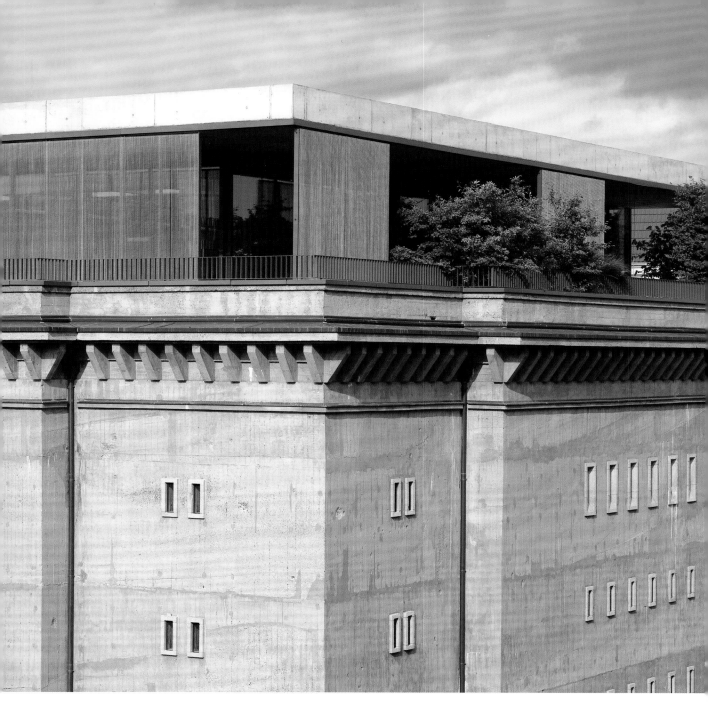

STYLE

By removing ceilings and walls, the 120 small low rooms of the original bunker were converted into 80 that were suitable for presenting the owners' art collection. In contrast to the dark bunker rooms that have no daylight, the penthouse built on top is surrounded, like Mies van der Rohe's National Gallery, by glass casing through which light can flow freely.

In dem Kriegsbunker wurden aus den ehemals 120 kleinen, niedrigen Räumen, 80 Orte geschaffen, um die Kunstsammlung zu präsentieren. Im Gegensatz zu den dunklen Räumen des Bunkers umgab man das daraufgebaute Penthouse ähnlich wie Mies van der Rohes Nationalgalerie mit einer Glashülle, durch die das Licht die Wohnräume durchfluten kann.

Dans ce qui était un bunker antiaérien, on a créé, à partir de 120 petits espaces bas de plafond, 80 pièces qui abritent la collection d'art. Contrastant avec les sombres pièces sans lumière diurne du bunker, le penthouse construit au-dessus a été doté, un peu comme la Nationalgalerie de Mies van der Rohe, d'une enveloppe de verre qui laisse pénétrer beaucoup de lumière.

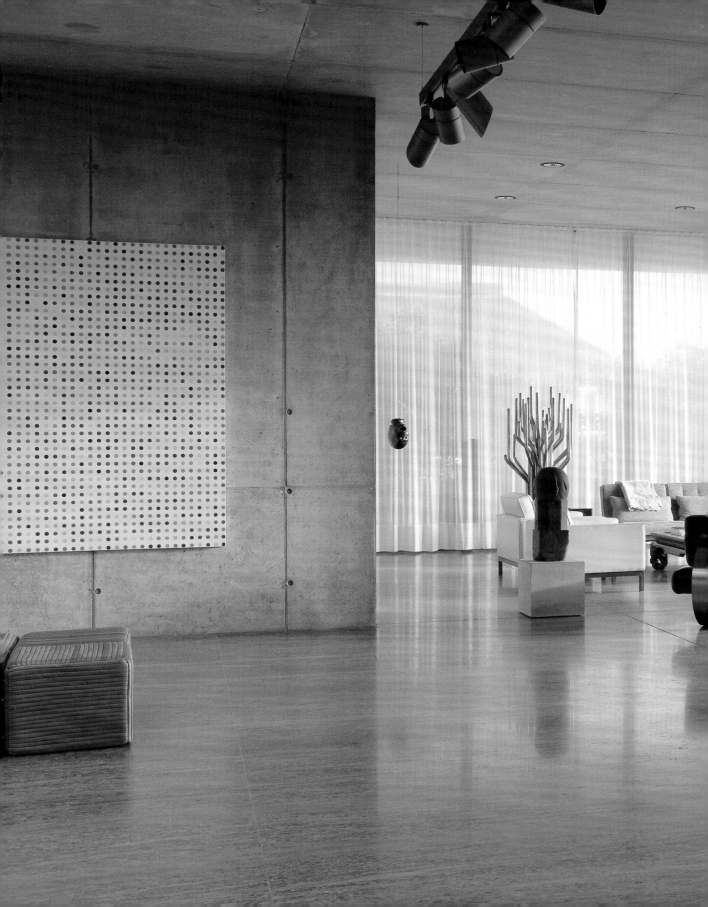

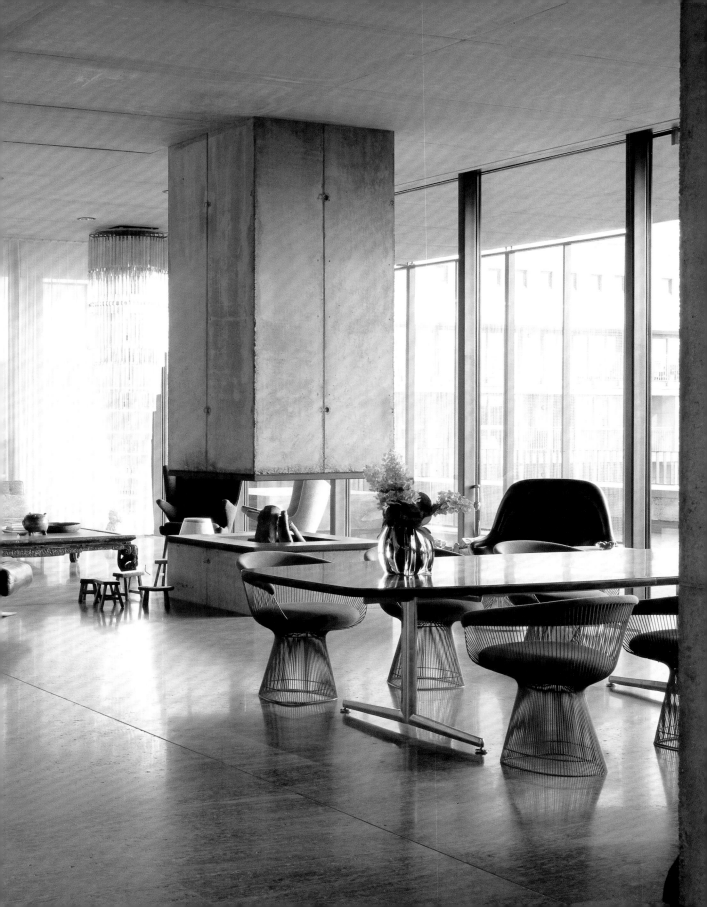

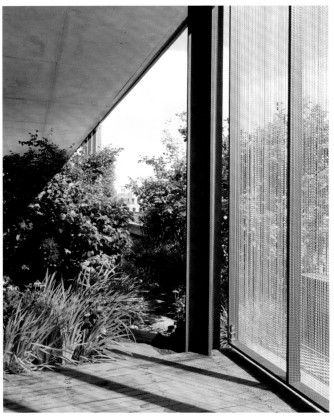
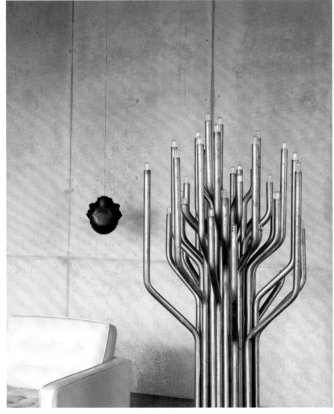

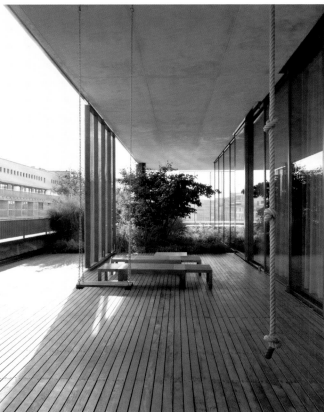

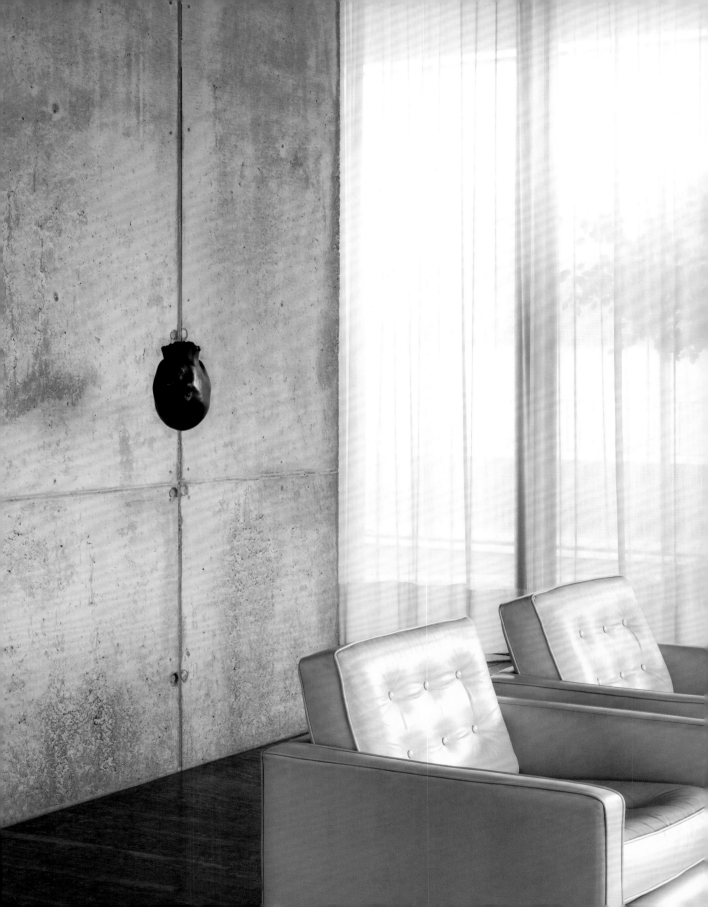

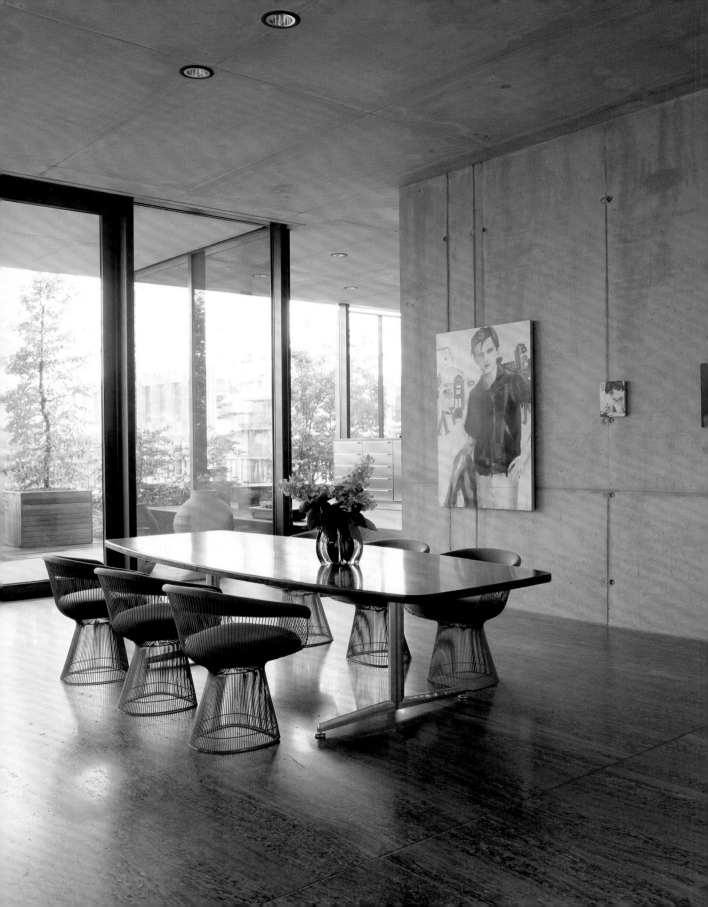

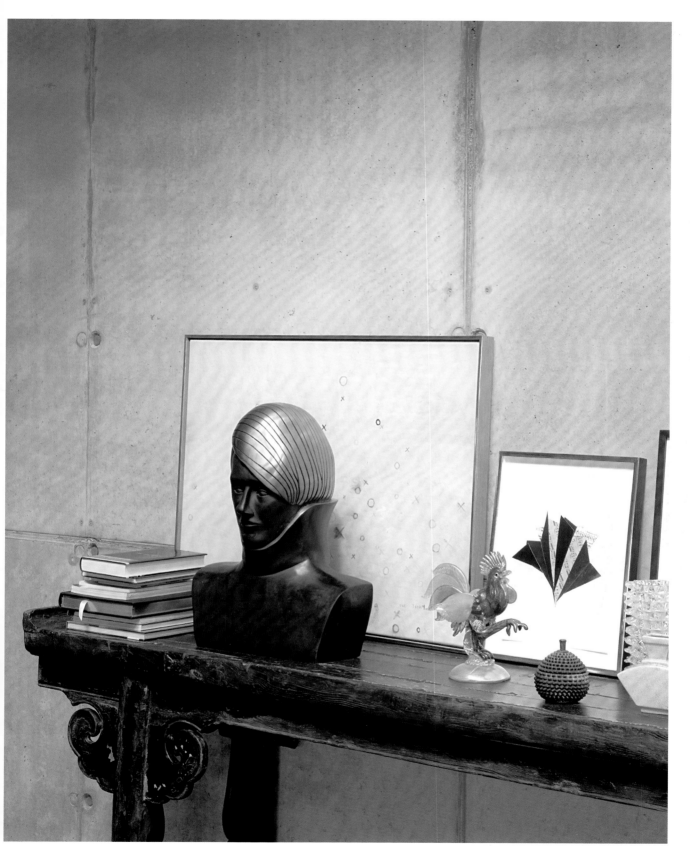

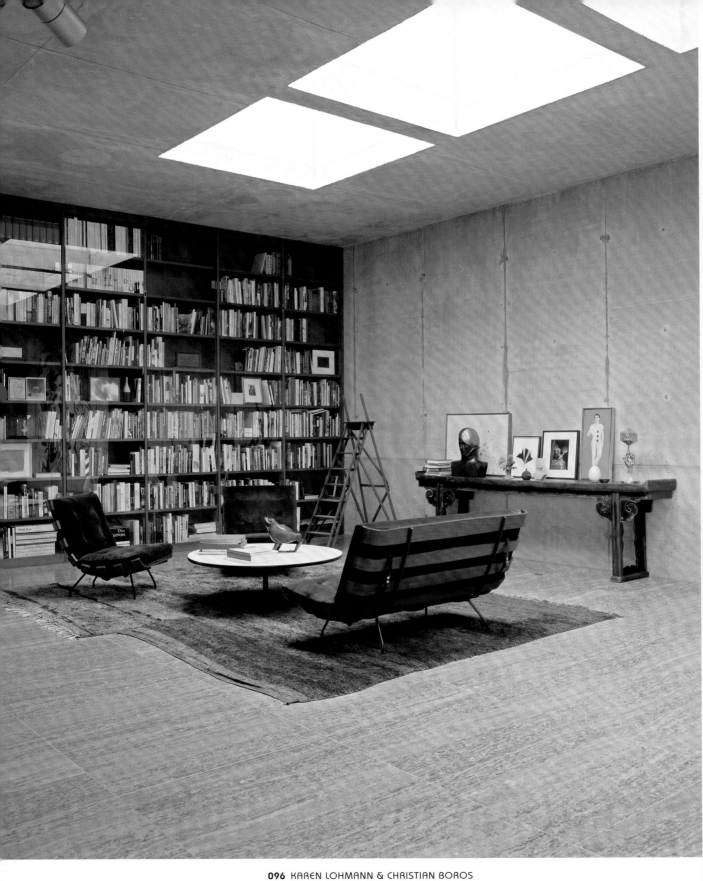

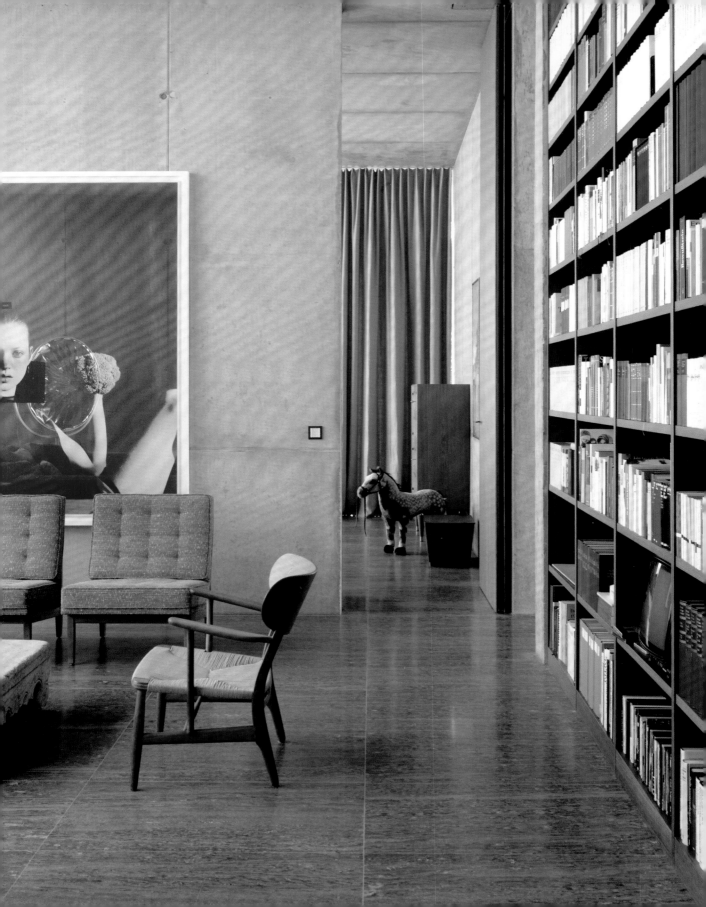

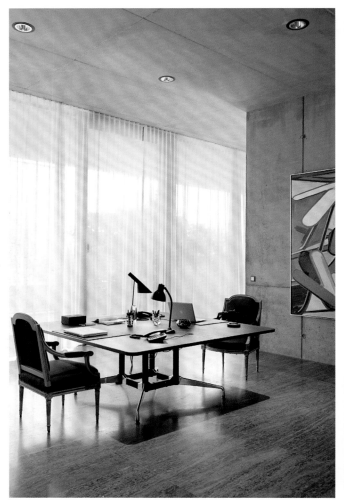

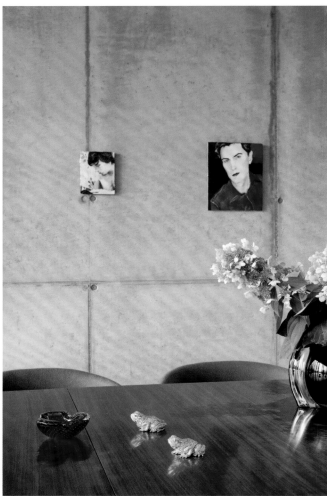

"Only art has the power
to turn a bunker into
something that is relevant
to us today."

»Nur die Kunst hat die Kraft,
aus einem Bunker etwas für uns
heute Relevantes zu machen.«

« Seul l'art a le pouvoir de
transformer un bunker en un
espace qui nous parle aujourd'hui. »

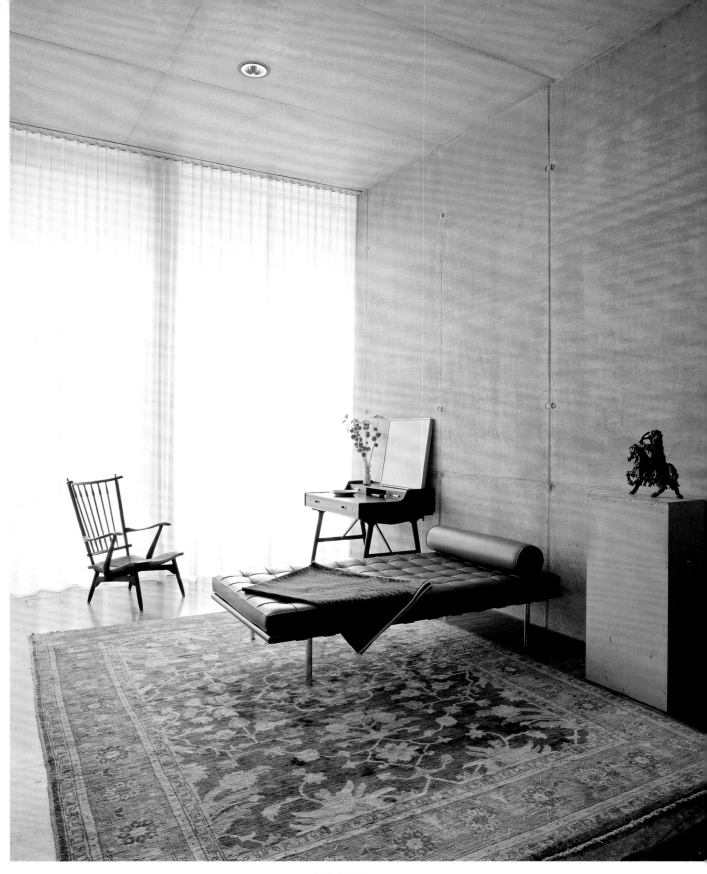

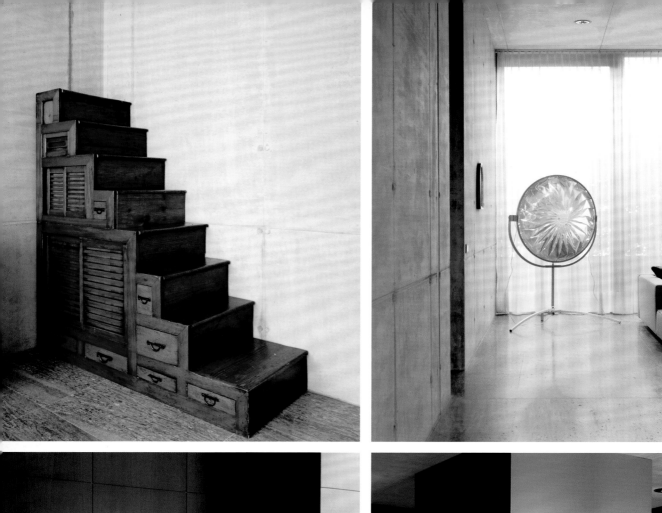
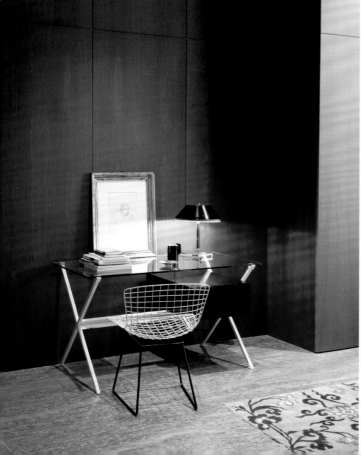
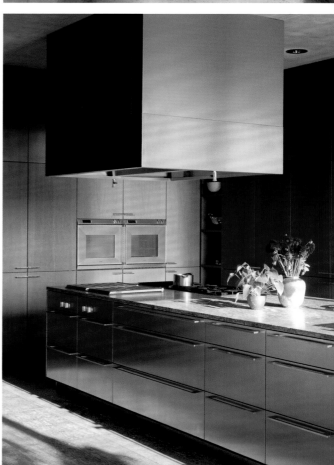

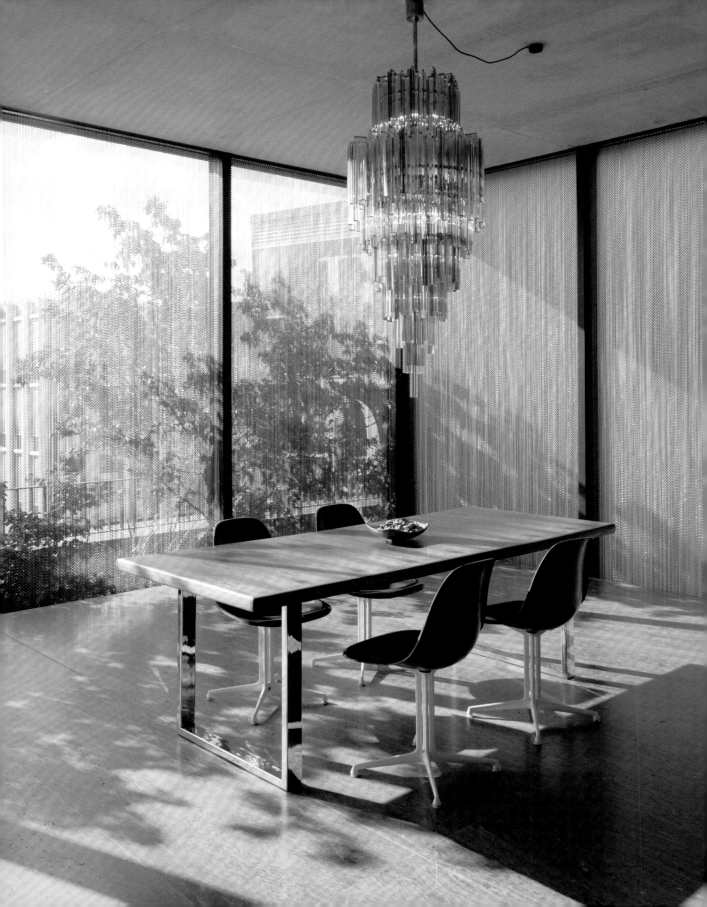

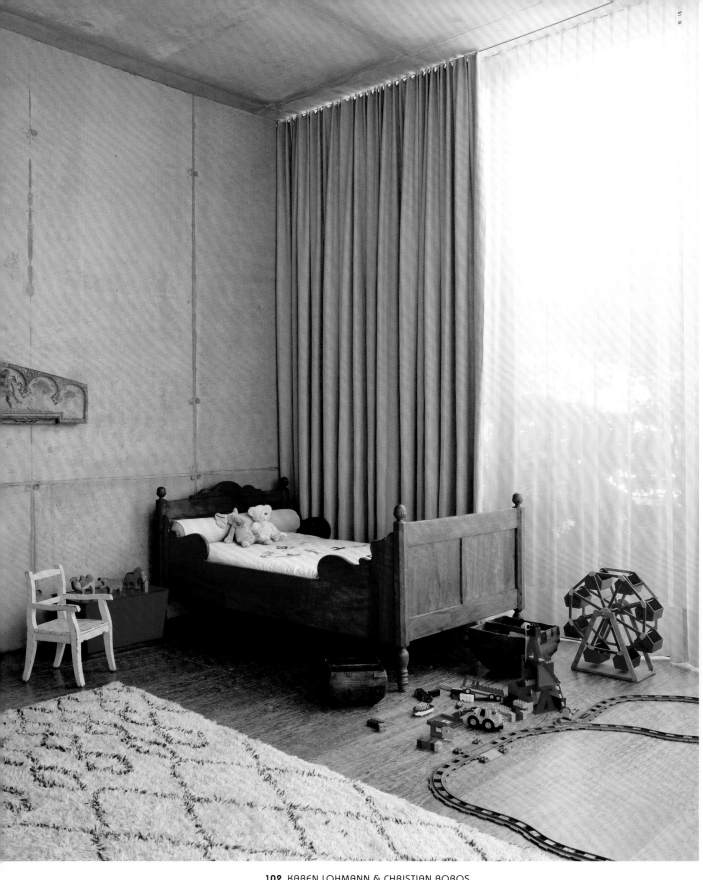

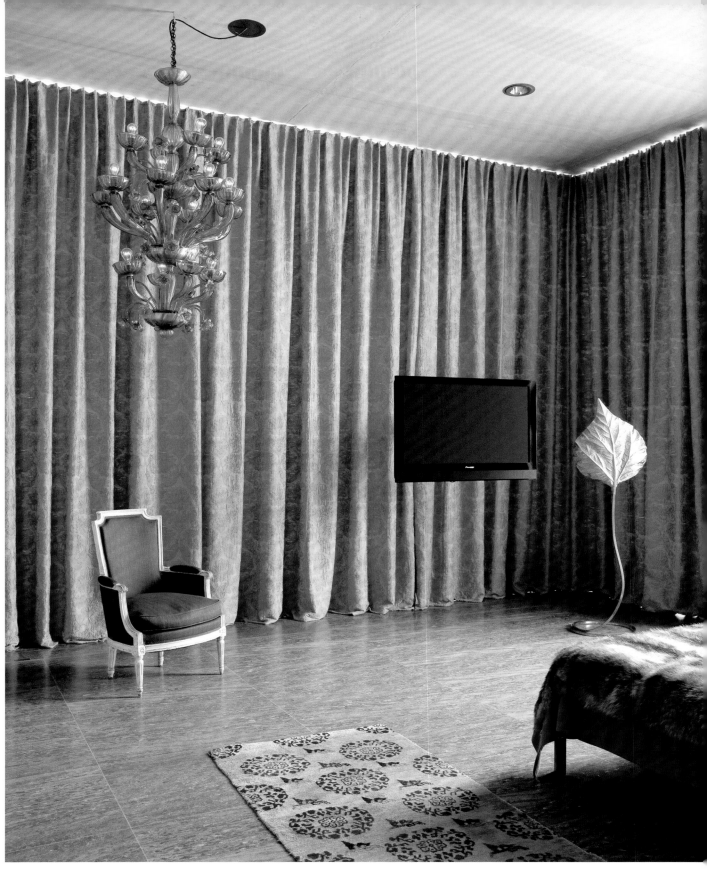

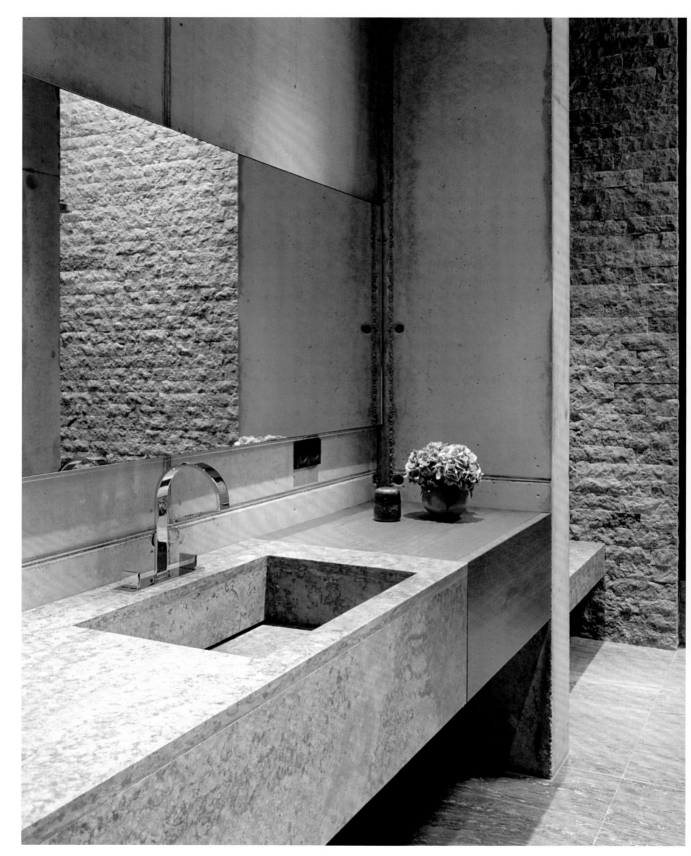

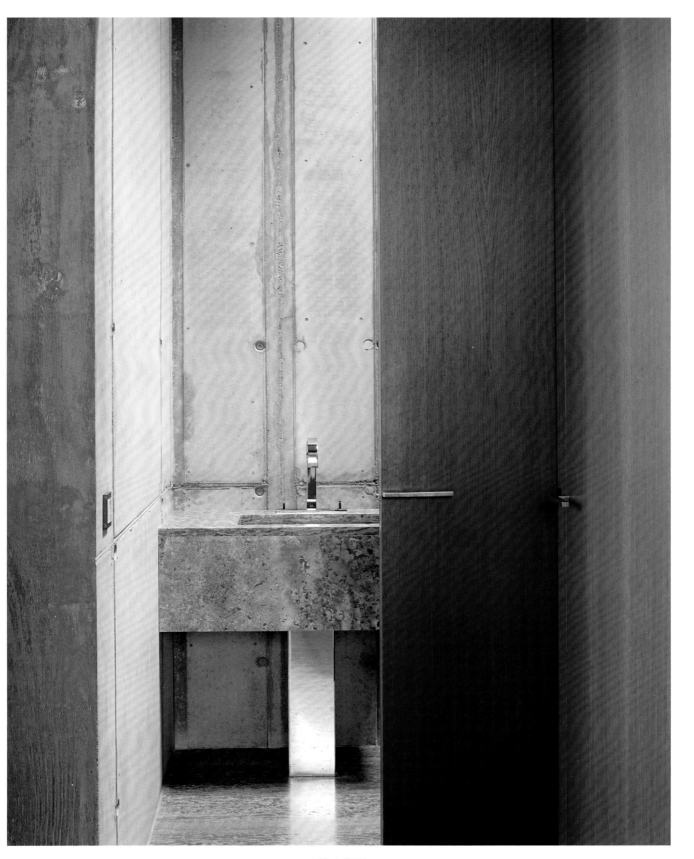

BERLIN

Germany

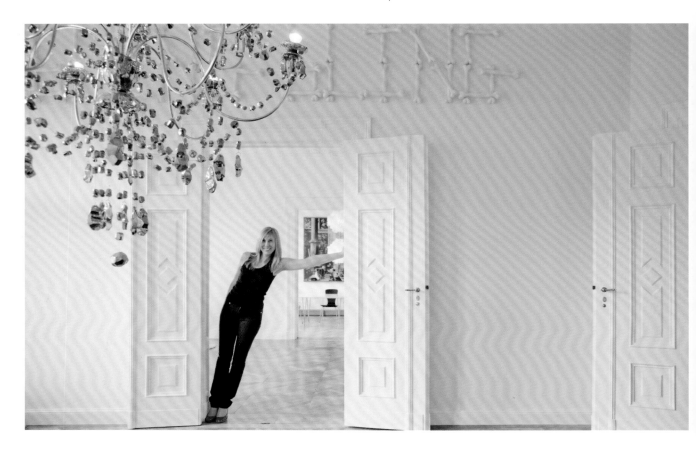

OWNER

Angelika Taschen

OCCUPATION

Publisher

PROPERTY

Apartment
230 sqm / 2,475 sq ft
1 floor; 6 rooms; 2 bathrooms

YEAR

Building: 1865
Remodelling: 2004

ARCHITECT

David Adjaye, London
www.adjaye.com

ART

Pae White chandelier; Nathan Mabry;
Thomas Struth; Martin Eder; Thomas Ruff;
Wolfgang Tillmans; Emilie Halpern; Portia
Hein; Martin Kippenberger; Juergen Teller

FURNITURE

Ferdinand Kramer grey "Knock Down"
table; Irwin & Estelle Laverne black "Lotus"
chairs; Tapio Wirkkala black "Nikke" chairs;
Rolf Heide stacking bed; Sigurd Resell chair;
Paavo Tynell lamp; Marcel Breuer side table;
Minotti sofa; Eero Aarnio "Cognac" chairs;
Piet Hein/Bruno Mathsson white table; Harry
Bertoia yellow "Diamond" chair; Verner
Panton "Fun" lamps & red "1-2-3 System"
seat; "PS" sideboards, Ikea; Arne Jacobsen
"Series 7" chairs; Ingo Maurer "Uchiwa"
lamp; Joe Colombo white "4801" chair

PHOTOGRAPHER

David Hiepler & Fritz Brunier, Berlin
www.hiepler-brunier.de

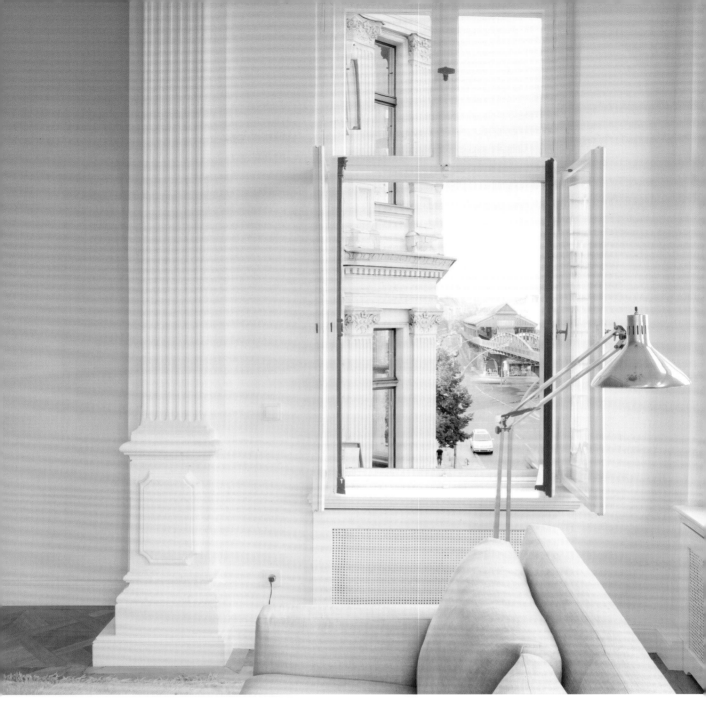

STYLE

David Adjaye has conceived the apartment in two halves: the rooms to the front remain 1865-style, with stucco ceilings, while those to the back have brilliant cast-resin floors, strict ceiling light lines and cubic built-in components. The heart of the apartment, linking the two halves, is a corridor in deep black stucco lustro.

David Adjaye hat die Wohnung in zwei Hälften konzipiert, in den vorderen Räumen blieben die Stuckdecken anno 1865 erhalten, die Räume nach hinten raus erhielten einen hochglänzenden Gießharzboden, strenge Lichtlinien an der Decke und kubische Einbauten. Das Herz der Wohnung, das die beiden Teile miteinander verbindet, ist ein in schwarzem Stucco Lustro ausgekleideter Flur.

David Adjaye a conçu l'habitation en la divisant en deux : les pièces du devant, avec plafonds en stuc, sont restées telles qu'en 1865 ; celles de derrière ont été dotées d'un sol en résine coulée très brillante, de strictes bandes lumineuses au plafond et d'équipements cubiques. Le cœur de l'appartement, qui relie les deux parties, est un couloir revêtu d'un noir stucco lustro.

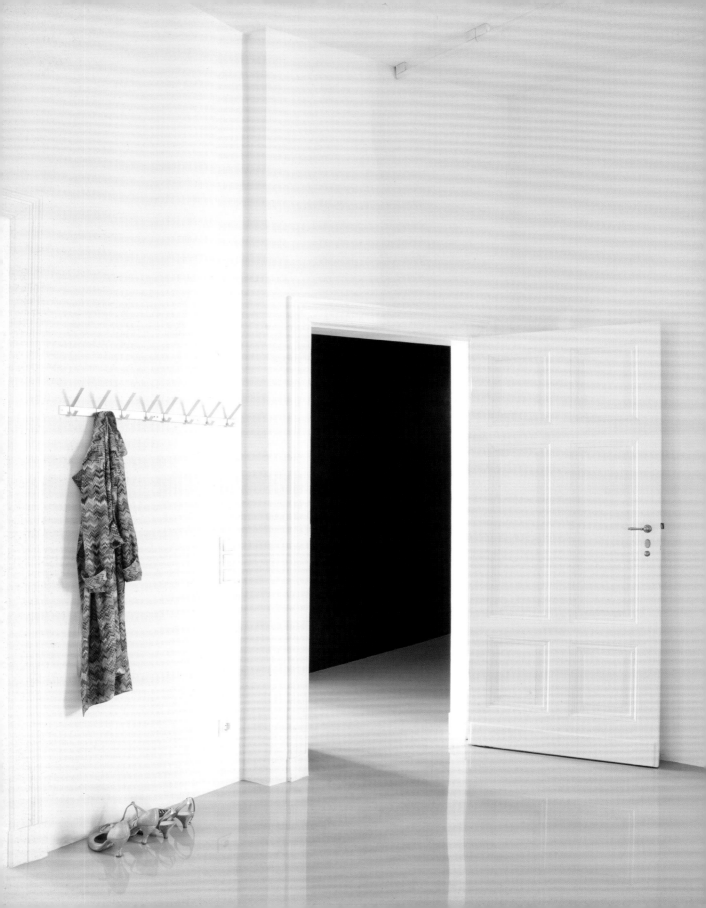

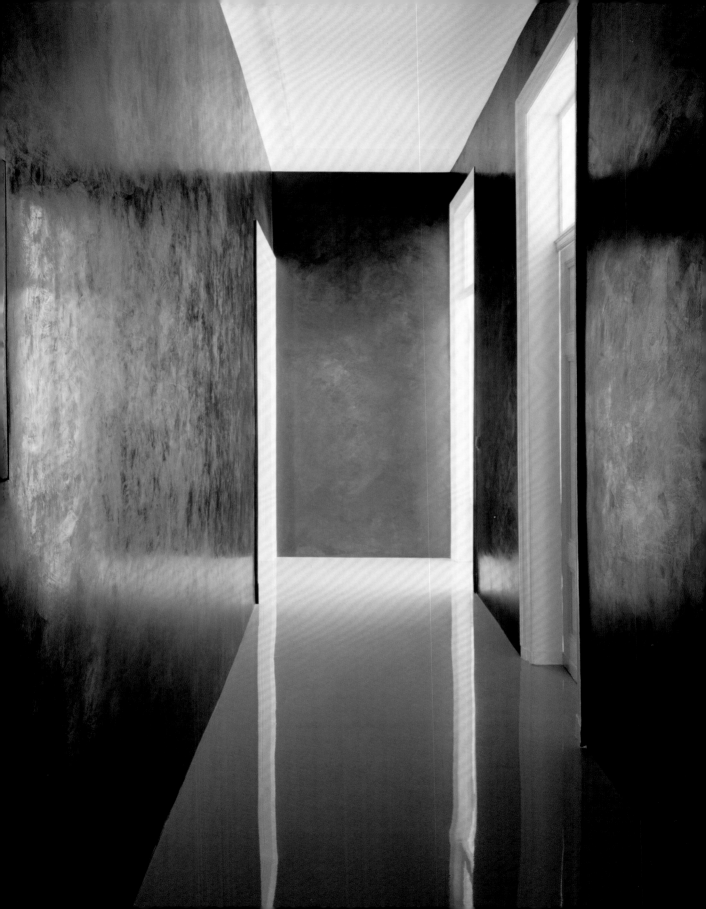

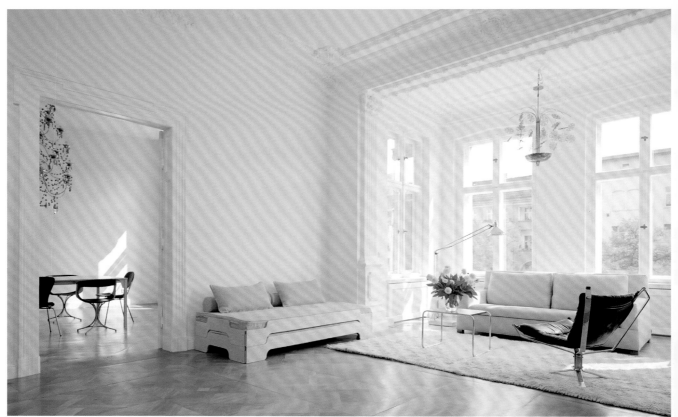

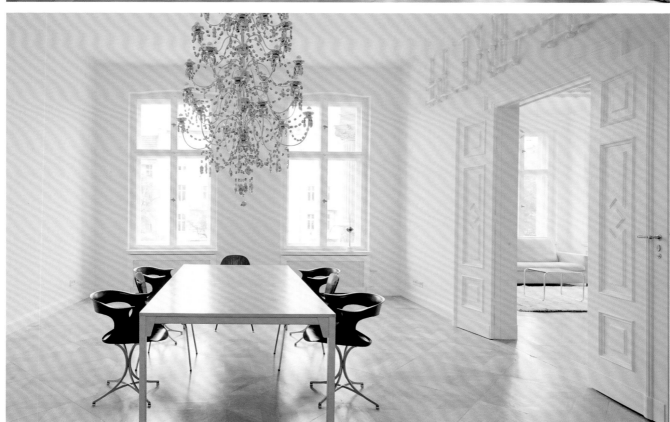

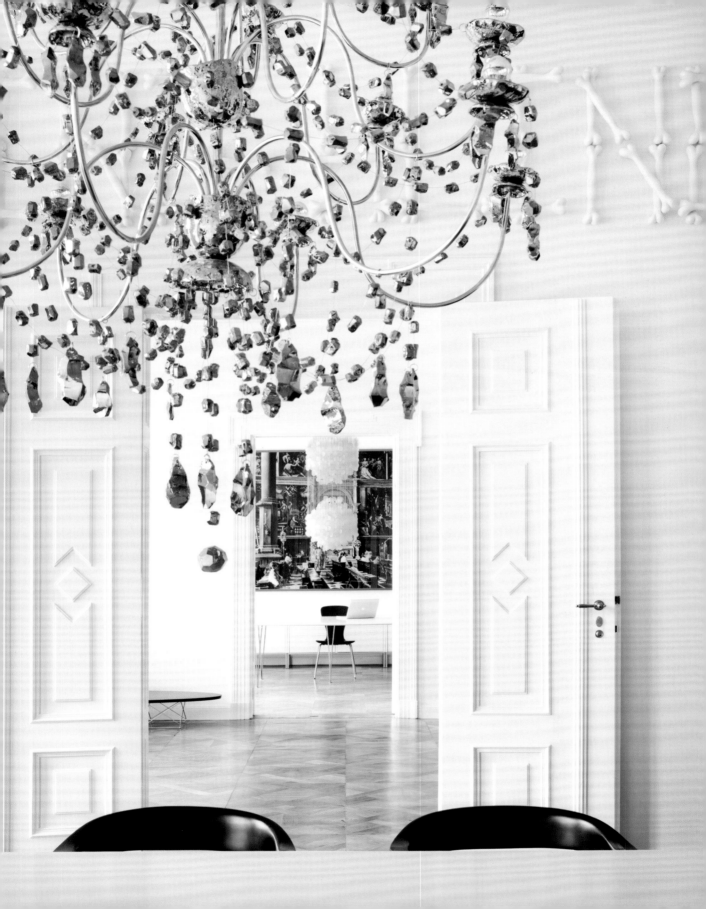

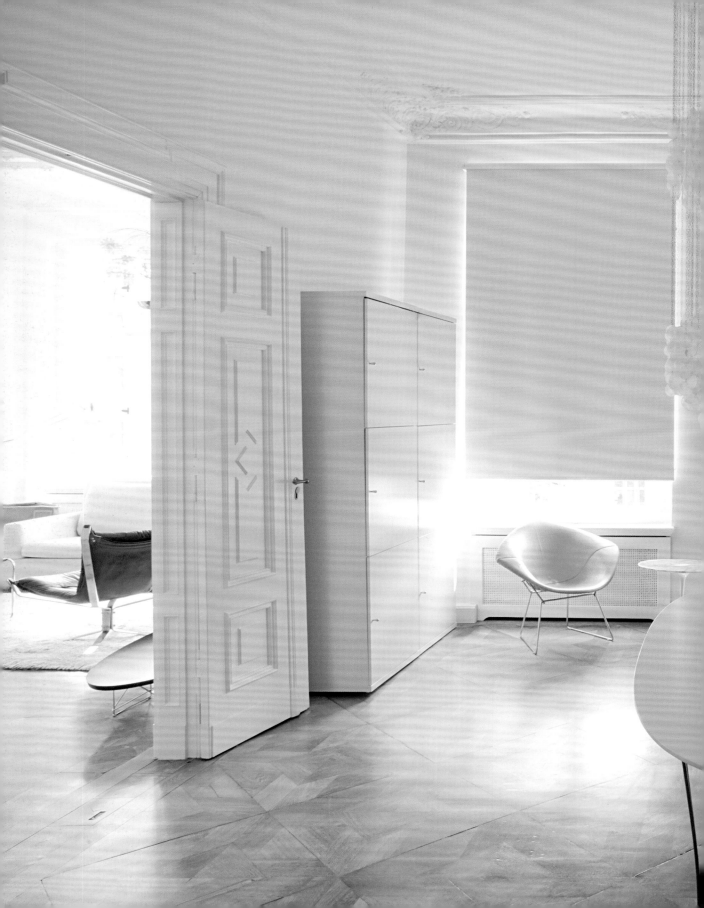

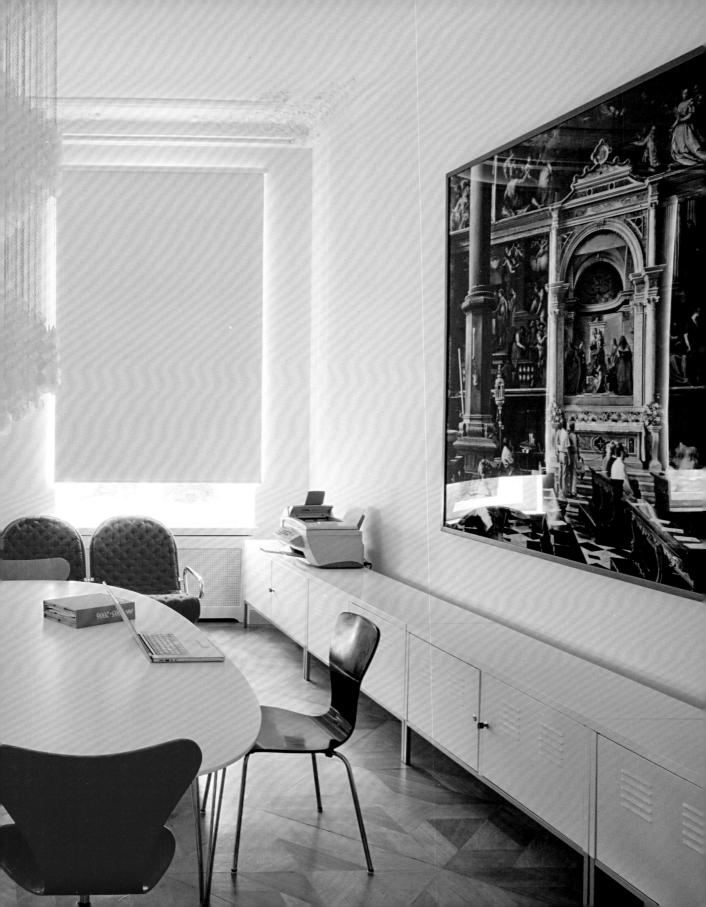

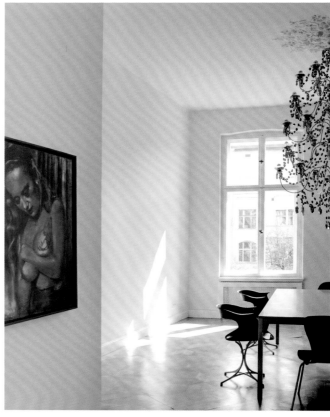

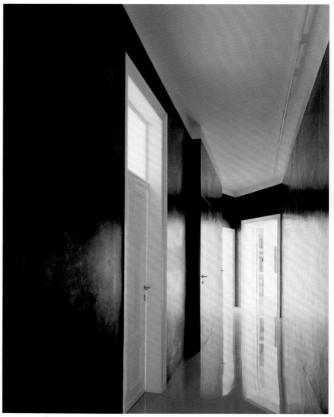

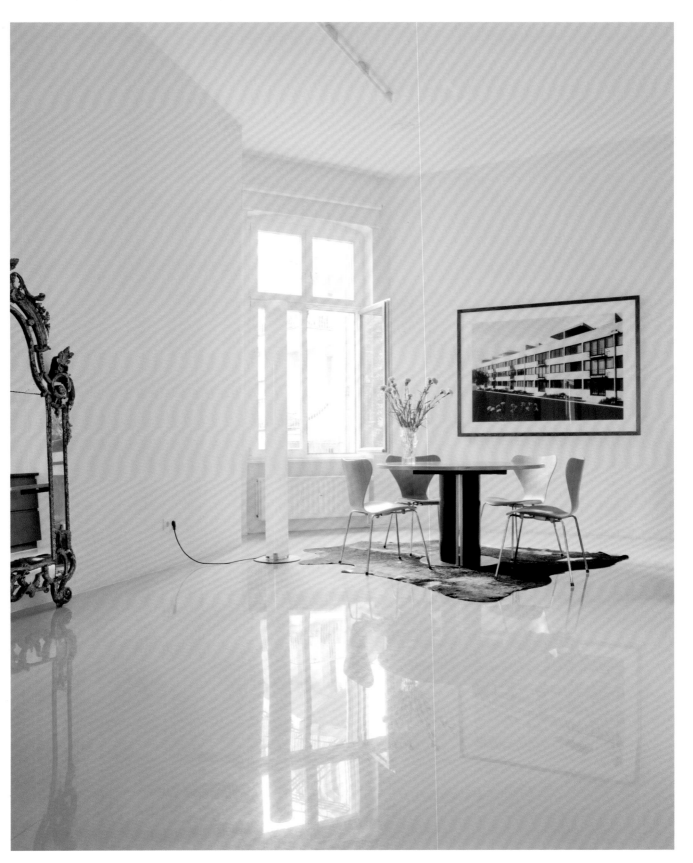

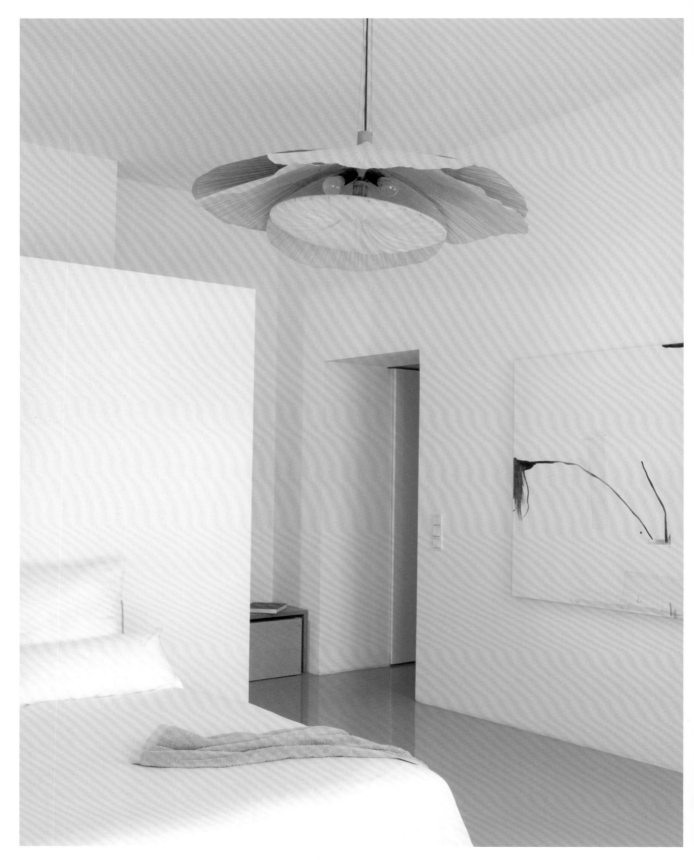

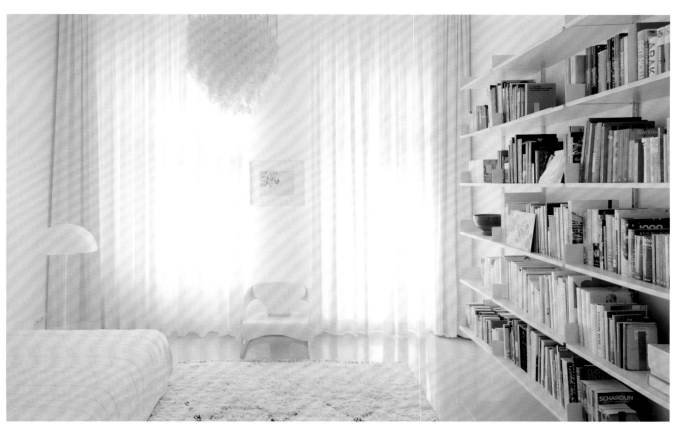

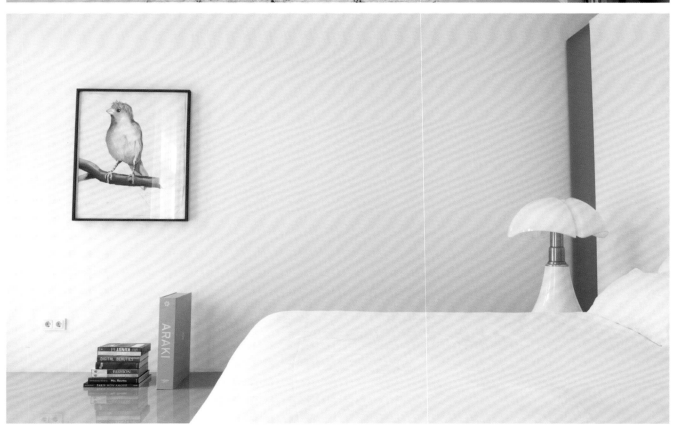

BERLIN
Nikolassee, Germany

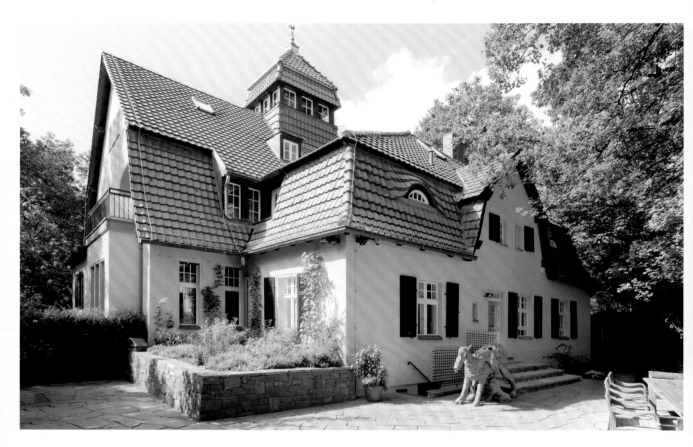

OWNERS
Nicole Hackert & Bruno Brunnet

OCCUPATION
Gallerists

PROPERTY
Villa
600 sqm / 6,450 sq ft
3 floors; 12 rooms; 6 bathrooms

YEAR
Building: 1908
Remodelling: 2006

ARCHITECTS
Emilie Winkelmann for Julie Meyer, 1908
Reconstruction 2006
Thomas Hillig Architekten, Berlin
www.hillig-architekt.de

INTERIOR DESIGNER
The owner in cooperation with
Etchika Werner (d 2008)

LANDSCAPE DESIGNER
Hartmut Teske
www.hartmut-teske.de

ART
Jonathan Meese; Tal R (Tal Rosenzweig);
Norbert Schwontkowski; Georg Baselitz;
Dash Snow; Daniel Richter; Dana Schutz;
Cecily Brown; Peter Doig; Uwe Lausen

FURNITURE
Hermann Muthesius original chair & lamp
(remodelled); Arne Jacobsen blue "Egg"
chair; Savoir beds; Moroccan tribal carpets

PHOTOGRAPHER
David Hiepler & Fritz Brunier, Berlin
www.hiepler-brunier.de

STYLE
"The term 'interior design' gives us the
creeps. It's got to be a 'lived' experience."

»Wenn wir den Begriff ›Interiordesign‹
hören, wird uns übel. Es muss eine gelebte
Erfahrung sein.«

« Le terme ‹ décoration d'intérieur › nous
donne la chair de poule. Il faut que ce soit
une expérience ‹ vécue ›. »

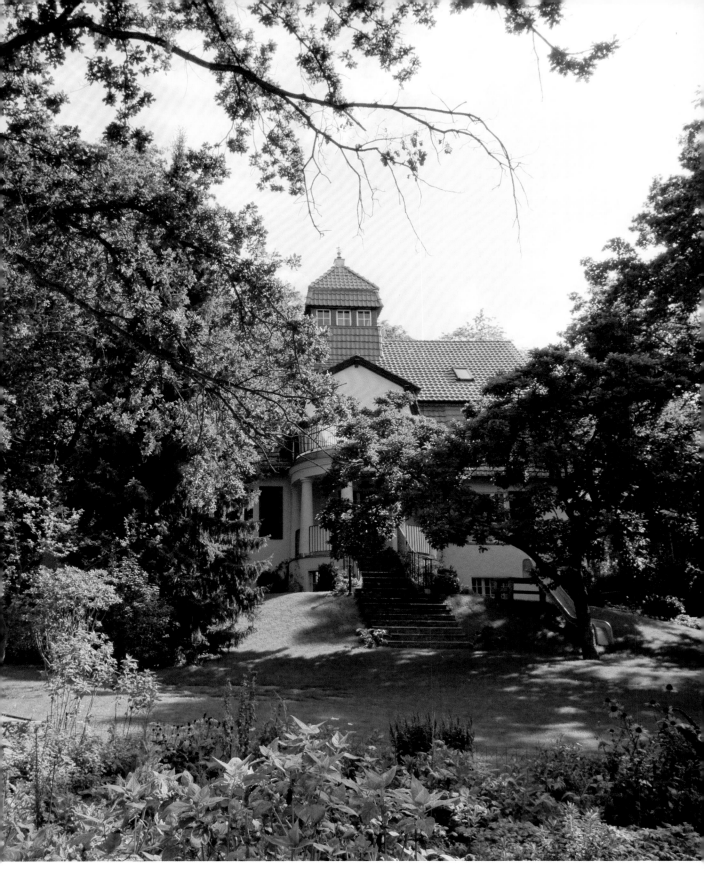

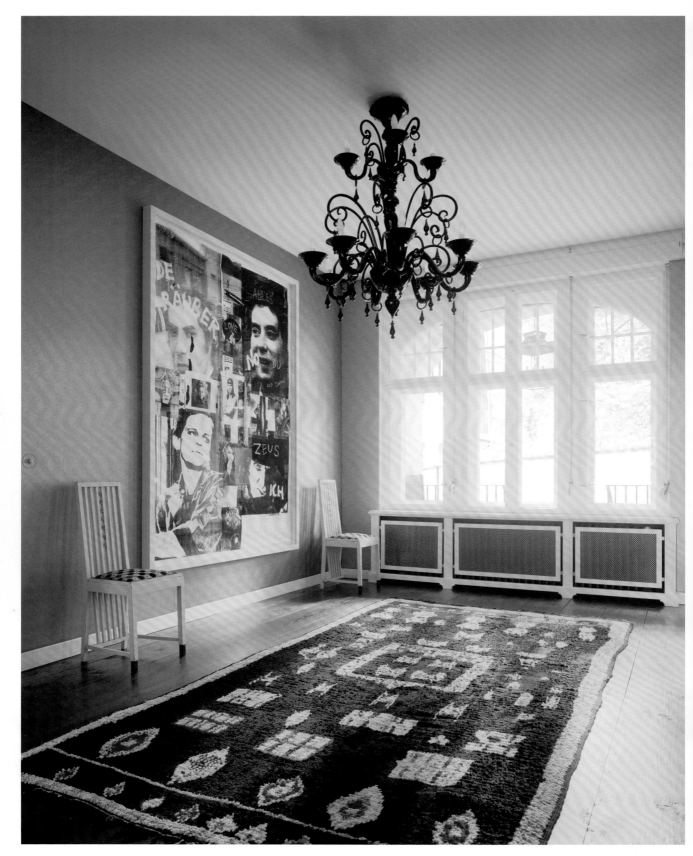

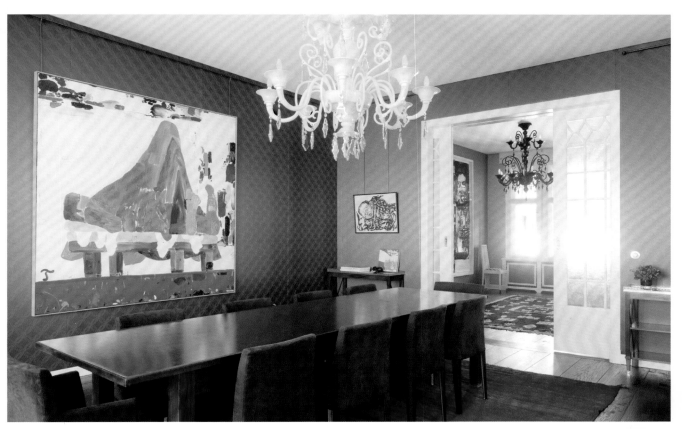

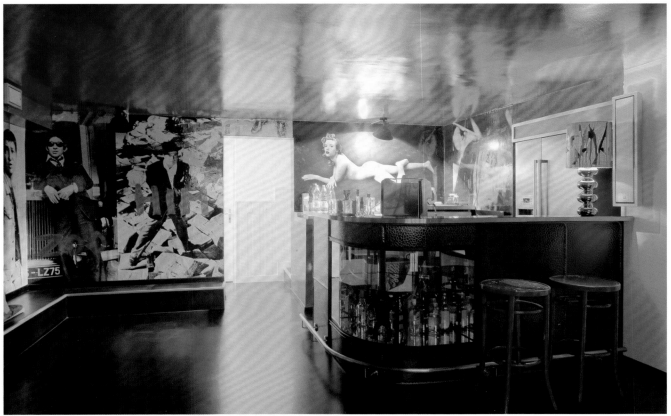

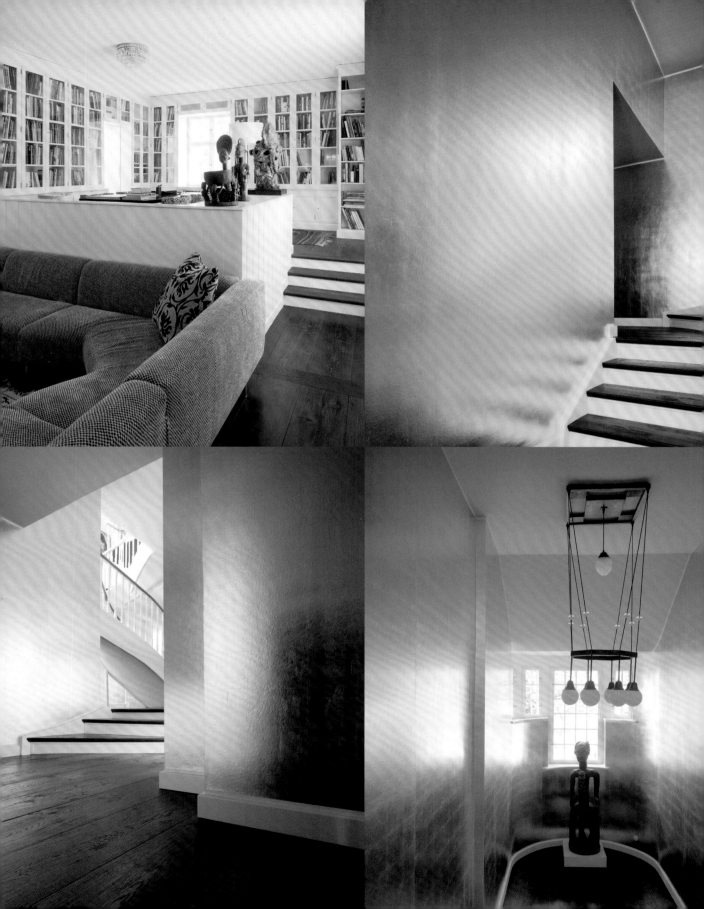

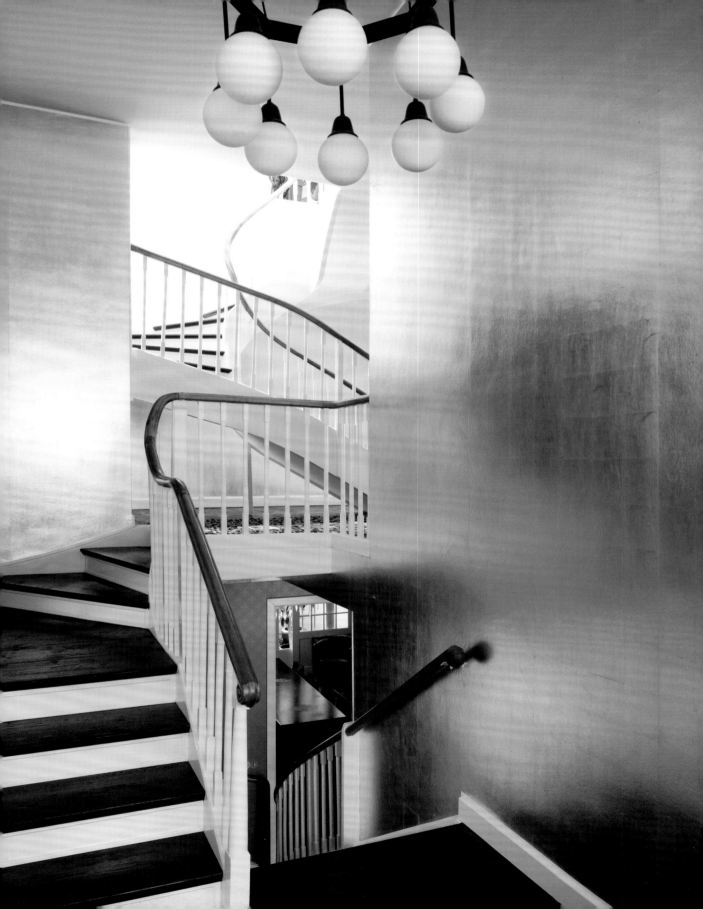

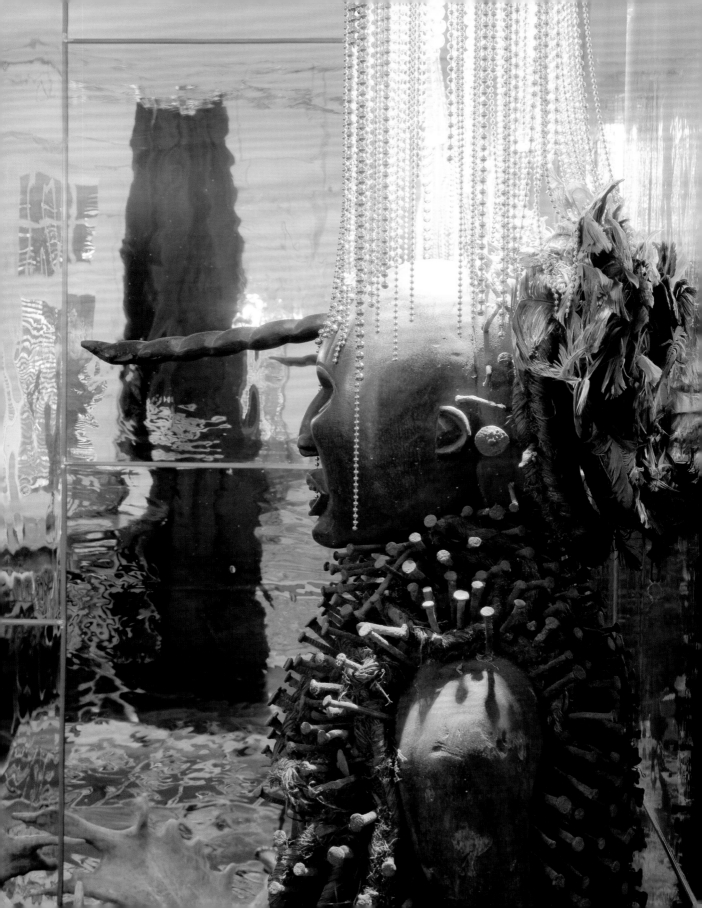

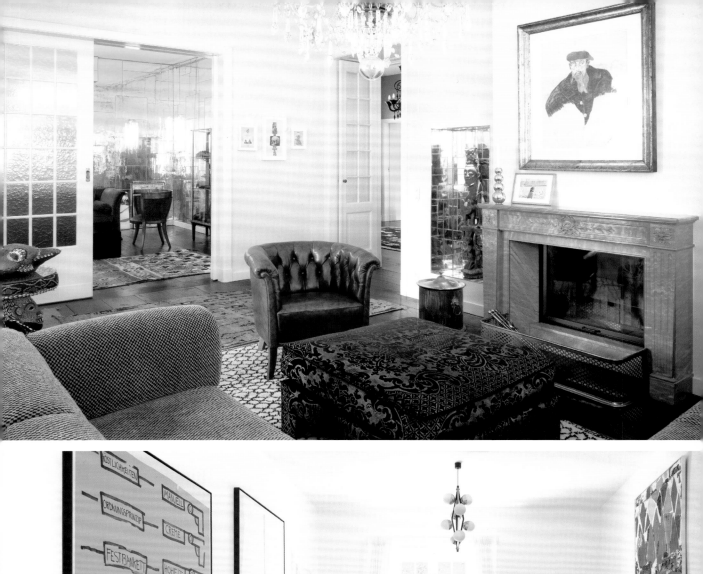
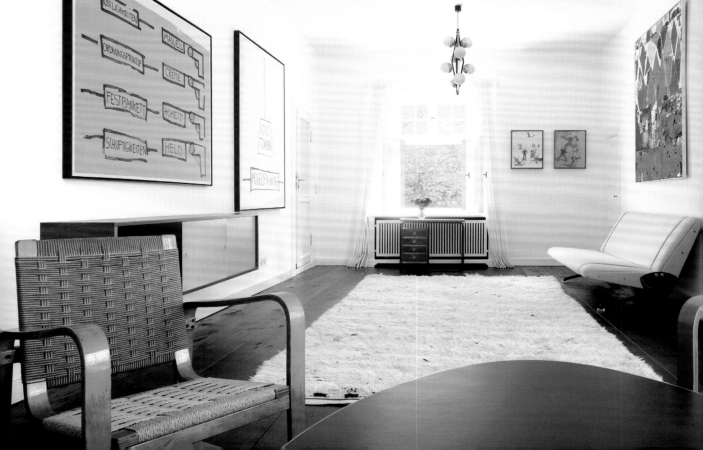

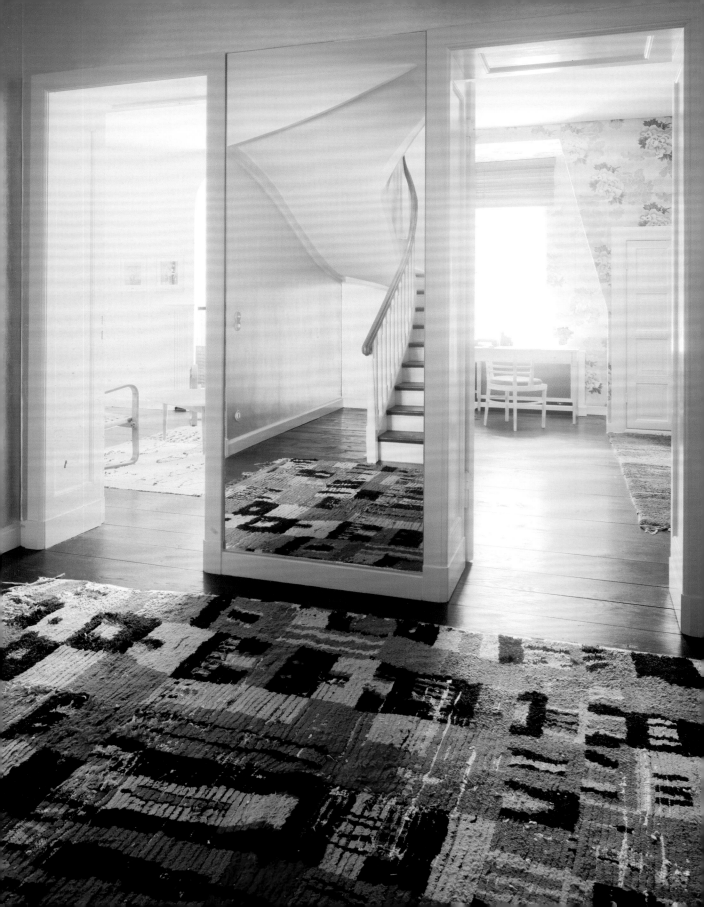

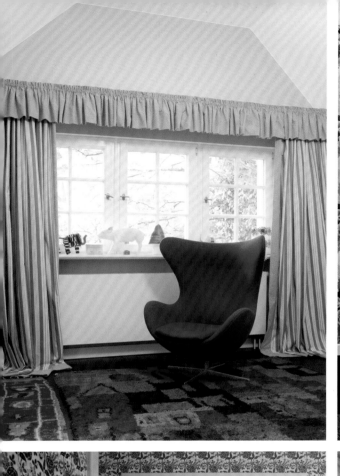

BRUGES
West-Flanders, Belgium

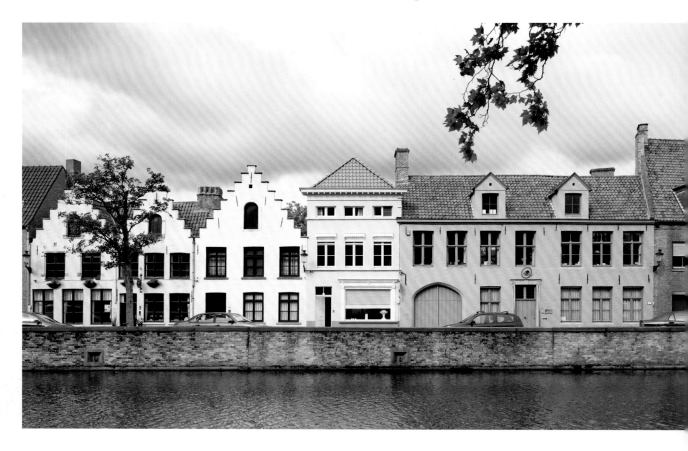

OWNERS
Mieke & Rob Persyn

OCCUPATION
Bio-engineer

PROPERTY
House
210 sqm / 2,260 sq ft
3 floors; 7 rooms; 2 bathrooms

YEAR
Building: 1845
Remodelling: 2007

ARCHITECTS & INTERIOR DESIGNER
51N4E, Brussels
www.51N4E.com

ART
Jenny Watson; 16th-century painting

FURNITURE
Eero Saarinen "Tulip" chairs & table;
Pierre Paulin chairs; Geoffrey Harcourt chairs

PHOTOGRAPHER
Åke E:son Lindman, OWI
Lindman Photography, Stockholm
www.lindmanphotography.com
www.owi.bz

PHOTO PRODUCER
Hilde Bouchez, OWI, Ghent, www.owi.bz

STYLE
The house provides two experiences. The wide window in the front affords a magnificent view of Bruges's Old Town; from the back you wonder if you are in New York or Moscow. Since the winters are long in Belgium, it is important to find all the comfort you need in your home.

Das Haus vermittelt sowohl die Erfahrung des Alten als auch der Moderne: Während man durch das breite Fassadenfenster einen herrlichen Blick auf die Altstadt von Brügge hat, fragt man sich im hinteren Teil, ob man in New York oder in Moskau ist. Da die Winter in Belgien lang sind, muss das eigene Zuhause allen nötigen Komfort bieten.

La maison dégage deux atmosphères : ancienne et contemporaine. La grande fenêtre sur le devant offre une vue superbe sur la vieille ville de Bruges. À l'arrière, on se demande si on est à New York ou à Moscou. Les hivers étant longs en Belgique, une maison doit être équipée de tout le confort nécessaire.

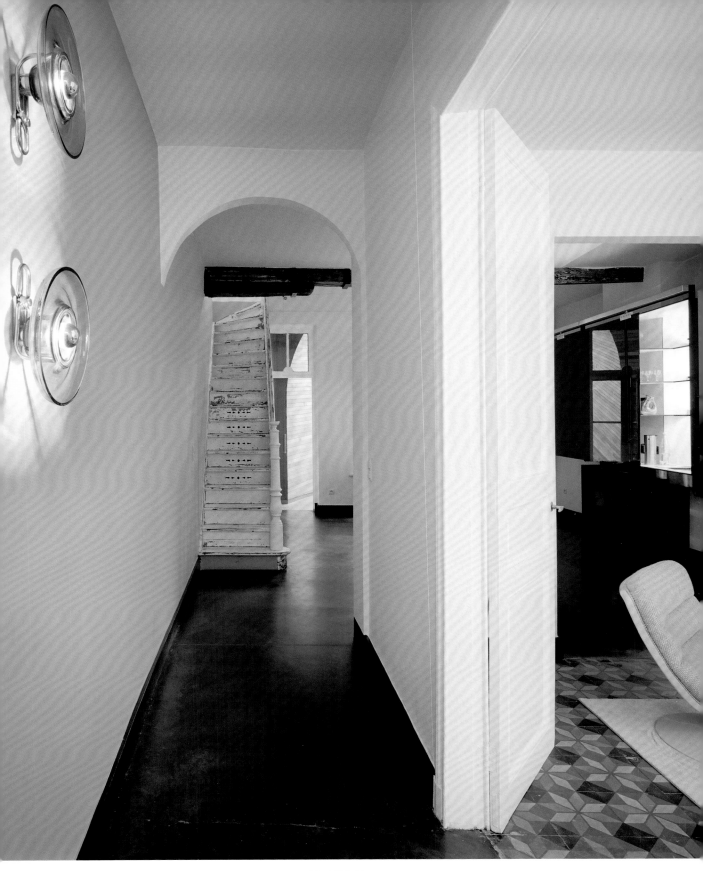

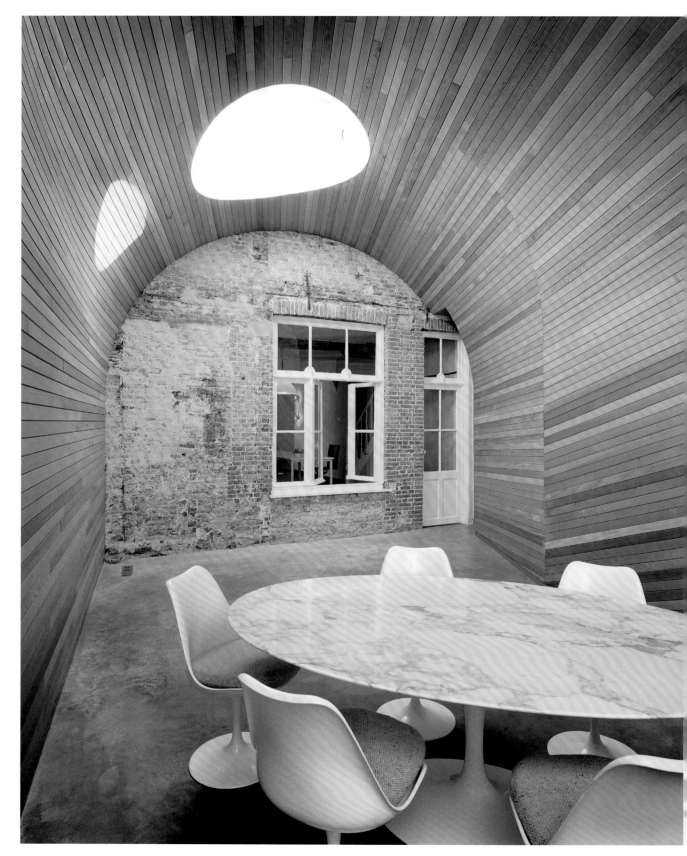

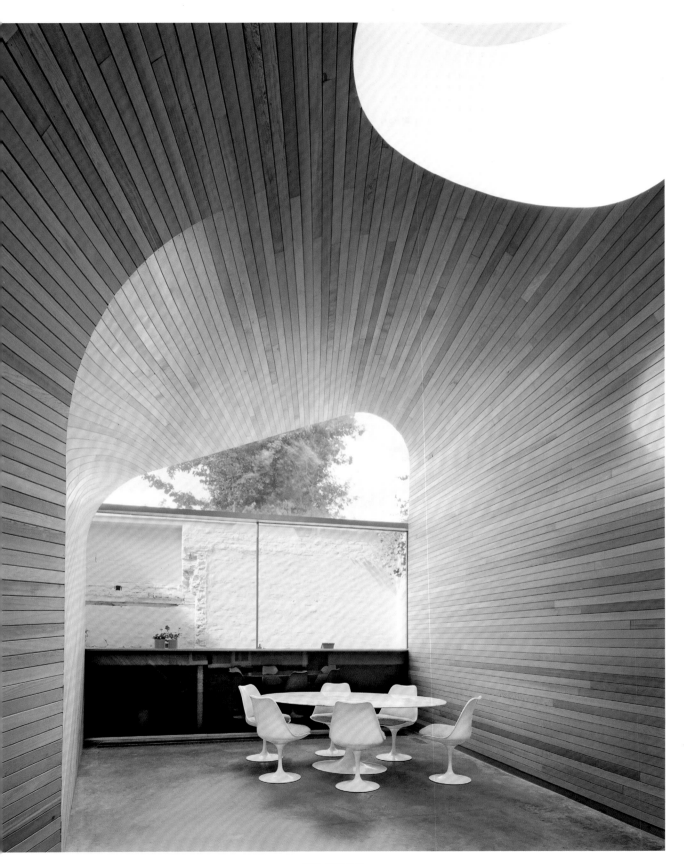

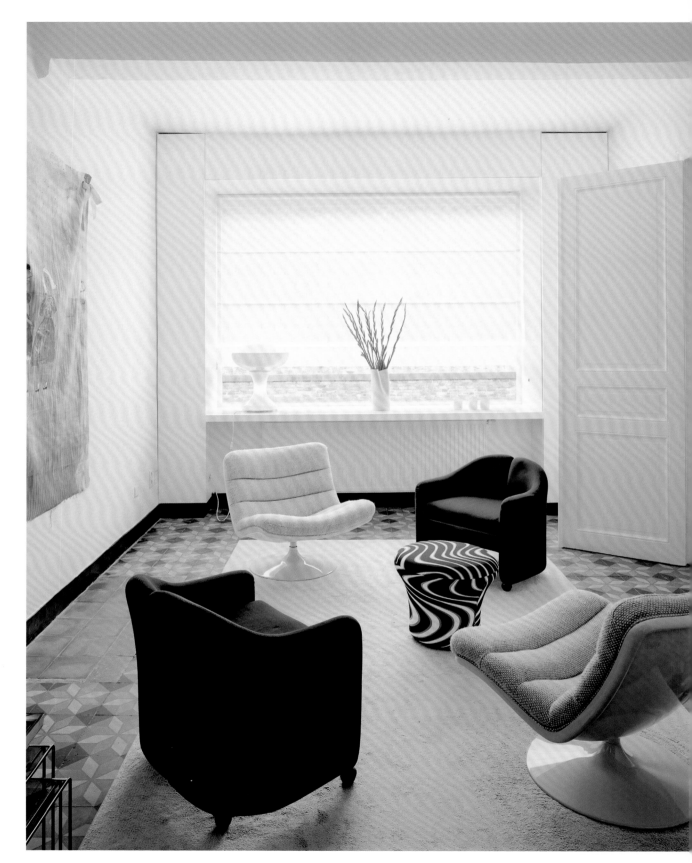

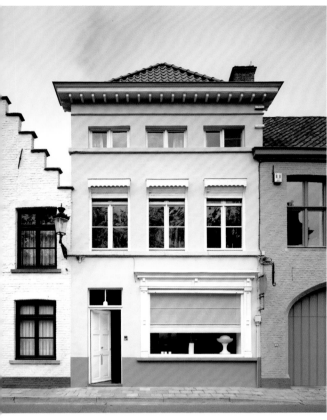

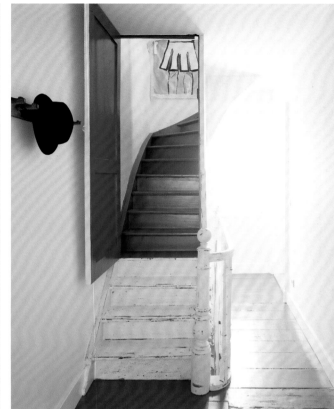

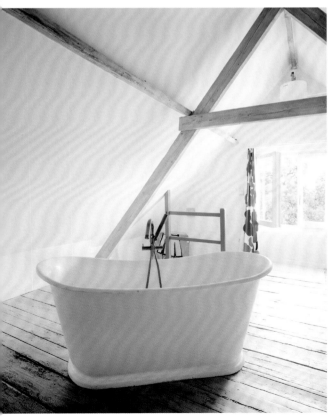

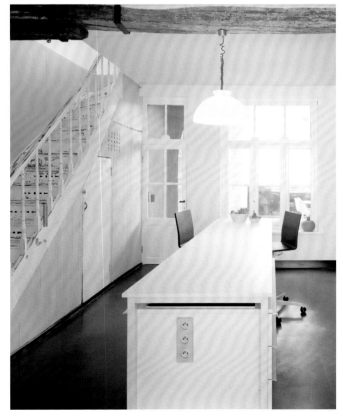

BRUSSELS
Schaerbeek, Belgium

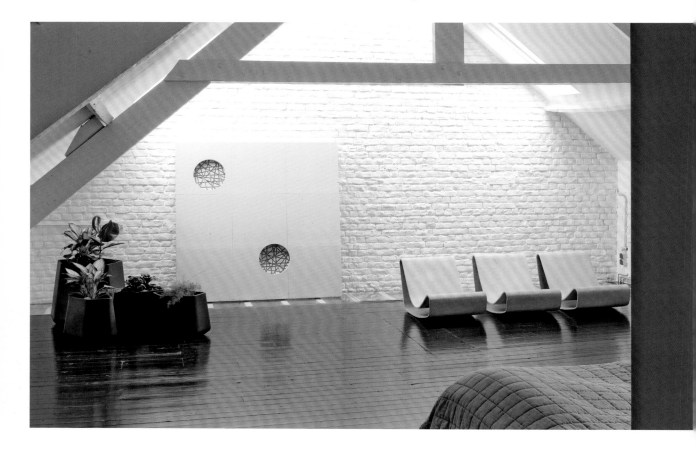

OWNERS
Rama & Alain Gilles

OCCUPATION
Art director, furniture & product designer

PROPERTY
Lofthouse
500 sqm / 5,400 sq ft
3 floors; 6 rooms; 1 bathroom

YEAR
Building: 1920
Remodelling: 2001

ARCHITECTS
Olivier Bastin & Sinan Logie
L'Escaut, Brussels
www.escaut.org

INTERIOR DESIGNER
Alain Gilles / The Studio, Brussels
www.alaingilles.com

ART
Alain Gilles "Perfection / Imperfection";
Oscar & Ora "Live Painting"; official
portraits of King Baudouin & Queen
Fabiola of Belgium; Yvonne Perrin
"Portrait of Actress Denise Volny"

FURNITURE
Willy Guhl Eternit chairs; Alain Gilles
"Tectonic" side tables, Bonaldo; Kho Liang
Le "416" sofa, Artifort; Alain Gilles "Catch-
Them-All" coat stand & "Rock Garden
Planters", Qui est Paul?; Pierre Guariche
"Jupiter" swivel chair, Meurop

PHOTOGRAPHER
Verne Photography, Ghent
www.verne.be

PHOTO PRODUCER & STYLIST
Marc Heldens
Studio Marc Heldens, Amsterdam

STYLE

A respectful transformation with a multiple layer concept: a historical renovation of the exterior and an open and minimal layout of the interior. The lofthouse is sprinkled with vintage and modern design pieces, raw materials and subtle colours and also includes a functionalist kitchen and bathroom.

Eine respektvolle Umgestaltung mit einem vielschichtigen Konzept – eine historische Renovierung des Äußeren und ein offener sparsamer Grundriss im Inneren. Das Ganze ist hier und da durchsetzt mit modernen Design-Elementen, und dazu kommen eine funktionelle Küche und ein Bad.

Une transformation respectueuse selon un concept à plusieurs niveaux : une restauration historique des façades et un plan ouvert et minimaliste pour l'intérieur. Parsemez l'ensemble de meubles design vintage et modernes, de matières brutes et de couleurs subtiles. Ajoutez une cuisine et une salle de bains fonctionnelles.

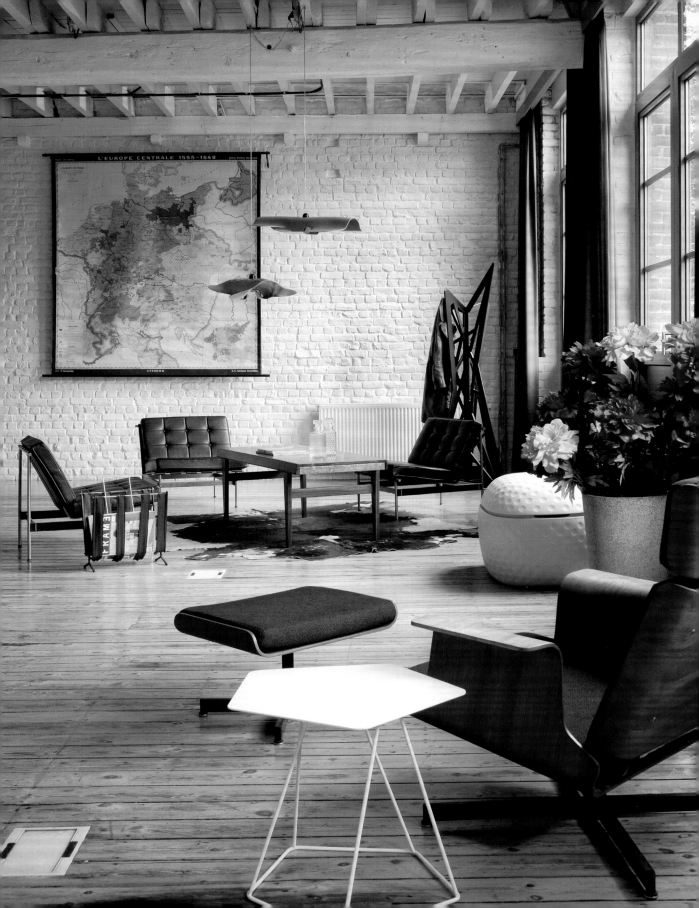

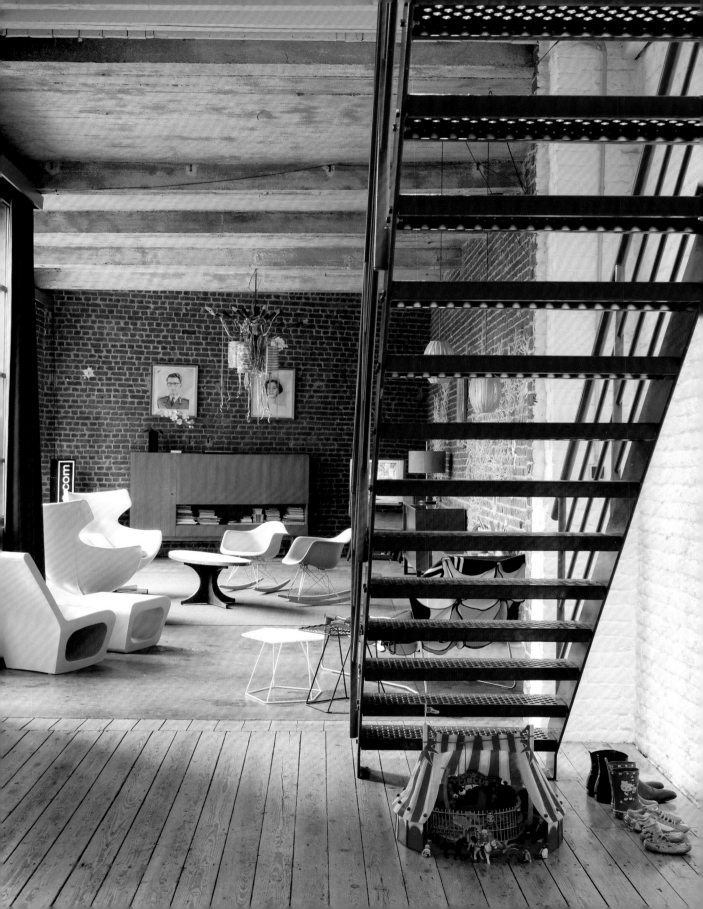

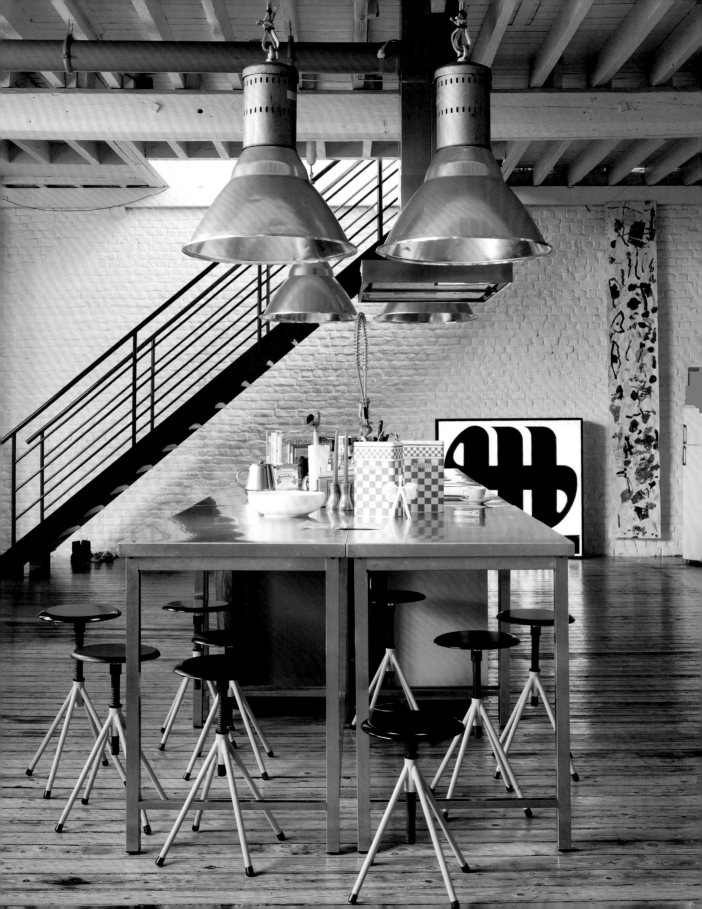

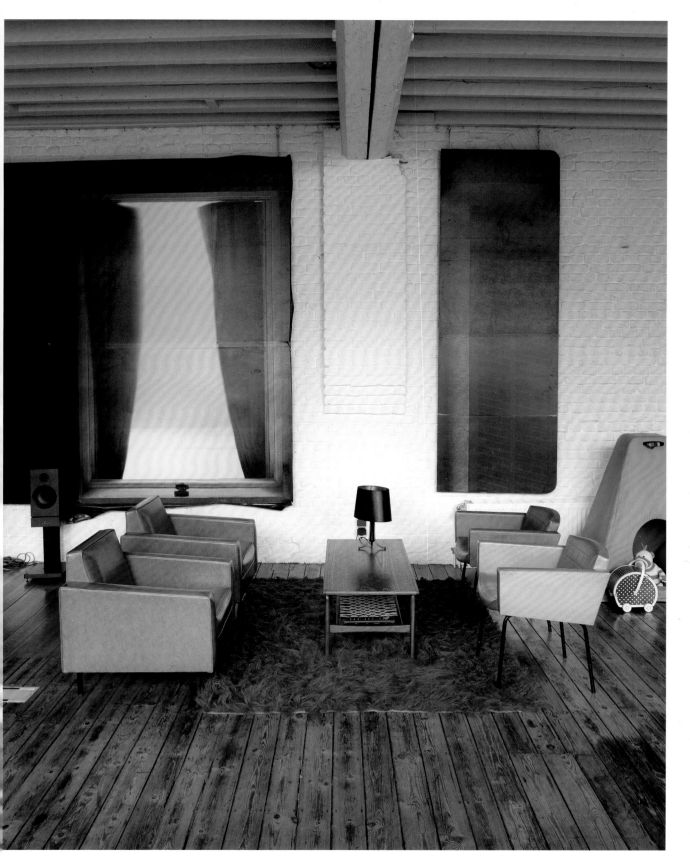

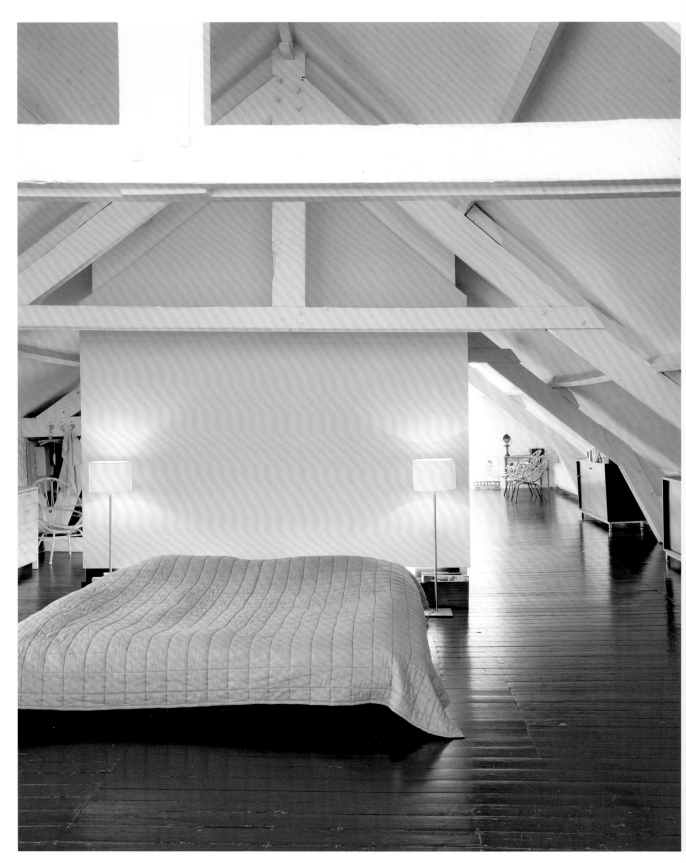

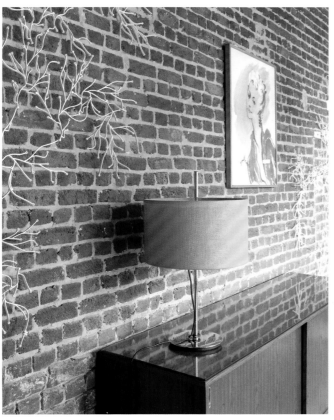

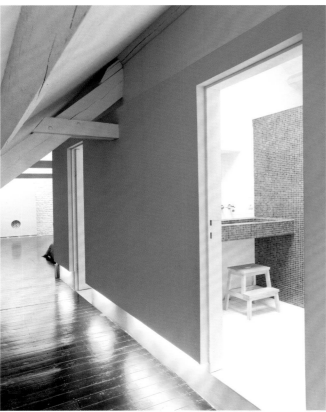

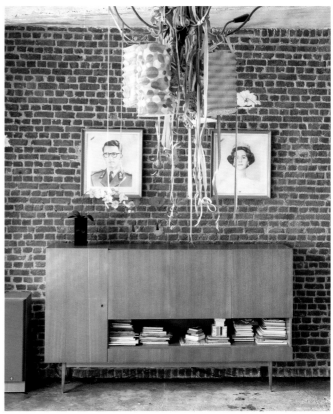

BUENOS AIRES
Puerto Madero, Argentina

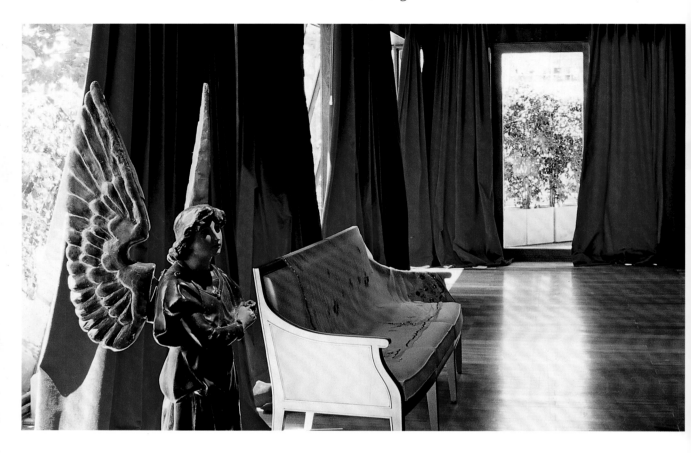

OWNER
Alan Faena

OCCUPATION
President of the Faena Group

PROPERTY
Loft
700 sqm / 7,500 sq ft
1 floor; 2 rooms; 3 bathrooms

YEAR
Building: 1900
Remodelling: 2000

ART
Andy Warhol

FURNITURE
Ceiling panels from an old church;
Philippe Starck kitchen & bathroom

PHOTOGRAPHER
Ricardo Labougle, Buenos Aires / Madrid
www.ricardolabougle.com

PHOTO PRODUCER & STYLIST
Ana Cardinale, Paris

STYLE
The interior resembles a stage set where
furniture and objects purchased in antique
shops and on travels are arranged in a spon-
taneous and eclectic manner.

Die Einrichtung ähnelt einem Bühnenbild,
bei dem Möbel und Objekte – die in
Antiquitätengeschäften und auf Reisen
gekauft wurden – spontan und eklektisch
arrangiert sind.

L'intérieur ressemble à un décor de théâtre,
avec ces meubles et ces objets achetés
chez des antiquaires ou au cours de voyages
et disposés de manière spontanée et
éclectique.

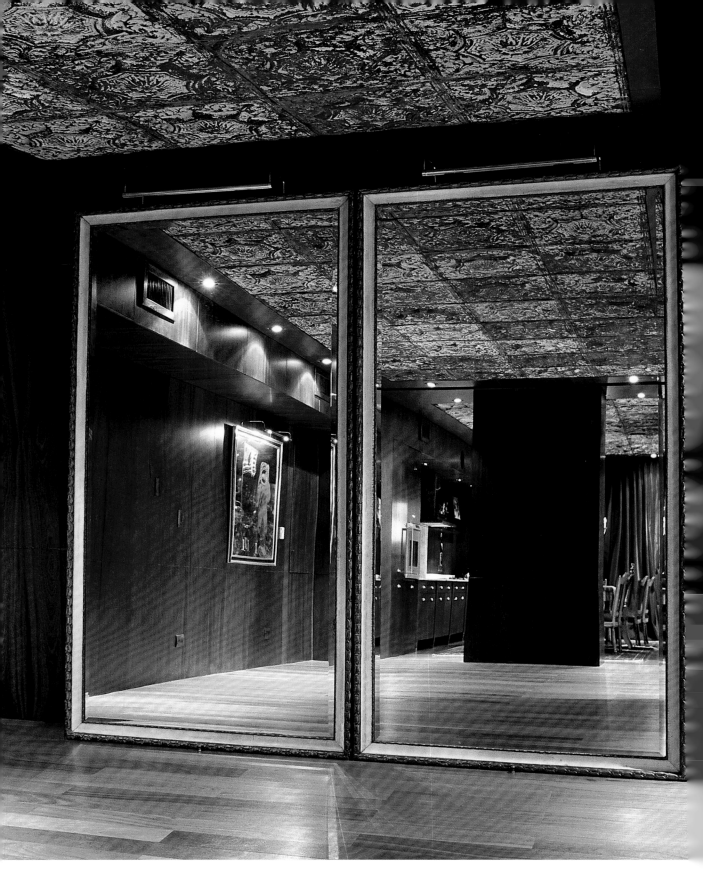

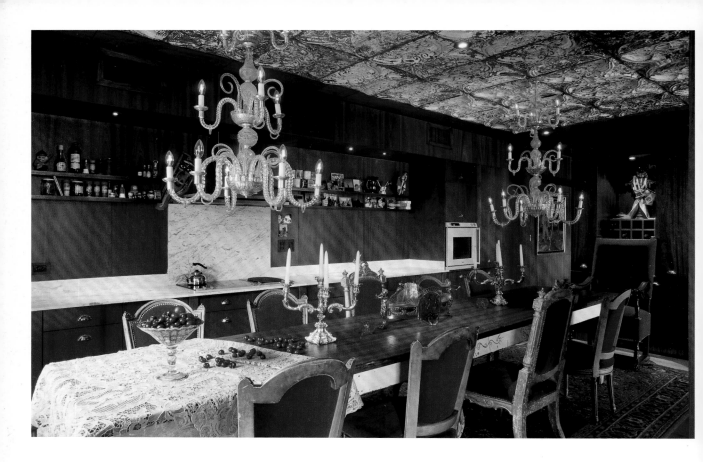

"A house should
be emotion."

»Ein Haus sollte
eine Emotion sein.«

« Une maison devrait
être une émotion. »

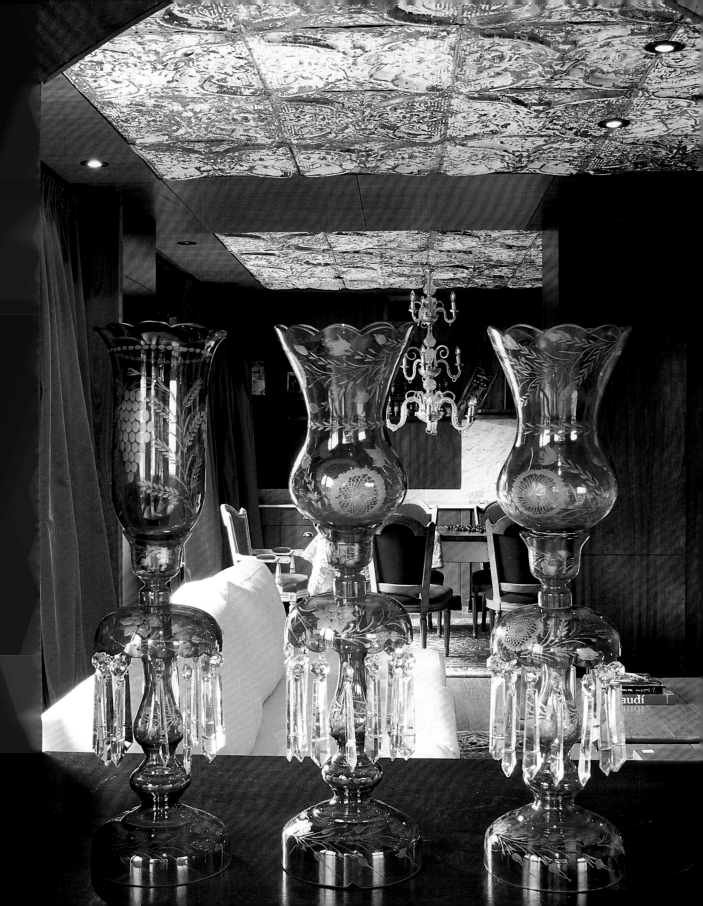

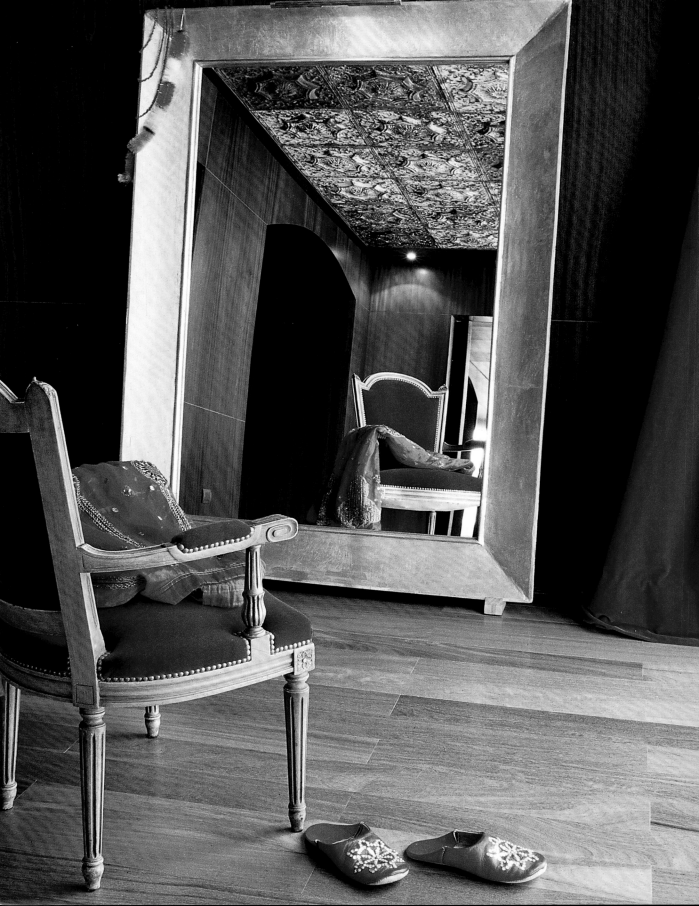

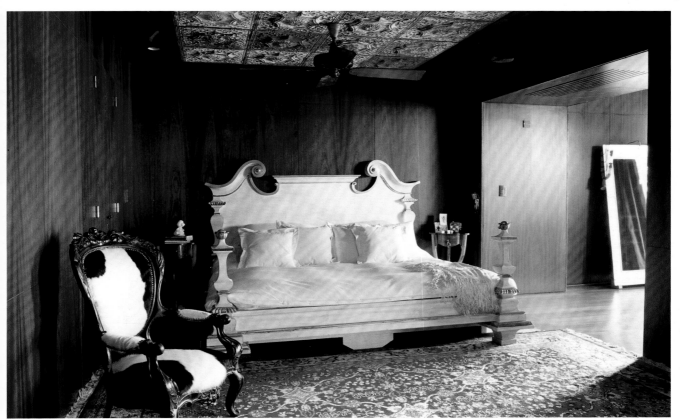

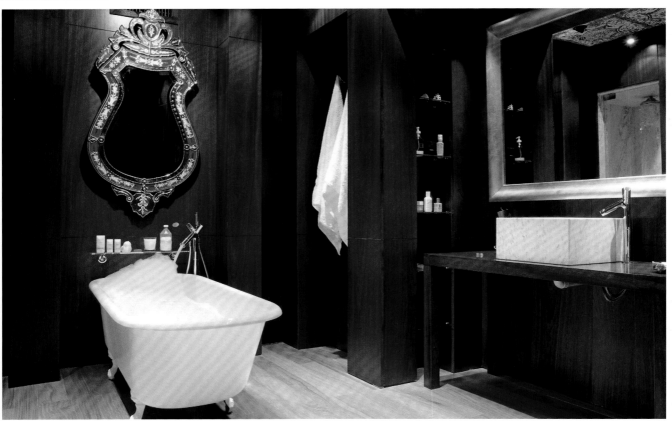

CHIANG MAI
Thailand

OWNERS
Antoinette Aurell & Rirkrit Tiravanija

OCCUPATION
Photographer / Artist

PROPERTY
House
600 sqm / 6,450 sq ft
2 floors; 10 rooms; 4 bathrooms

YEAR
Building: 2007

ARCHITECTS
Rirkrit Tiravanija, Antoinette Aurell &
Aroon Puritat, in collaboration with
Fernlund & Logan Architects, New York
www.fernlundlogan.com

INTERIOR DESIGNER
Nam Bo Luang Carpenters Co-operative
NBLCC, Chiang Mai
www.nblcarpenterscooperative.com

ART
Yayoi Kusama; Nim Kruasaeng; Kosit
Juntaratip; Susan Cianciolo; Marc Hundley;
Charlie Griffin; Hmong tribe textiles

FURNITURE
Charles & Ray Eames "DSW" & moulded
plywood "DCM" chairs; George Nelson
"Bubble Lamps H-764, H-736, H-733",
"Action Office" desk & "4753" drop-leaf
desk, Herman Miller; Poul Henningsen
"PH5" pendant lamps; Konstantin Grcic
"One" chair; built-in furniture by NBLCC

PHOTOGRAPHER
Jason Schmidt, New York
www.jasonschmidtartists.com

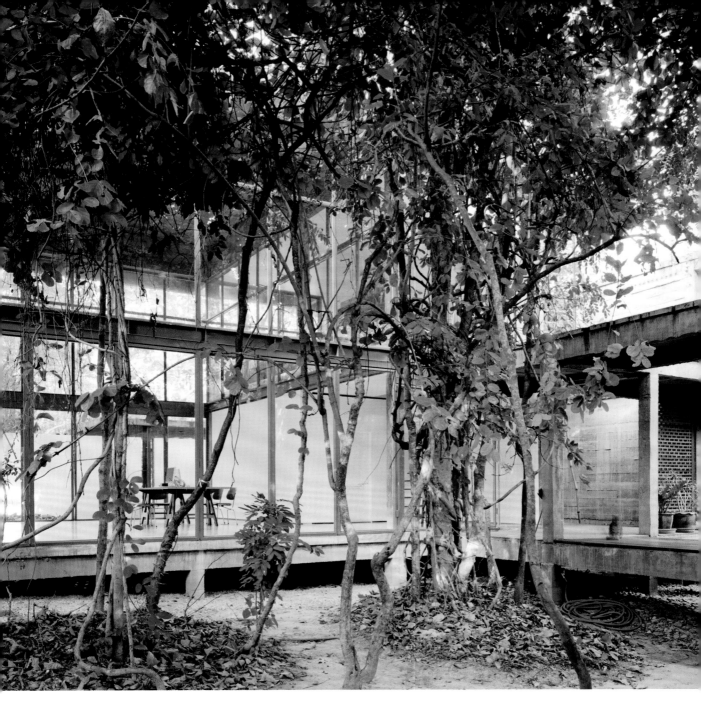

STYLE

The aesthetics are indigenous, oriental, tropical and functionalist modern. The house is modern and typical Thai: you can sit down everywhere. External decks flow into interior terrazzo floors with subtle plane shifts. The flow is designed to accommodate heat, rain and humidity, elevated by stilts for air flow and circulation.

Die Ästhetik ist einheimisch, tropisch und funktionalistisch. Das Haus ist modern und typisch thailändisch – man kann sich überall hinsetzen. Außendecks gehen durch die subtile Verschiebung der Ebenen in die Terrazzo-Böden der Innenräume über. Die Übergänge sollen Hitze, Regen und Feuchtigkeit aufnehmen. Und das Haus steht auf Pfählen, damit die Luft zirkulieren kann.

L'esthétique est indigène, orientale, tropicale et fonctionnelle. La maison est moderne et typiquement thaïlandaise ; on peut s'asseoir partout. Les terrasses en bois se prolongent vers les sols en mosaïque à l'intérieur, avec de subtiles changements de niveau adaptés à la chaleur, à la pluie et à l'humidité, le tout sur des pilotis pour laisser l'air circuler.

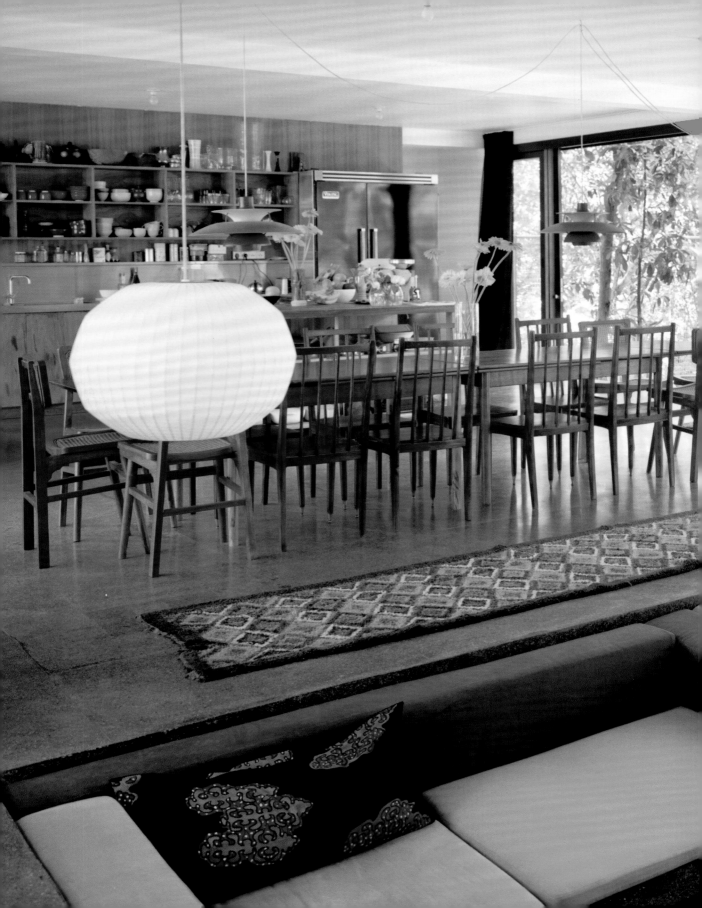

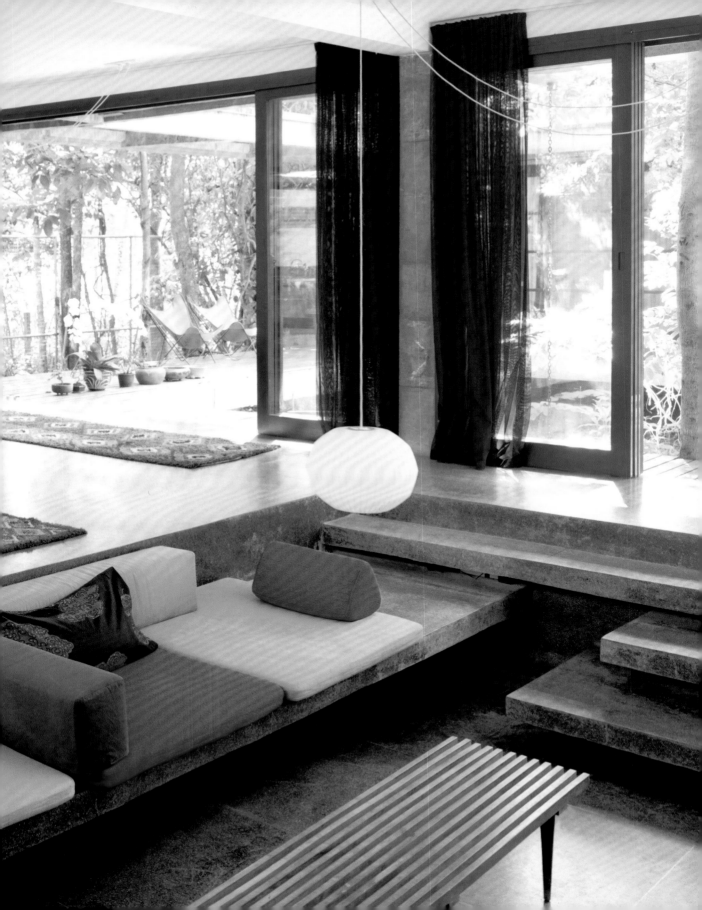

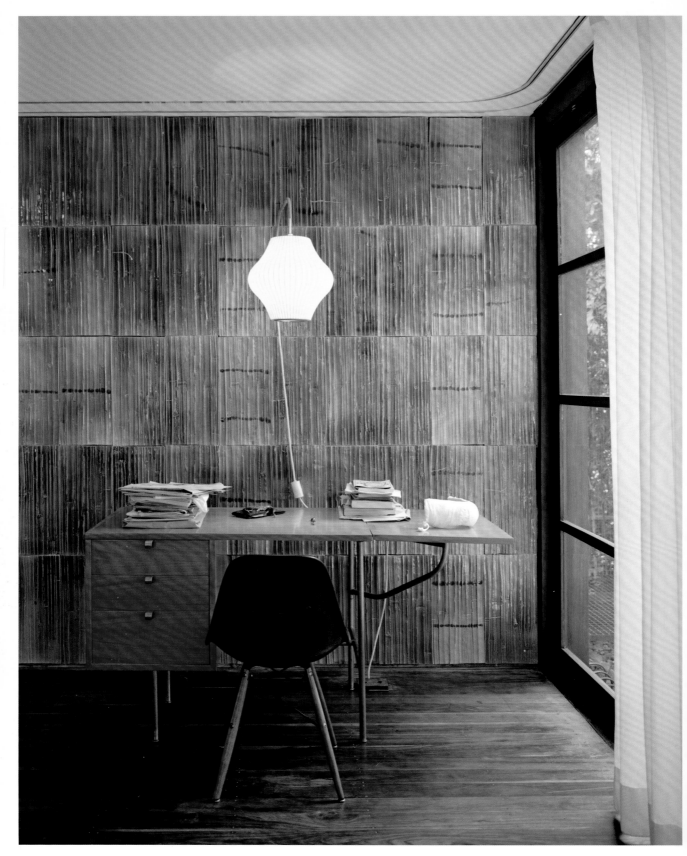

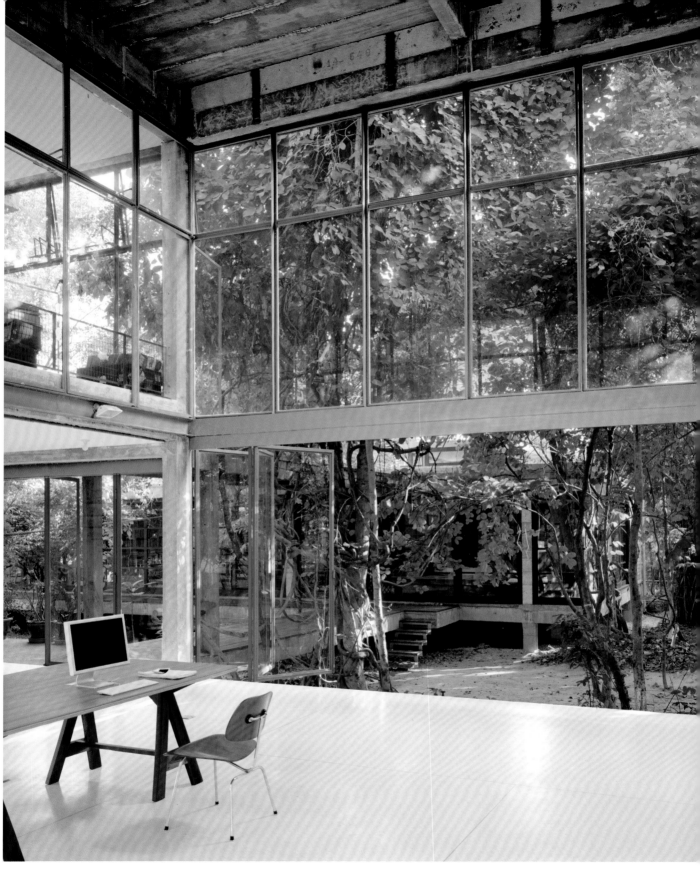

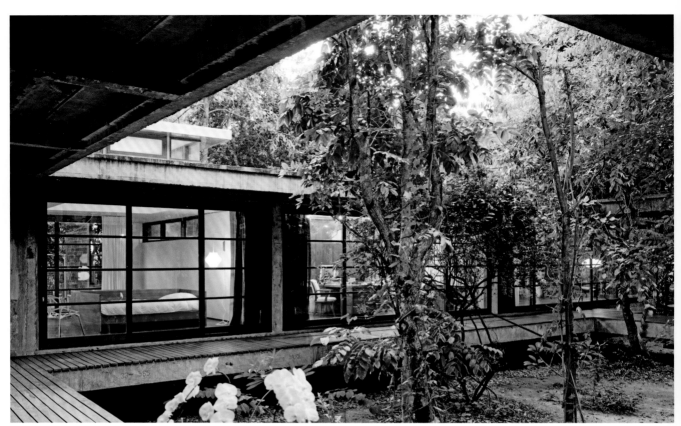

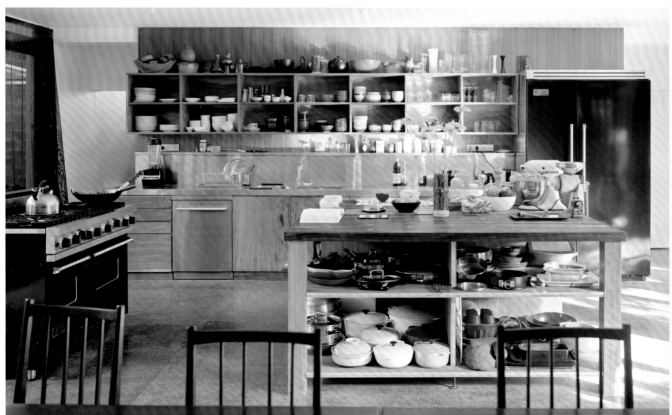

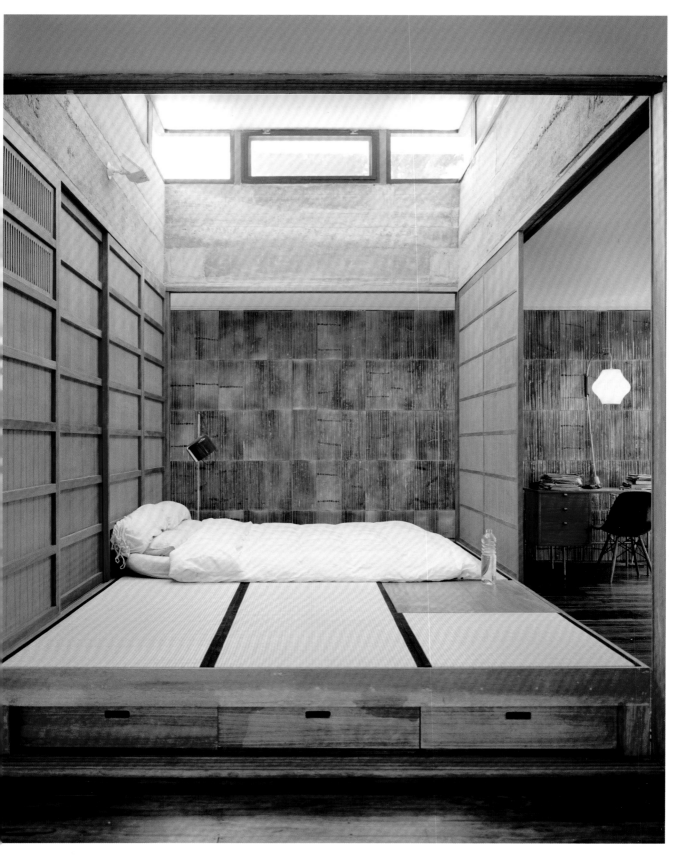

COPENHAGEN

Klampenborg, Denmark

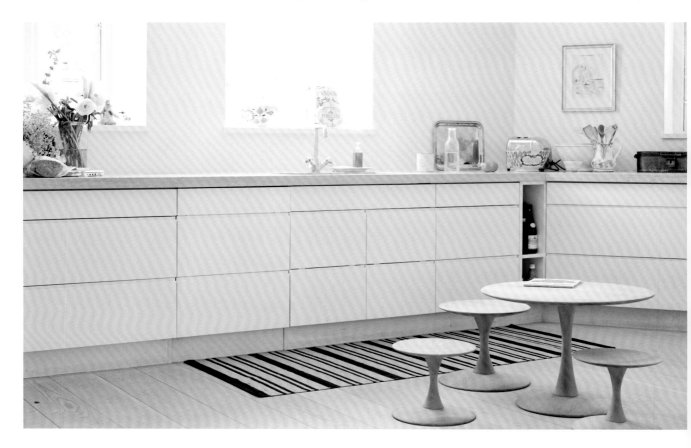

OWNERS
Barbara Bendix Becker & Jacob Holm

OCCUPATION
Industrial designer
CEO of Fritz Hansen

PROPERTY
Townhouse
450 sqm / 4,850 sq ft
4 floors; 11 rooms; 4 bathrooms

YEAR
Building: 1903
Remodelling: 2004

ART
Poul Lundstrøm; Mogens Andersen;
Edgar Degas; Pablo Picasso;
Daniel Lergon; et al.

FURNITURE
Nanna Ditzel; Arne Jacobsen; Poul
Kjærholm; Hans J. Wegner; Cecilie Manz;
Piero Lissoni; Poul Henningsen; Swedish
and French 18th-century pieces

PHOTOGRAPHER
Ditte Isager, New York
www.ditteisager.com
www.edgereps.com

STYLE

Timeless and modern with a mix of Danish functionalism and a lot of art and antiques. Because of the long, grey winters in Denmark all the floors and walls in the house are painted white. Every inch of the house and every piece of furniture is used by the kids, cats and dogs.

Zeitlos und modern, mit einer Mischung aus dänischem Funktionalismus und viel Kunst und Antiquitäten. Wegen der langen, grauen Winter in Dänemark sind alle Böden und Wände des Hauses weiß gestrichen. Jeder Zentimeter des Hauses und jedes Möbelstück werden von den Kindern, den Katzen und den Hunden genutzt.

Intemporel et moderne, avec un mélange de fonctionnalisme danois et de beaucoup d'œuvres d'art et d'antiquités. Pour pallier les longs hivers gris du Danemark, tous les sols et les murs sont peints en blanc. Chaque recoin de la maison et tous les meubles sont utilisés par les enfants, les chats et les chiens.

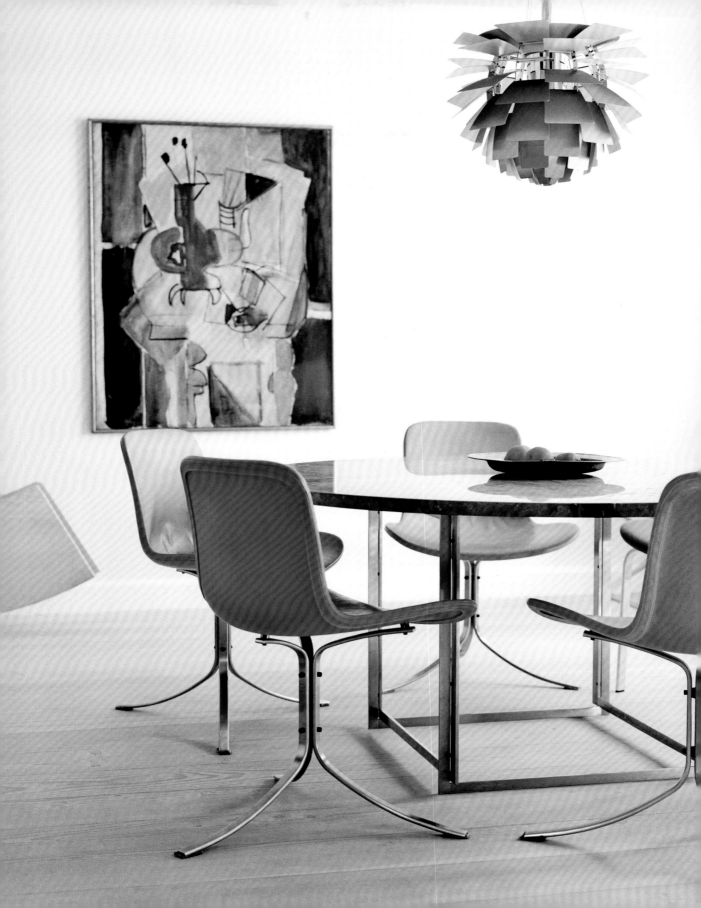

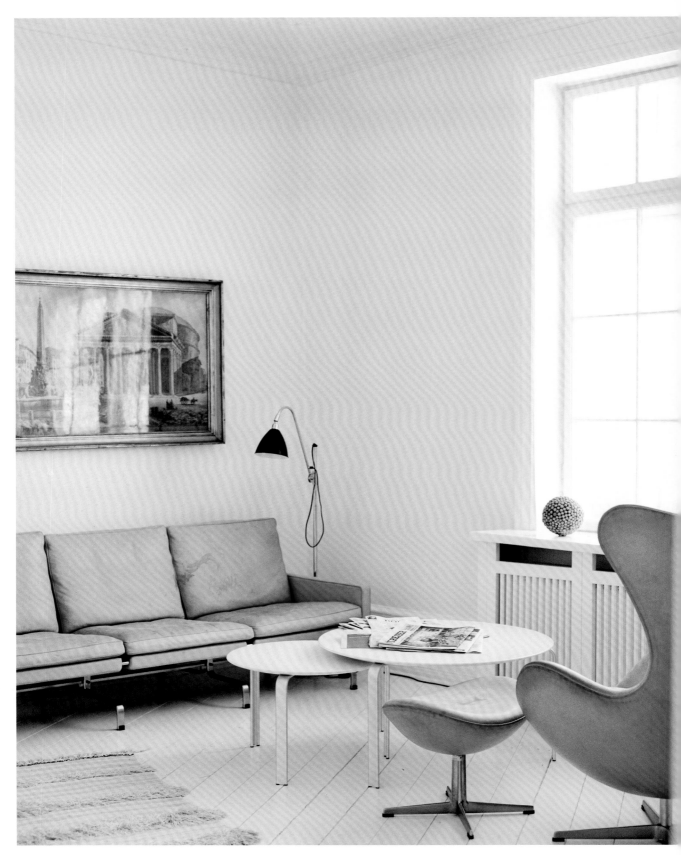

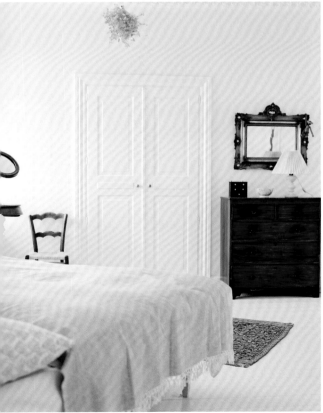

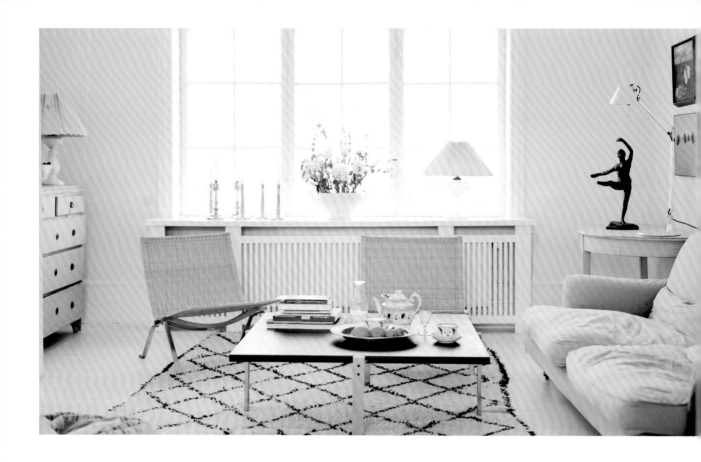

"A home should reflect
the people living there."

»Ein Haus sollte die Menschen
widerspiegeln, die in ihm leben.«

«Une demeure devrait refléter
les gens qui y vivent. »

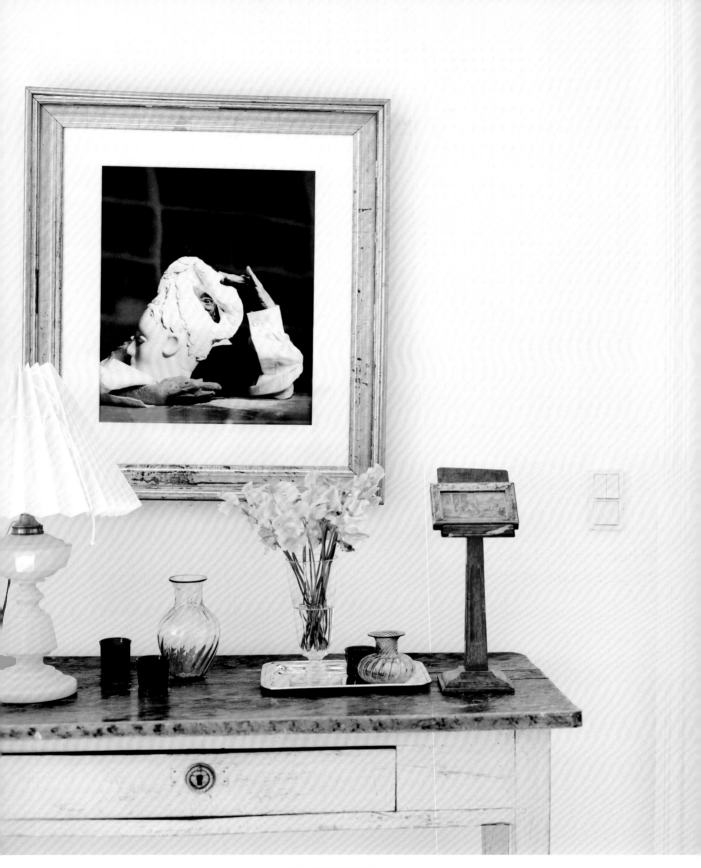

GHENT

East Flanders, Belgium

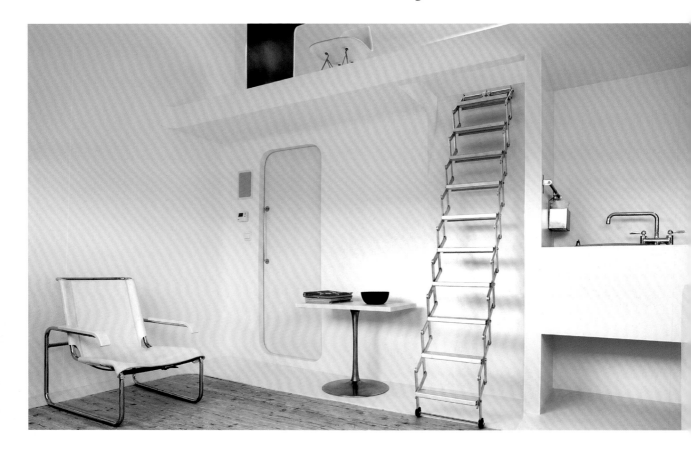

OWNERS
Geneviève Marginet & Ronny Duquenne

OCCUPATION
Interior designer / Graphic designer

PROPERTY
Attic apartment (duplex)
38 sqm / 410 sq ft
2 floors; 1 room; 1 bathroom

YEAR
Building: ca. 1930
Remodelling: 2002

INTERIOR DESIGNER
Geneviève Marginet, Ghent

FURNITURE
Marcel Breuer "B35" armchair; folding
ladder, Map Zoldertrappen, Belgium;
Charles & Ray Eames "DSR Eiffel" chairs,
Vitra; plastic chair, Ikea

PHOTOGRAPHER
Filip Dujardin, Ghent
www.filipdujardin.be

STYLE
The dominating theme of this duplex apart-
ment is "white and curved", so function
had to follow form. Every square centimetre
is functional. Every item of furniture is
multifunctional where possible, with attuned
lighting, personality and a sense of humour.

Das vorherrschende Thema dieser Maiso-
nettewohnung lautet ›Weiß und kurvig‹;
daher musste die Funktion der Form folgen.
Jeder Quadratzentimeter ist funktional und
jedes Möbelstück ist (wenn möglich) multi-
funktional – mit abgestimmter Beleuchtung,
Persönlichkeit und einem guten Schuss
Humor.

Le thème dominant de ce duplex est « blanc
et incurvé », si bien que la fonction a dû
suivre la forme. Chaque centimètre carré est
fonctionnel. Tous les meubles sont, dans la
mesure du possible, polyvalents, avec un
éclairage adapté, du caractère et un bon
sens de l'humour.

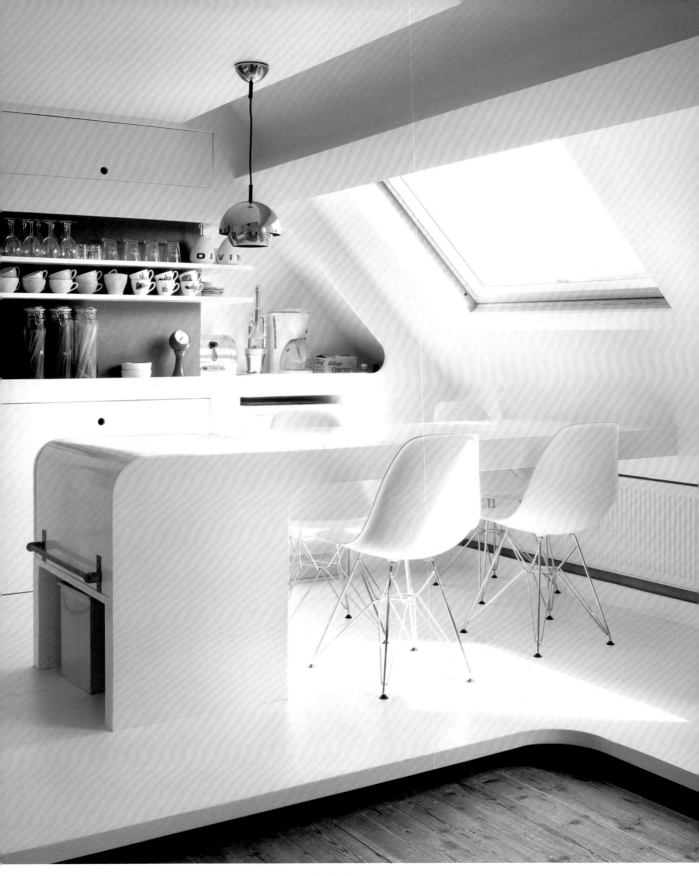

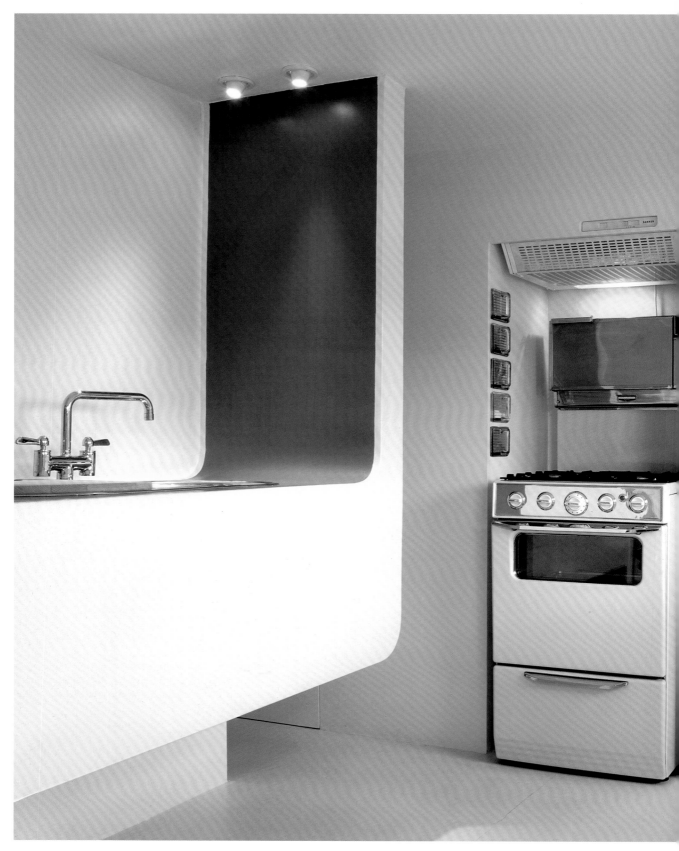

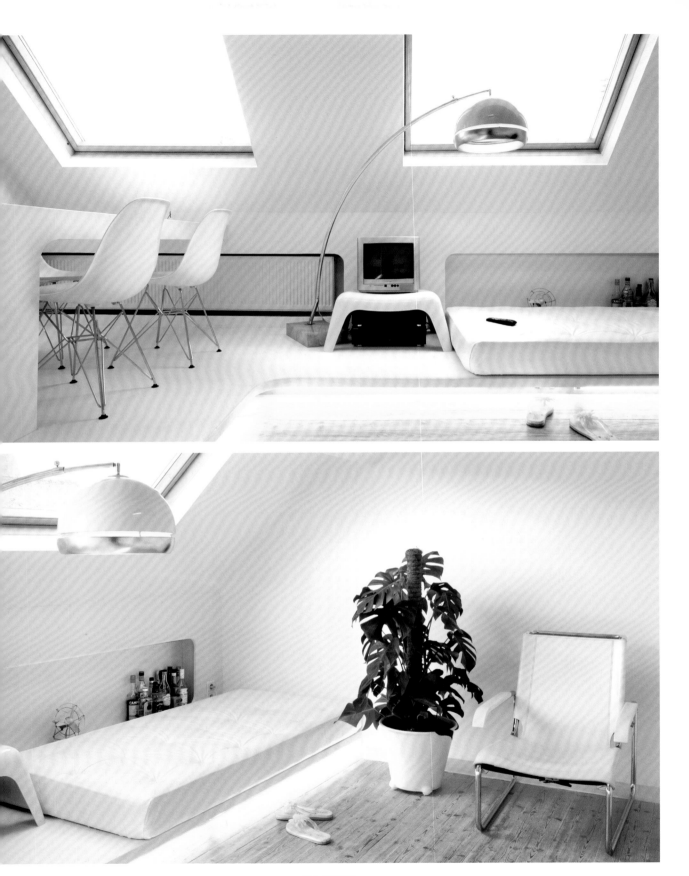

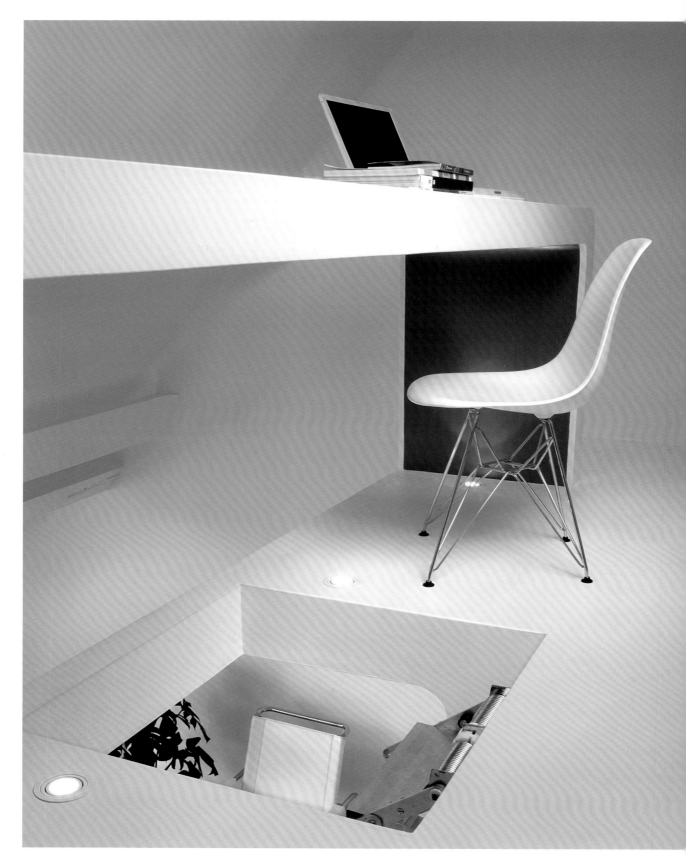

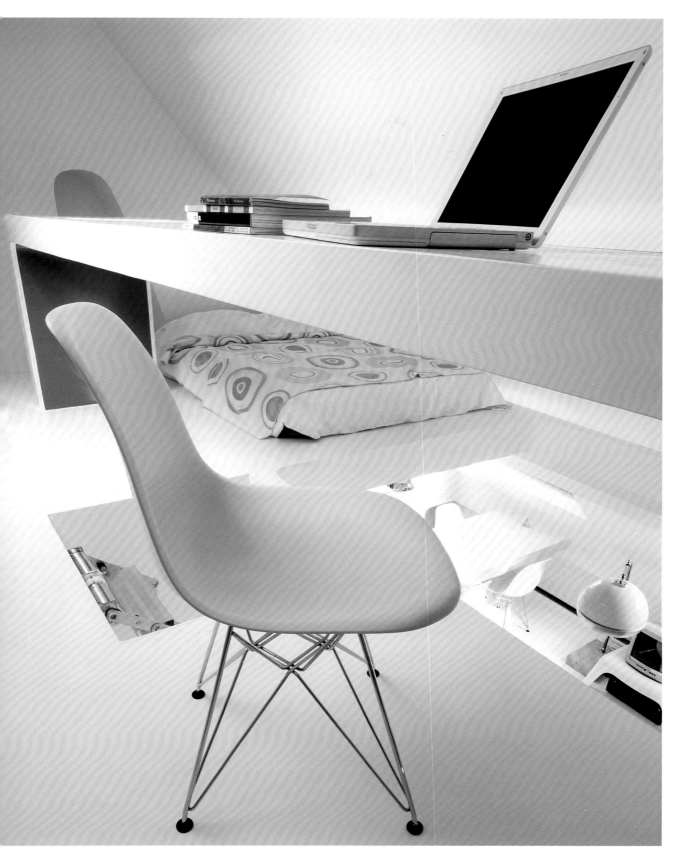

IBIZA

San Mateo, Baleares, Spain

OWNERS
Annika & Jean Ferre

OCCUPATION
Retired

PROPERTY
Country house
400 sqm / 4,300 sq ft
1 floor; 5 rooms; 5 bathrooms

YEAR
Building: 1550
Remodelling: 2000

ARCHITECT
Pascal Cheik-Djavadi
Atelier Arcos Architecture, Paris
www.arcosarchitecture.fr

LANDSCAPE DESIGNER
Ignacio Eligi, Ibiza

FURNITURE
Achille Castiglioni "Arco" lamp &
"Alfa" sofa, Zanotta; Harry Bertoia
"Diamond" chair; Arne Jacobsen
"Series 7" chairs; Pascal Cheik-Djavadi
custom-made dining table; Eero Saarinen
"Tulip" chairs & table; Verner Panton
"Fun" lamp; Alvar Aalto; Charles & Ray
Eames; John Pawson; Hans J. Wegner
chair; ethnic artefacts & textiles

PHOTOGRAPHER
Albert Font, Barcelona
www.albertfont.com

PHOTO STYLIST
Ino Coll, Barcelona
www.inocoll.com

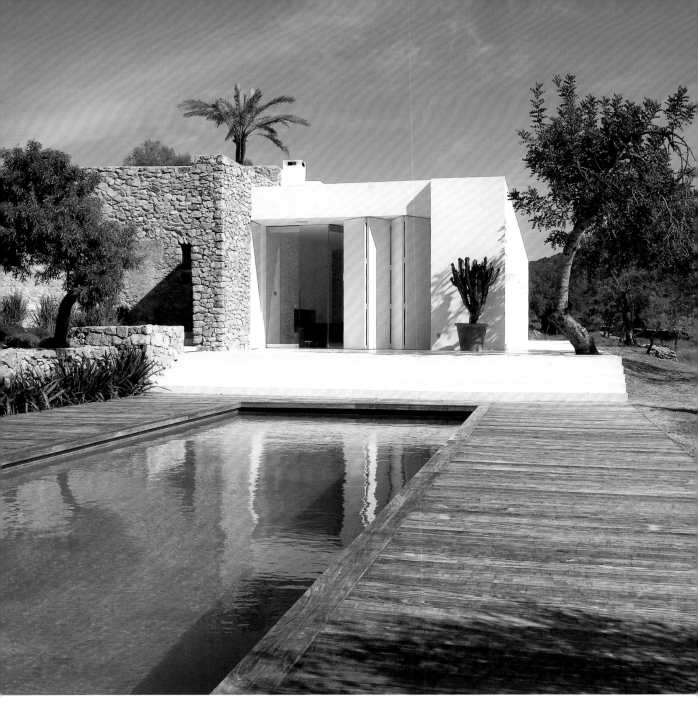

ascal Cheik-Djavadi converted sheep pens nto a kitchen and barns into bedrooms and uilt a completely new wing. Whitewashed alls and polished-cement floors provide neutral backdrop for the couple's classic nodern furniture and tribal and ethnic ntiques.

Pascal Cheik-Djavadi wandelte Schafställe in eine Küche und Scheunen in Schlafzimmer um und erbaute einen vollständig neuen Flügel. Weiß getünchte Wände und polierte Zementböden bieten hier einen neutralen Hintergrund für die klassisch-modernen Möbel und die Volkskunstsammlung des Paares.

Pascal Cheik-Djavadi a transformé la bergerie en cuisine, les granges en chambres et a construit une nouvelle aile. Les murs blanchis à la chaux et les sols en ciment poli offrent une toile de fond neutre aux meubles modernes/classiques ainsi qu'aux antiquités tribales et ethniques du couple.

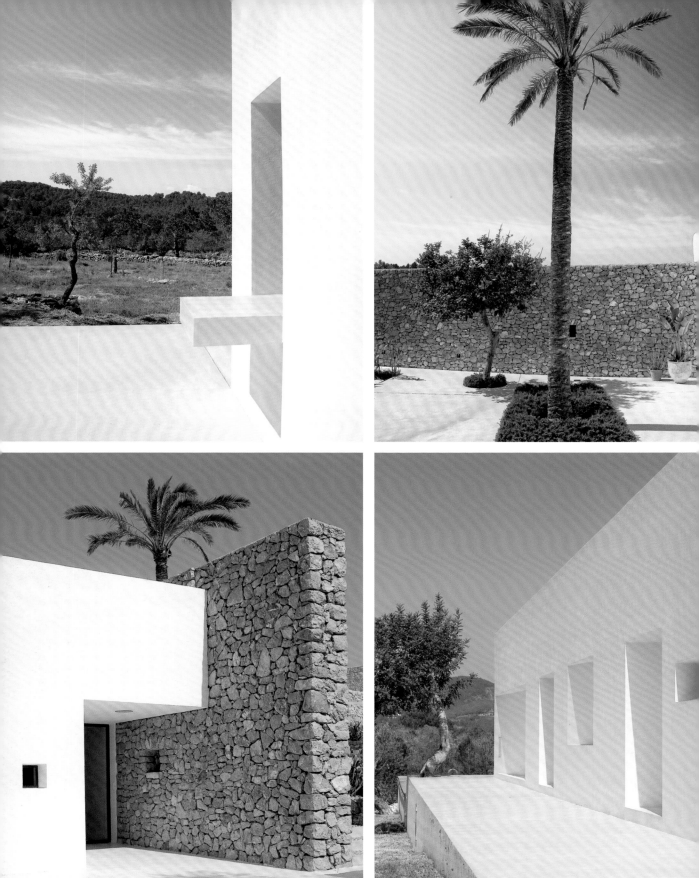

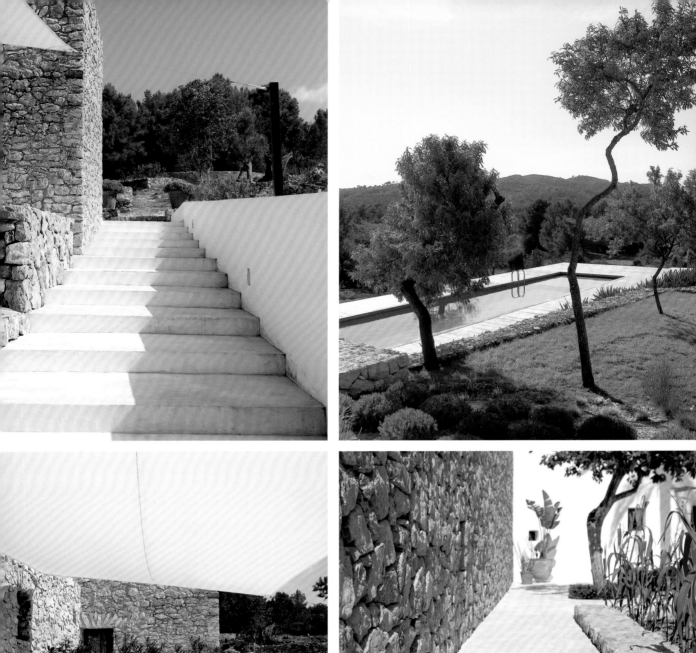
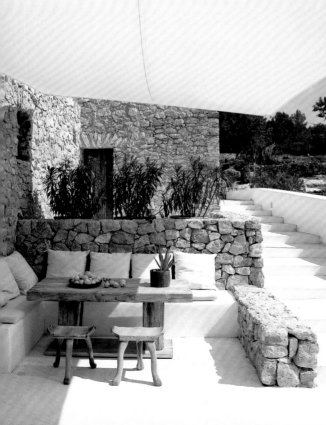

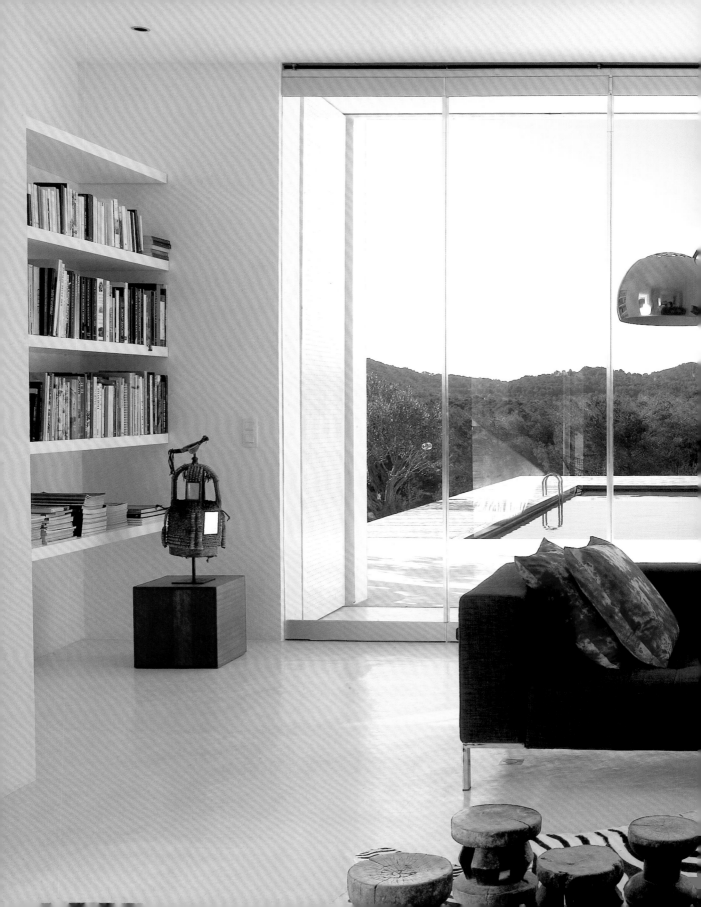

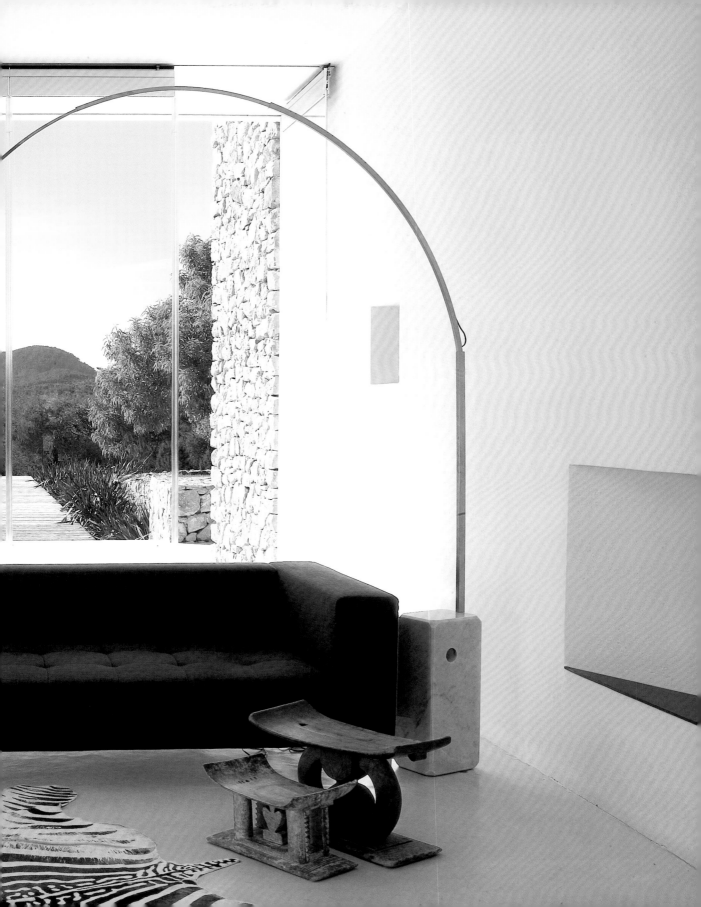

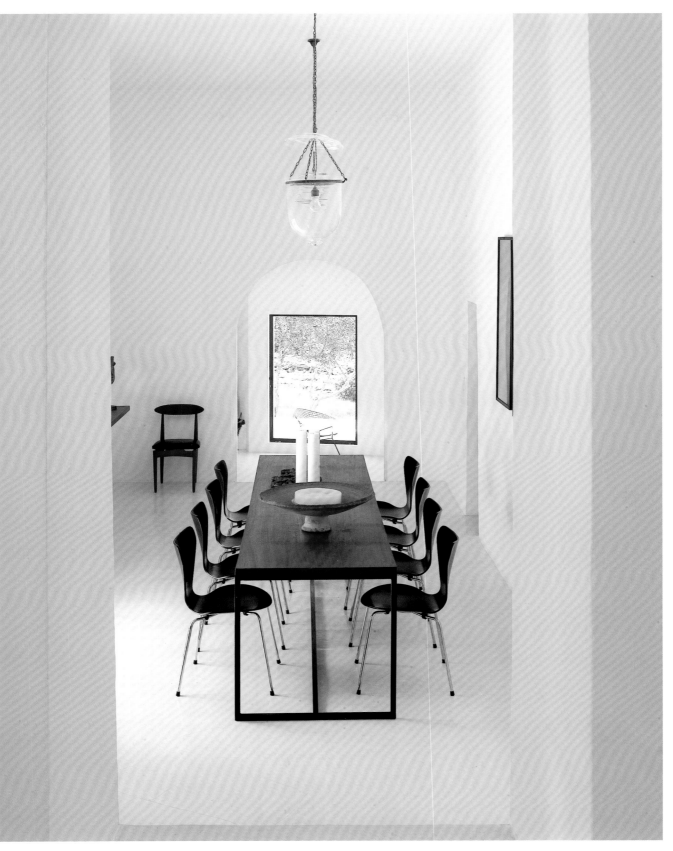

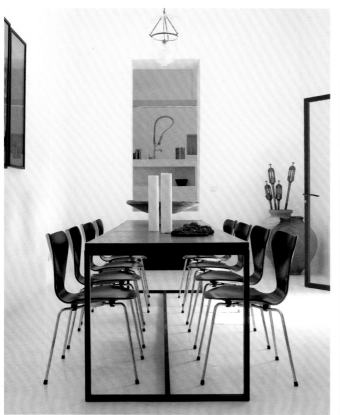

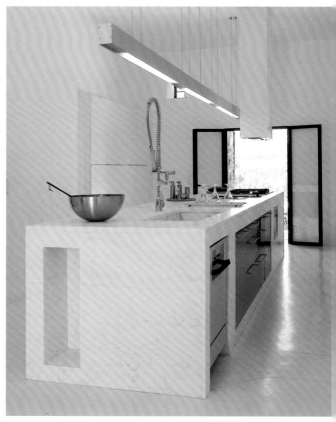

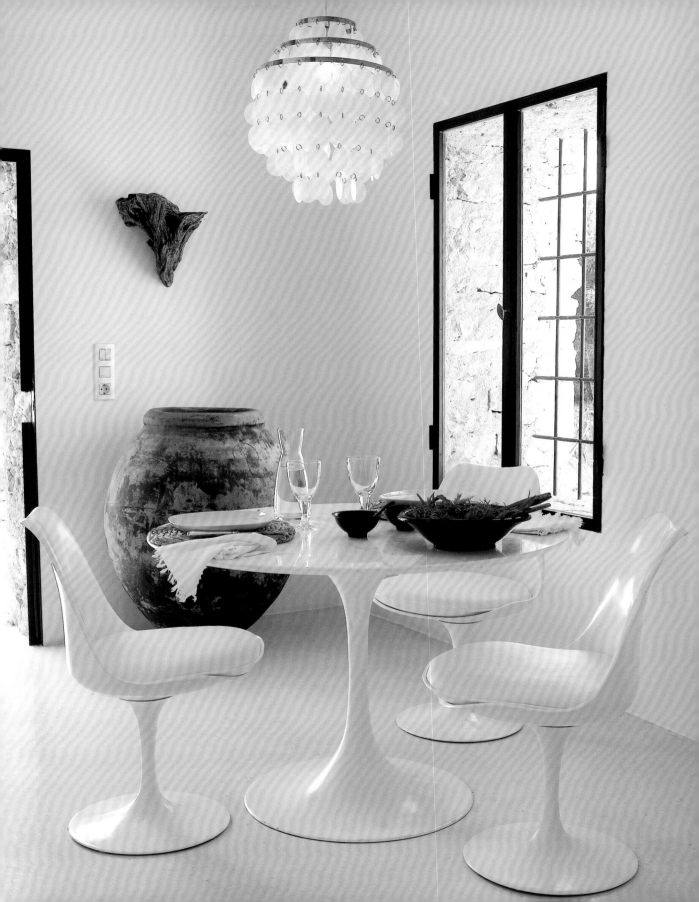

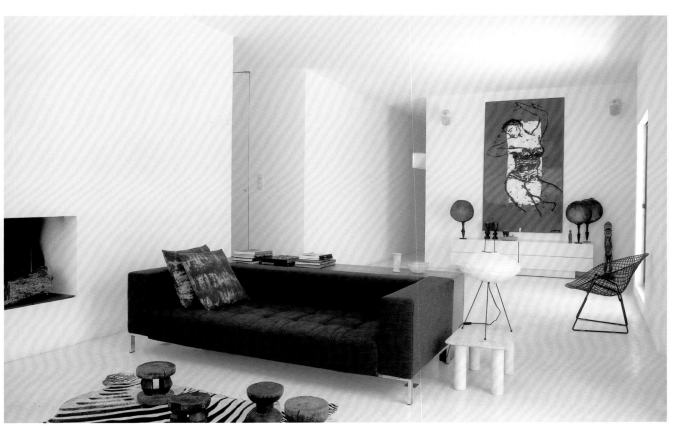

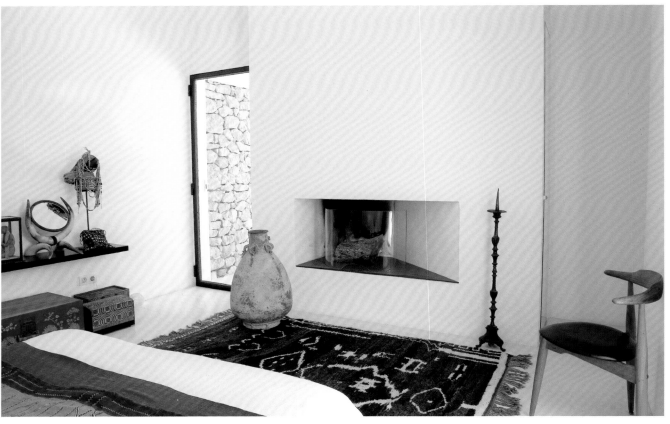

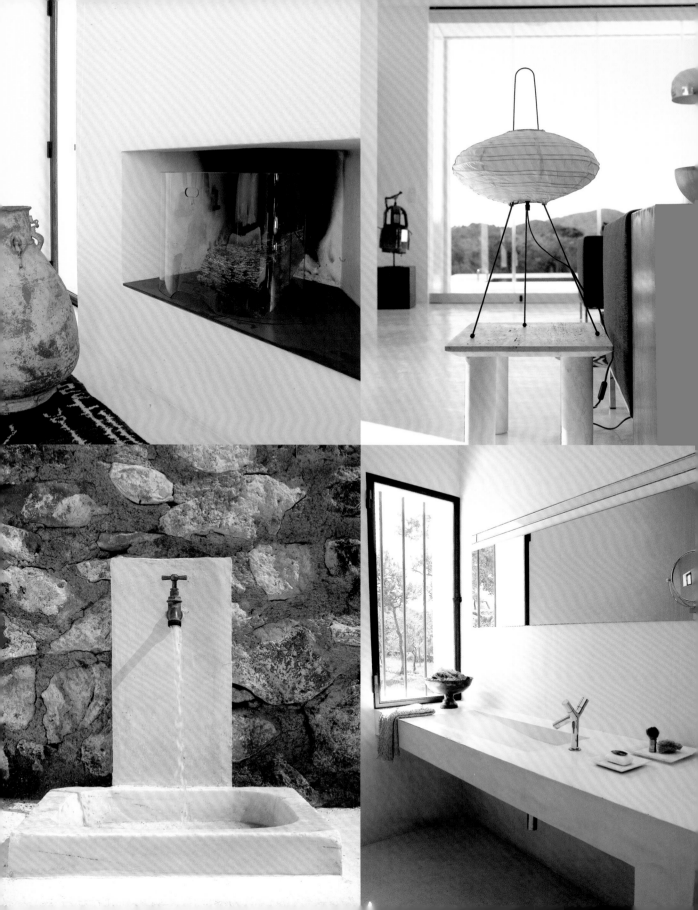

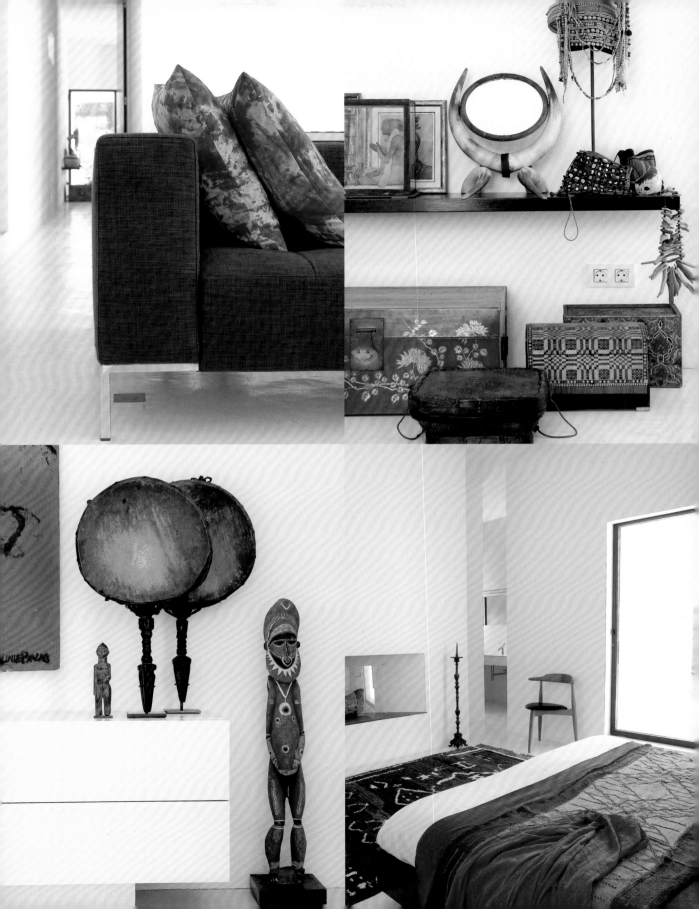

ISTANBUL
Turkey

OWNER
Seyhan Özdemir

OCCUPATION
Architect

PROPERTY
Apartment
150 sqm / 1,600 sq ft
1 floor; 2 rooms; 1 bathroom

YEAR
Building: 1900
Remodelling: 2006

ARCHITECTS & INTERIOR DESIGNERS
Seyhan Özdemir & Sefer Çağlar
Autoban, Istanbul
www.autoban212.com

ART
Painting by Habip Aydoğdu

FURNITURE
The majority of the furniture was designed
by Autoban. Also "King", "Magnolia",
"Octopus", "Lamba" and "Tulip" lighting
are by Autoban; Charles & Ray Eames chaise
longue & stools

PHOTOGRAPHER
Richard Powers, Arcaid
www.richardpowers.co.uk
www.arcaid.co.uk

PHOTO PRODUCER
Amanda Talbot, Arcaid
www.arcaid.co.uk

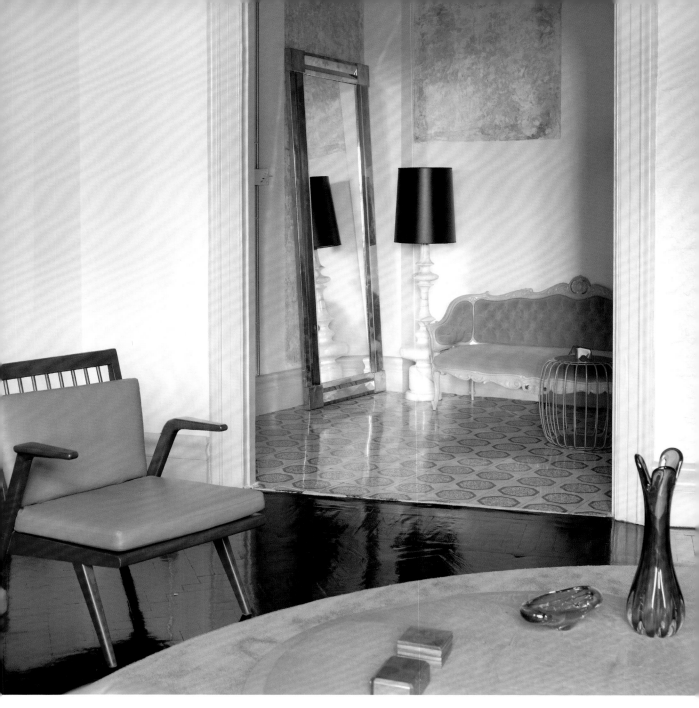

STYLE

The design is mainly influenced by Istanbul. Strong contrasts are a firm favourite in our style, as they are in this city. We like mixing the old with the new, raw surfaces with glossy materials. We create our own movie sets by carefully balancing traditional elements with the simplicity of modernism, so that they blend effortlessly.

Das Design wurde hauptsächlich von der Stadt selbst beeinflusst – die für Istanbul typischen starken Kontraste bestimmen auch unseren Stil. Wir mischen gerne das Alte mit dem Neuen, raue Oberflächen mit glänzenden Materialien. Wir schaffen unser eigenes Filmset, indem wir ein Gleichgewicht zwischen traditionellen Elementen und der Einfachheit des Modernismus herstellen.

Le décor est principalement influencé par Istanbul, avec ses puissants contrastes qui caractérisent notre style. Nous aimons mélanger l'ancien et le moderne, les surfaces brutes et les matériaux brillants. Nous créons nos décors de cinéma en équilibrant les éléments traditionnels avec la simplicité du modernisme afin qu'ils s'harmonisent naturellement.

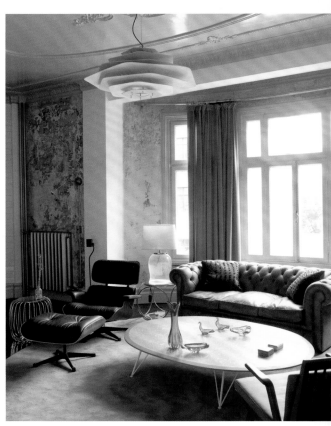

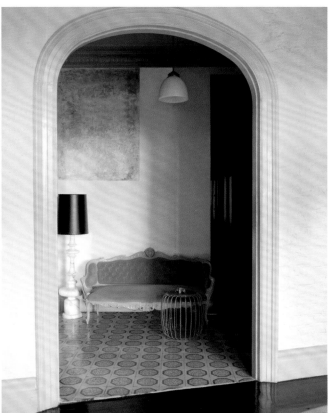

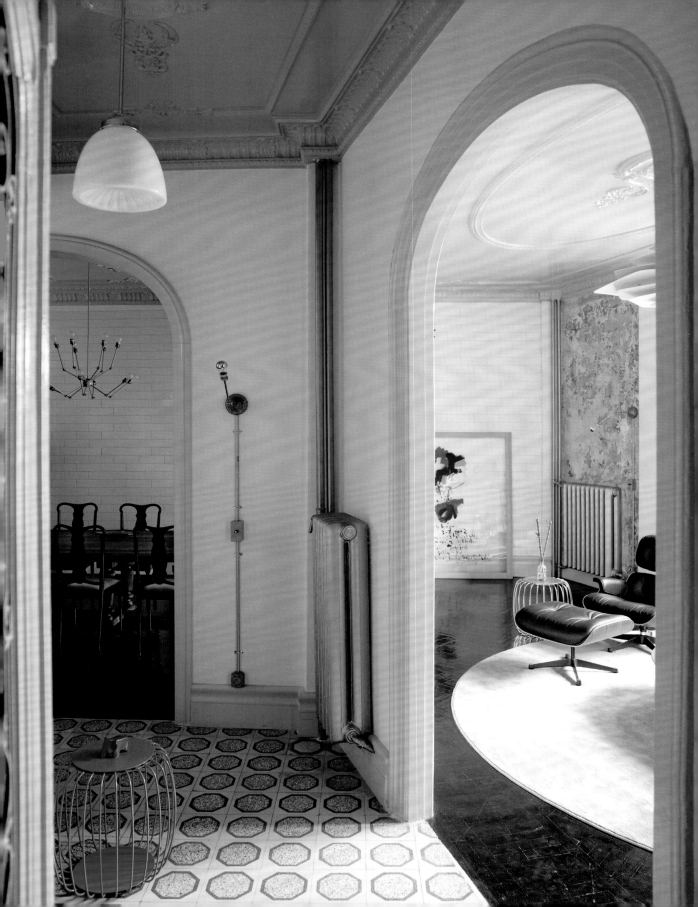

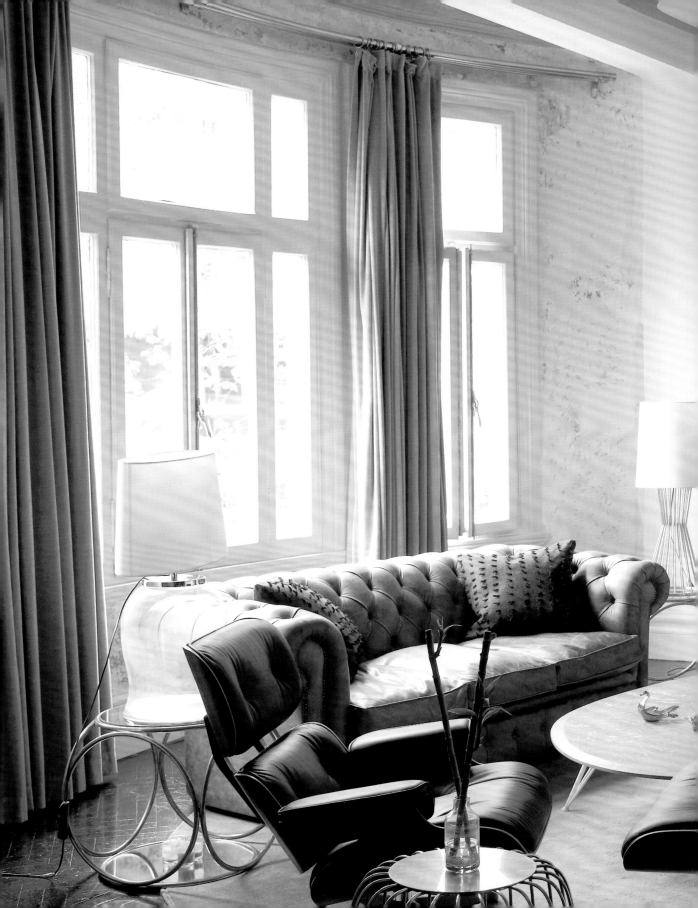

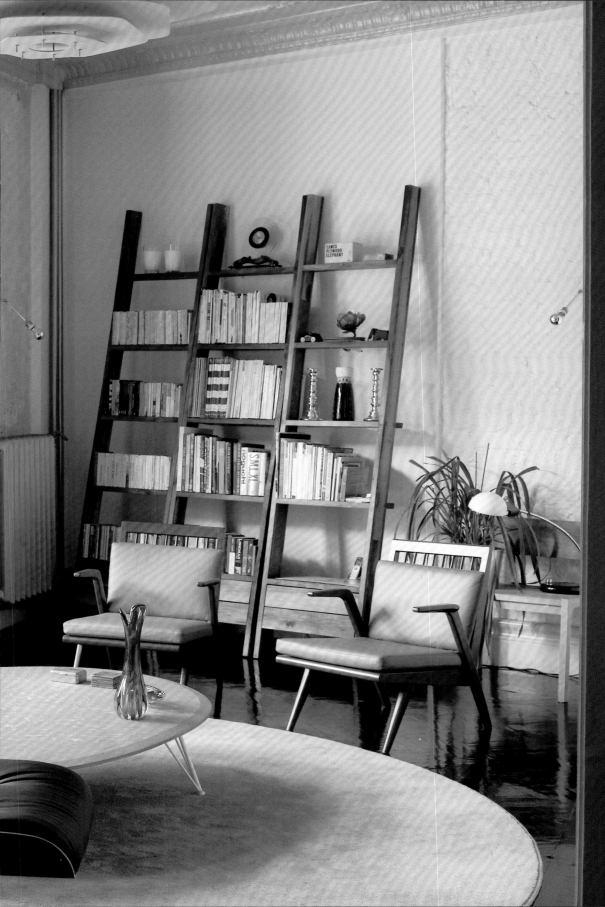

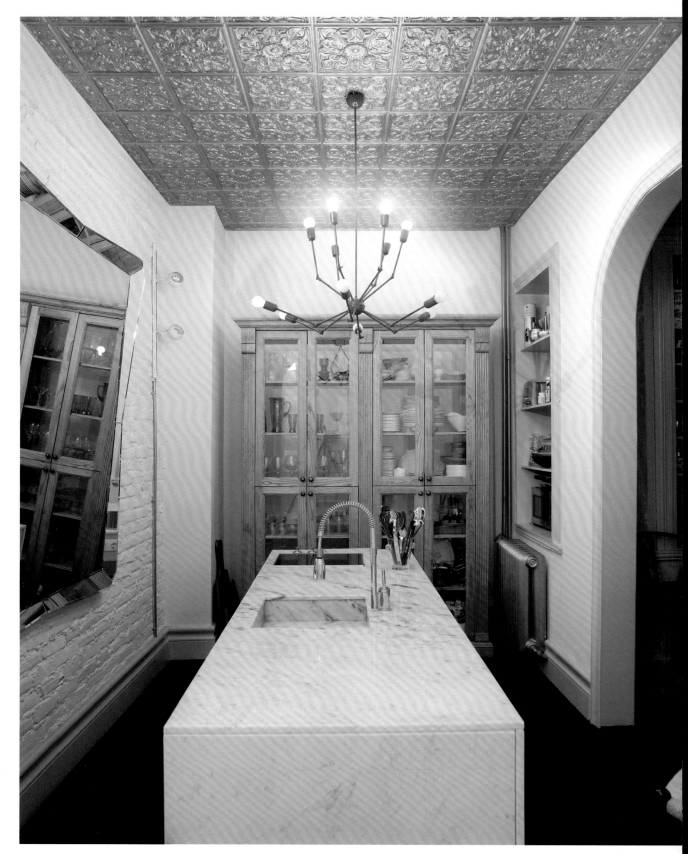

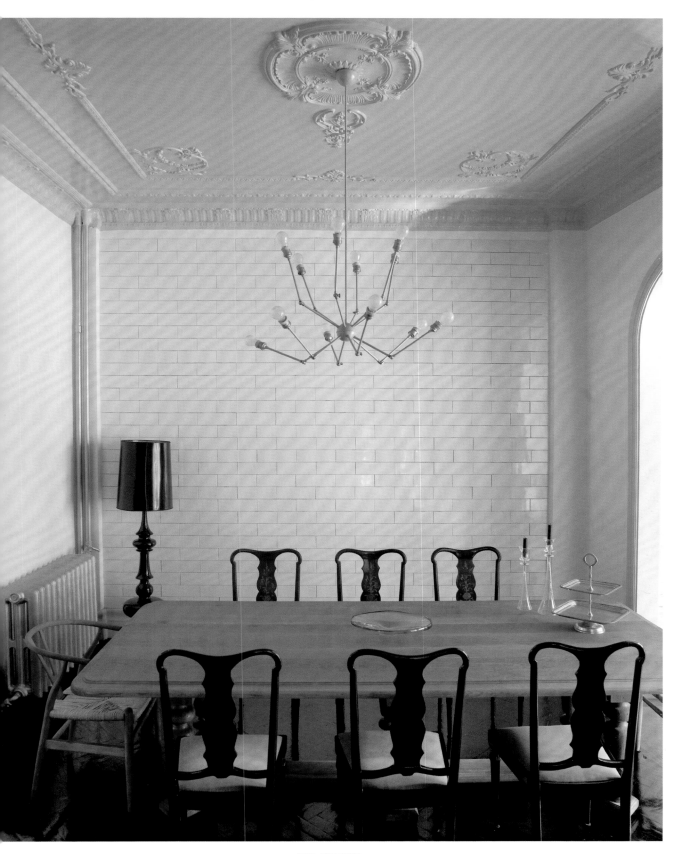

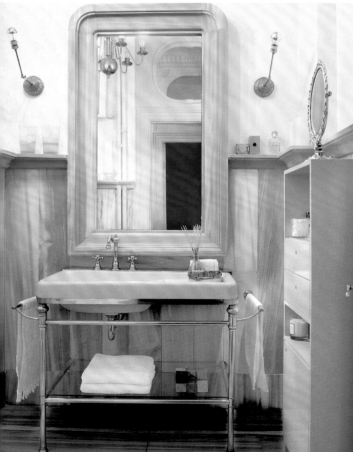
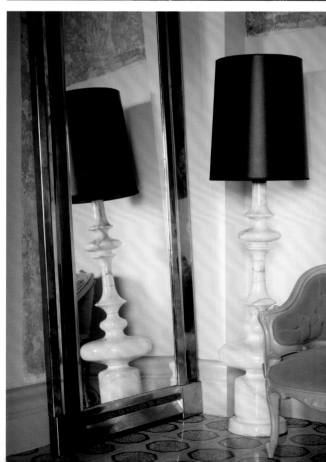

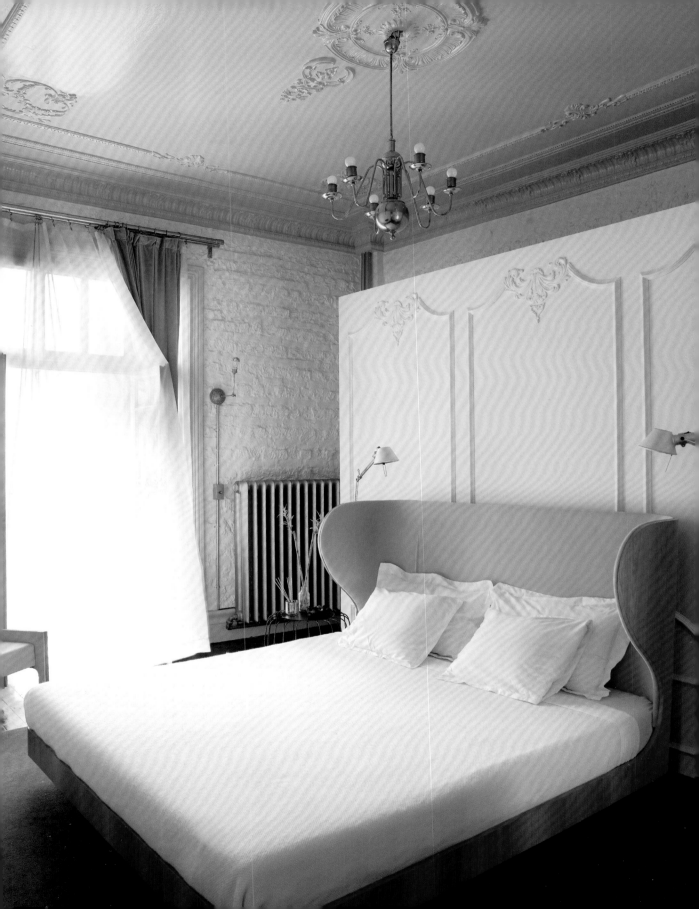

LÖDERUP

Skåne, Sweden

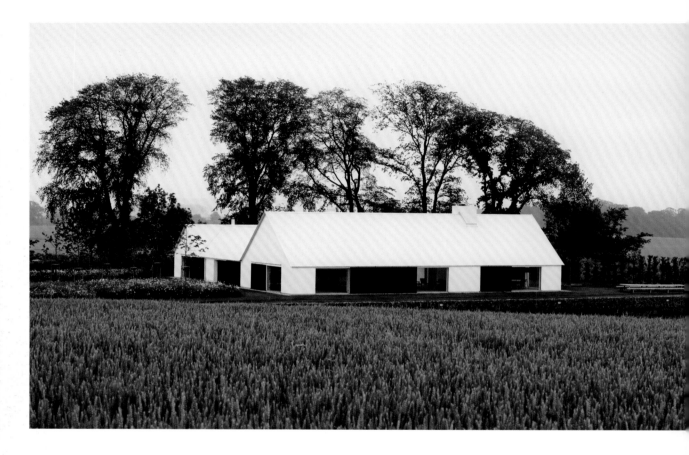

OWNER
Fabien Baron

OCCUPATION
Founder and creative director of
Baron & Baron

PROPERTY
Summer house
Property: 3,500 sqm / 38,000 sq ft
House: 500 sqm / 5,400 sq ft
1 floor + basement; 4 bedrooms;
5 bathrooms

YEAR
Building: 2005

ARCHITECT
John Pawson, London
www.johnpawson.com

FURNITURE
John Pawson tables, sofa, kitchen,
bed; Poul Kjærholm "PK 24" chaise;
Poul Hundevad stools; Verner Panton
"Bachelor" chairs & ottomans;
Hans J. Wegner "Wishbone" chairs

PHOTOGRAPHER
Fabien Baron
Baron & Baron, Inc., New York
www.baron-baron.com

STYLE
The design of the house draws significantly
on local vernacular models. These are trans-
formed through the introduction of elements
of new materiality and detailing, to create
volumes with a contemporary quality of
abstraction whose interiors are bathed in
light and views.

Die Gestaltung des Hauses ist sehr stark an
regionale, traditionelle Vorbilder angelehnt.
Durch die Kombination mit neuartigen
Materialien und Detaillösungen entstehen
Räume von zeitgenössischer Abstraktion, die
in Licht getaucht sind und den Blick öffnen.

La conception de cette maison s'inspire
beaucoup de modèles locaux revisités en
y introduisant de nouveaux matériaux et
détails. Les volumes ainsi créés ont une
qualité d'abstraction contemporaine avec
des intérieurs inondés de lumière et de vue
panoramiques.

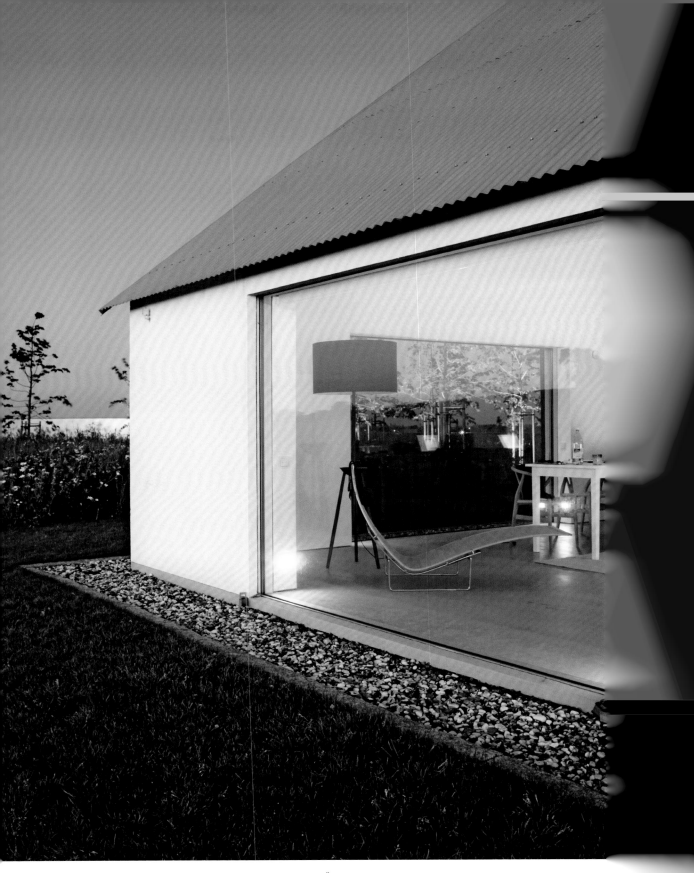

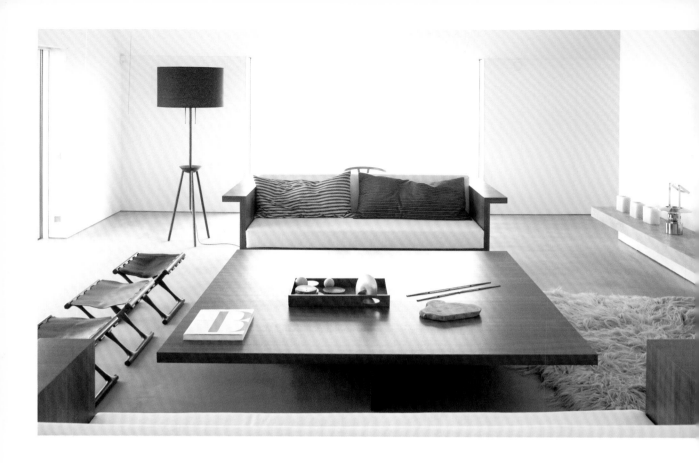

"You can think more
freely in rooms that
are almost empty."

»In fast leeren Räumen
kann man freier denken.«

« On est plus libre de penser
dans des pièces presque vides. »

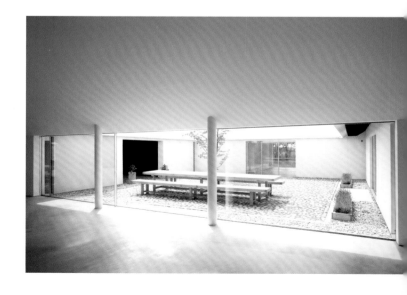

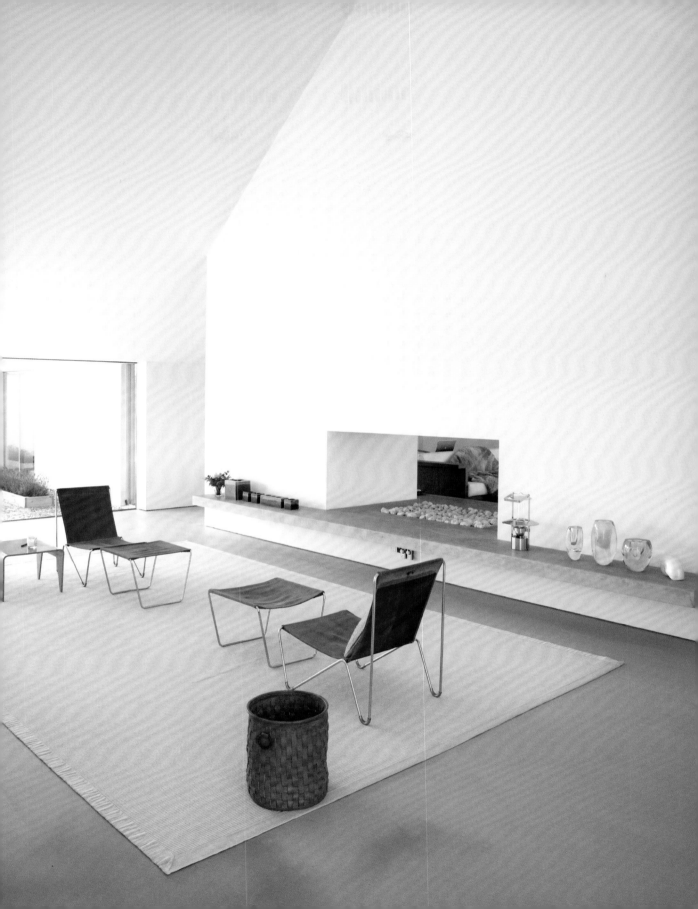

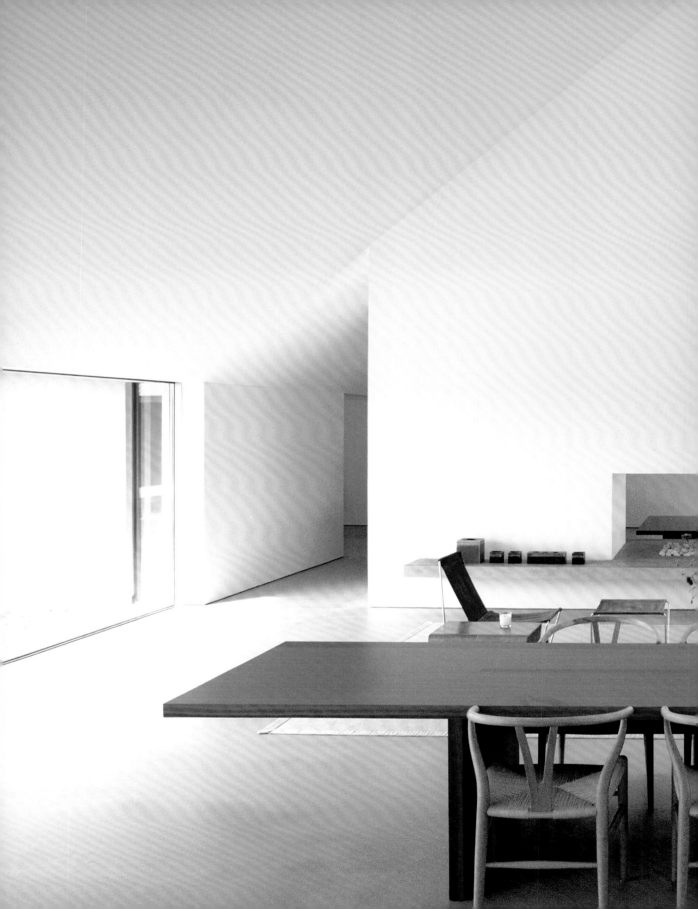

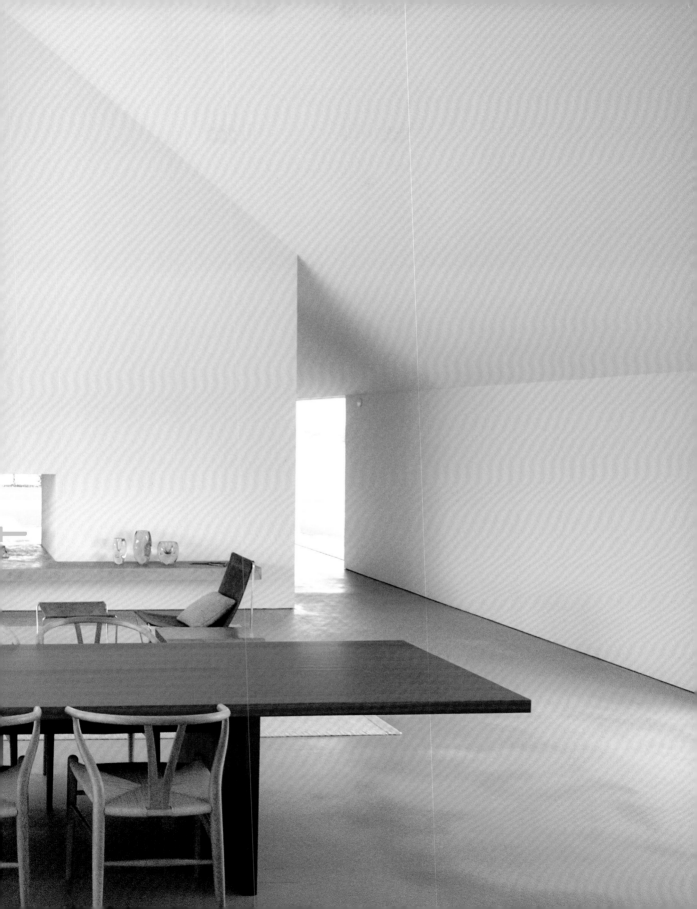

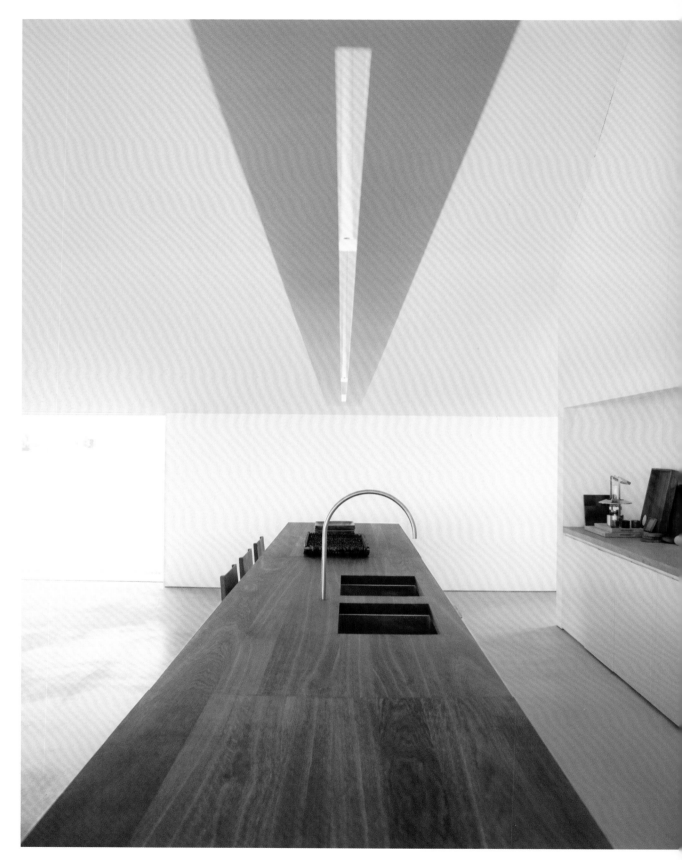

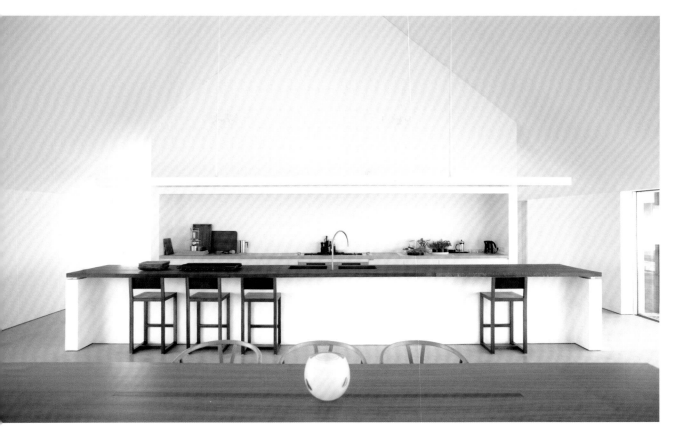

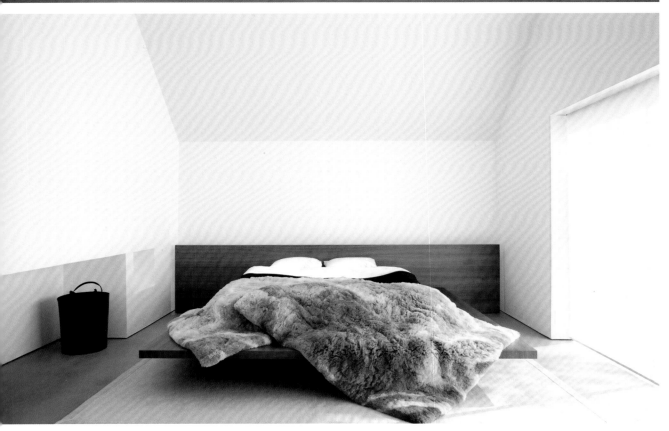

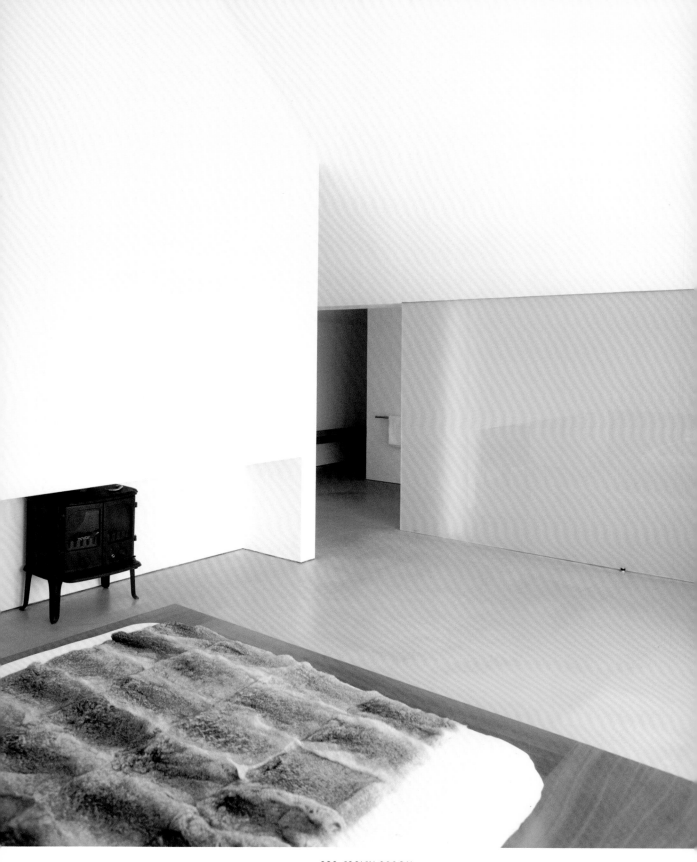

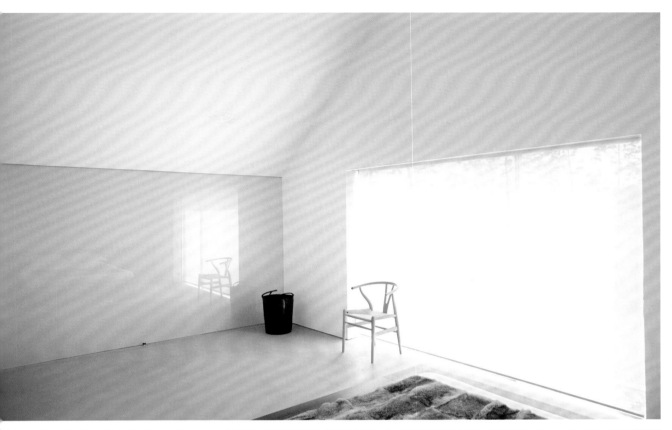

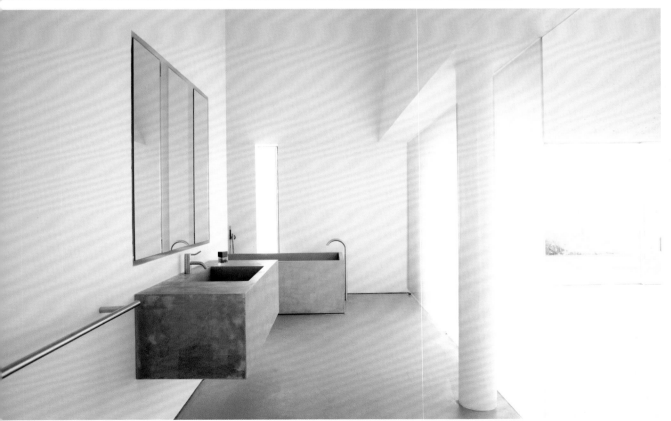

LONDON
England, United Kingdom

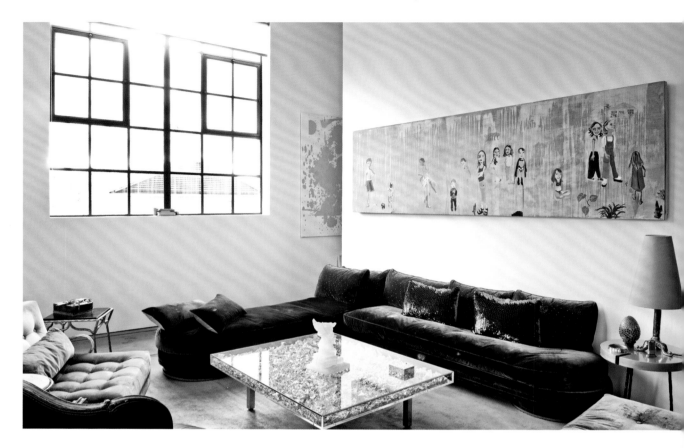

OWNER
David Gill

OCCUPATION
Gallerist

PROPERTY
Handbag factory converted
into a gallery & flat
2,415 sqm / 26,000 sq ft
3 floors; 10 rooms; 3 bathrooms

YEAR
Building: 1900
Remodelling: 1999

ARCHITECT & INTERIOR DESIGNER
David Gill, London
www.davidgillgalleries.com

ART
Chantal Joffe; Giacinto Cerone; Barnaby
Barford; Franz West; Richard Prince;
Christopher Wool; Albert Oehlen; Paul
McCarthy; Rudolf Stingel; Josh Smith;
Jean Cocteau; Ugo Rondinone; Francesco
Clemente; Nate Lowman; et al.

FURNITURE
Mattia Bonetti; Fredrikson Stallard;
Yves Klein; Elizabeth Garouste & Mattia
Bonetti; Charlotte Perriand; Jean Prouvé;
Serge Mouille; Eugène Printz; et al.

PHOTOGRAPHER
Ricardo Labougle, Buenos Aires / Madrid
www.ricardolabougle.com

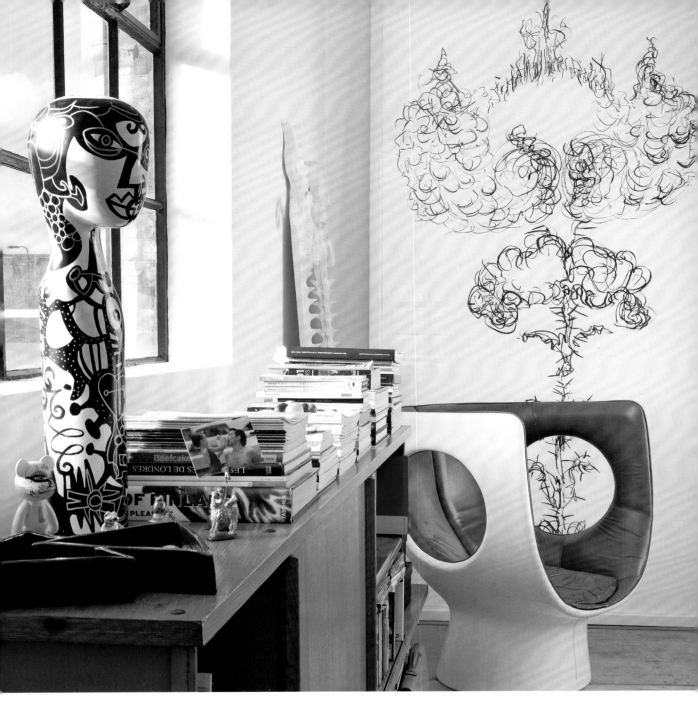

STYLE

Using Corbusian principles of volume and space, I have created an environment in which diverse artworks can be appreciated and gain from surprising context and juxtaposition. I want my home to be like a painter's palette – imaginative and inspiring.

Nach den Volumen- und Raumprinzipien von Le Corbusier habe ich eine Umgebung geschaffen, in der verschiedene Kunstwerke betrachtet werden können und durch überraschenden Kontext und Gegenüberstellung zur Geltung kommen. Mein Apartment soll wie die Palette eines Malers sein: fantasievoll und inspirierend.

En reprenant les principes de volume et d'espace de Le Corbusier, j'ai créé un environnement où des œuvres d'art très diverses peuvent être appréciées et bénéficient d'un contexte et d'une juxtaposition surprenants. Je voudrais que ma maison soit comme la palette d'un peintre, créative et stimulante.

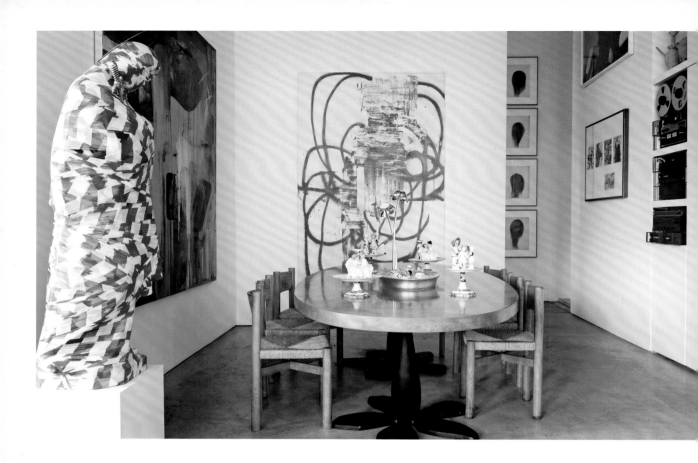

"It is about individuality, and the creation of something extraordinary."

»Es geht um Individualität und darum, etwas Außergewöhnliches zu schaffen.«

« Il s'agit d'individualité et de créer quelque chose d'extraordinaire. »

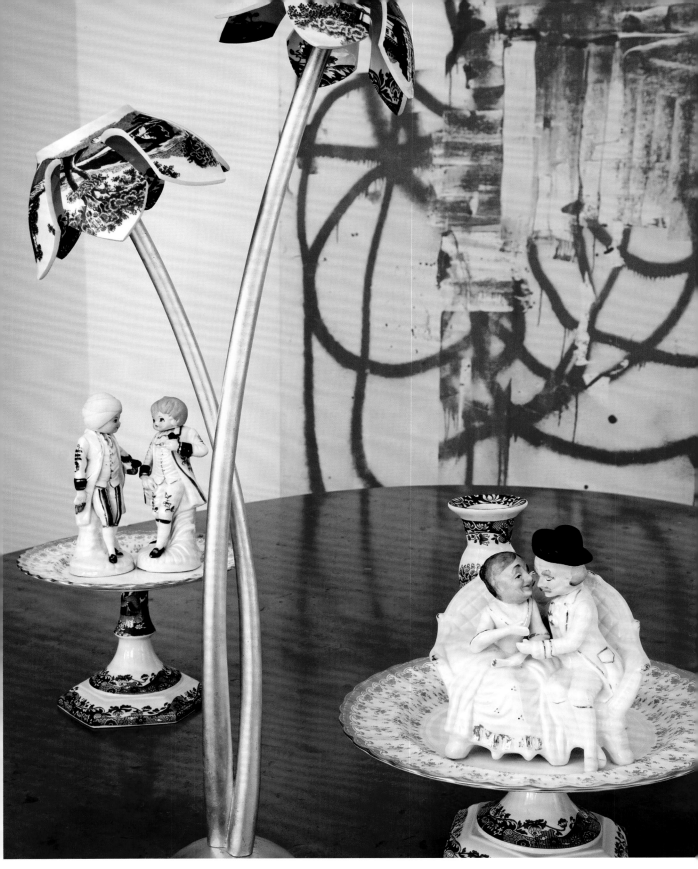

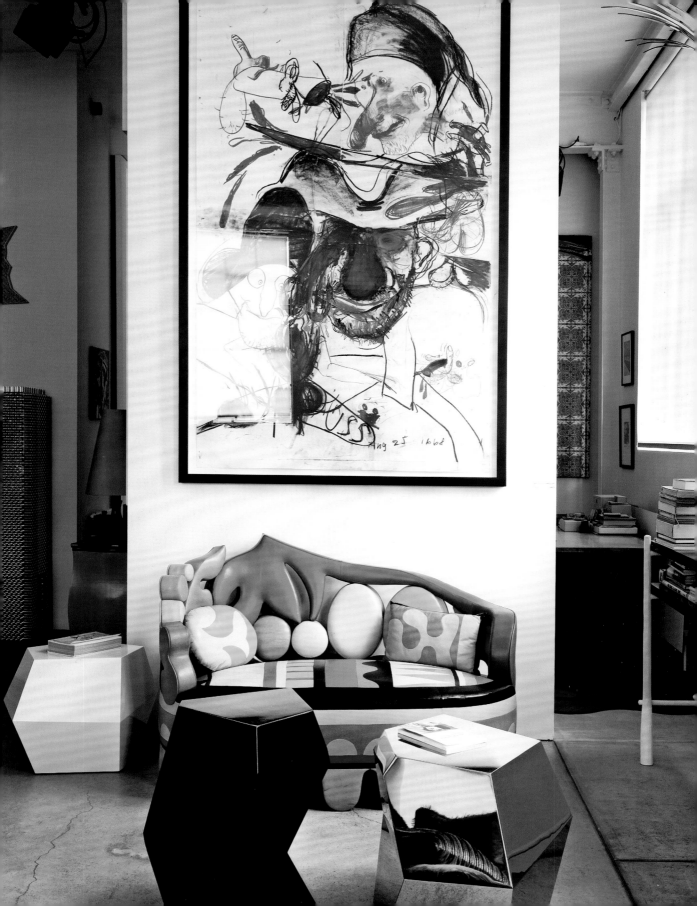

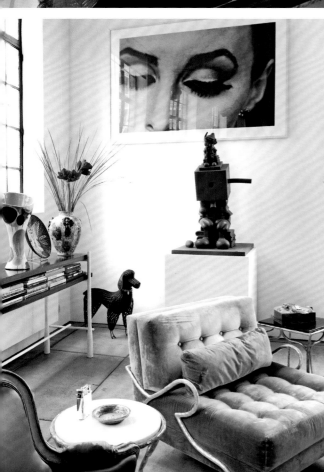
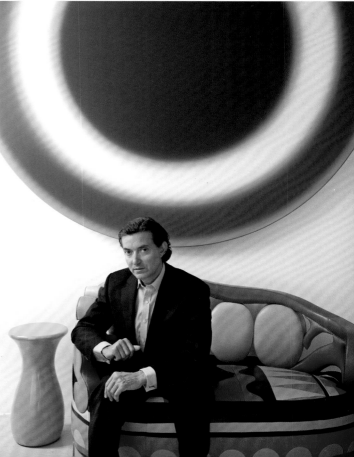

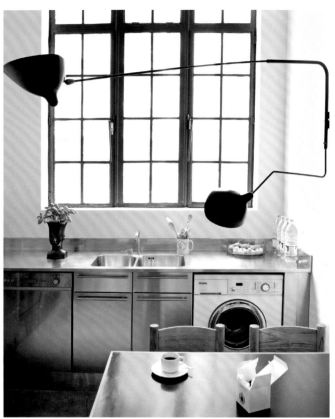
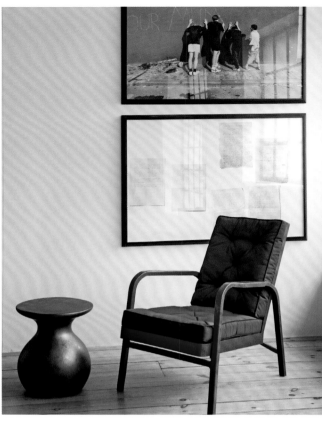
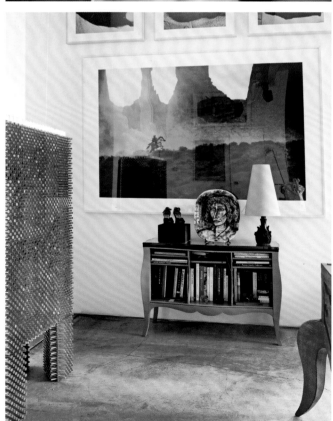
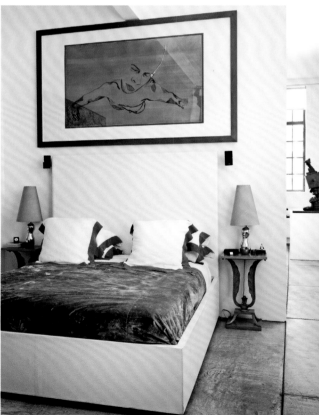

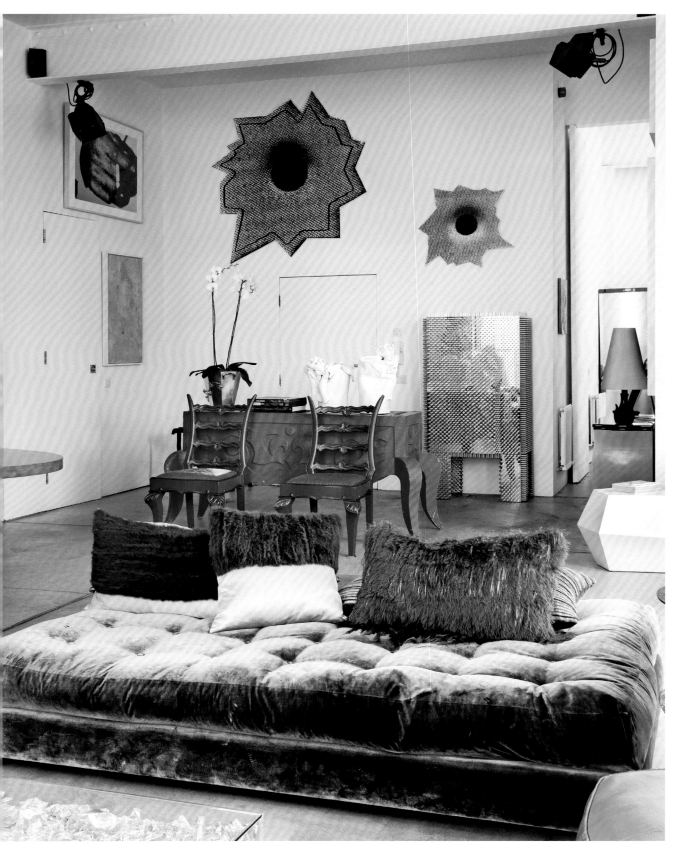

LOS ANGELES
Beverly Hills, California, USA

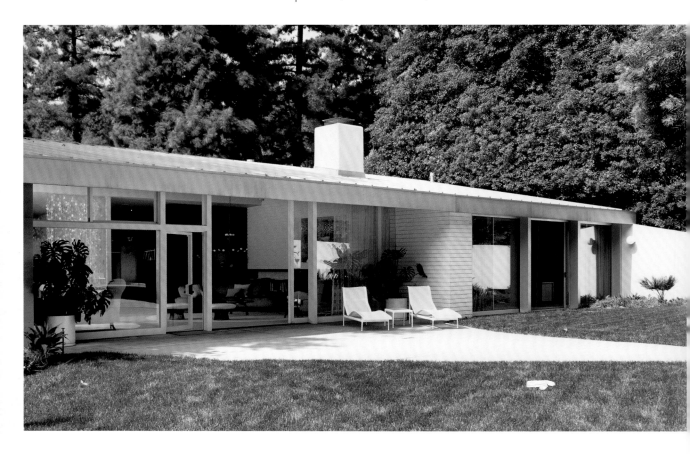

OWNERS
Sally & Michel Perrin

OCCUPATION
Fashion business

PROPERTY
House
500 sqm / 5,400 sq ft
1 floor; 10 rooms; 4 bathrooms

YEAR
Building: ca. 1950
Remodelling: 2006

ARCHITECT
Victor Gruen, ca. 1950

INTERIOR DESIGNER
Chahan Minassian
Chahan Interior Design, Paris
www.chahan.com

LANDSCAPE DESIGNER
Judy Kameon
Elysian Landscapes, Los Angeles
www.elysianlandscapes.com

ART
Gregory Ryan; Nancy Lorenz;
Philippe Hiquily; Joan Hernandez Pijuan

FURNITURE
Richard Schultz; Mathieu Matégot; Warren
Platner; Vladimir Kagan; Paul László; T. H.
Robsjohn-Gibbings; Edward Wormley;
Paul T. Frankl; Tony Duquette; Serge Mouille;
Ado Chale; Steve Chase Design; French &
American vintage furniture; Chahan Minassian

PHOTOGRAPHER
Roger Davies, Los Angeles
www.rogerdaviesphotography.com

PHOTO PRODUCER & STYLIST
Ian Phillips, Paris
www.tripodagency.com

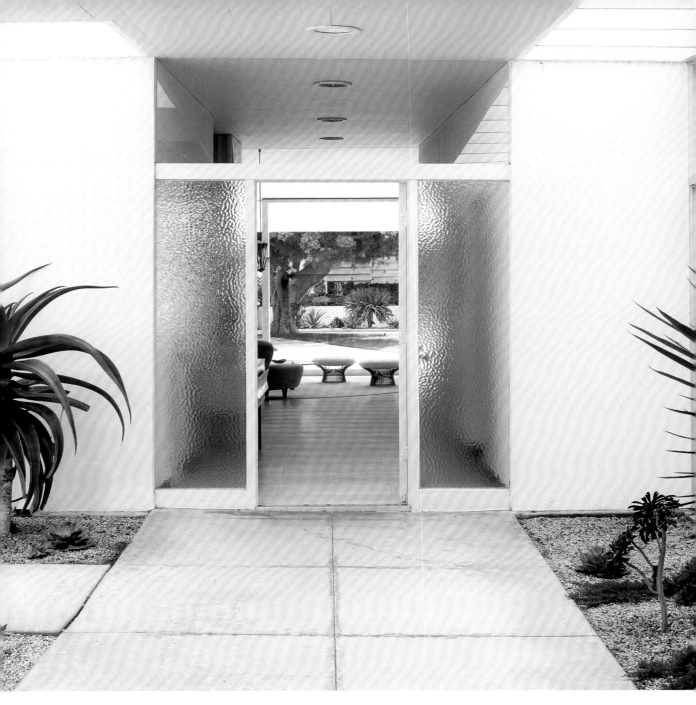

STYLE

Chahan Minassian's meticulous lighting and harmonious colours provide a framework for materials such as stone and pale woods, textured monochrome fabrics and a superb collection of decorative arts, especially American designers from the 1930s to the 1960s.

Chahan Minassians maßgeschneiderte Beleuchtung und Farbharmonien schaffen eine Struktur für Materialien wie Steine, helle Hölzer, monochrome Webstoffe und eine fantastische Sammlung dekorativer Kunst, insbesondere von amerikanischen Designern der 1930er bis 1960er Jahre.

L'éclairage soigné et les harmonies de couleur de Chahan Minassian offrent une structure aux matières telles que la pierre et les bois clairs, à la monochromie texturée des tissus et à une superbe collection d'arts décoratifs, notamment de designers américains des années 1930 aux années 1960.

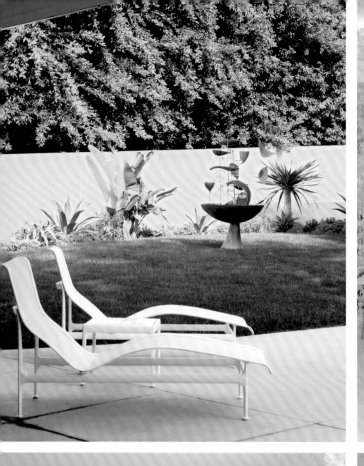
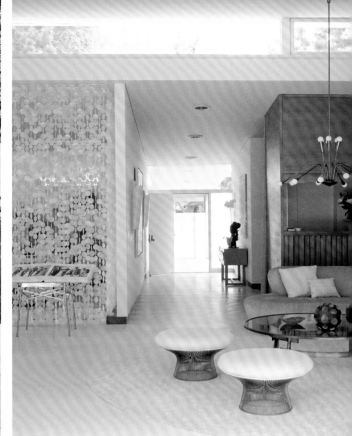
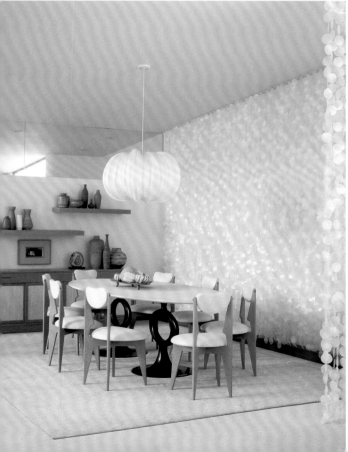
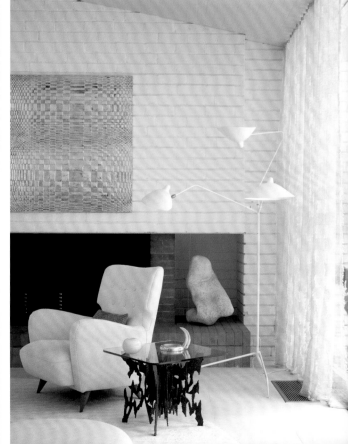

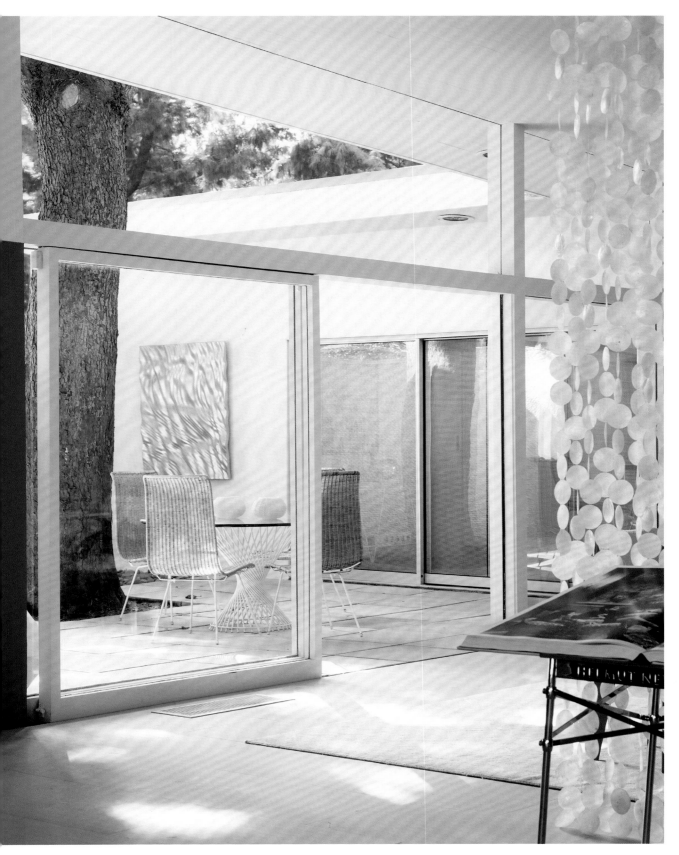

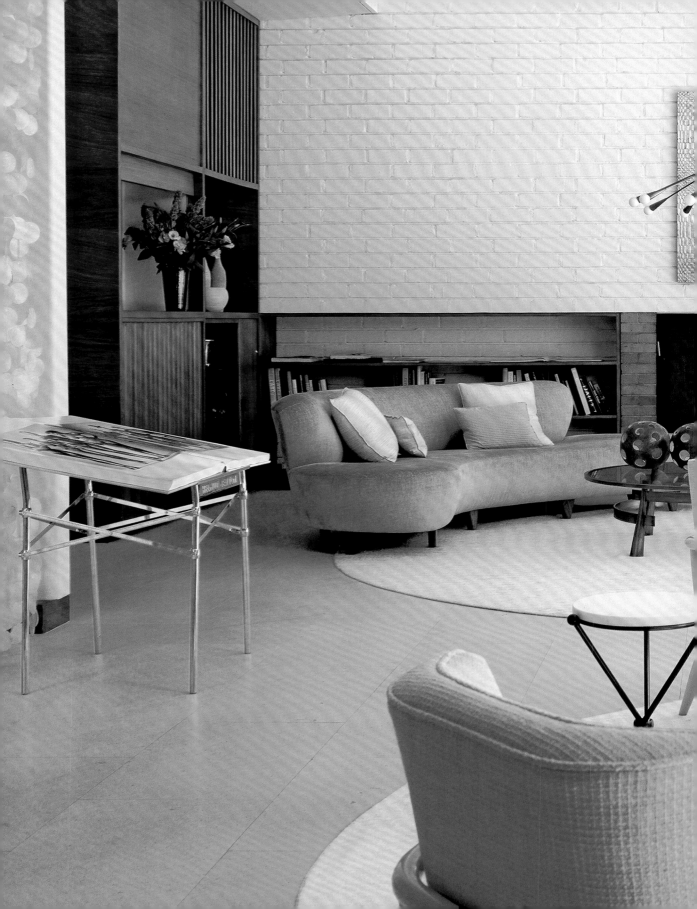

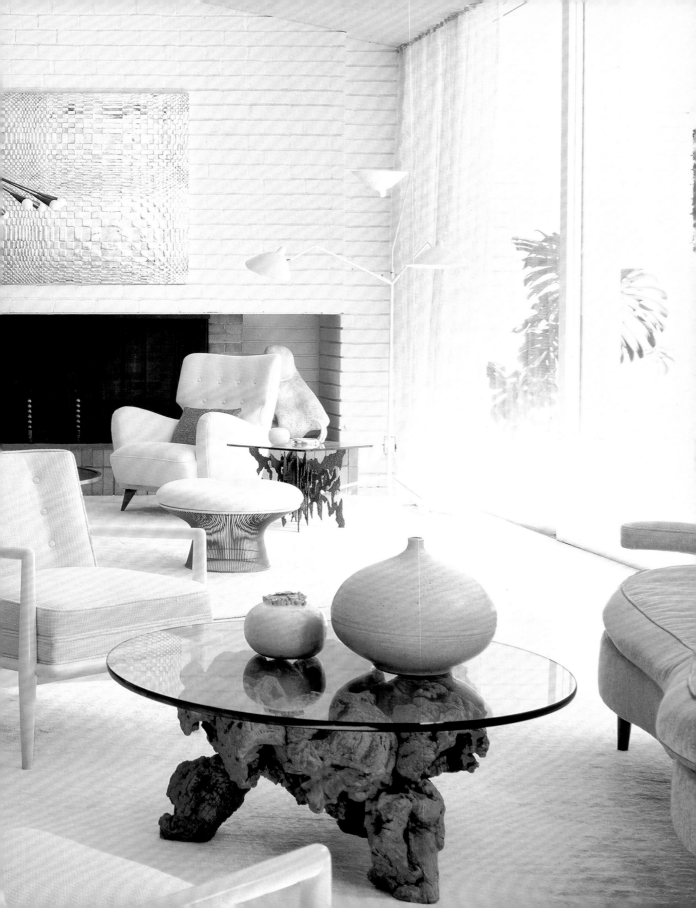

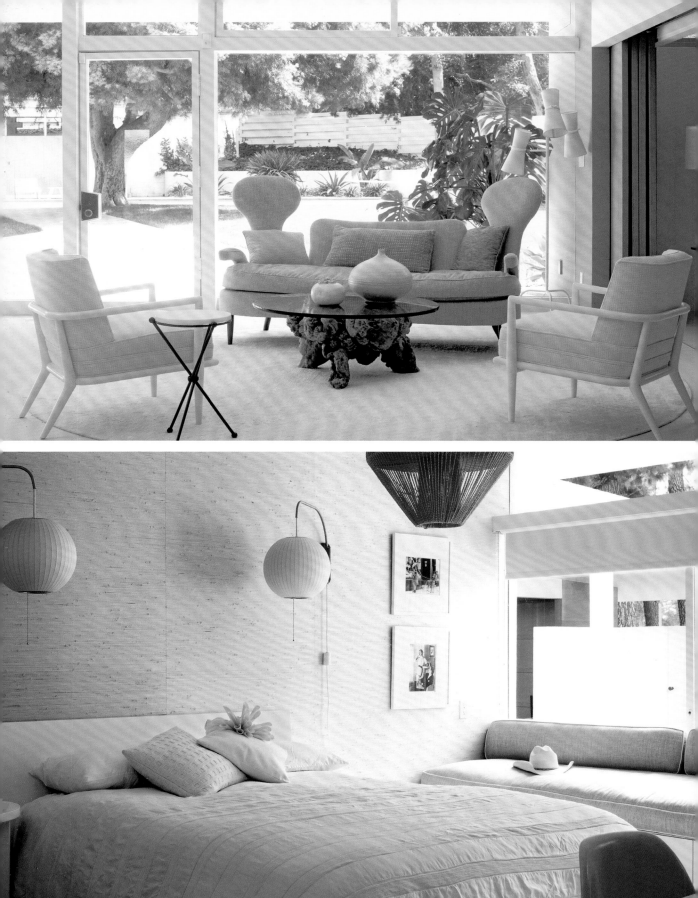

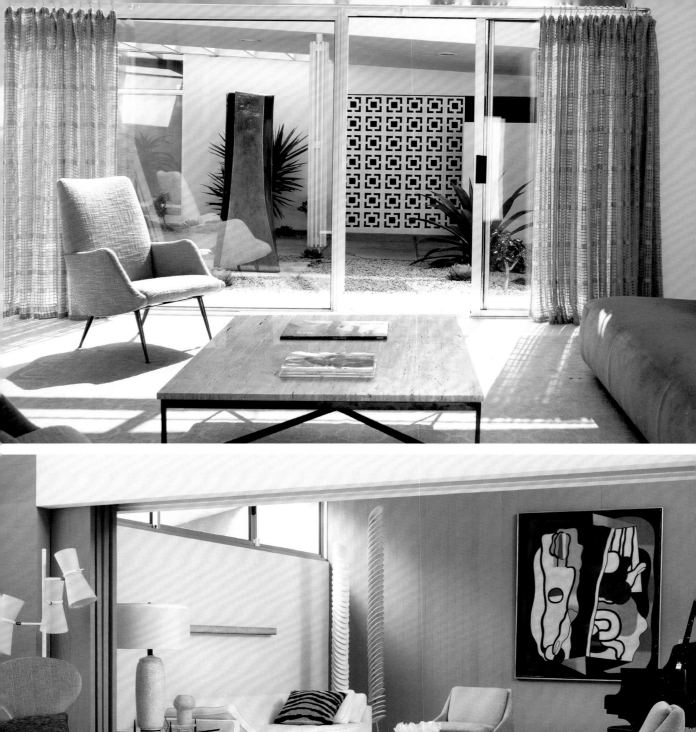
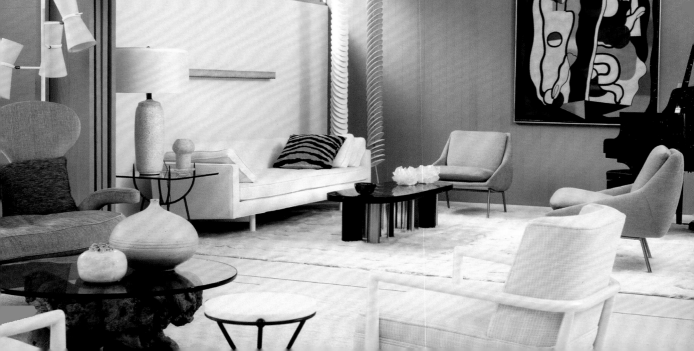

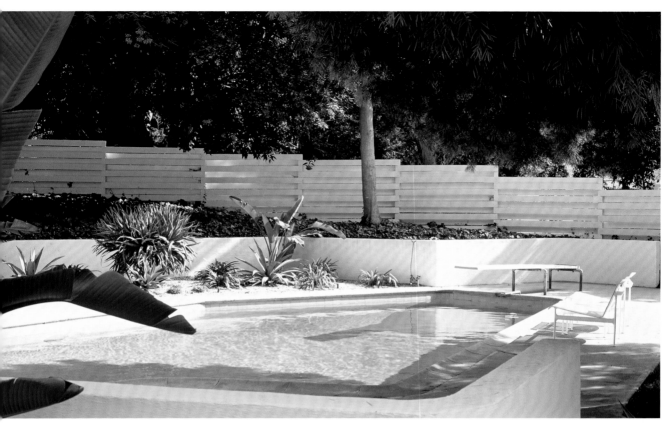

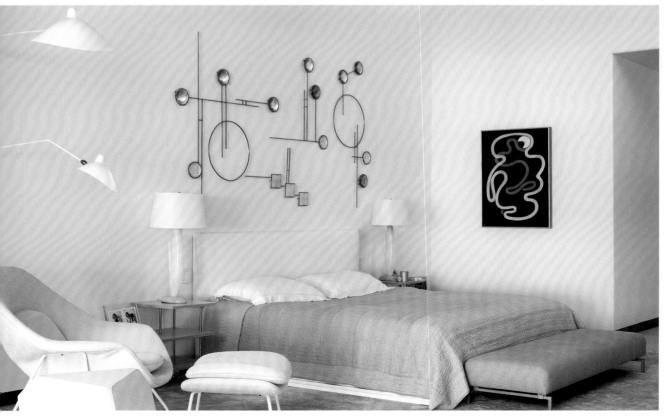

MALLORCA
Baleares, Spain

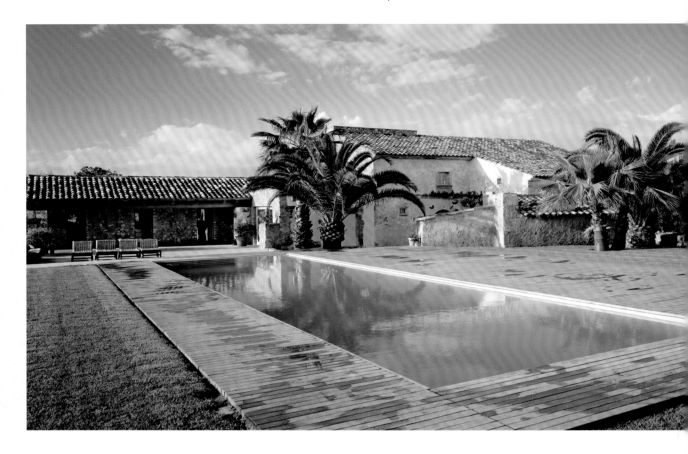

OWNERS
Carla Plessi Ventura & Fabrizio Plessi

OCCUPATION
Architect / Artist

PROPERTY
Country house
1,000 sqm / 10,750 sq ft
2 floors; 6 rooms; 7 bathrooms

YEAR
Building: ca. 1400
Remodelling: 2004

ARCHITECTS & INTERIOR DESIGNERS
Carla Plessi Ventura & Fabrizio Plessi

ART
Fabrizio Plessi "L'Enigma Degli Addii 2"

FURNITURE
The Arclinea kitchen is a special fabrication
designed by Antonio Citterio;
Fabrizio Plessi custom-made table

PHOTOGRAPHER
Andrea Martiradonna, Milan
www.martiradonna.it

PHOTO PRODUCER
Roberta Angelini, Paris

STYLE
Interior and exterior blend to form a single
entity. In the absence of furniture, light, air
and emptiness unfold. Art and life intersect,
creating a fusion of nature and culture.

Innen und außen sollen zu einer Einheit
verschmelzen. Möbel fehlen, stattdessen
breiten sich Licht, Luft und Leere aus. Es
überschneiden sich Kunst und Leben, eine
Fusion zwischen Natur und Kultur.

L'intérieur et l'extérieur devraient se fondre
pour former un tout. En l'absence de meu-
bles, la lumière, l'air et l'espace se déploient.
L'art et la vie se rencontrent, une fusion de la
nature et de la culture.

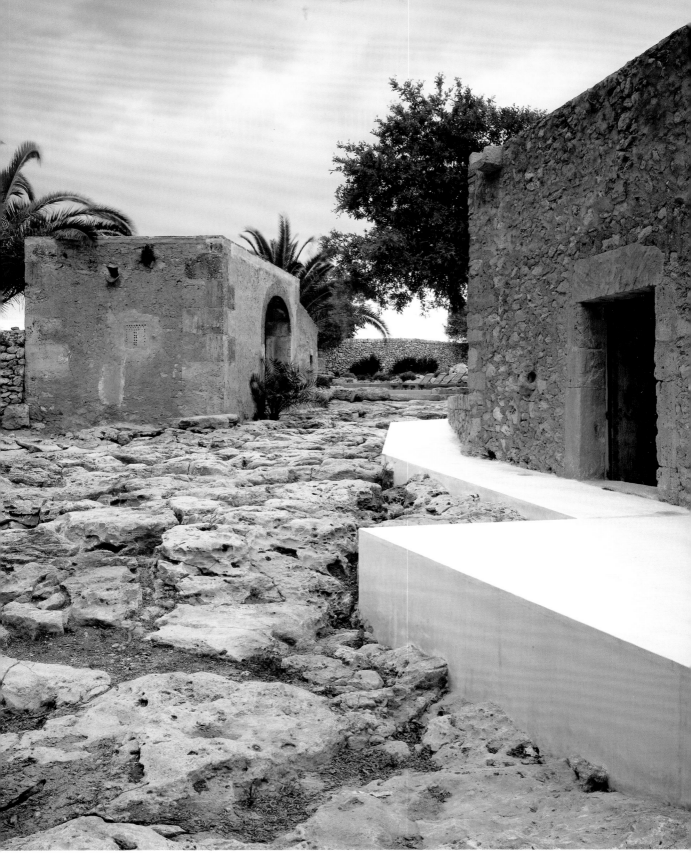

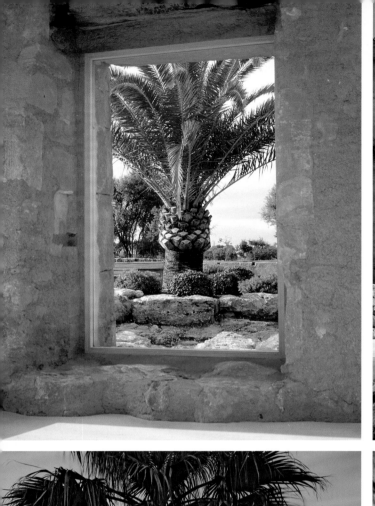
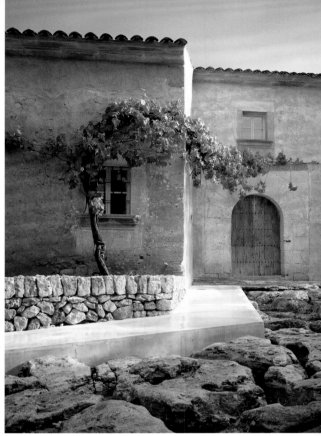
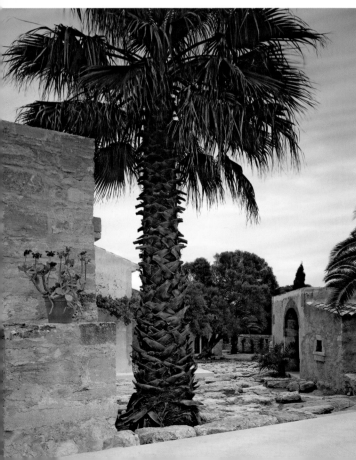
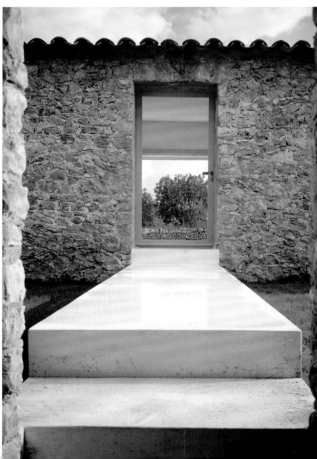

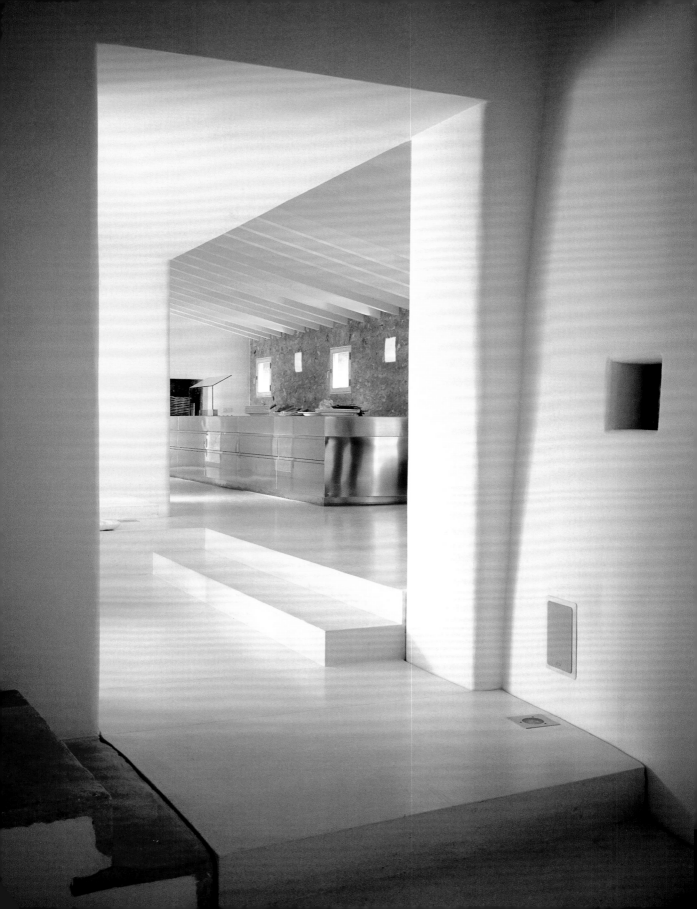

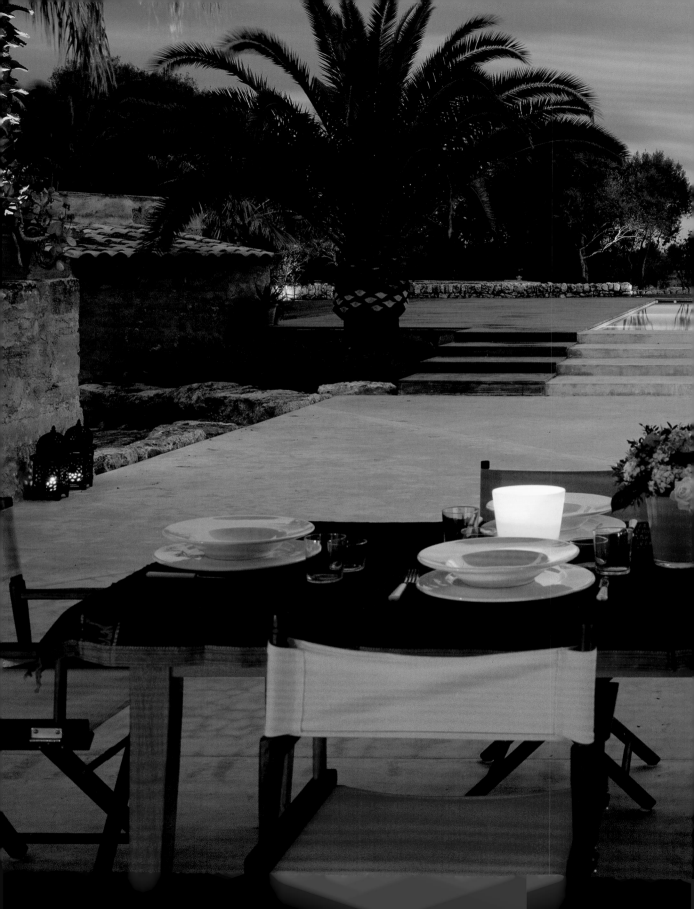

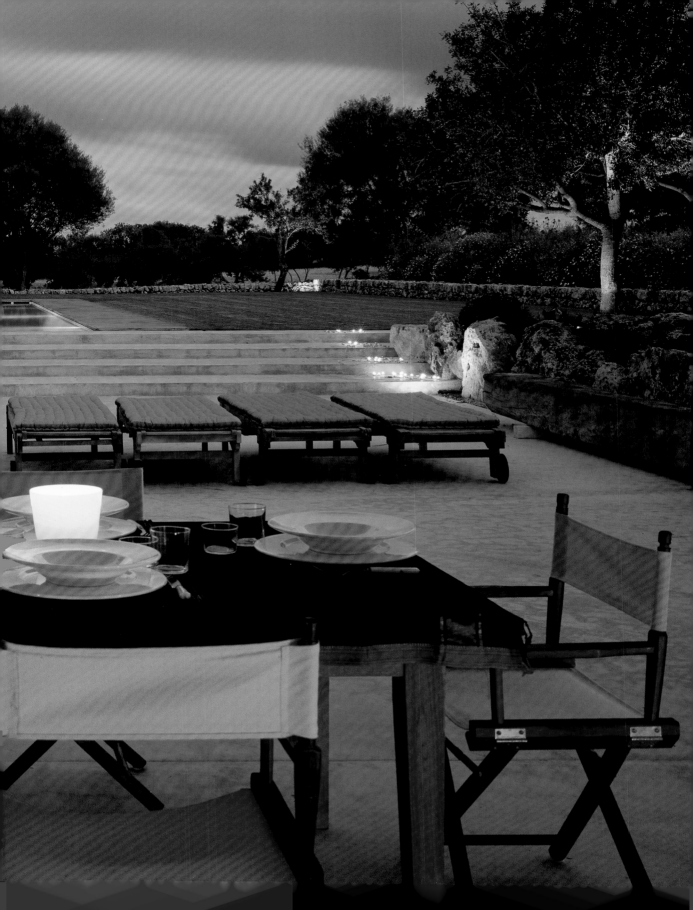

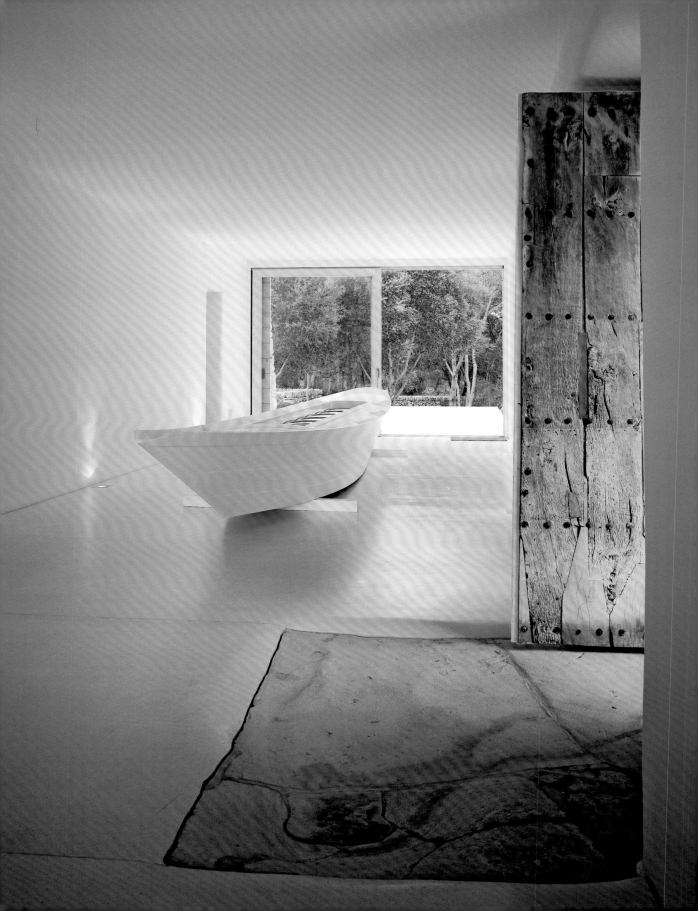

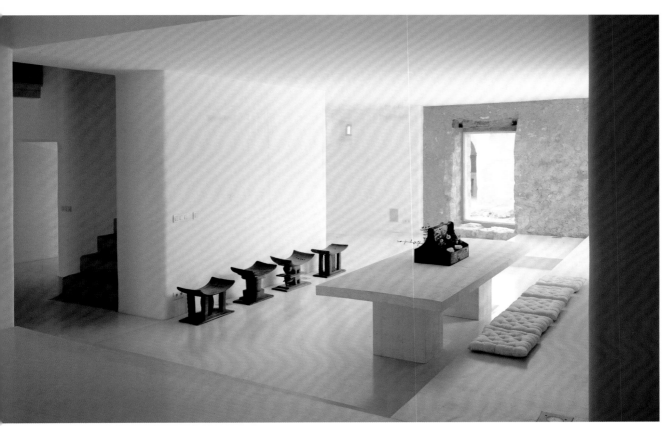

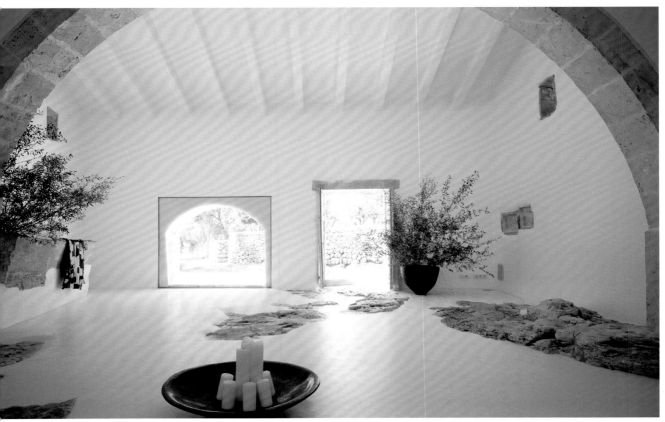

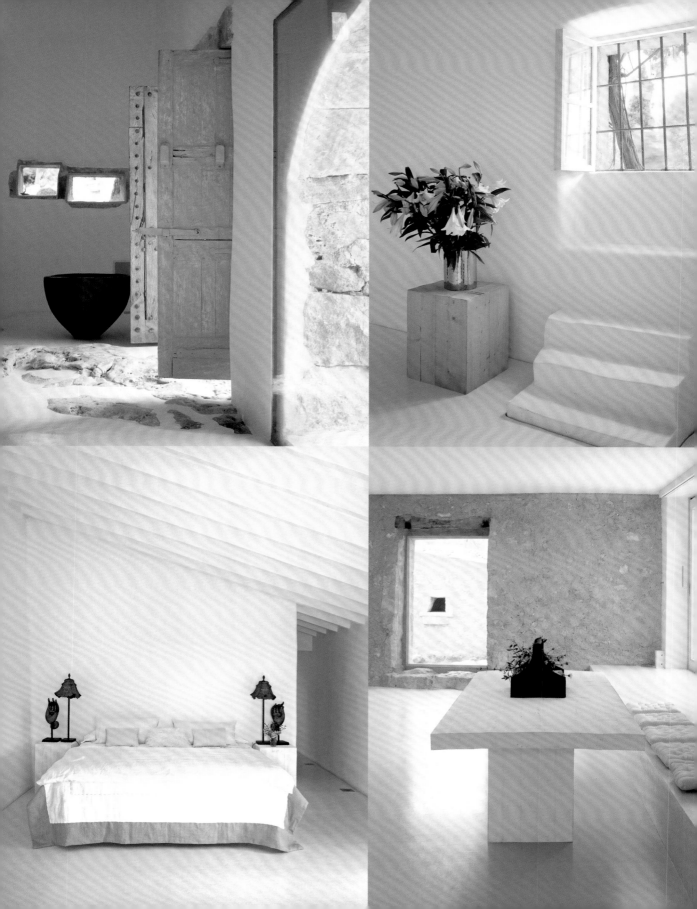

MARFA

Texas, USA

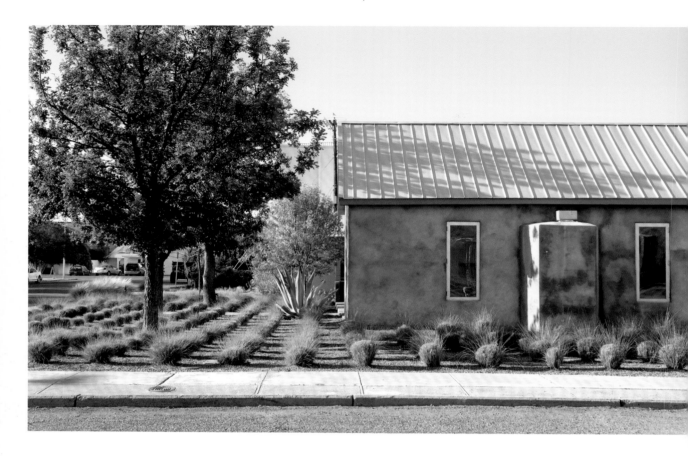

OWNERS
Amelia & Holden Shannon

OCCUPATION
Mother / Airline executive

PROPERTY
Weekend house
170 sqm / 1,800 sq ft
1 floor; 1 room; 1 kitchen; 1 bathroom

YEAR
Building: ca. 100 years old
Remodelling: 2003–2004

ARCHITECT & INTERIOR DESIGNER
Barbara Hill Design, Houston
www.barbarahilldesign.com

GARDEN DESIGNERS
Barbara Hill, Houston & Jim Martinez, Marfa

ART
Photograph printed on aluminium
by Victoria Samnubaris

FURNITURE
French vintage table; white Arne Jacobsen
"Series 7" chairs; recovered 1930s
armchairs; Warren Platner side table; Harry
Bertoia "Diamond" chairs; George Nelson
side table; Charles & Ray Eames natural
leather sofas; Florence Knoll credenza;
Raymond Loewy credenza

PHOTOGRAPHER
Michel Arnaud, GAP Interiors
www.michelarnaud.com
www.gapinteriors.com

PHOTO PRODUCER
Lauren Sara, Philadelphia

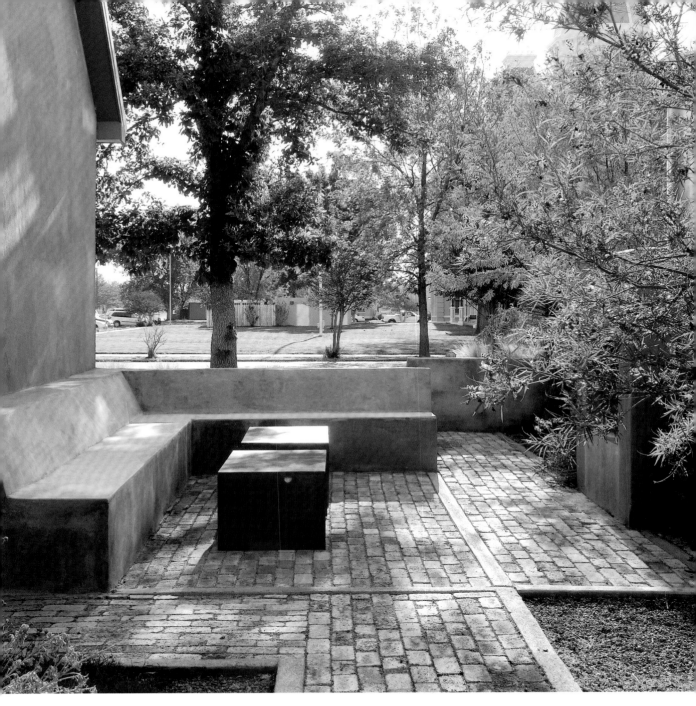

TYLE

his holiday home is made for total relaxa-
on. There is no TV in the house. In the
venings the family plays board games and
angs out at the outdoor fireplace. The
terior turned out quiet and peaceful with
mooth surfaces such as chalk finishes on
e wall and white pine floors.

Das Ferienhaus dient der totalen Ent-
spannung. Es gibt keinen Fernseher; am
Abend spielt die Familie Brettspiele oder
versammelt sich draußen um die Feuerstelle.
Auch die Innenräume spenden Ruhe und
Frieden, mit glatten Oberflächen, poliertem
Kalk an den Wänden und weiß lasierten
Kieferböden.

Cette maison de vacances est conçue pour
une détente totale. Il n'y a pas de télévision ;
le soir, la famille joue à des jeux de société
ou se détend près de la cheminée extérieure.
L'intérieur est paisible avec des surfaces
lisses et des finitions à la chaux sur les murs
et les parquets blancs en pin.

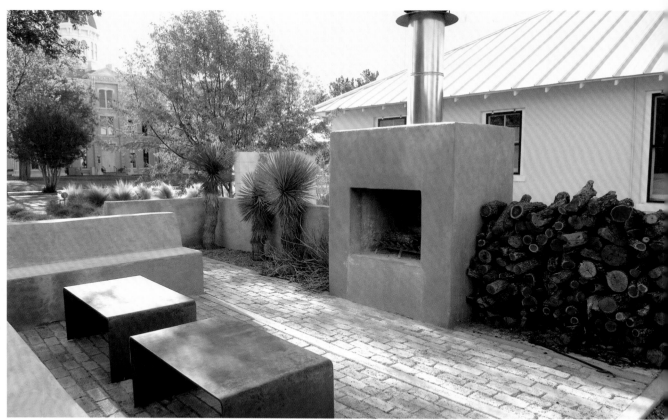

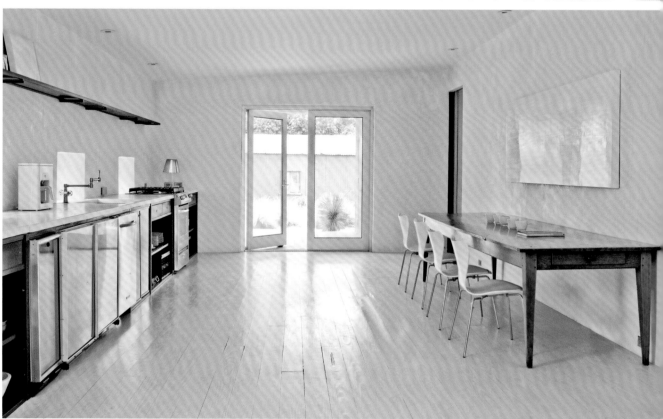

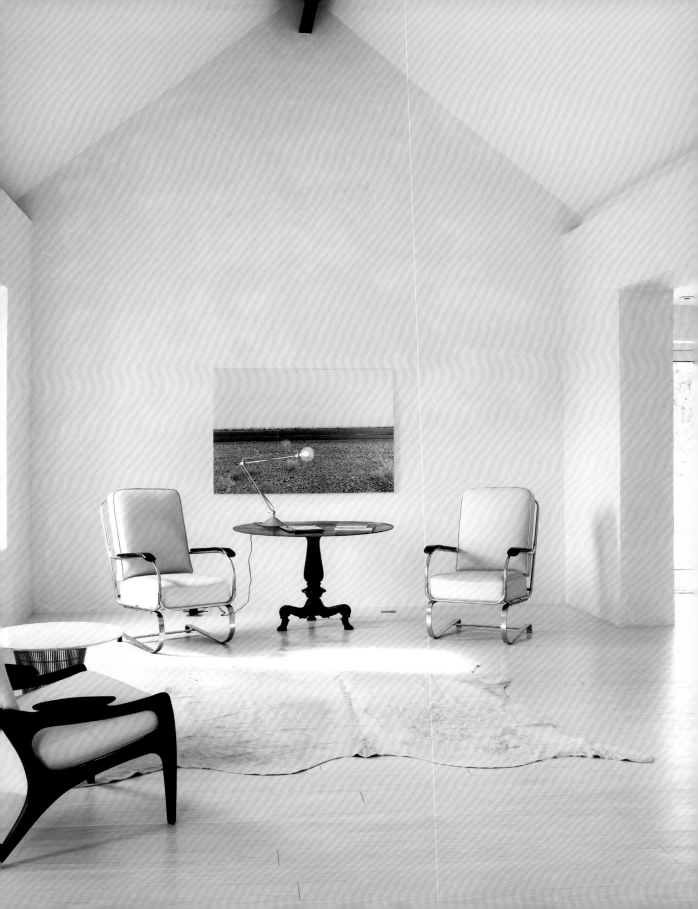

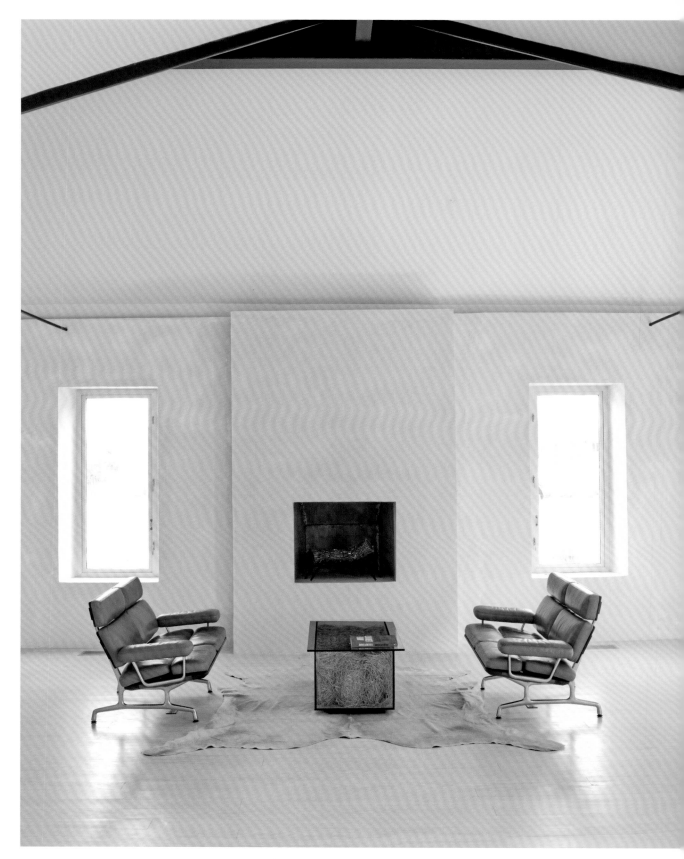

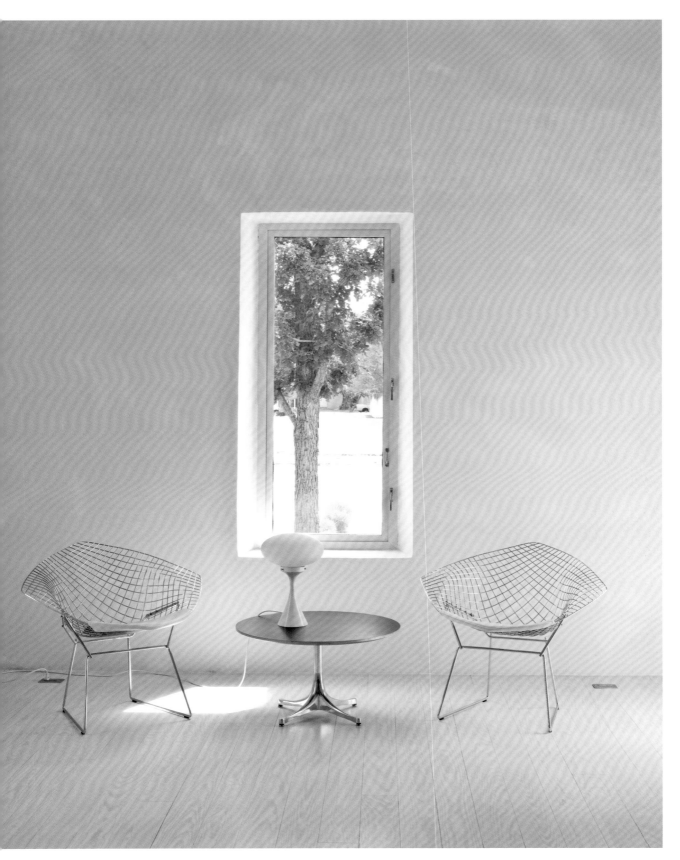

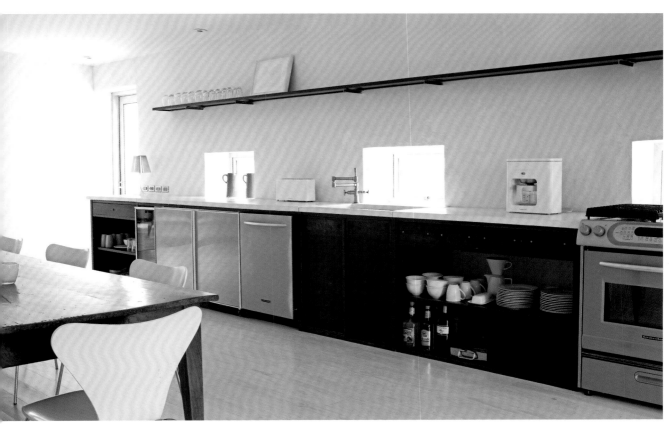

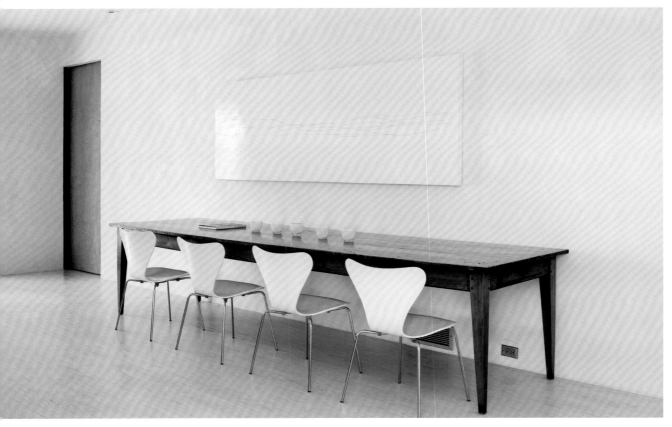

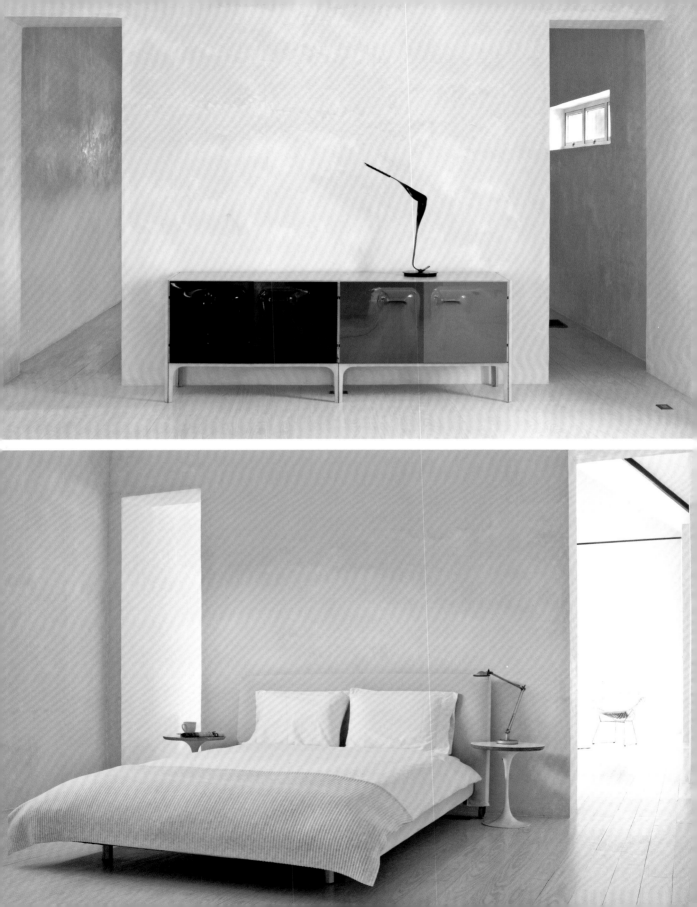

MARTHA'S VINEYARD
Massachusetts, USA

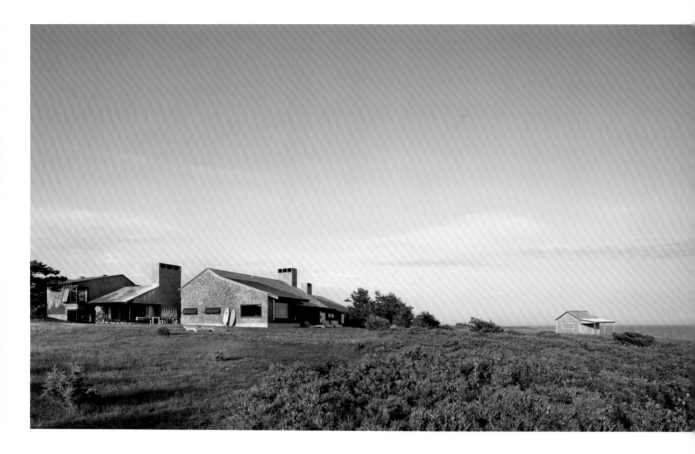

OWNERS
An American family

PROPERTY
House
325 sqm / 3,500 sq ft
2 floors; 8 rooms

YEAR
Building: 2007

ARCHITECT
Peter Rose, Rose + Guggenheimer Studio
New York / Cambridge
www.roseguggenheimer.com

INTERIOR DESIGNERS
Shelton, Mindel & Associates, New York
www.sheltonmindel.com

ART
Noriko Furunishi; Keith Tyson

FURNITURE
Fernando & Humberto Campana "Sushi"
sofa; V'Soske custom rugs; Pierre Chapo low
coffee table; Nanna Ditzel plywood chairs;
Franco Albini rattan armchair; Arne Vodder
woven leather chaise; Isamu Noguchi side
table at fireplace; Fabricius & Kastholm
dining table; Hans J. Wegner "Wishbone"
chairs; Jacques & Dani Ruelland ceramics;
Line Vautrin mirror above fireplace in
bedroom; French freeform orange fibreglass
table; Jean Prouvé metal outdoor chaise;
Mathieu Matégot table; Munder-Skiles
wooden outdoor chaise

PHOTOGRAPHER
Michael Moran, New York
www.moranstudio.com

STYLE
The interior is what connects the architecture
with the landscape. Wood, stone and steel
combined with the context of sky, sea and
grasses comprise the palette of the interior.

Das Interieur verbindet die Architektur
und Landschaft. Holz, Stein und Stahl in
Kombination mit dem Hintergrund aus
Himmel, Meer und Gras machen die Palette
der Einrichtung aus.

L'intérieur assure le lien entre l'architecture
et le paysage. Bois, pierre et acier, associés
au ciel, à la mer et à la végétation, forment
la palette décorative.

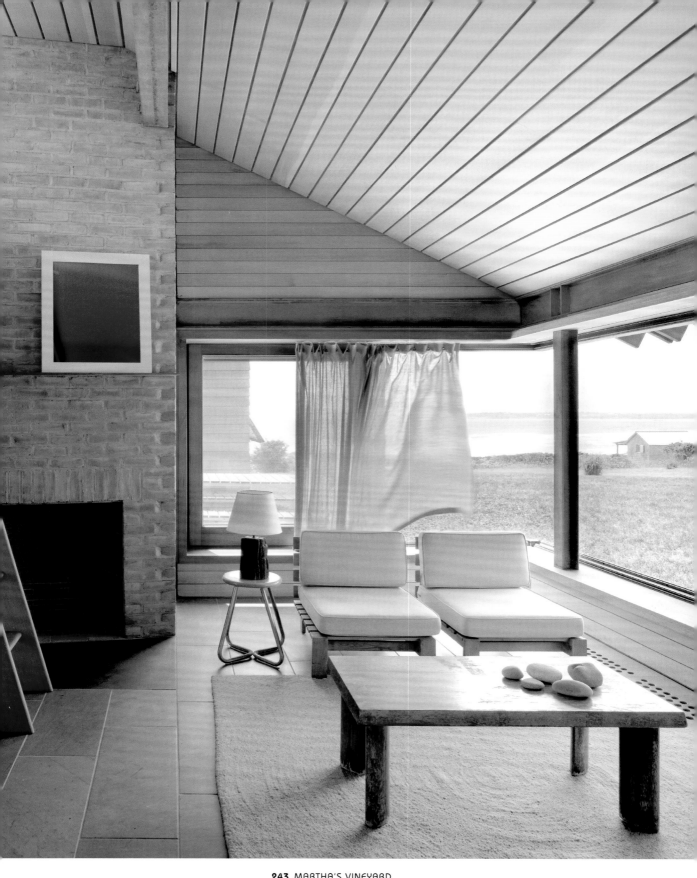

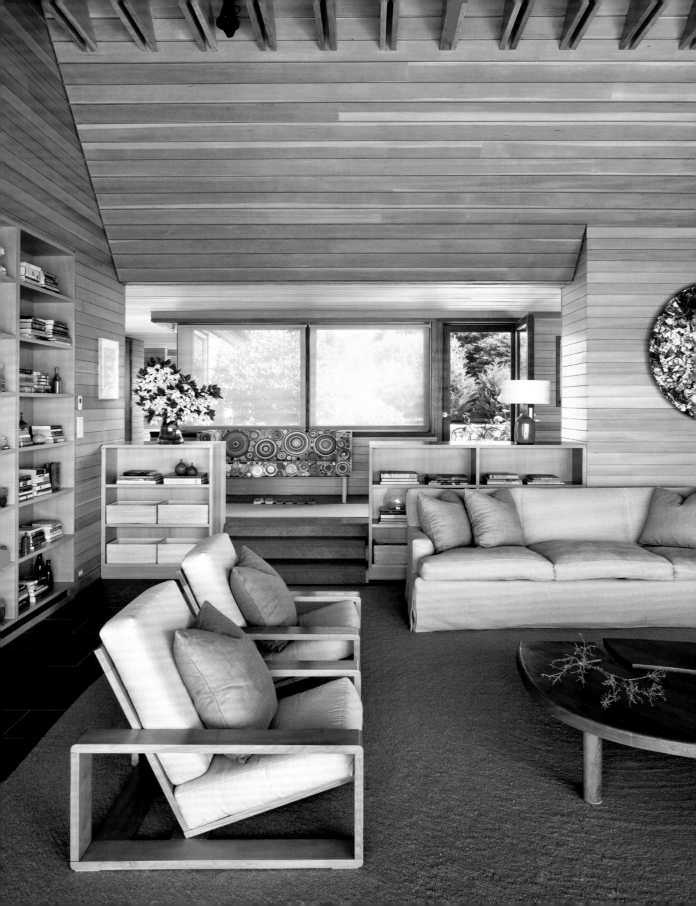

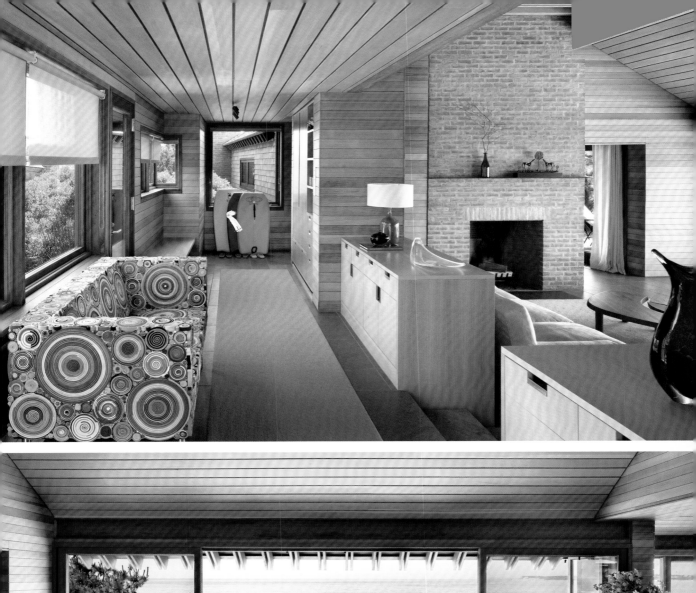
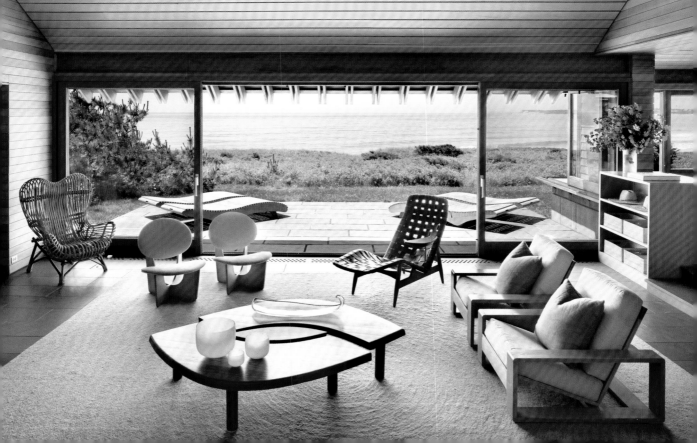

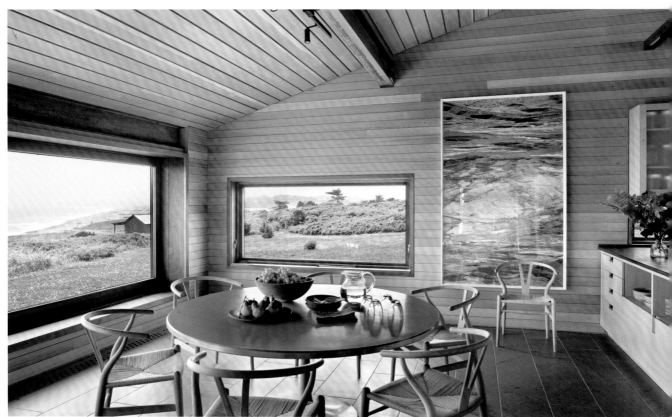

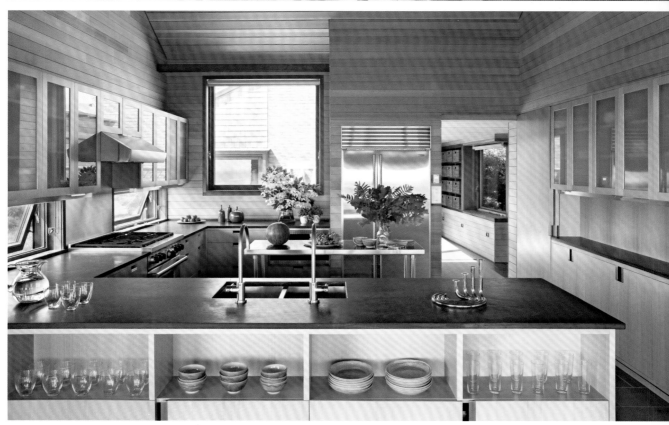

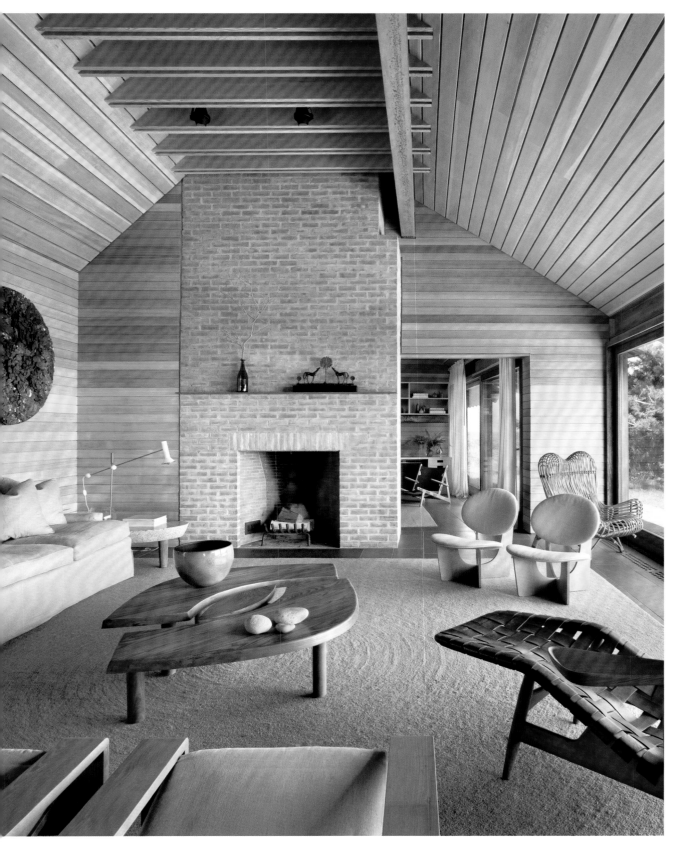

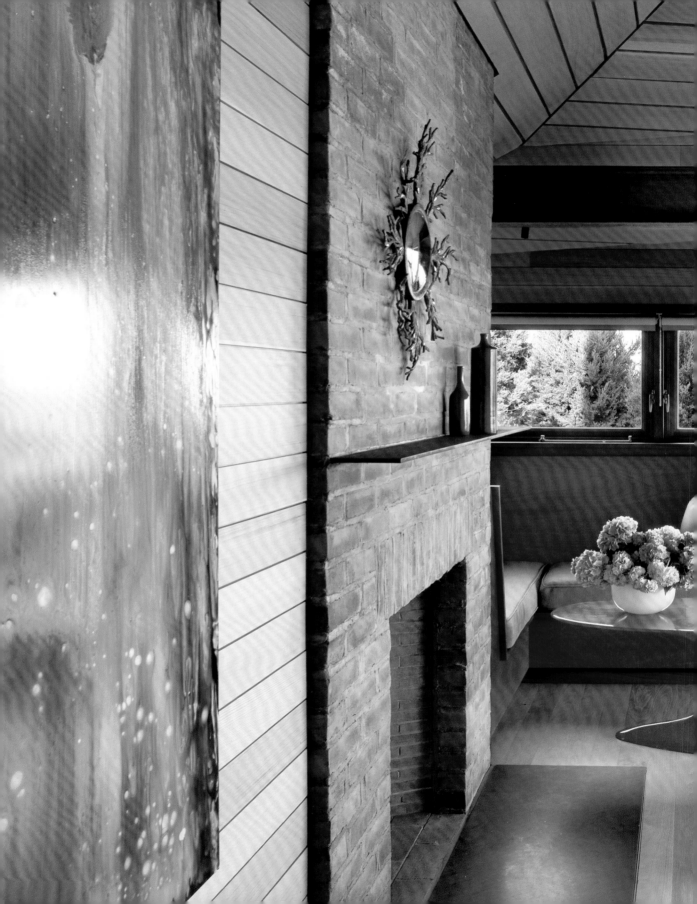

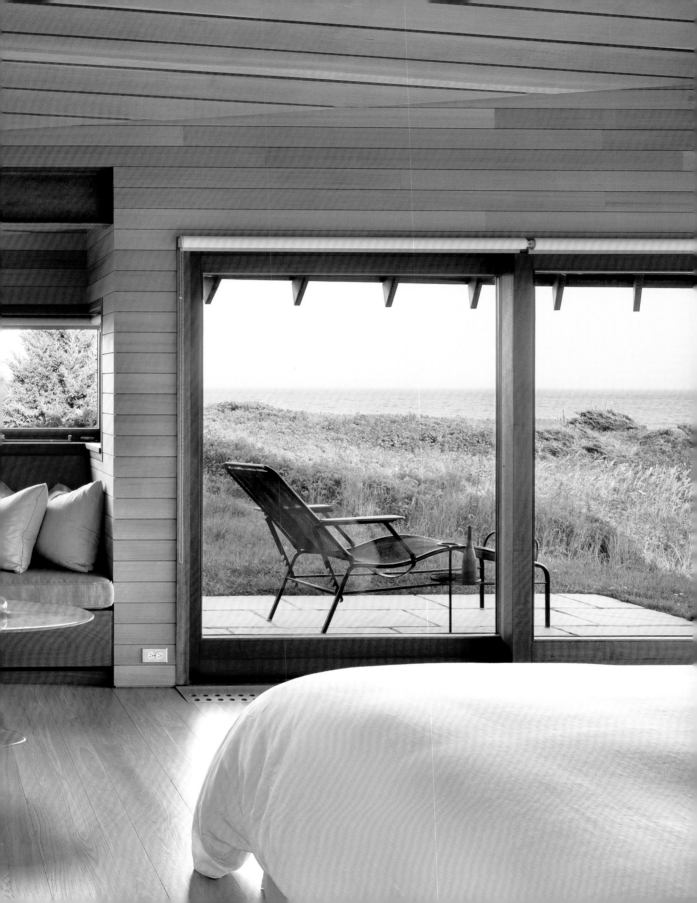

MEXICO CITY
Vista del Valle, Mexico

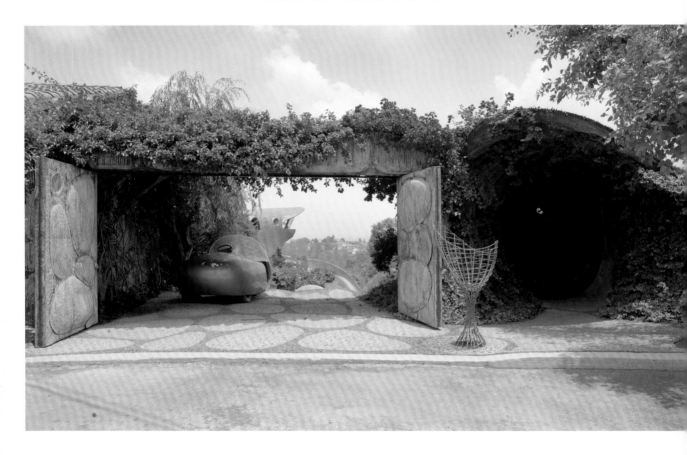

OWNERS
Paloma & Javier Senosiain

OCCUPATION
Architect

PROPERTY
House
170 sqm / 1,800 sq ft
100 sqm / 1,100 sq ft (underground)
2 floors; 2 rooms; 1 bathroom

YEAR
Building: 1984

ARCHITECT & INTERIOR DESIGNER
Javier Senosiain
Senosiain Architects, Mexico City
www.arquitecturaorganica.com

FURNITURE
Besides a few rustic wooden stools and a coffee table made from a sequoia trunk, almost all the furniture was custom-made to fit seamlessly into the house.

PHOTOGRAPHER
Heiner Orth, Marschacht
www.heiner-orth.de

STYLE
In the tradition of the biomorphic or organic architecture of Bruce Goff, Paolo Soleri and Frank Lloyd Wright as well as Antonio Gaudí, Senosiain looked to seashells, skulls and sponges for formal inspiration for the ferrocement construction of his own house, which is in the shape of a shark.

In der Tradition großer biomorpher oder organischer Architekten wie Bruce Goff, Paolo Soleri, Frank Lloyd Wright und Antoni Gaudí suchte Senosiain beim Bau seines eigenen Hauses – eine Ferrozement-Konstruktion in Form eines Hais – formale Inspiration bei Muscheln, Schädeln und Schwämmen.

Se situant dans la tradition de l'architecture biomorphique ou organique à l'instar de Bruce Goff, Paolo Soleri, Frank Lloyd Wright ou encore Antoni Gaudí, Senosiain s'est inspiré de coquillages, de crânes et d'éponges pour créer sa demeure en béton armé reprenant la forme d'un requin.

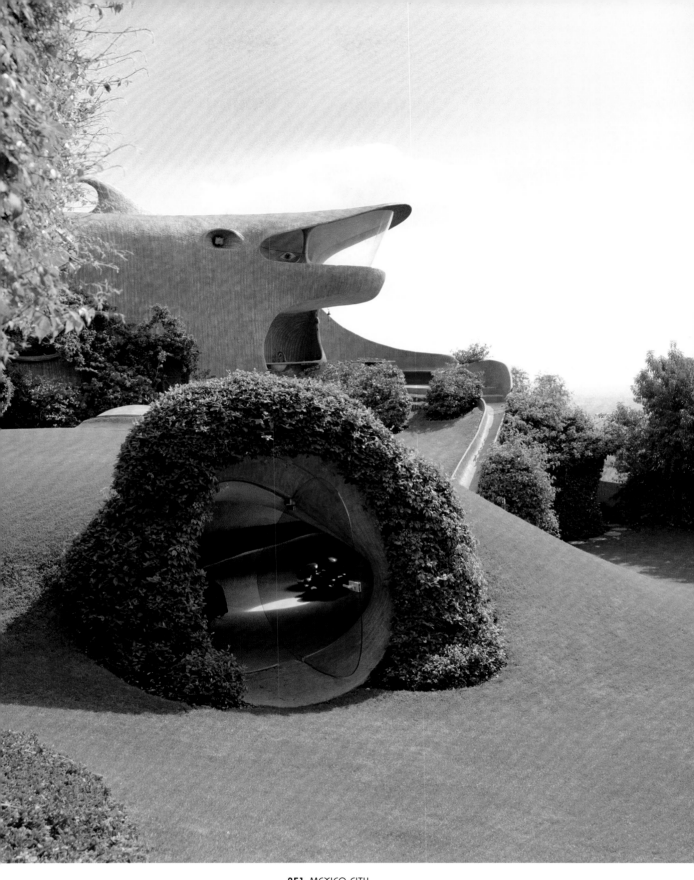

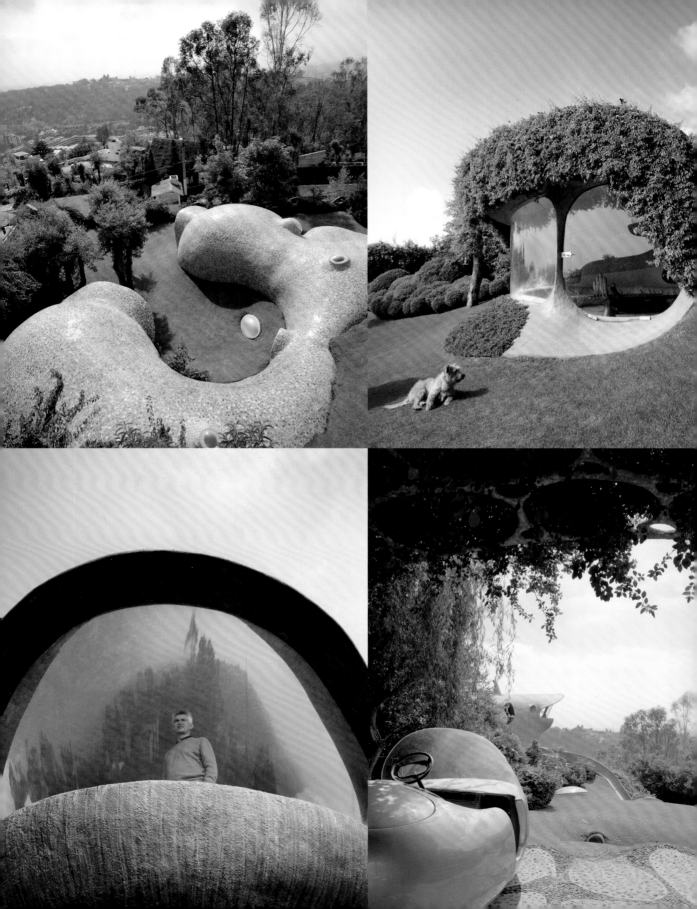

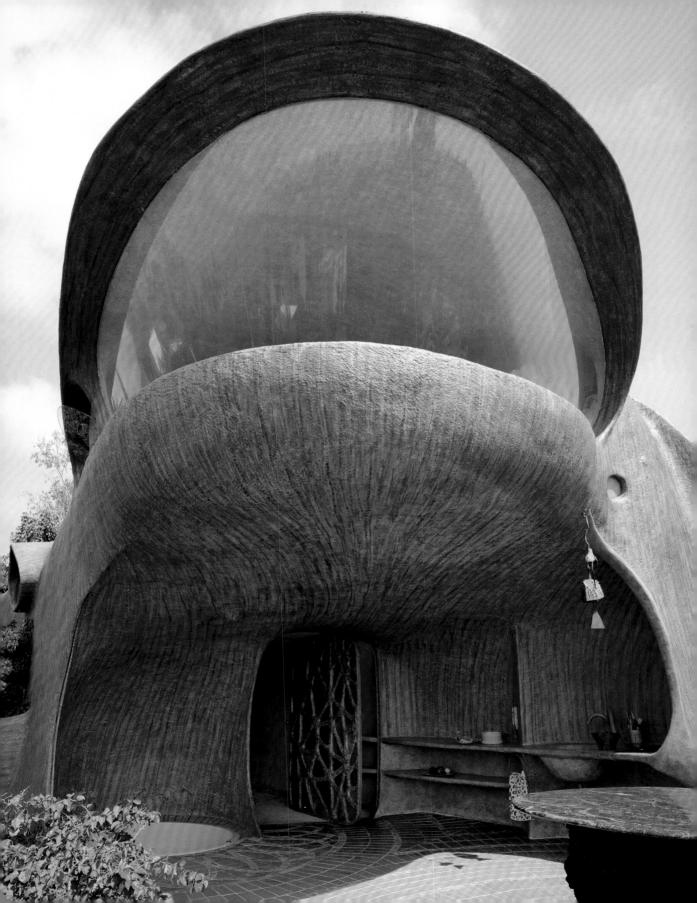

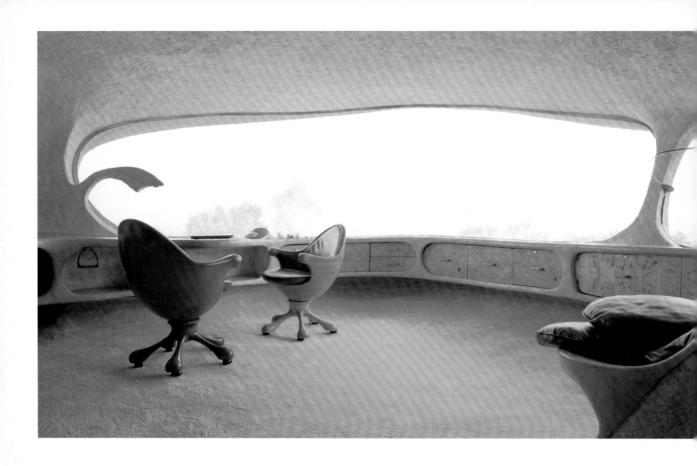

"The idea is to recline,
like an animal in a cave."

»Die Bewohner sollen sich in
dieses Haus zurückziehen können
wie Tiere in eine Höhle.«

« L'idée est de se tapir comme
un animal dans sa tanière. »

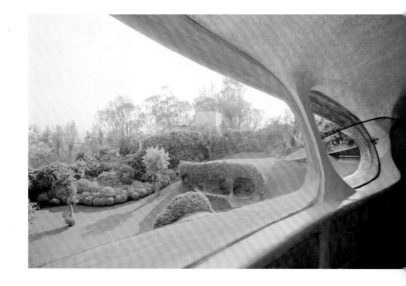

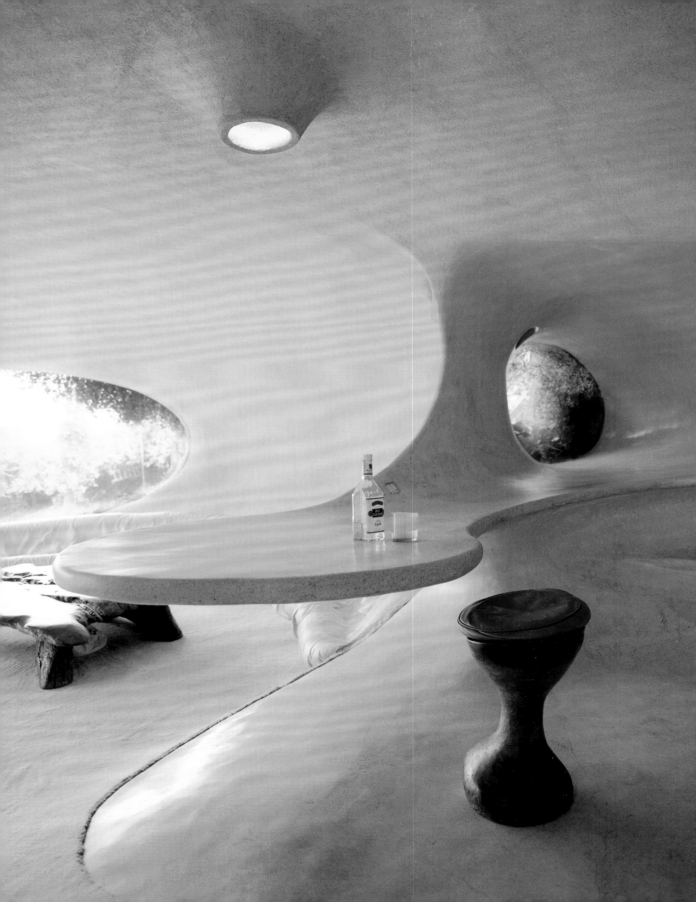

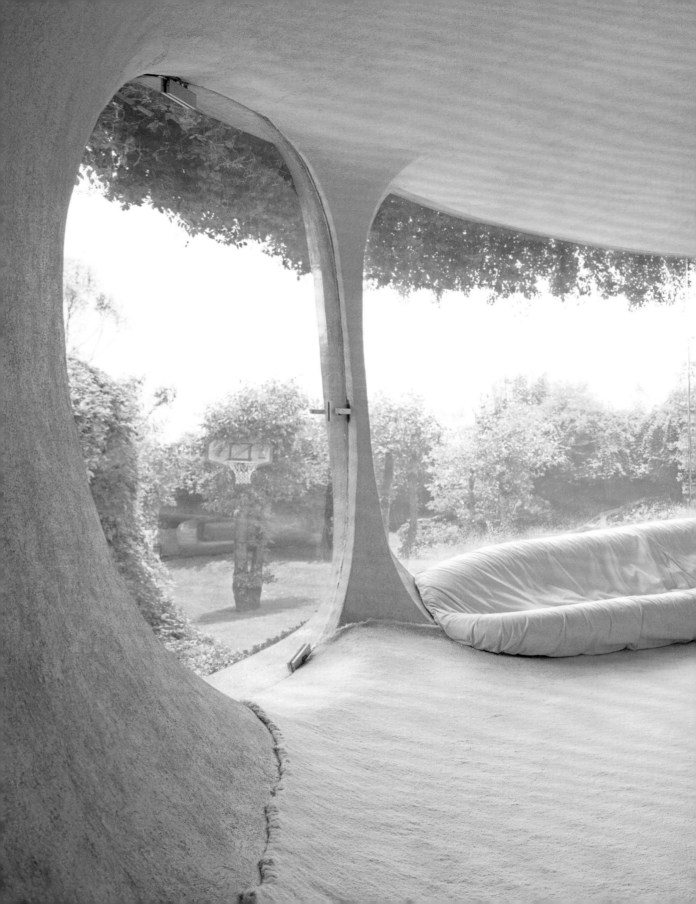

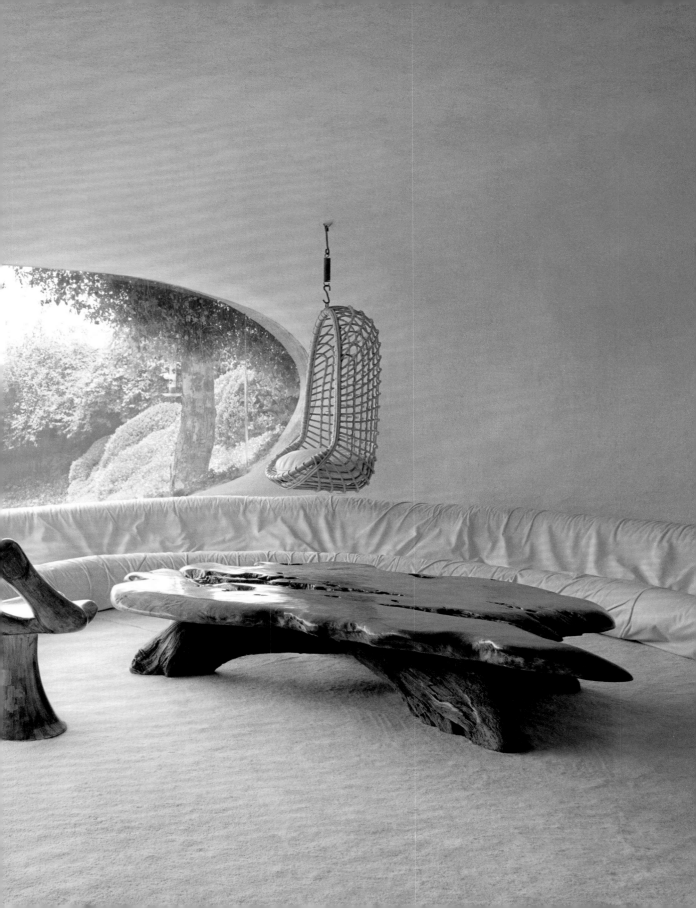

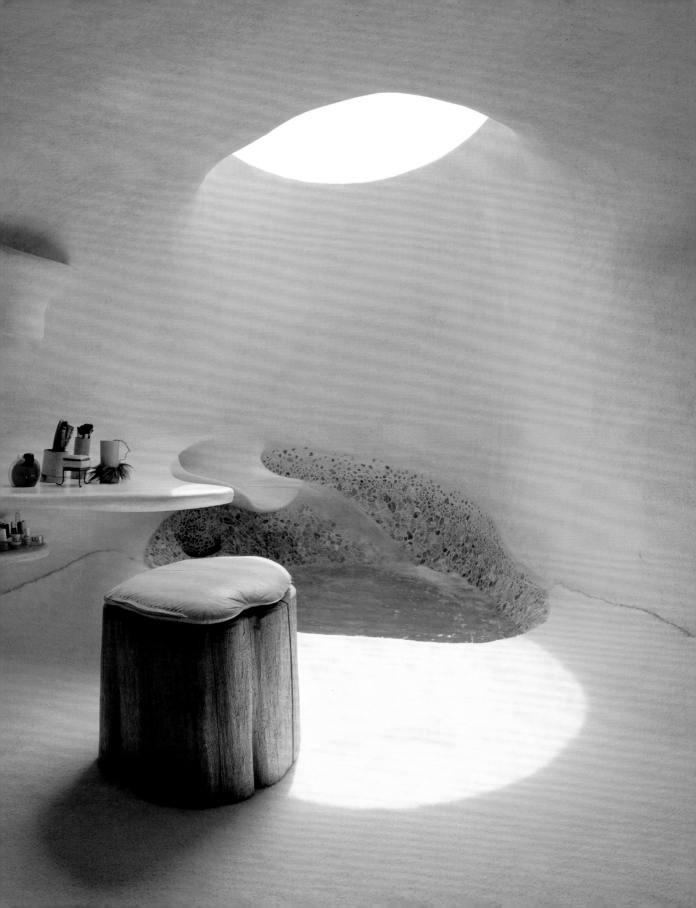

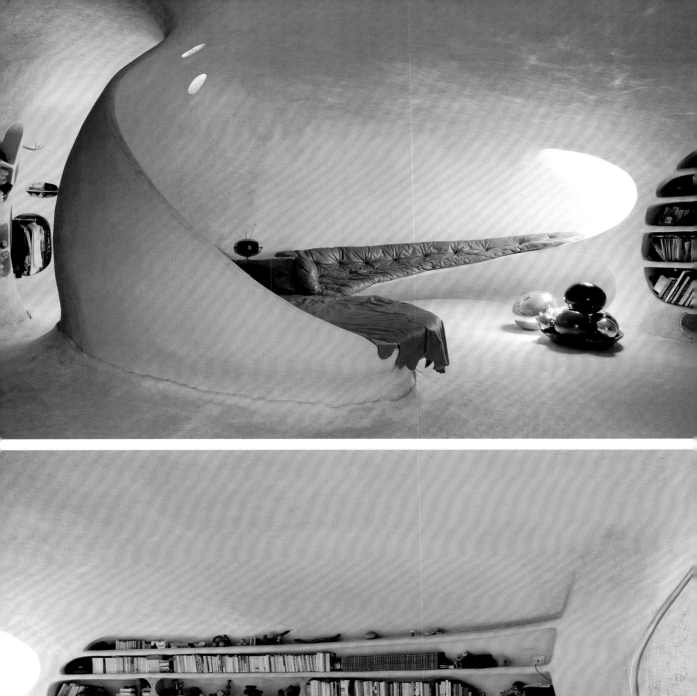
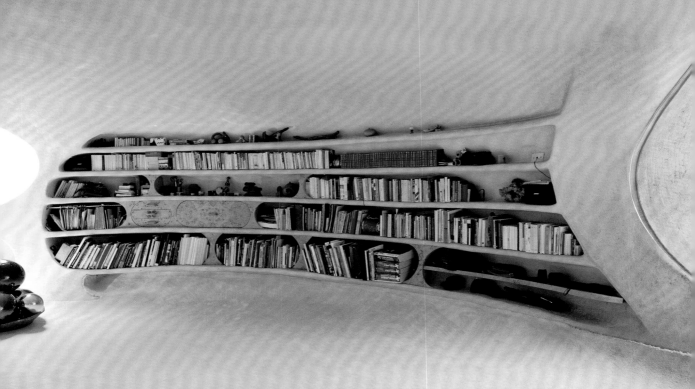

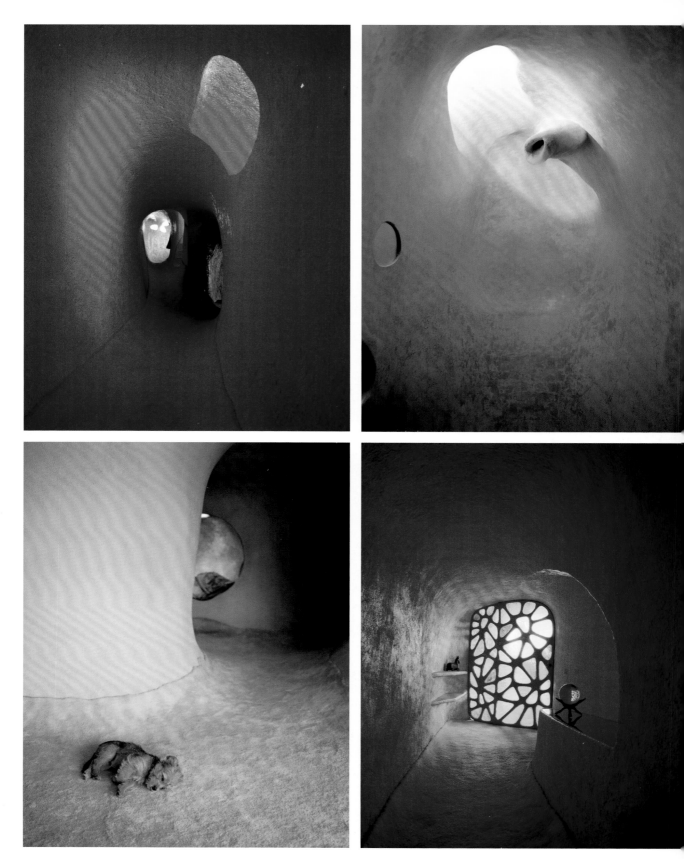

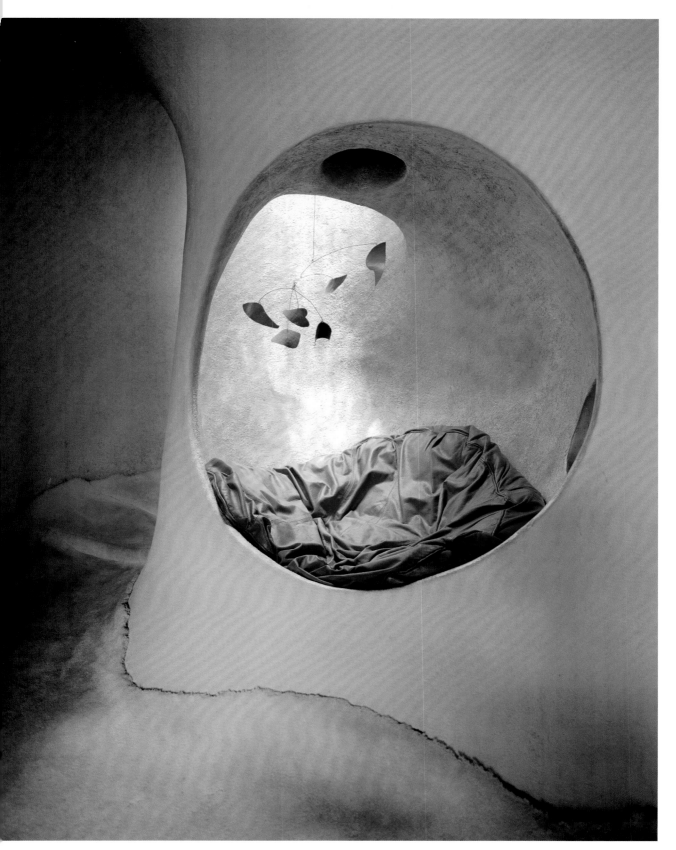

MIAMI

Davis Harbor, Florida, USA

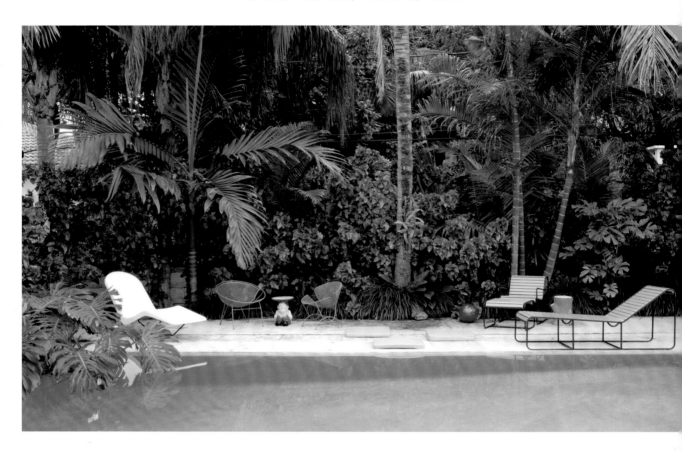

OWNERS
Kristin & Allan Kirshner

OCCUPATION
Retired

PROPERTY
House
240 sqm / 2,600 sq ft
1 floor; 6 rooms; 3 bathrooms

YEAR
Building: 1951
Remodelling: only original kitchen
and bathroom updated

ARCHITECT
Wahl John Snyder (1910–1989) was one
of the most important architects to bring
modern architecture to South Florida

ART
Max Miller watercolours above fireplace,
orange Op Art painting, pink painting of the
owners' Norwich terrier "Louie Armstrong"

FURNITURE
Doug Meyer Plexiglas screens & colourful
wall cabinets; Paul Evans 1970s bronze
lamps; Florence Knoll white credenza;
Eero Saarinen marble-top table; "DS 600"
modular leather sofa, de Sede; 1940s bar
stools, Heywood-Wakefield; Florence Knoll
walnut credenza; Russell Spanner 1950s
wood chair with web strapping; Harry
Bertoia white chairs

PHOTOGRAPHER
Giorgio Baroni, Caravaggio
www.giorgiobaroni.com

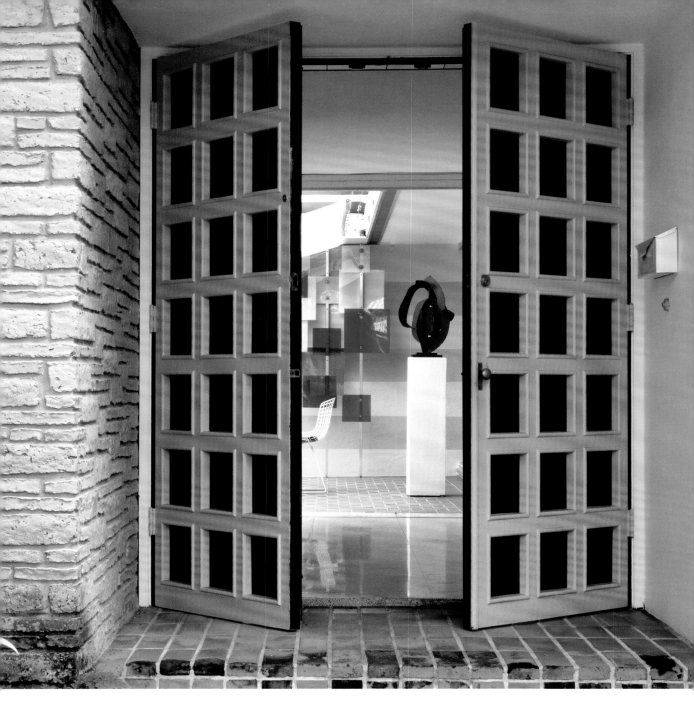

TYLE

his house is a fine example of early (1951) ropical mid-century modern style. Windows nd sliding glass doors open the house to he garden and pool. The bright Miami light perfect to accentuate bold colour. The olour makes the interior design seem more ontemporary and not stuck in a time warp.

Dieses Haus aus dem Jahr 1951 ist ein gutes Beispiel für die frühe tropische Moderne. Fenster und Schiebetüren aus Glas öffnen das Haus zum Garten und zum Pool. Das strahlende Sonnenlicht von Miami bringt die kräftigen Farben perfekt zur Geltung. Und die Farben sorgen dafür, dass die Innenausstattung zeitgenössisch wirkt – und nicht so, als stecke sie in einer Zeitschleife fest.

Cette maison est un bel exemple du style moderne tropical du milieu du 20e siècle (1951). Les fenêtres et les baies vitrées ouvrent la maison sur le jardin et la piscine. La lumière éclatante de Miami est idéale pour accentuer les couleurs vives. Ces dernières rendent la décoration intérieure plus moderne et non figée dans une époque.

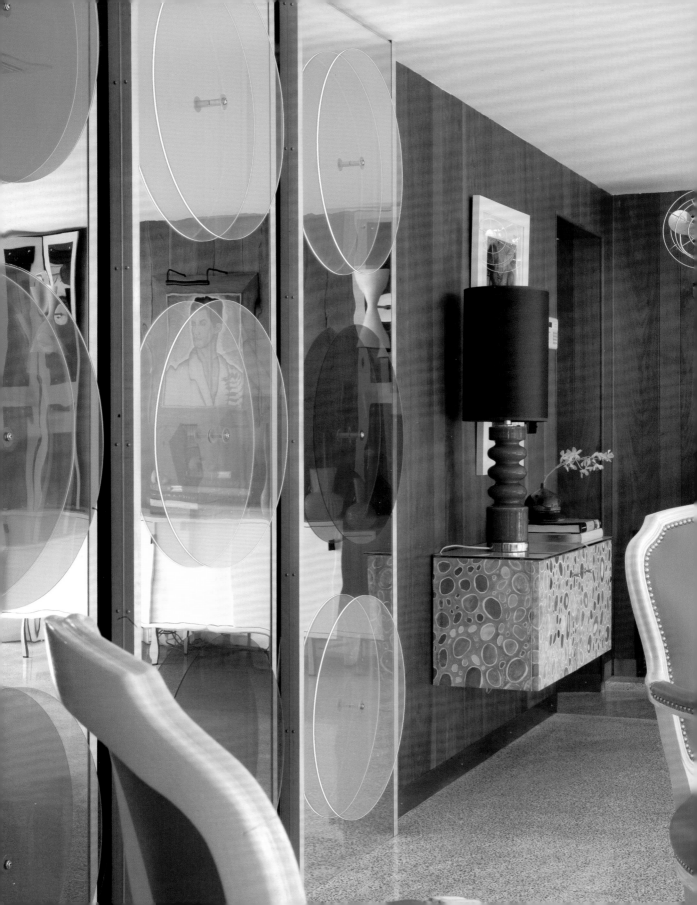

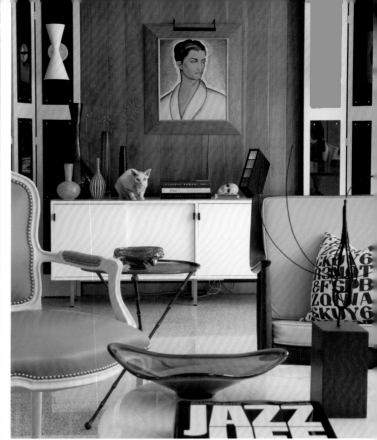
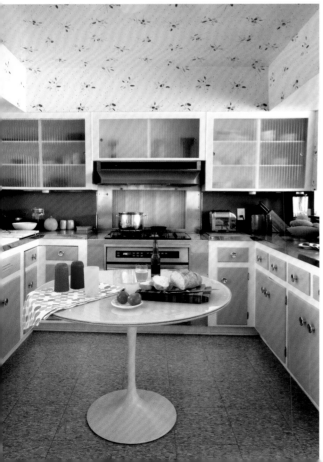
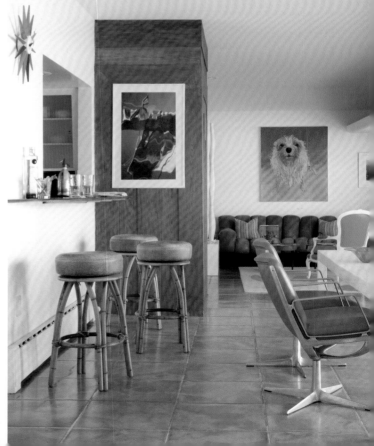

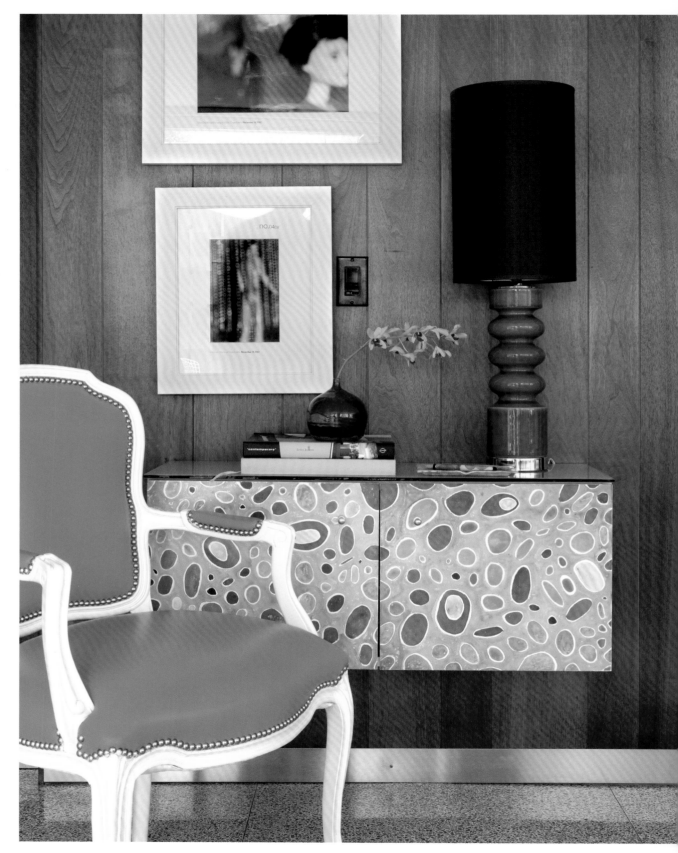

"My interior would not
translate well to a more
temperate climate."

»Mein Design würde sich nicht
gut in ein gemäßigteres Klima
übertragen lassen.«

« Mon intérieur passerait mal
sous un climat plus tempéré. »

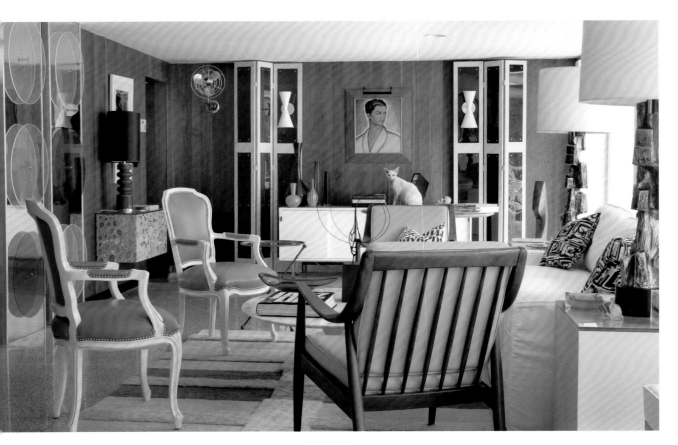

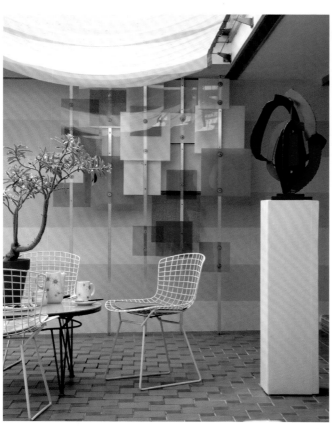

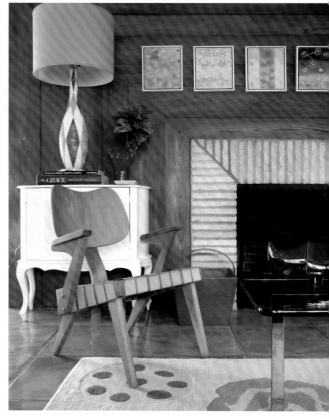

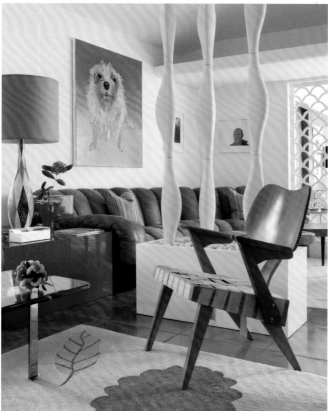

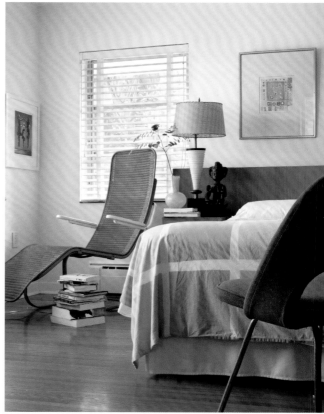

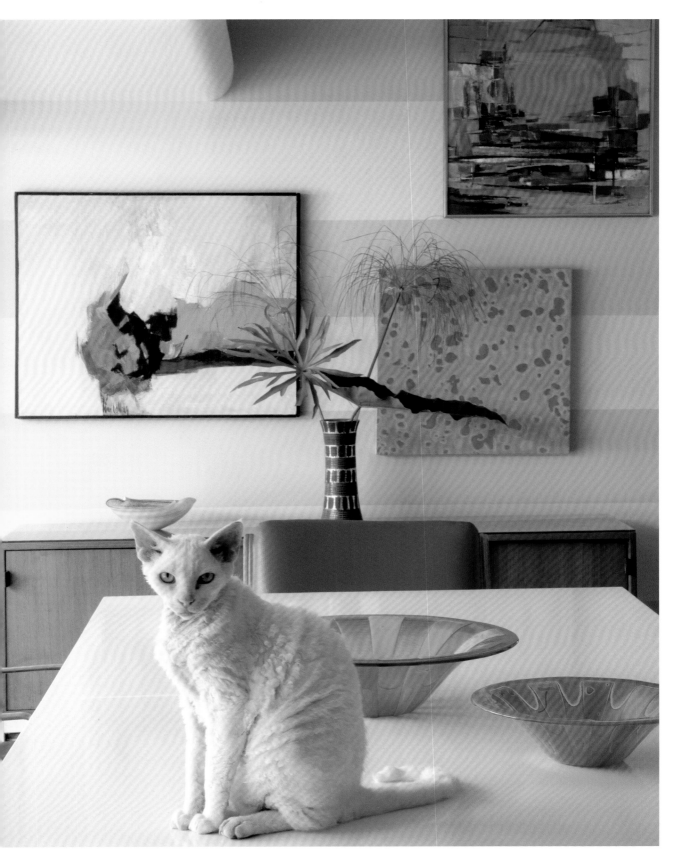

MILAN
Italy

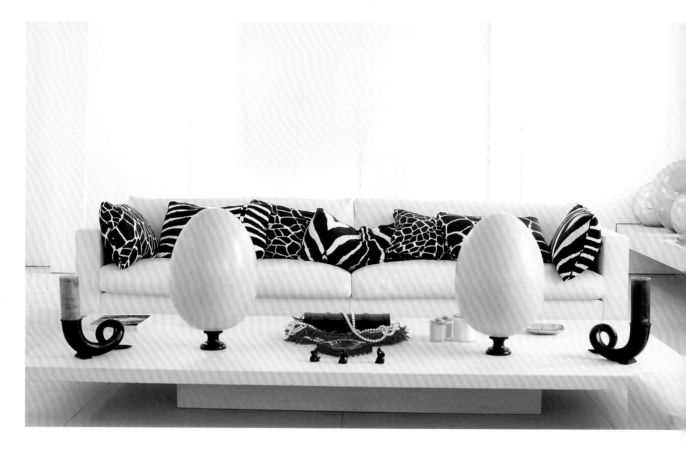

OWNERS
Eva & Roberto Cavalli

OCCUPATION
Fashion business / Fashion designer

PROPERTY
Apartment
400 sqm / 4,300 sq ft
1 floor; 1 open room; 1 bathroom

YEAR
Building: 1953 (Ferdinando Innocenti)
Remodelling: 2000

ARCHITECTS
Claudio Silvestrin, London
www.claudiosilvestrin.com

INTERIOR DESIGNER
Roberto Cavalli, Milan

ART
Julian Schnabel portrait of Roberto Cavalli

FURNITURE
19th-century French sofa upholstered with
zebra skin, decorated with antilope and
gnu horns and ivory knobs; on the floor
Roberto Cavalli's self-designed object "Lucky
Charm"; wooden horse from the East

PHOTOGRAPHER
Conrad White, Zapaimages
www.zapaimages.com

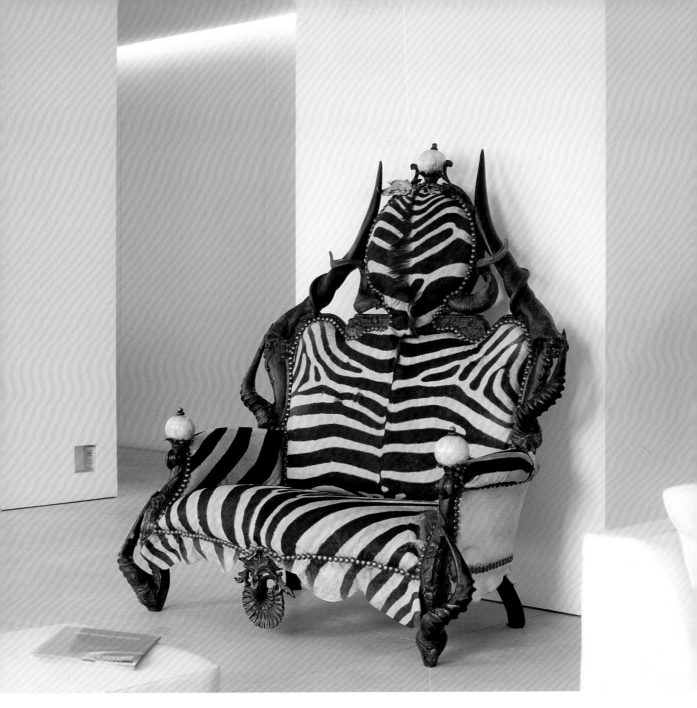

STYLE

conceived this apartment as a giant white box, a neutral space that enables me to highlight my beloved objects. Besides, I do believe in eclecticism and never want to repeat myself. At first sight, this apartment greatly differs from the style of my creations. However, it perfectly reflects my nature.

Ich habe mir diese Wohnung als eine gigantische weiße Box vorgestellt, einen neutralen Raum, der es mir ermöglicht, meine geliebten Objekte zur Geltung zu bringen. Außerdem glaube ich an Eklektizismus und möchte mich nie wiederholen. Auf den ersten Blick unterscheidet sich diese Wohnung stark vom Stil meiner Kreationen. Aber sie spiegelt trotzdem perfekt meine Natur wider.

J'ai conçu cet appartement comme une grande boîte blanche, un espace neutre qui met en valeur mes chers objets. En outre, je crois en l'éclectisme et n'aime pas me répéter. À première vue, cet intérieur est très différent du style de mes créations. Pourtant, il reflète parfaitement ma nature.

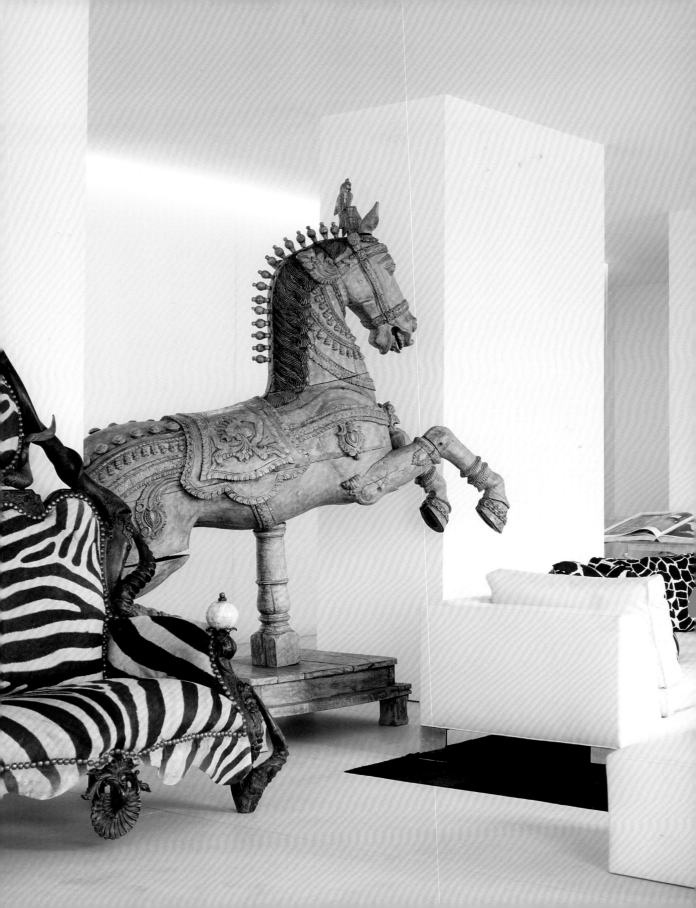

MOSCOW

Russia

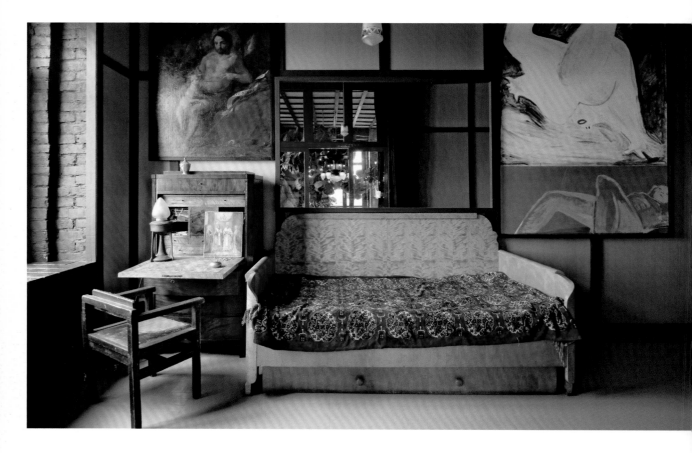

OWNER
Alexander Timofeevsky

OCCUPATION
Writer

PROPERTY
Apartment
165 sqm / 1,776 sq ft
1 floor; 5 rooms; 2 bathrooms

YEAR
Building: 1913
Remodelling: 2002

INTERIOR DESIGNER
Nicola Samonov, Moscow

ART
Oil, acrylic paintings by Nicola Samonov;
an Italian painting of the 17th century

FURNITURE
Classical Russian furniture (end of 18th /
beginning of 19th century); Art Nouveau
furniture and ceramics; Charles Rennie
Mackintosh chairs (re-editions); lamps
from the beginning of the 20th century;
standing lamp made of a milk can,
designed by Nicola Samonov

PHOTOGRAPHER
Toni Meneguzzo, GMAimages
www.tonimeneguzzo.com
www.gmaimages.com

STYLE
A modern interpretation of Art Deco style.
The apartment is a mix between a palace and
a factory. It feels like the dwelling of an artist.

Eine moderne Interpretation des Art-Déco-
Stils. Das Apartment ist eine Mischung aus
einem Palast und einer Fabrik: Man kommt
sich vor wie in der Wohnung eines Künstlers.

Une réinterprétation moderne du style Art
Déco. Cet appartement est un croisement
entre un palais et une usine. On dirait l'antre
d'un artiste.

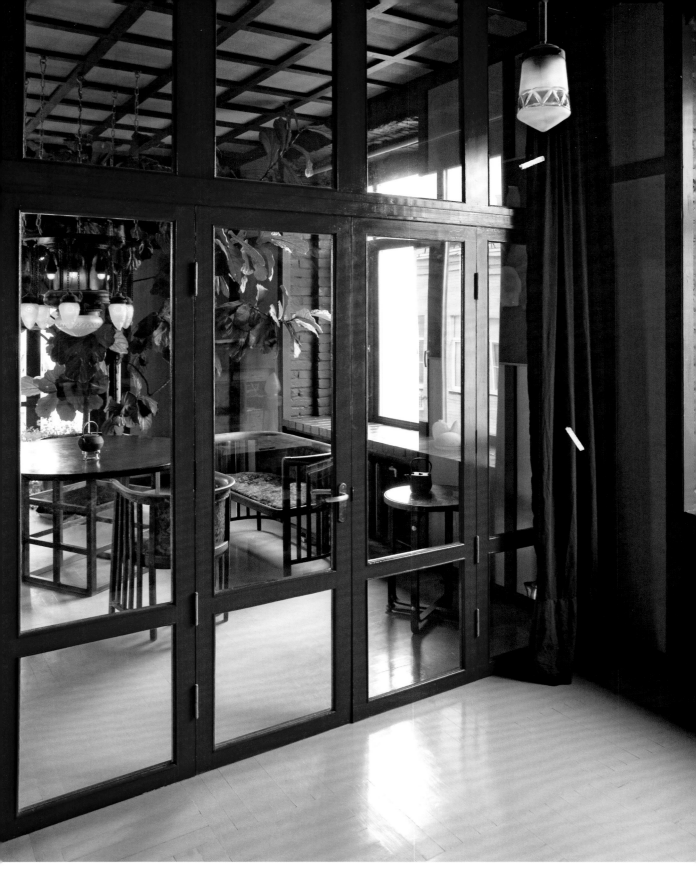

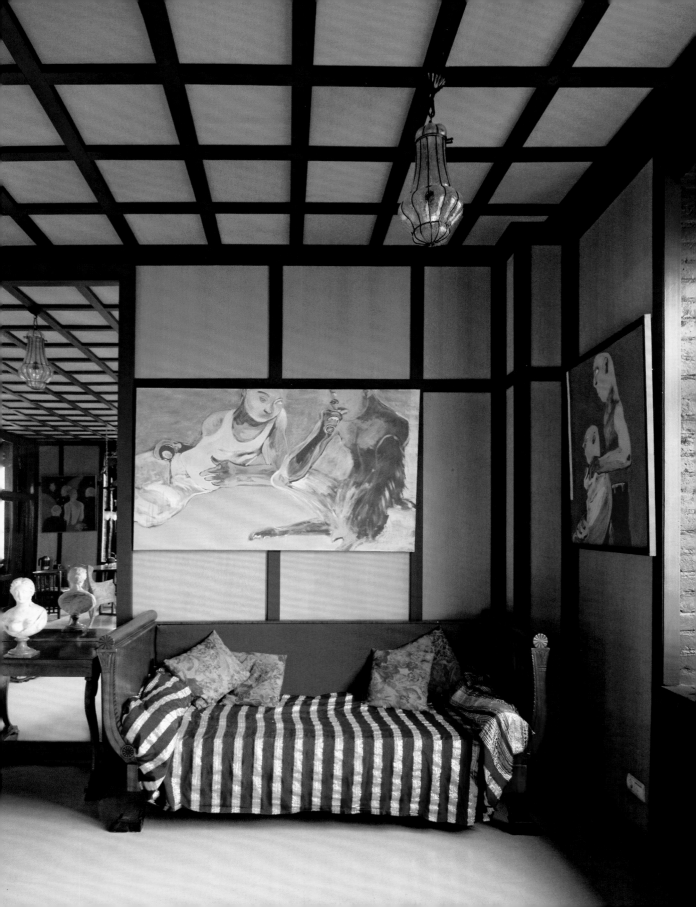

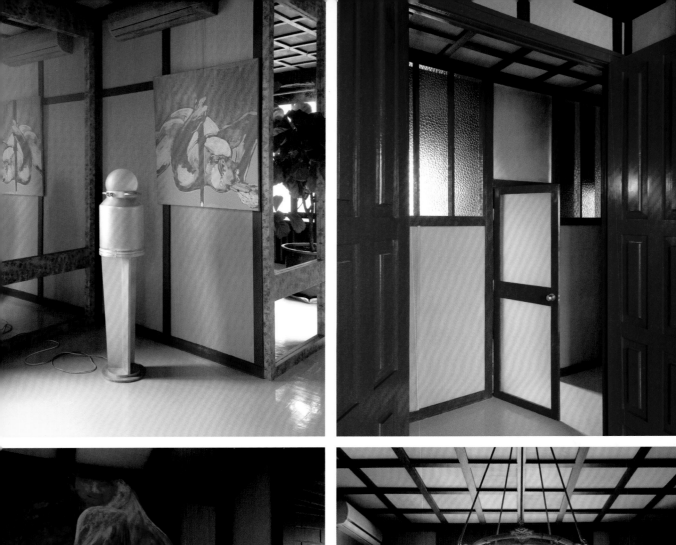

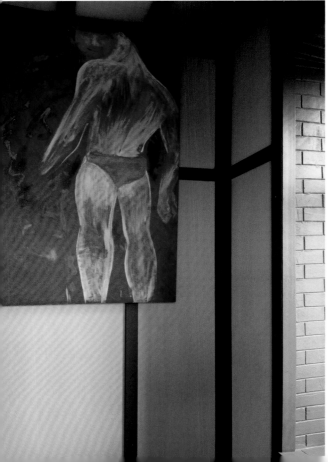

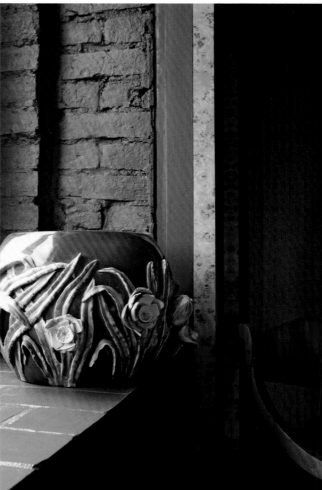

"There is such a lack of
beauty in Moscow that to
have some at home is
a great privilege."

»In Moskau gibt es so wenig
Schönheit, dass ich es als großes
Privileg empfinde, ein wenig davon
im eigenen Zuhause zu haben.«

« Il y a si peu de beauté dans
Moscou qu'en avoir un peu chez
soi est un grand privilège. »

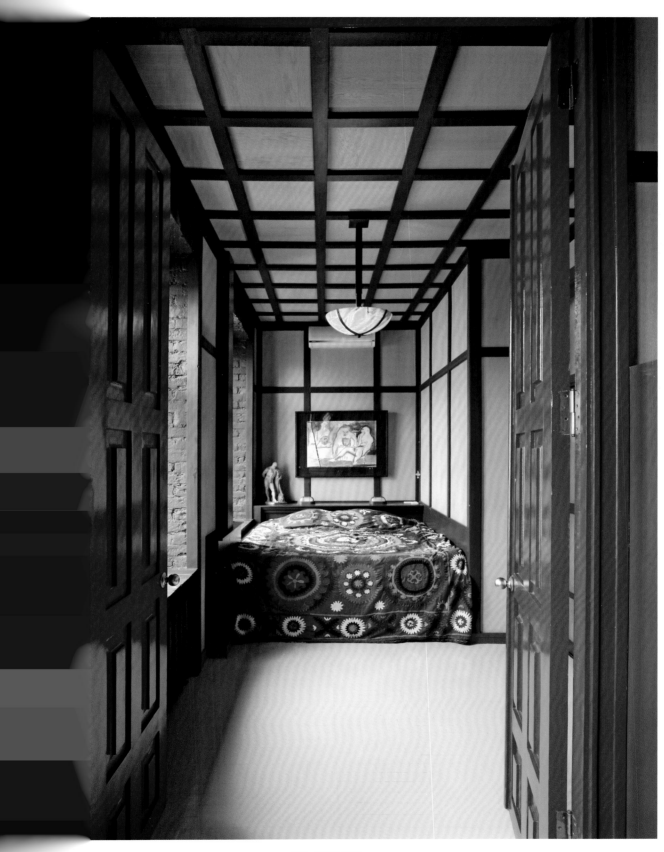

MUMBAI
Bandra, India

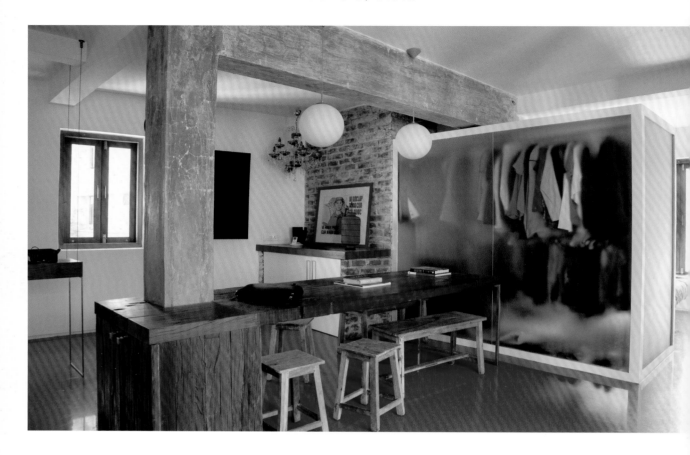

OWNERS
Arjun Bhasin & Emmanuel Balayer

OCCUPATION
Fashion director, GQ India
Luxury marketing consultant

PROPERTY
Apartment
64 sqm / 690 sq ft
1 floor; 1 room; 1 bathroom

YEAR
Building: 1973
Remodelling: 2004

ARCHITECT
Pinakin Patel, Mumbai
www.pinakin.in

INTERIOR DESIGNER
Bhavesh Katira, Mumbai

FURNITURE
The built-in furniture was designed
by Arjun Bhasin; the dining table is made
from recycled railway sleepers; the dining
stools are by local carpenters

PHOTOGRAPHER
Giorgio Possenti, Vega MG, Milan

STYLE
Bombay is messy and chaotic. I wanted my
home to be a simple, calm place without
falling into the trap of being minimal. I
wanted colour and design but most of all
comfort. I think a home needs to reflect the
people who live in it; mine is funny and a
little insane.

Bombay ist schmutzig und chaotisch. Meine
Wohnung sollte ein schlichter, ruhiger Ort
sein, ohne dabei allzu minimalistisch zu wir-
ken. Ich wollte Farbe und Design, aber vor
allem Komfort. Ich glaube, eine Wohnung
sollte die Menschen widerspiegeln, die in
ihr leben – also ist meine witzig und ein
wenig verrückt.

Bombay est sale et chaotique. Je voulais
faire de ma maison un lieu simple et calme,
sans tomber dans le piège du minimalisme,
avec de la couleur et du design mais surtout
du confort. Pour moi, un intérieur doit reflé-
ter la personne qui y vit. Le mien est drôle
et un peu fou.

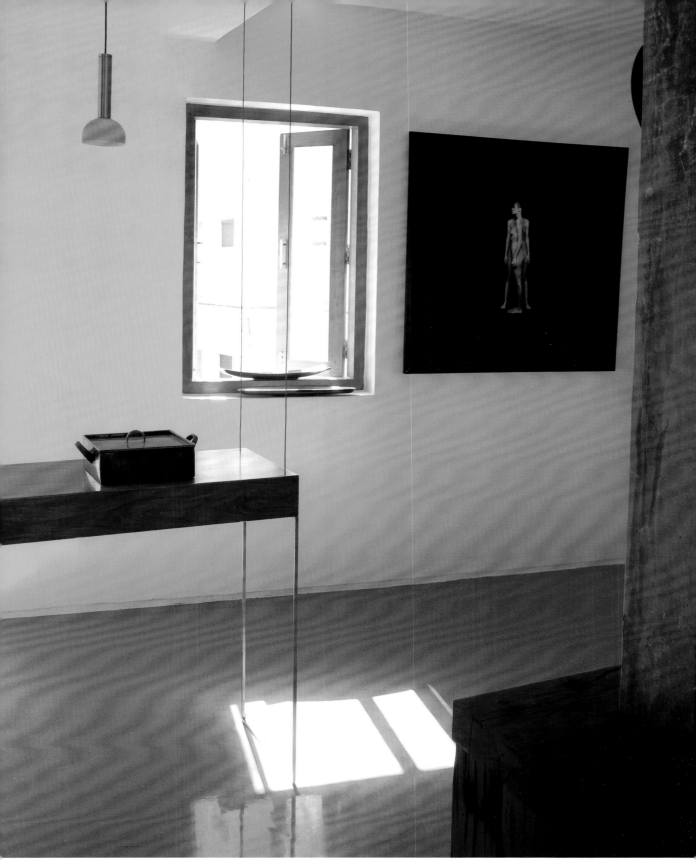

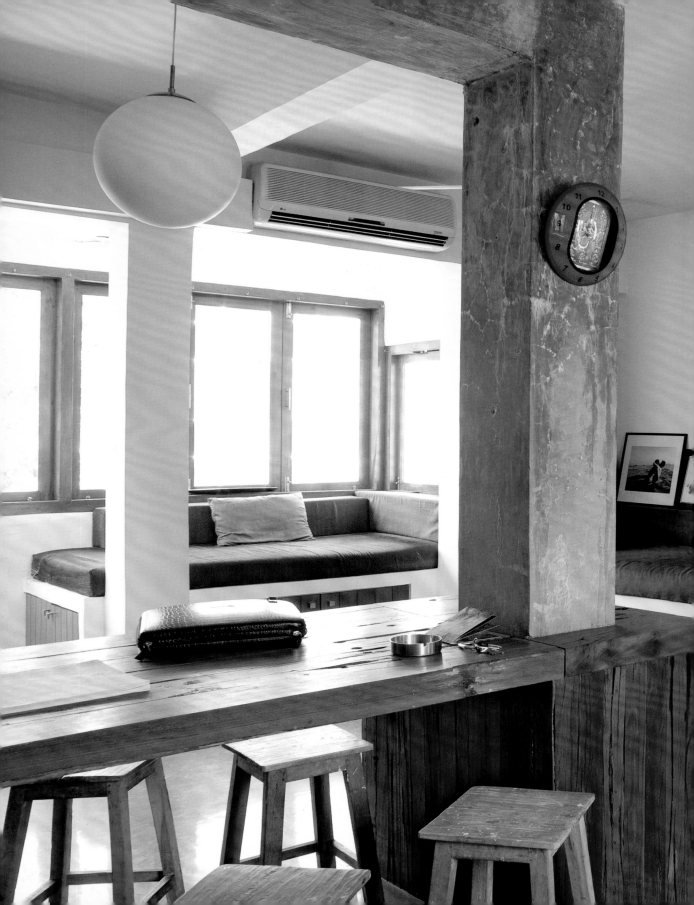

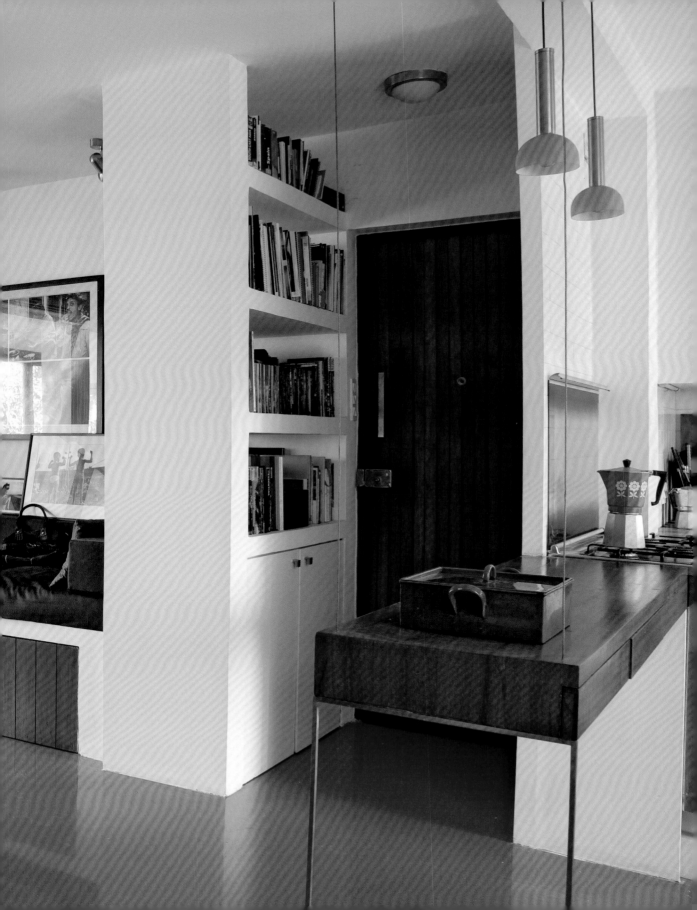

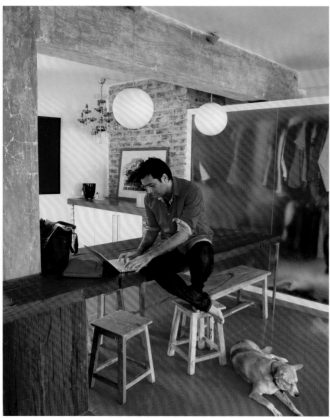

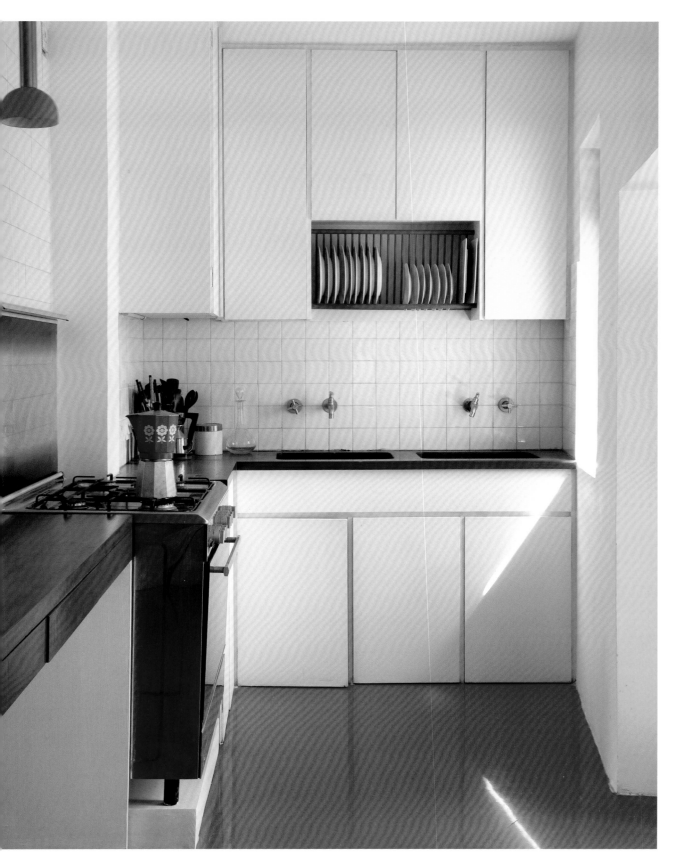

NAGANO PREFECTURE
Karuizawa, Japan

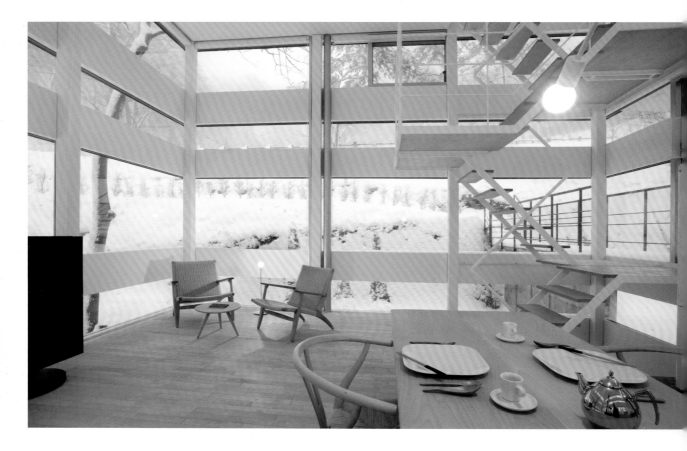

OWNERS
A Japanese family

PROPERTY
Weekend house
102 sqm / 1,098 sq ft
3 floors; 4 rooms; 1 bathroom

YEAR
Building: 2006

ARCHITECTS
Makoto Takei & Chie Nabeshima
TNA, Takei-Nabeshima-Architects, Tokyo
www.tna-arch.com

STRUCTURAL ENGINEER
Akira Suzuki
ASA, Tokyo
www.akirasuzuki.com

LIGHTING PLANNER
Masahide Kakudate
www.bonbori.com

FURNITURE
Hans J. Wegner "Wishbone" chairs &
table, original "ch25" armchairs & table;
Alvar Aalto stools

PHOTOGRAPHER
Jimmy Cohrssen, Los Angeles
www.jimmycohrssen.com

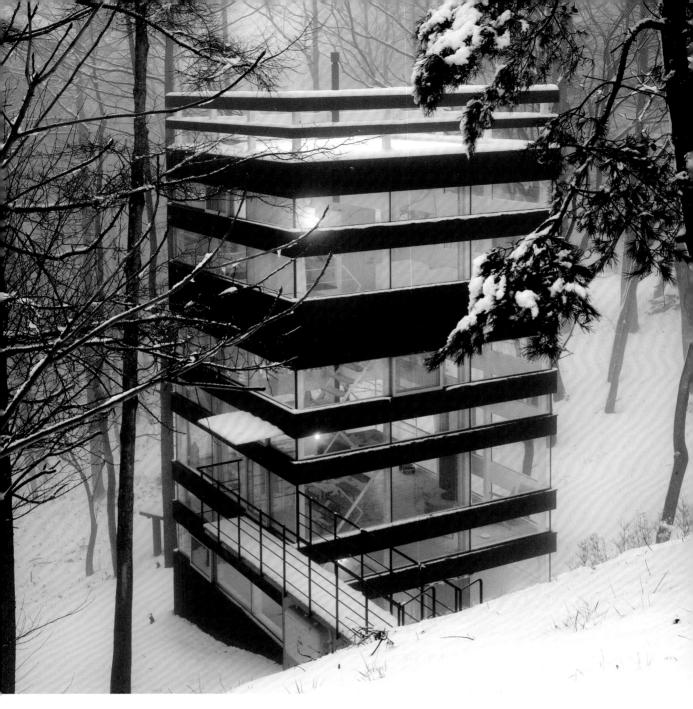

his "Ring House" consists of a wooden
ame construction arranged at intervals
d indicating the volume of the overall
onstruction. The alternating white and
ansparent glass bands on the inside make
the house's layers. Although you are in
e interior of a house, you feel as if you
ere in the forest.

Das »Ring House« wurde als Holzrahmen-
konstruktion erbaut und an der Höhe der
Ringe ausgerichtet, sodass dadurch das
Volumen des Hauses kontrolliert wird. Die
weißen und die transparenten Glasbänder
im Inneren definieren die Ebenen des
Hauses.

L'ossature de la « Ring House » est composée
de structures en bois disposées à intervalles
et indiquant le volume de l'ensemble du
bâtiment. À l'intérieur, l'alternance des vitres
et des bandes en verre blanc définit les
différents niveaux. Même dans la maison,
on a l'impression d'être dans la forêt.

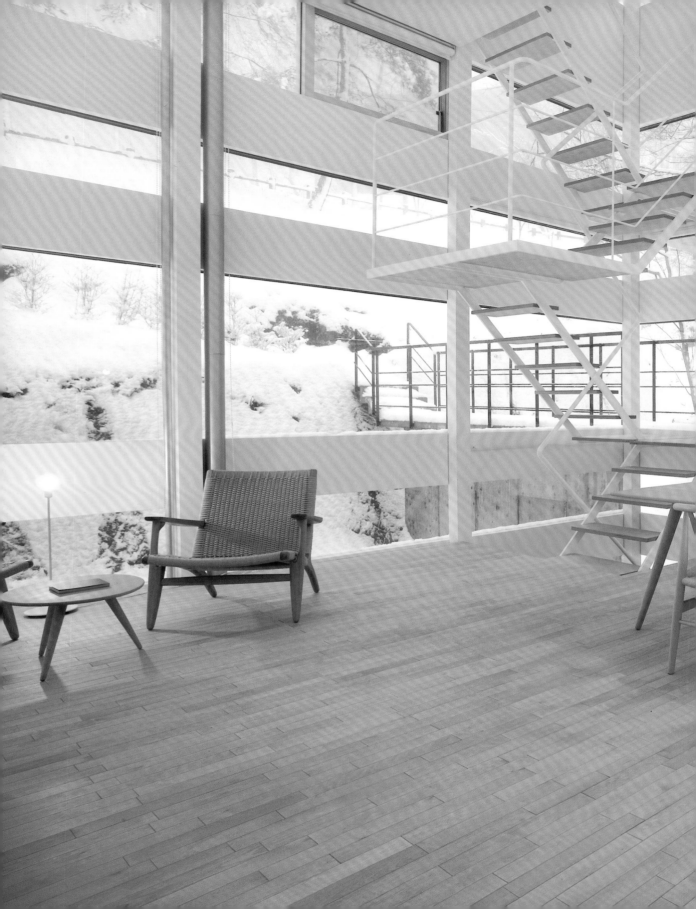

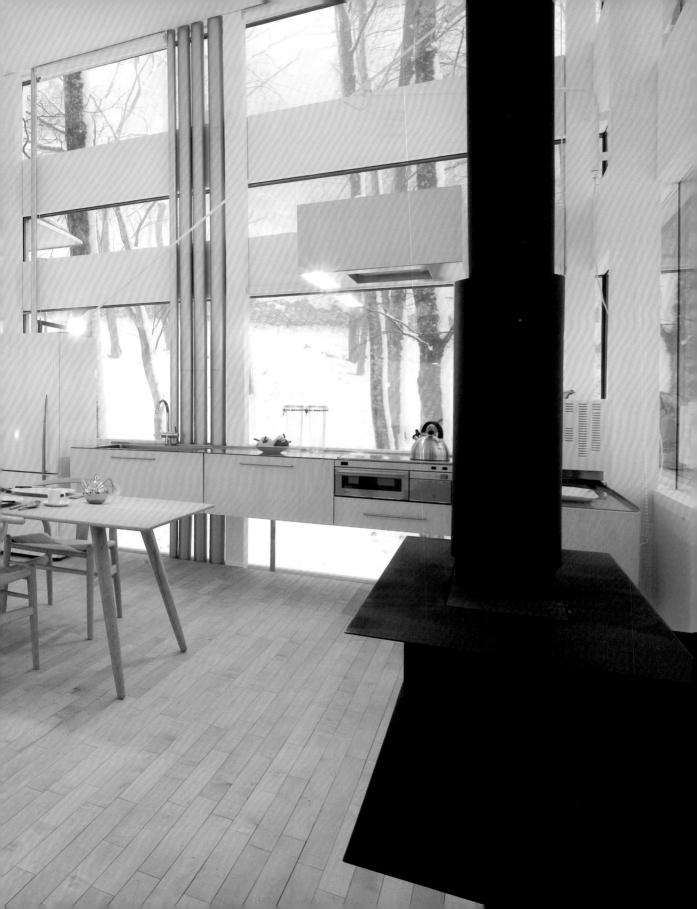

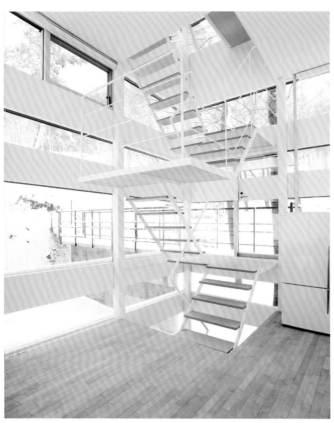
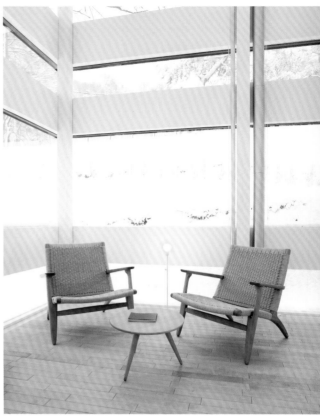
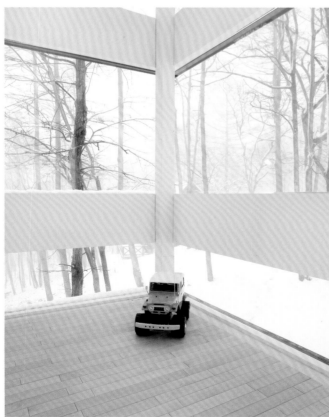
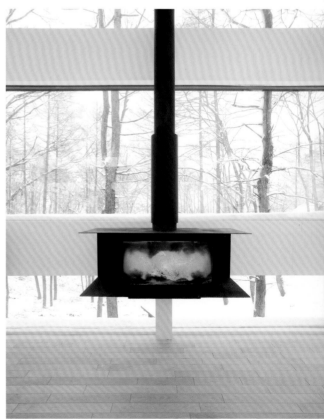

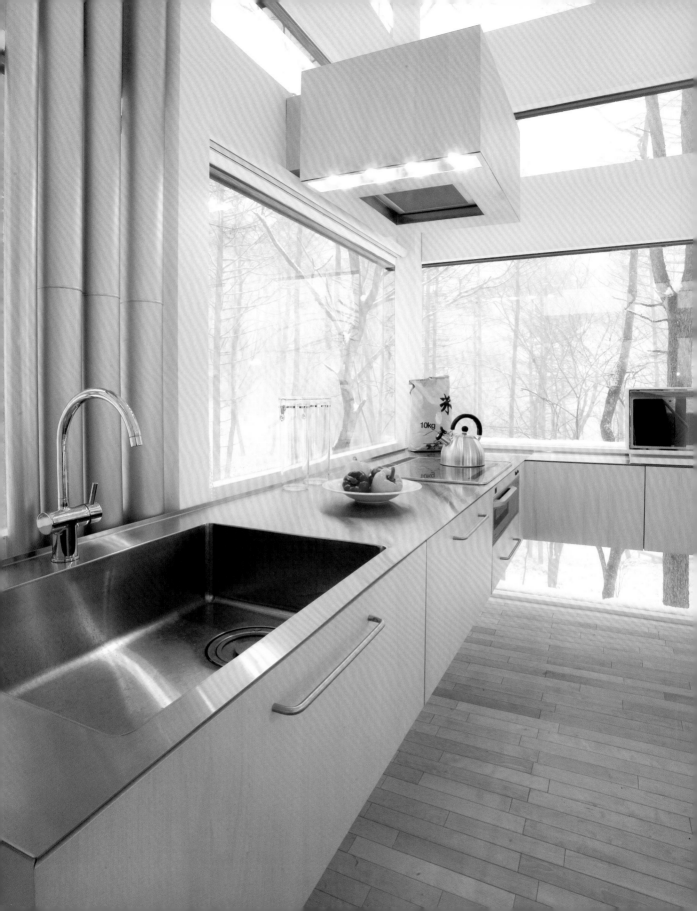

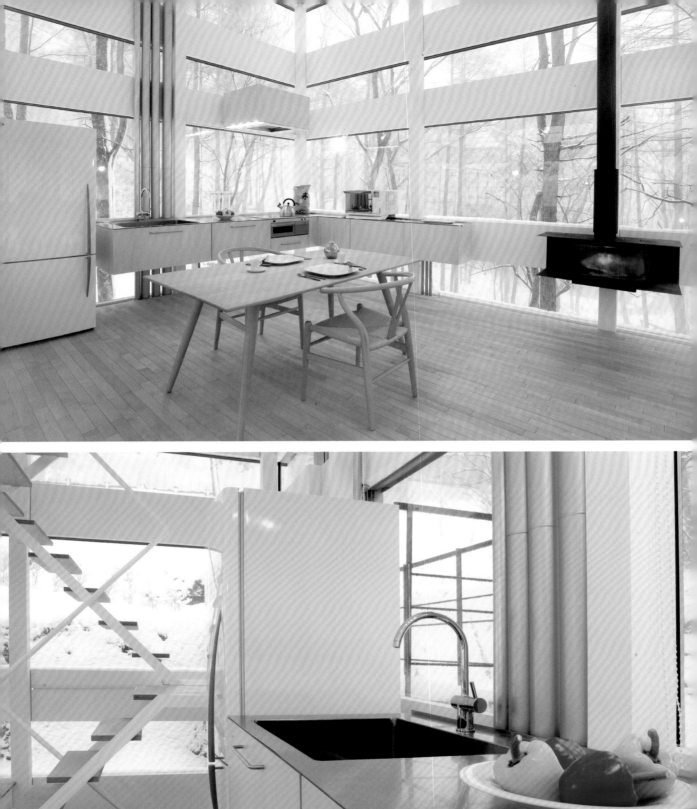

"We want the interior to be quiet, like the forest outside."

»Das Interieur soll so friedlich sein wie der Wald da draußen.«

»Nous voulons un intérieur aussi paisible que la forêt au dehors. »

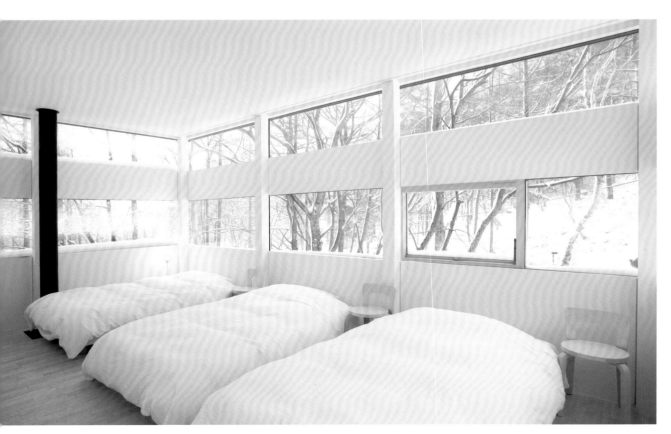

NEW YORK CITY

Manhattan, New York, USA

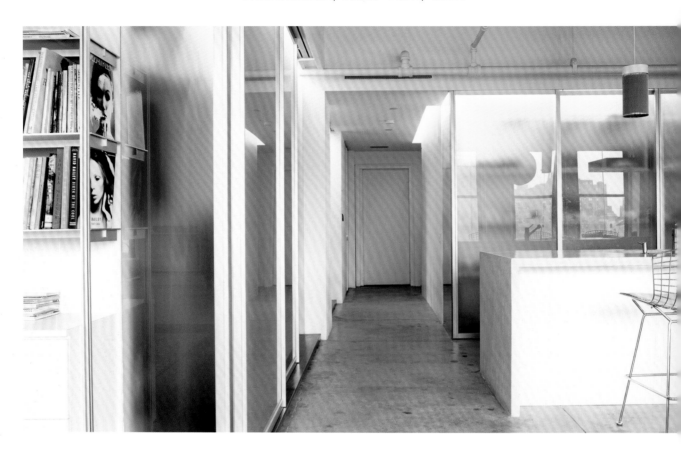

OWNERS
Jo Shane & John Cooper

OCCUPATION
Artist/Photographer

PROPERTY
Loft
246 sqm / 2,650 sq ft
1 floor; 5 rooms; 2 bathrooms

YEAR
Building: 1927
Remodelling: 2001

ARCHITECT & INTERIOR DESIGNER
Juergen Riehm
1100 Architect, New York / Frankfurt am Main
www.1100architect.com

FURNITURE
Harry Bertoia bar stools & white "Diamond" chair; Florence Knoll blue sofa; George Nelson beige "Coconut" chair & walnut chest of drawers; Warren Platner side table; Eero Saarinen red "Womb" chair; Charles & Ray Eames "Surfboard" table & "DCM" chair

PHOTOGRAPHER
Verne Photography, OWI, Ghent
www.verne.be
www.owi.bz

PHOTO PRODUCER
Hilde Bouchez, OWI, Ghent
www.owi.bz

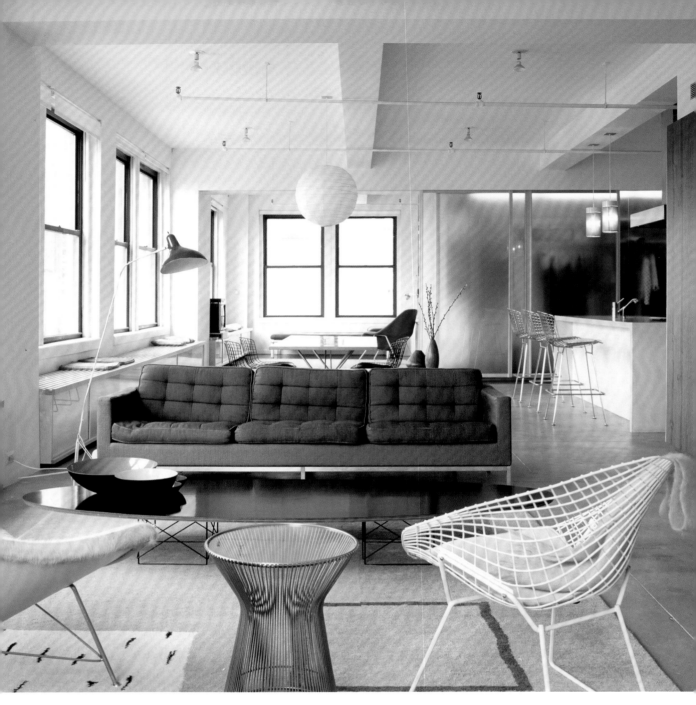

his 2,650-square-foot loft in Midtown
lanhattan, a home for a family of four, is
esigned as a hybrid between a conven-
onal apartment and a loft, maintaining
uidity and openness while providing a
rge amount of privacy.

Dieses 246 Quadratmeter große Loft im
Zentrum von Manhattan, eine Wohnung
für eine vierköpfige Familie, wurde als eine
Art Kreuzung zwischen einer konventionel-
len Wohnung und einem Loft entworfen
– fließende und offene Raumeindrücke
blieben bewahrt, während gleichzeitig viel
Privatsphäre geboten wird.

Ce loft de 246 mètres carrés à Midtown,
où vit une famille de quatre personnes, est
conçu comme un hybride entre l'appar-
tement traditionnel et le loft, offrant un
espace fluide et ouvert tout en assurant un
maximum d'intimité.

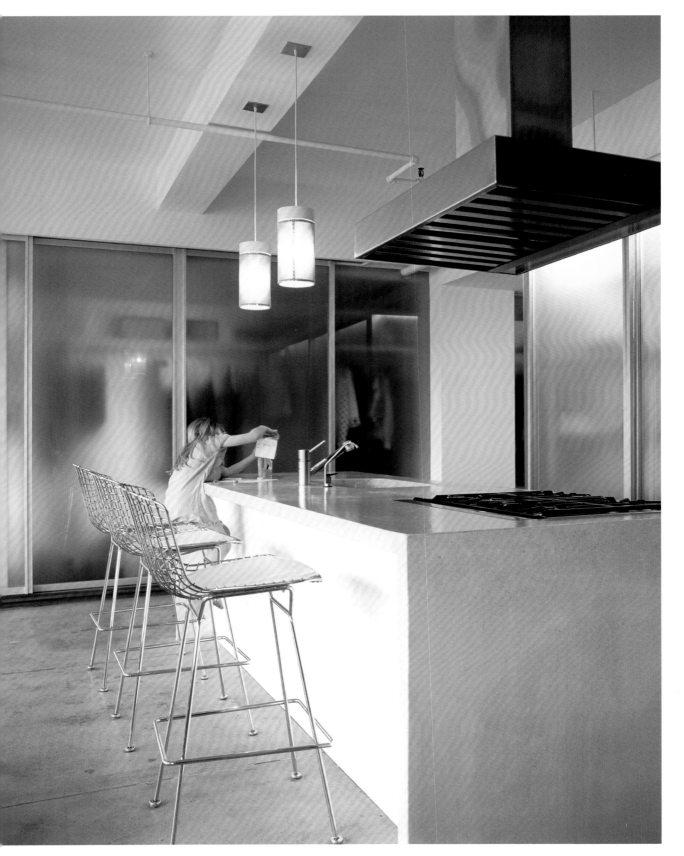

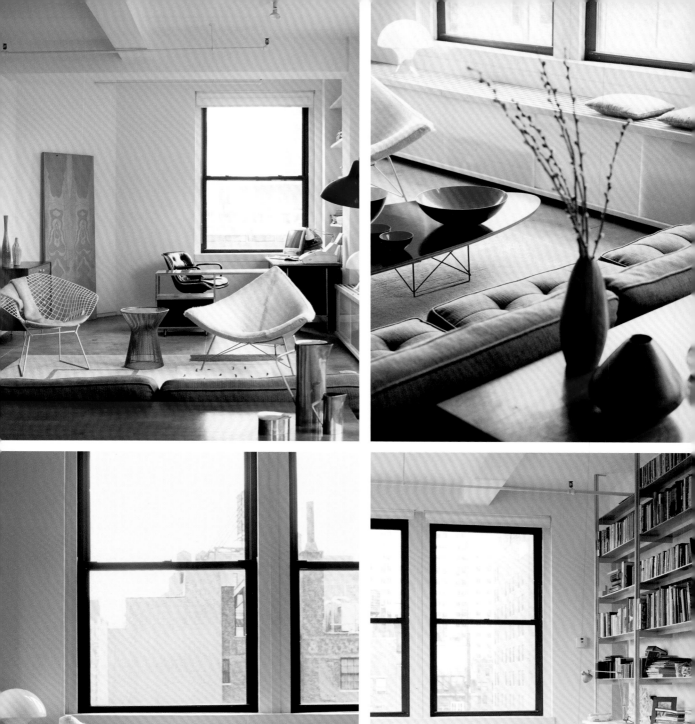

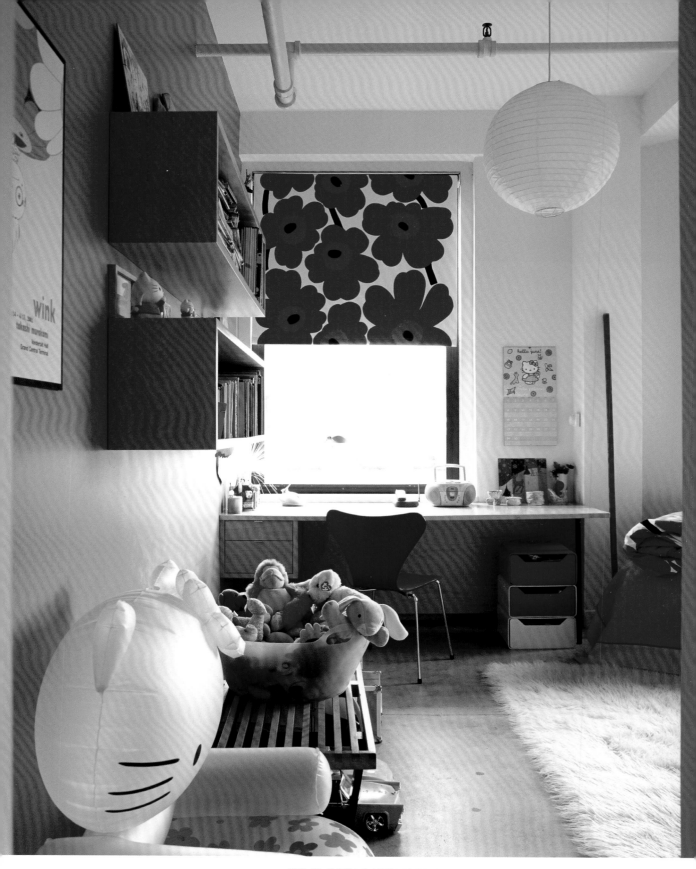

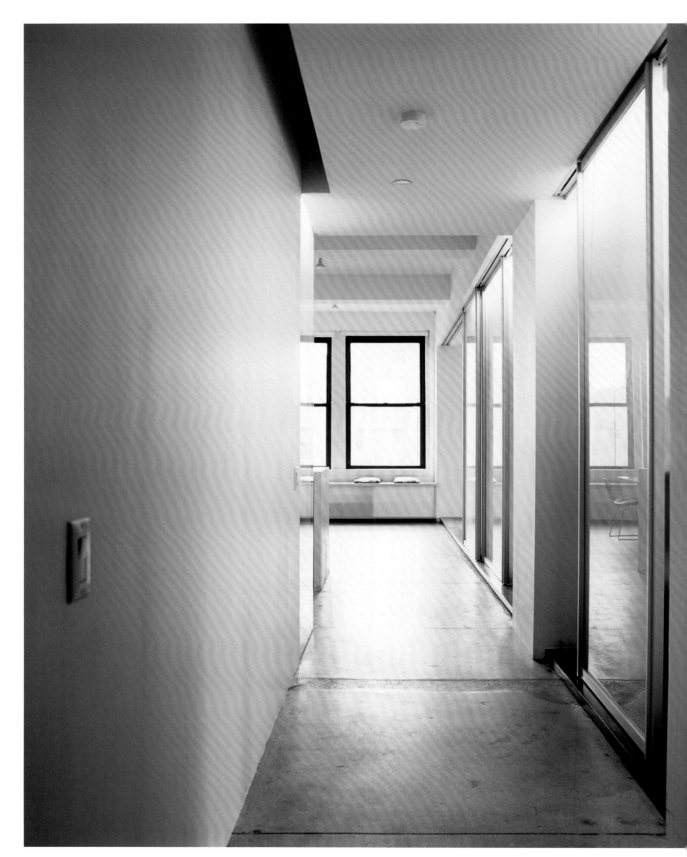

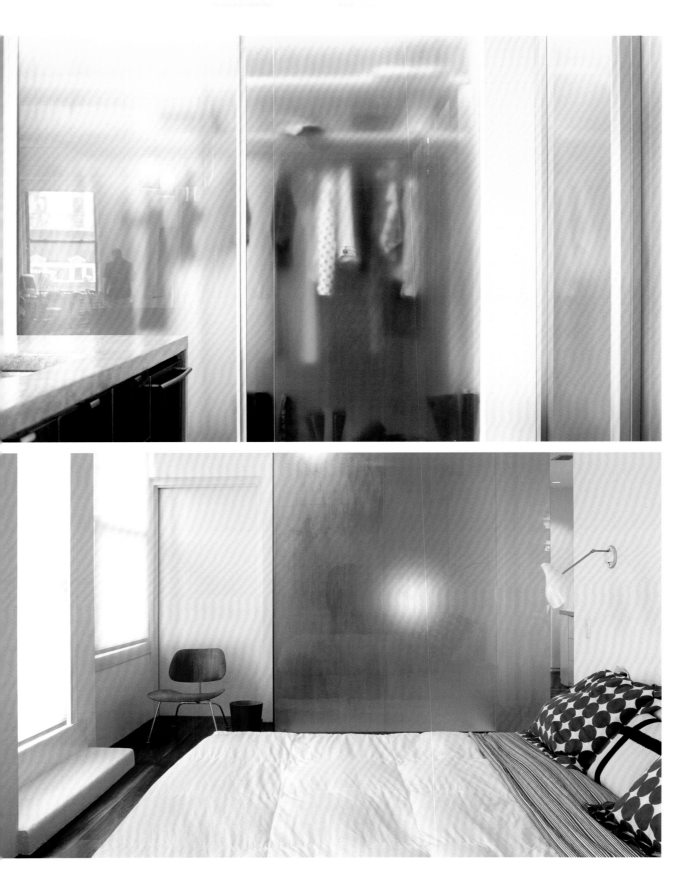

PANTELLERIA
Sicily Islands, Italy

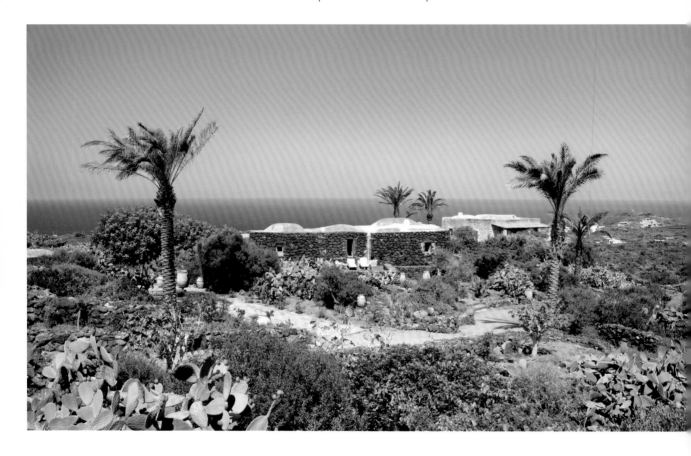

OWNERS
Doriana Mandrelli Fuksas
& Massimiliano Fuksas

OCCUPATION
Architects

PROPERTY
House on 25 hectares of land
1,100 sqm / 11,800 sq ft
1 floor; 26 rooms + 6 kitchens;
14 bathrooms
Covered terrace of 600 sqm / 6,500 sq ft

YEAR
Remodelling: 2004–2005

ARCHITECT & INTERIOR DESIGNER
Doriana Mandrelli Fuksas, Rome / Paris
www.fuksas.it

FURNITURE
Ethnic furniture collected during travels to
India, Morocco, North Africa, Turkey, China

PHOTOGRAPHER
diephotodesigner, Berlin
www.diephotodesigner.de

PHOTO PRODUCER & AUTHOR
Rixa von Treuenfels for German Vogue,
Munich

STYLE
The relationship with the territory was
the biggest problem, and this was under-
estimated in the beginning. Figuring out
how to open an access road with regard to
the natural surroundings, creating connec-
tions and replanting was the most difficult
phase of the work.

Die Beziehung zum Gelände war das größte
Problem – das wurde allerdings zu Anfang
unterschätzt. Die schwierigste Phase der
Arbeiten bestand darin, einen Zugangsweg
unter Berücksichtigung der Natur anzule-
gen, Verbindungen zu schaffen und für eine
neue Bepflanzung zu sorgen.

Le plus gros problème, sous-estimé au
départ, fut la relation avec l'environnement
L'ouverture d'une voie d'accès, la création
de connexions et les nouvelles plantations
constituèrent la phase la plus difficile des
travaux.

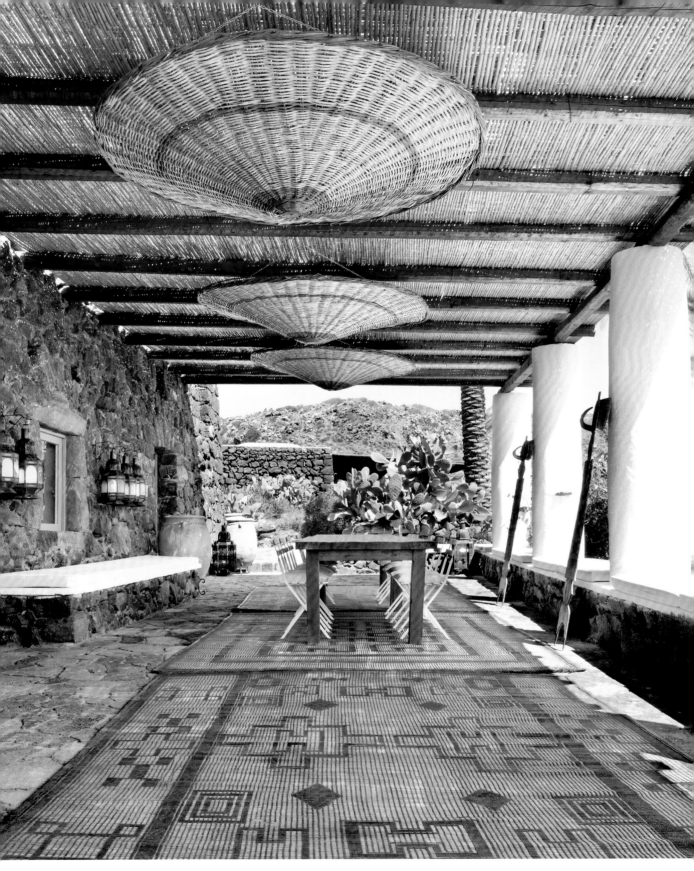

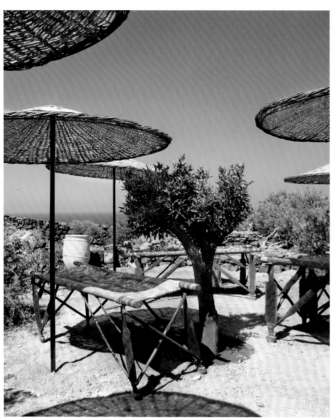

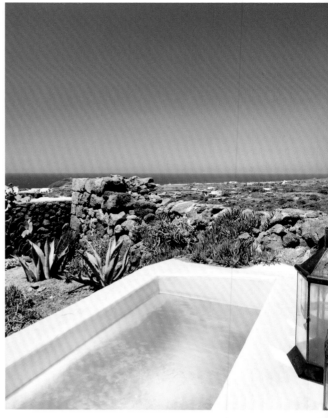

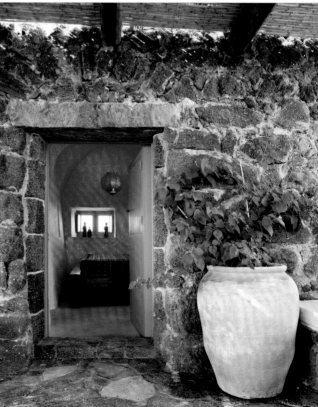

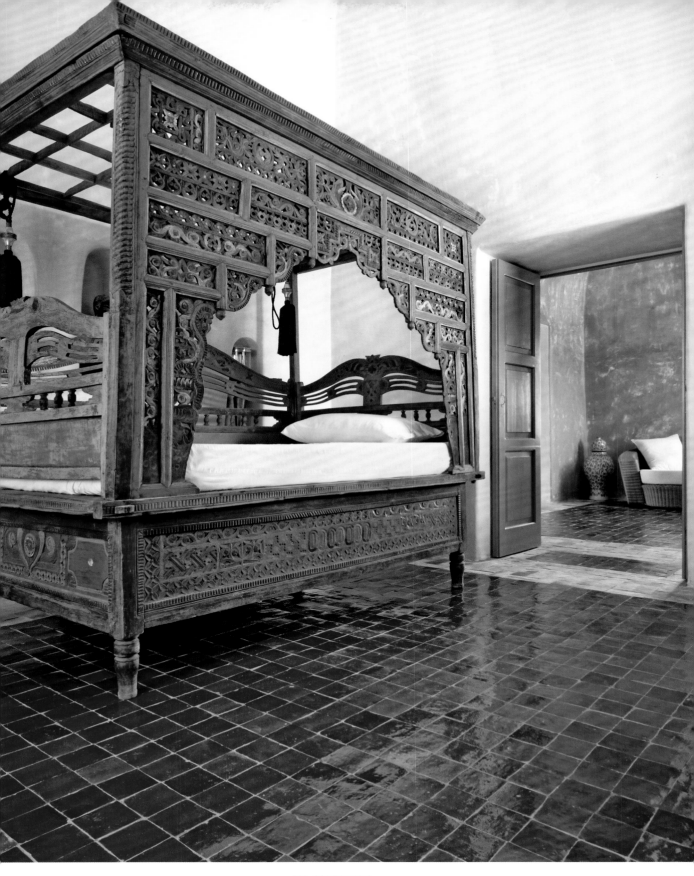

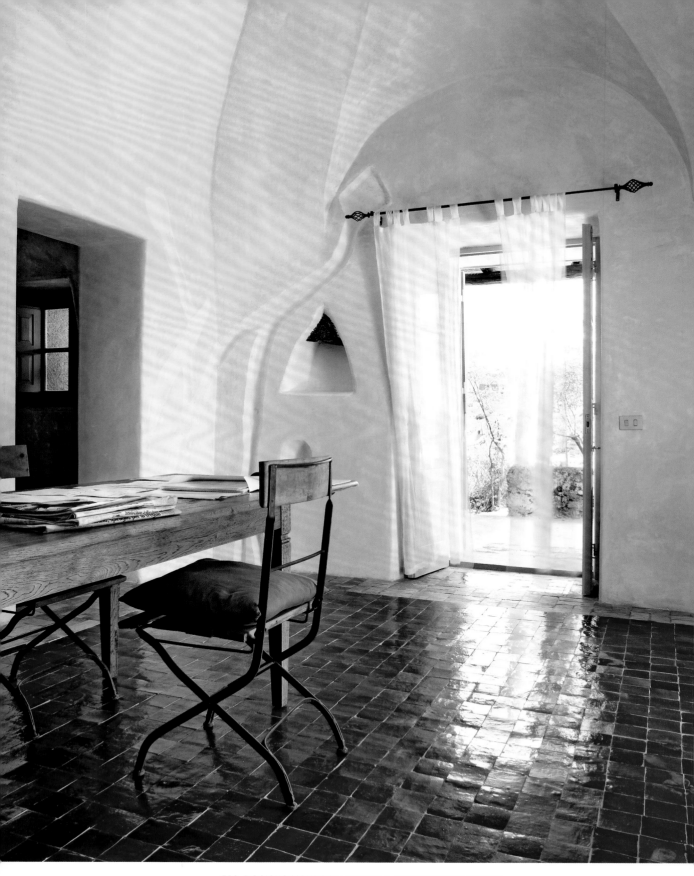

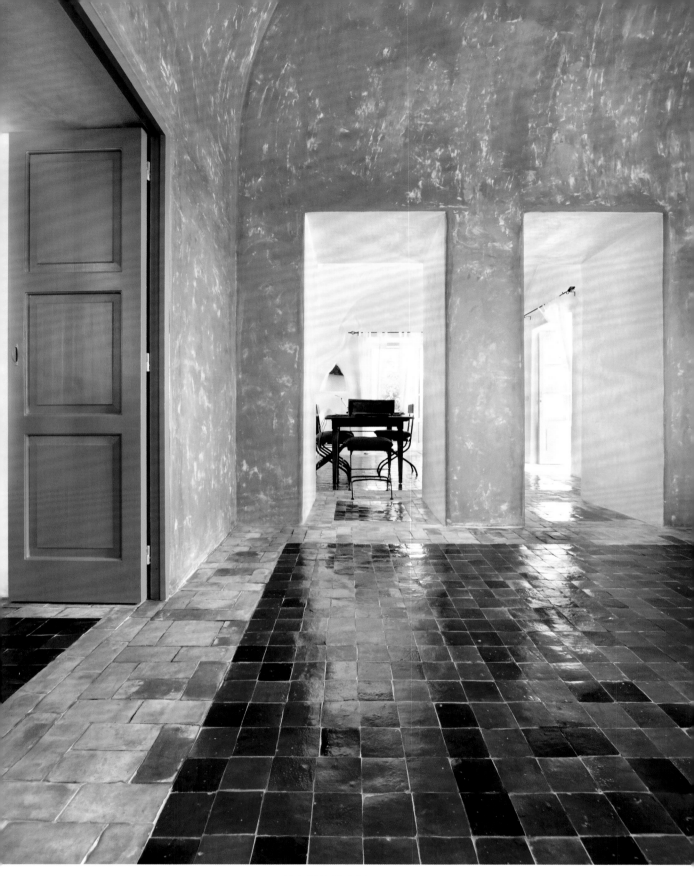

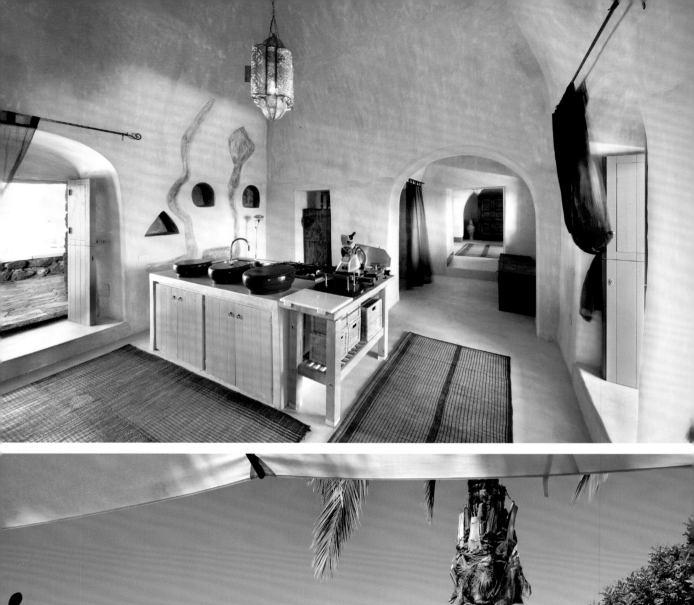
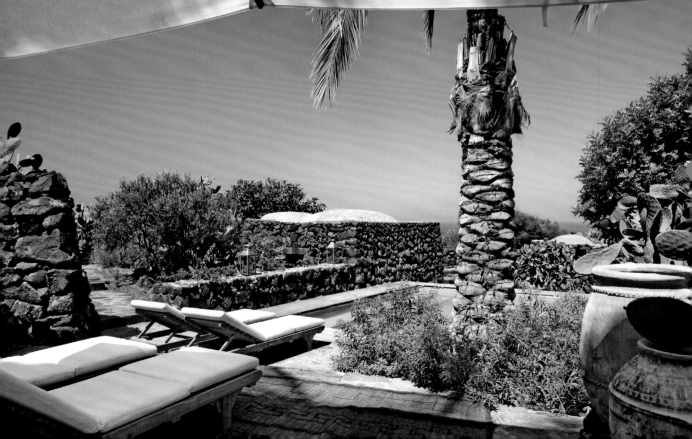

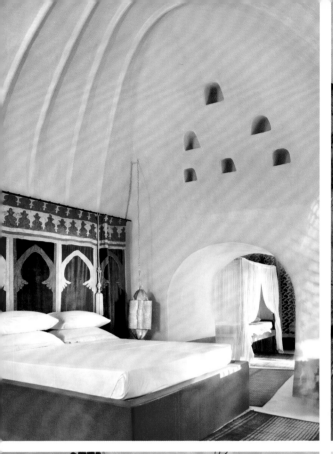
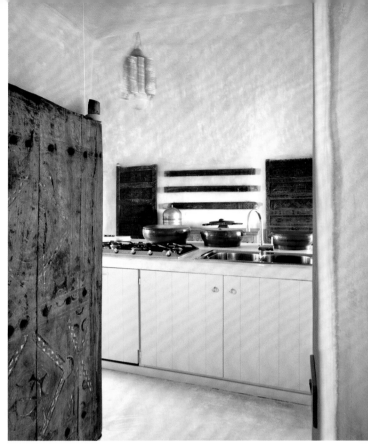
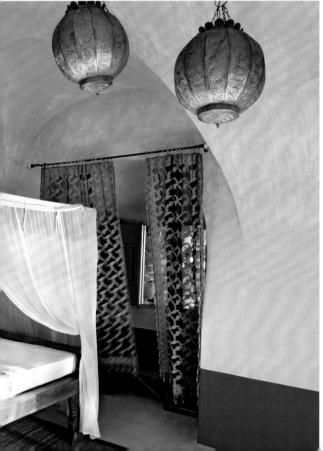
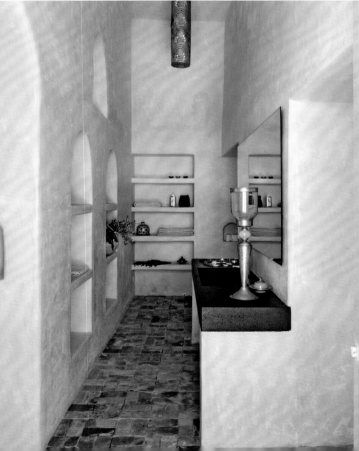

PARIS

France

OWNERS
Laurence & Patrick Seguin

OCCUPATION
Furniture dealers

PROPERTY
Apartment
235 sqm / 2,530 sq ft
2 floors; 6 rooms; 3 bathrooms

YEAR
Building: 17th century

ART
Raymond Pettibon; Roman Signer; Cindy Sherman; Alexander Calder; Andy Warhol; Edward Ruscha; Rob Pruitt; Hiroshi Sugimoto; Franz West; Thomas Grünfeld; Jeff Koons; Banks Violette

FURNITURE
Charlotte Perriand, Ateliers Jean Prouvé; Jean Prouvé; Charlotte Perriand; Alexandre Noll; Serge Mouille; Le Corbusier; Pierre Jeanneret; Jasper Morrison; André Cazenave; Jean Royère; Georges Jouve

PHOTOGRAPHER
Guy Bouchet, Paris
www.photononstop.com

STYLE
Each room is a harmoniously composed ensemble. Seguin counters the retrospective character of the furniture with a future-oriented selection of contemporary art, with highly subtle correspondences between the artworks and the mid-century design.

Jeder Raum präsentiert sich als harmonisch komponiertes Ensemble. Dem retrospektive Charakter seiner Möbelkollektion begegnet Seguin mit einem vorwärtsgewandten Kontr ausgewählter Gegenwartskunst, jedoch mit feinen Korrespondenzen zwischen den Kunstwerken und dem Design der 1950er Jahre.

Chaque pièce constitue un ensemble harmonieusement composé. Seguin a contré l caractère rétrospectif du mobilier avec une sélection d'art contemporain tourné vers l'avenir, de très subtiles correspondances unissant les œuvres et le design des année 1950.

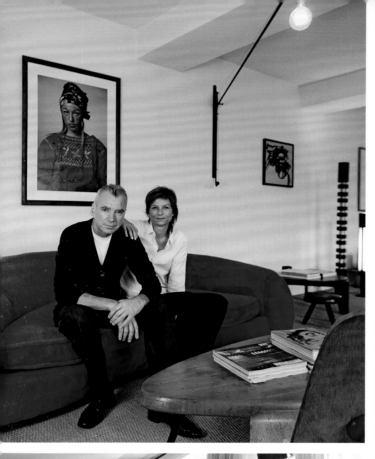

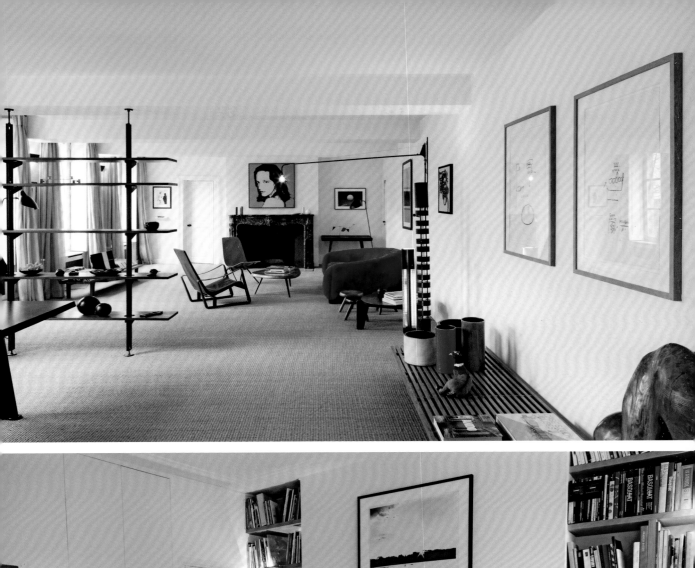
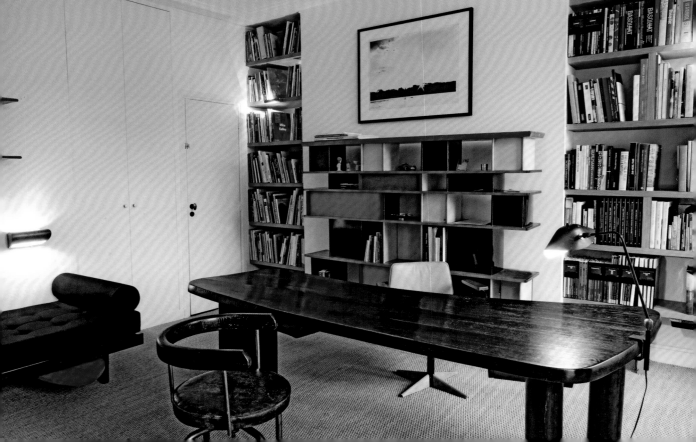

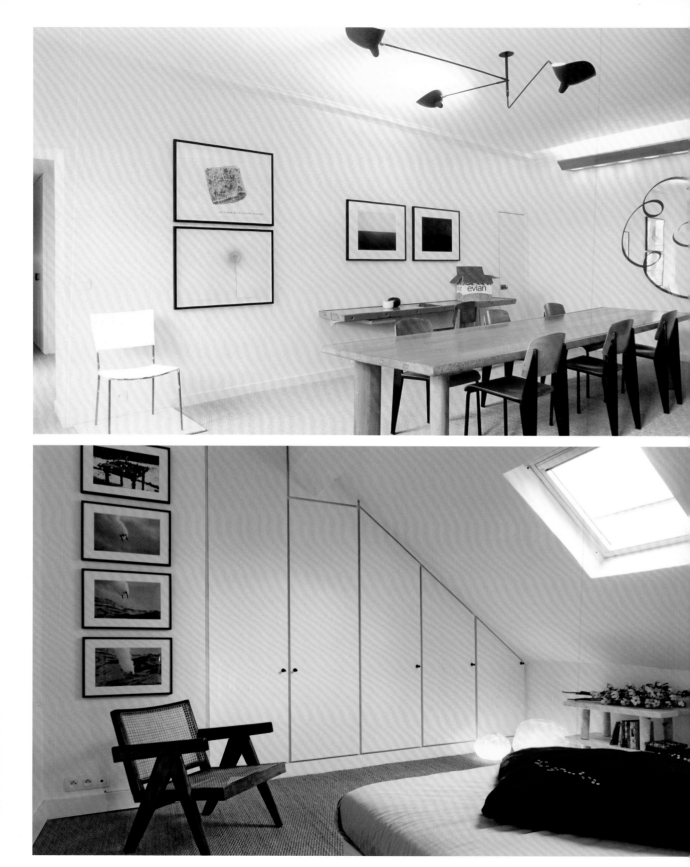

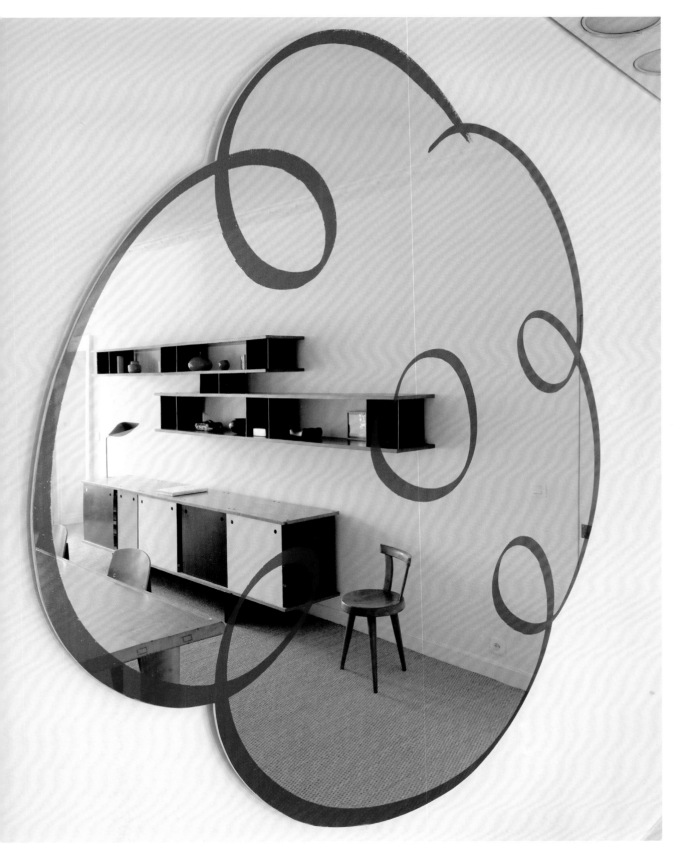

POCONOS

Pennsylvania, USA

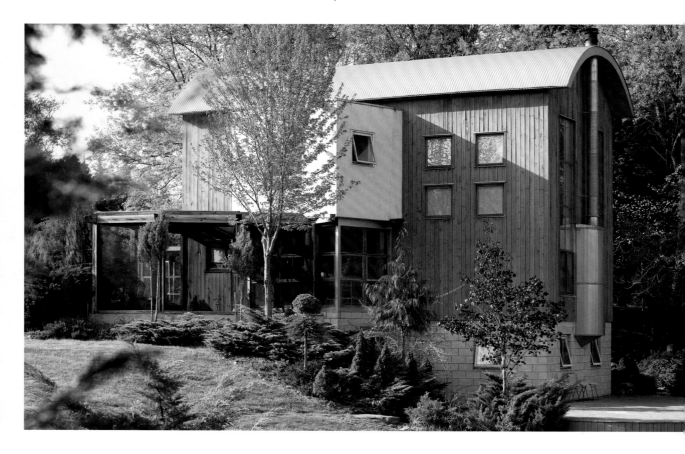

OWNERS
Todd Oldham & Tony Longoria

OCCUPATION
Fashion & interior designer
Business partner

PROPERTY
Weekend house
130 sqm / 1,400 sq ft
3 floors; 2 bedrooms; 2 bathrooms

YEAR
Building: 1995

INTERIOR DESIGNER
Todd Oldham, New York
www.toddoldham.com

ART
Ellen Berkenblit; Charley Harper;
Jim Shaw

FURNITURE
Todd Oldham; Jonathan Adler;
Alexander Girard; Russel Wright;
Heywood-Wakefield

PHOTOGRAPHER
Richard Powers, Arcaid
www.richardpowers.co.uk
www.arcaid.co.uk

PHOTO PRODUCER & STYLIST
Amanda Talbot, Arcaid
www.arcaid.co.uk

s house has neither beginning nor end,
t is constantly in motion. Like a piece of
thing, it is a question of feeling good in
ur apartment. It must suit you. The colours
t match your face are also right for your
artment.

Dieses Haus hat keinen Anfang und kein
Ende, es ist in ständiger Bewegung. Wie
bei einem Kleidungsstück geht es darum,
dass man sich in seiner Wohnung wohlfühlt
und sie zu einem passt. Die Farben, die uns
gut zu Gesicht stehen, sind auch für unsere
Wohnung gut.

Cette maison n'a ni début ni fin ; elle est en
mouvement perpétuel. Il faut se sentir bien
chez soi, comme dans un vêtement. Votre
intérieur doit bien vous aller. Les couleurs
qui flattent votre teint conviennent égale-
ment à votre appartement.

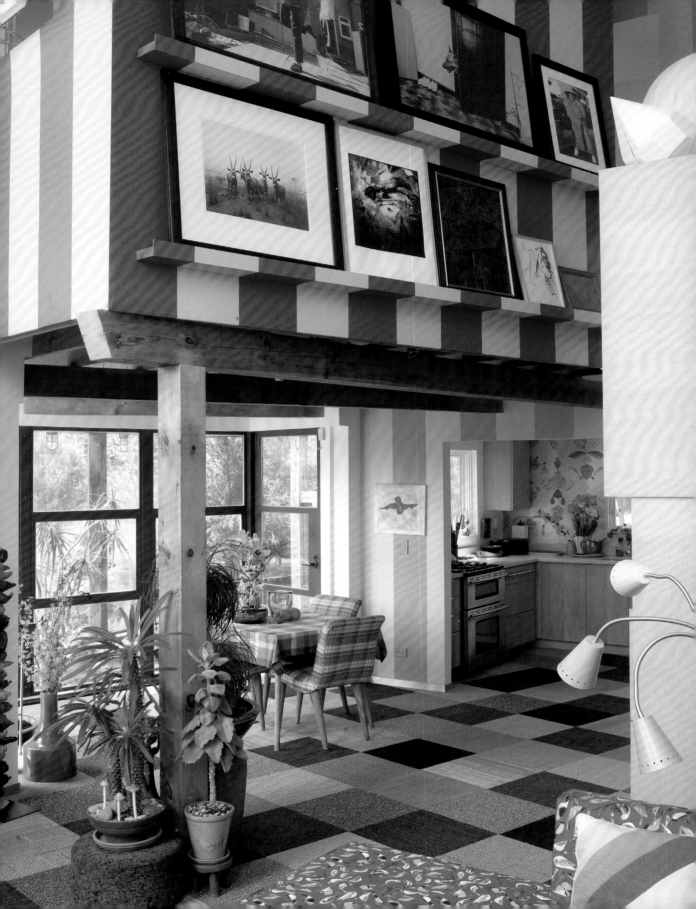

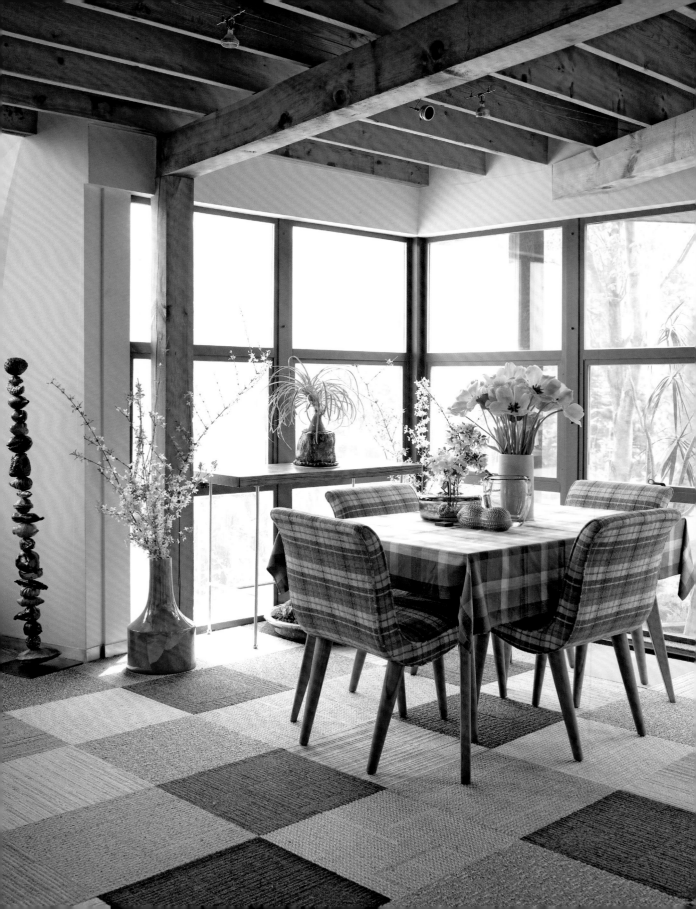

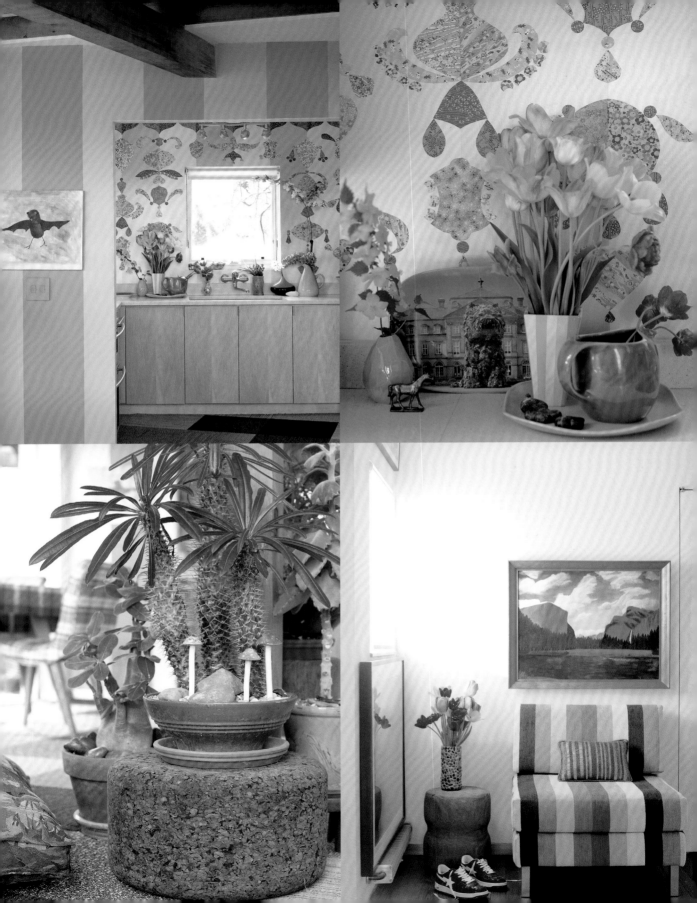

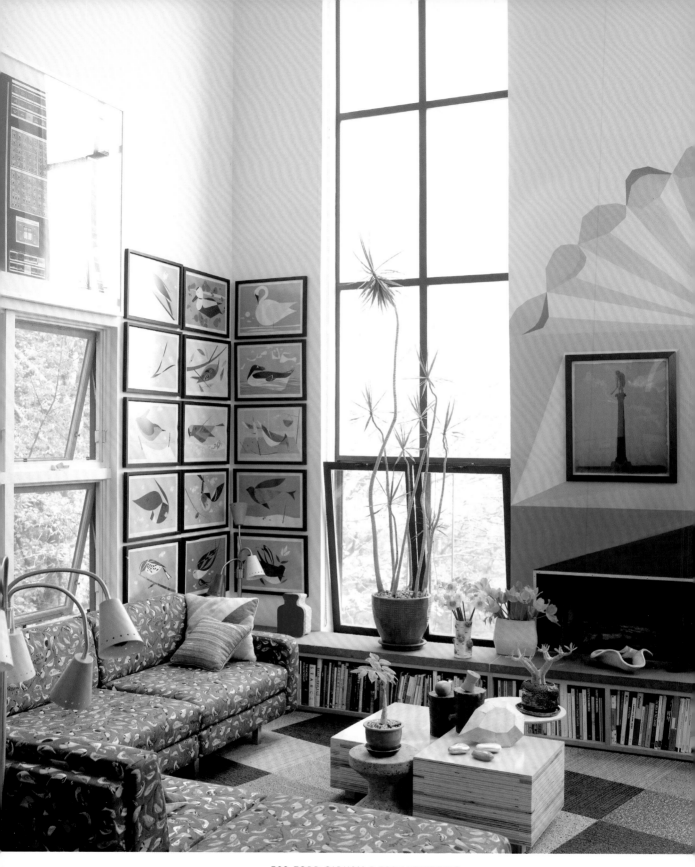

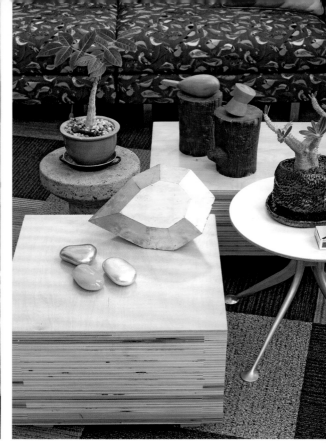
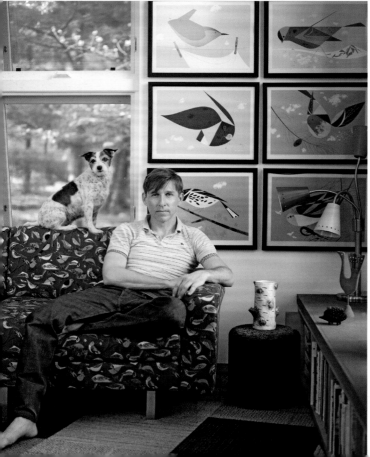

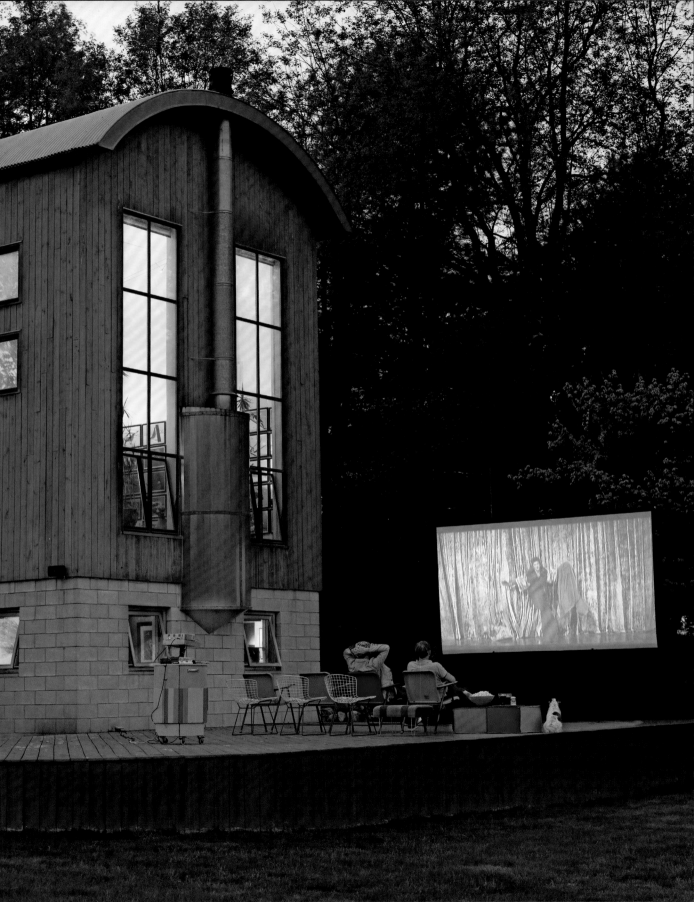

PRATO

near Florence, Tuscany, Italy

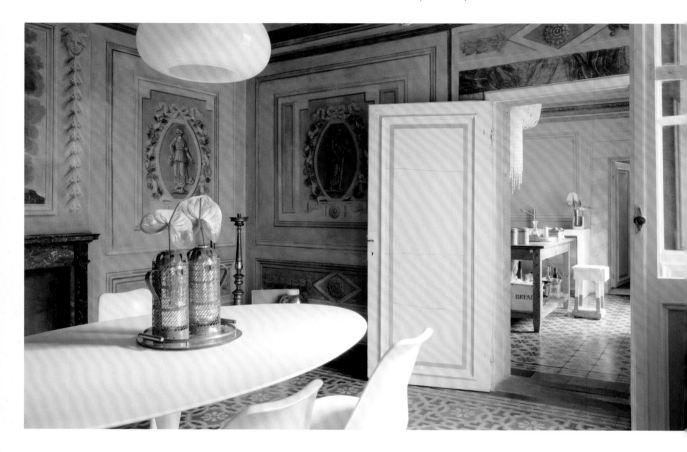

OWNER
Sabrina Bignami

OCCUPATION
Architect

PROPERTY
Historic palazzo
250 sqm / 2,700 sq ft
1 floor; 14 rooms; 3 bathrooms

YEAR
Building: 1790
Remodelling: 2005

ARCHITECT & INTERIOR DESIGNER
Sabrina Bignami
b-arch studio, Prato
www.b-arch.it

ART
Casa Orlandi was richly decorated
by Luigi Catani (1762–1840), one
of the main Tuscan fresco painters

FURNITURE
Eero Saarinen "Tulip" chairs & table; 1930s
original floor tiles; modern chandelier, Solzi
Luce (kitchen); Verner Panton chairs (terrace);
seating system, Living Divani; main bedroom,
Cyrus Company; Eero Saarinen white "Tulip"
side table; 1930s chandelier; vintage chairs

PHOTOGRAPHER
Lorenzo Nencioni, Vega MG, Milan
www.lorenzonencioni.com

STYLE
The very glamour of the Casa Orlandi stems
from its alternating mix of ancient and con-
temporary. A contemporaneity that is neither
stereotypical nor, as often happens, depend-
ent only on the big names of Italian design.

Der Glamour der Casa Orlandi entsteht aus
der Mischung von Alt und Modern – eine
Modernität, die nicht stereotyp ist und sich
auch nicht, wie so häufig, nur auf die großen
Namen des italienischen Designs verlässt.

Tout le glamour de la Casa Orlandi vient
de l'alternance de l'ancien et du moderne.
Une contemporanéité qui n'est ni un
stéréotype ni, comme c'est souvent le cas,
uniquement dépendante des grands noms
du design italien.

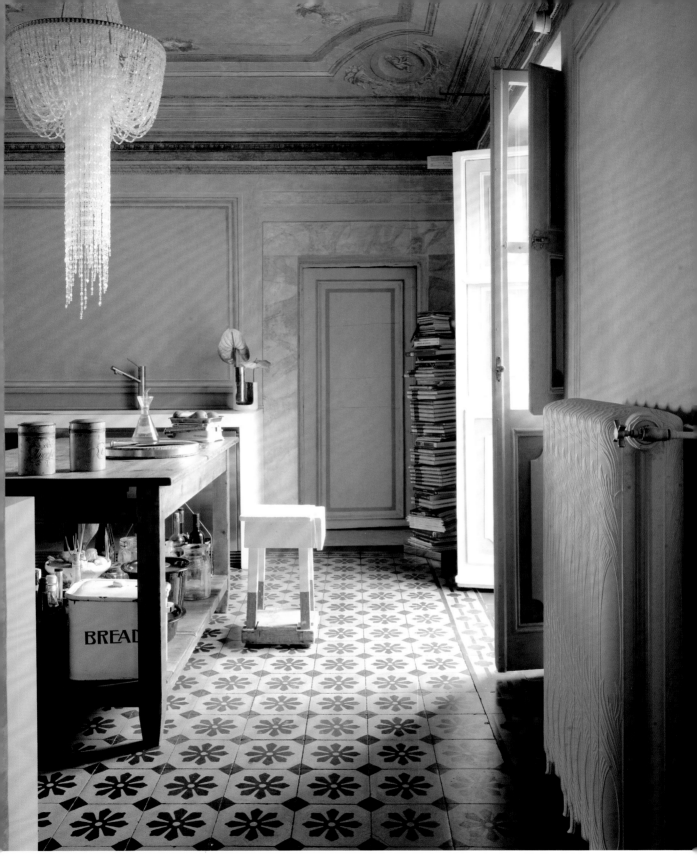

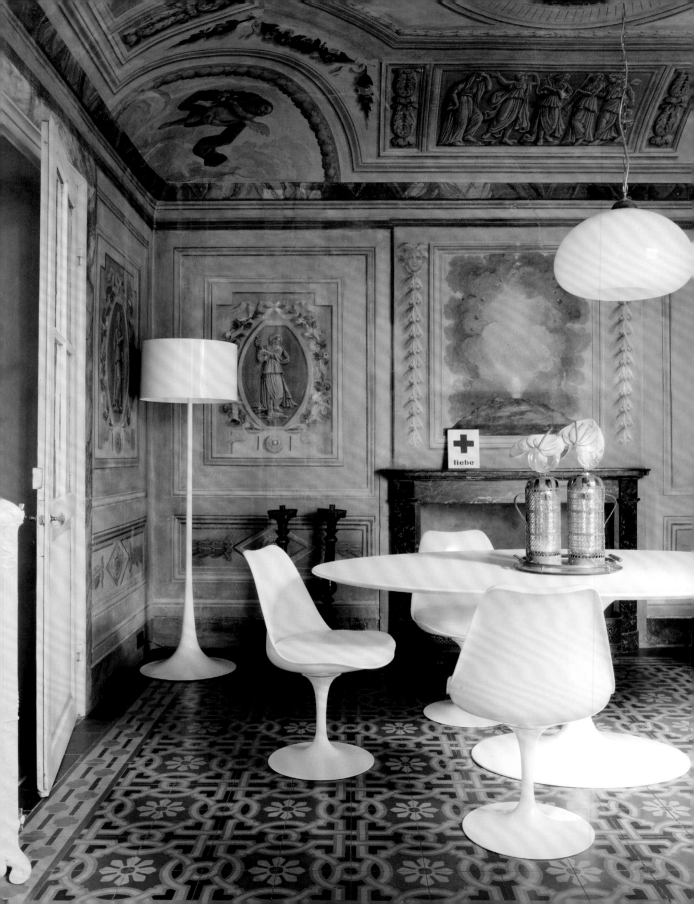

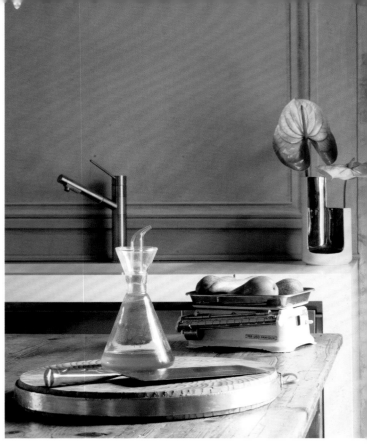
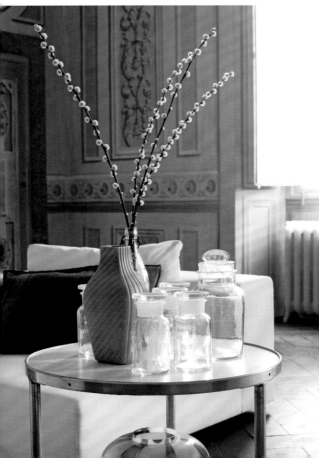

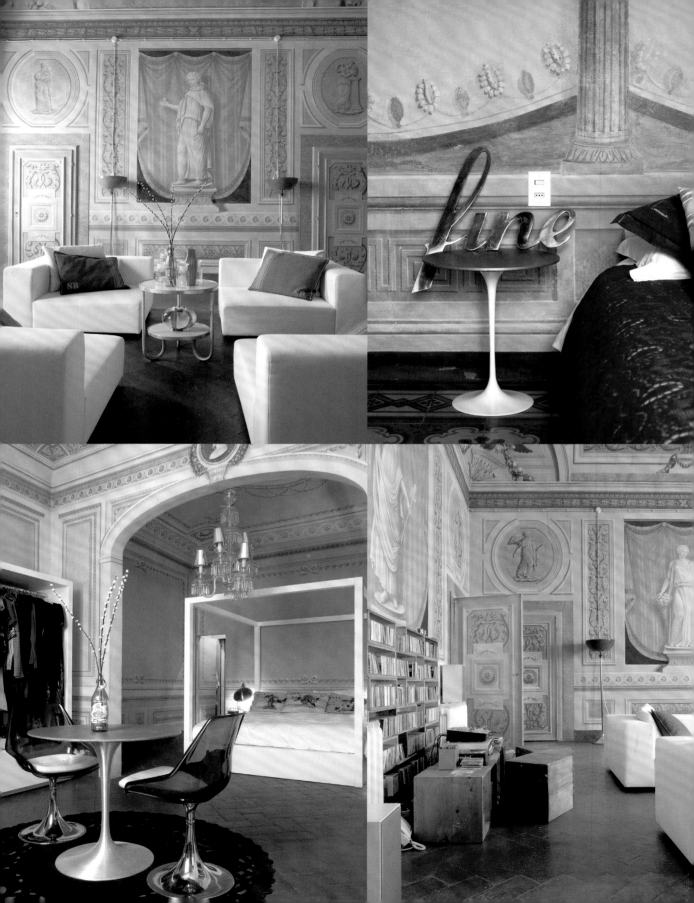

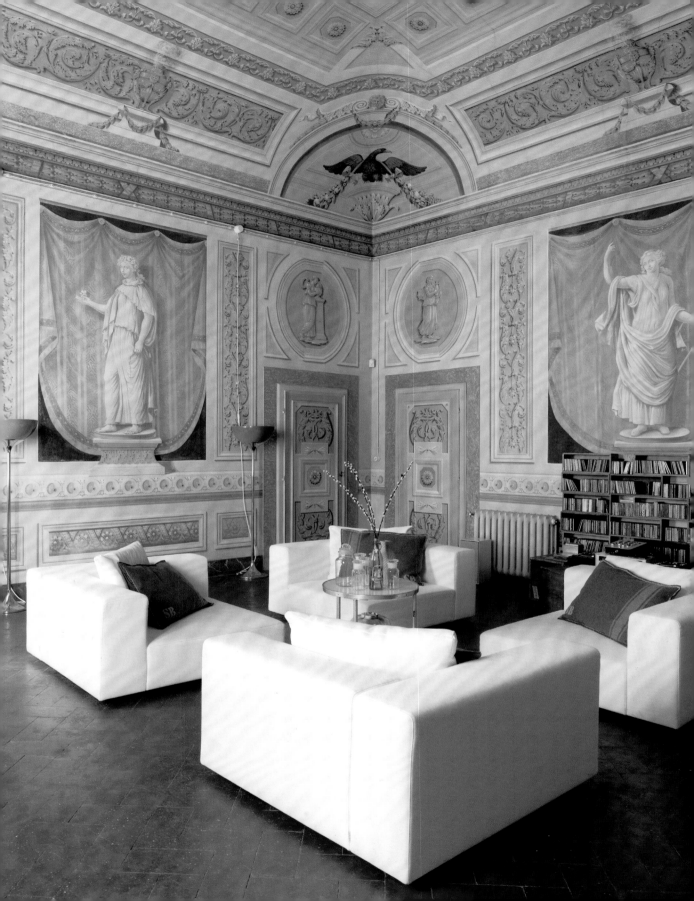

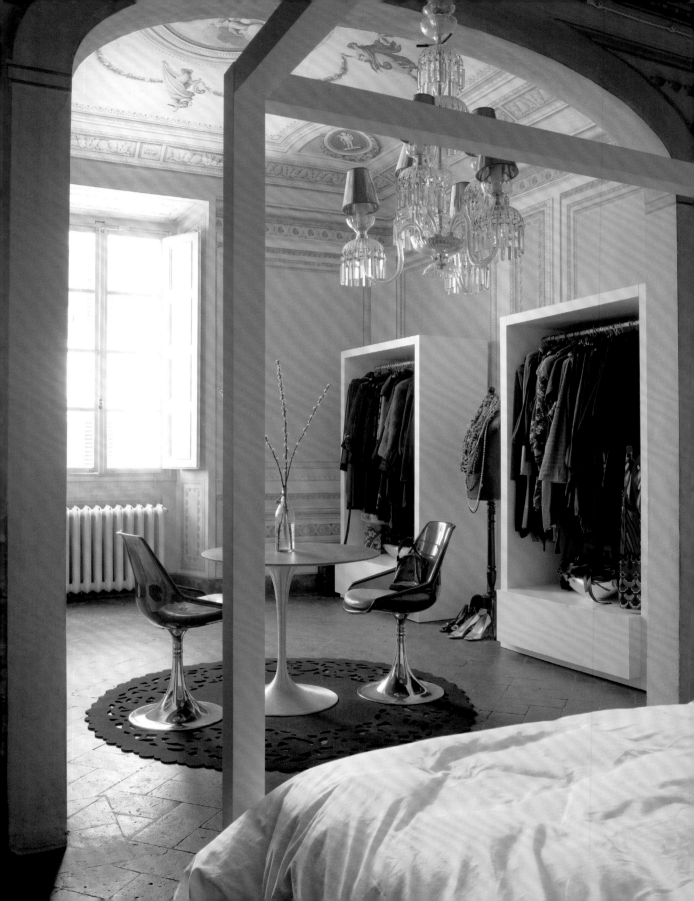

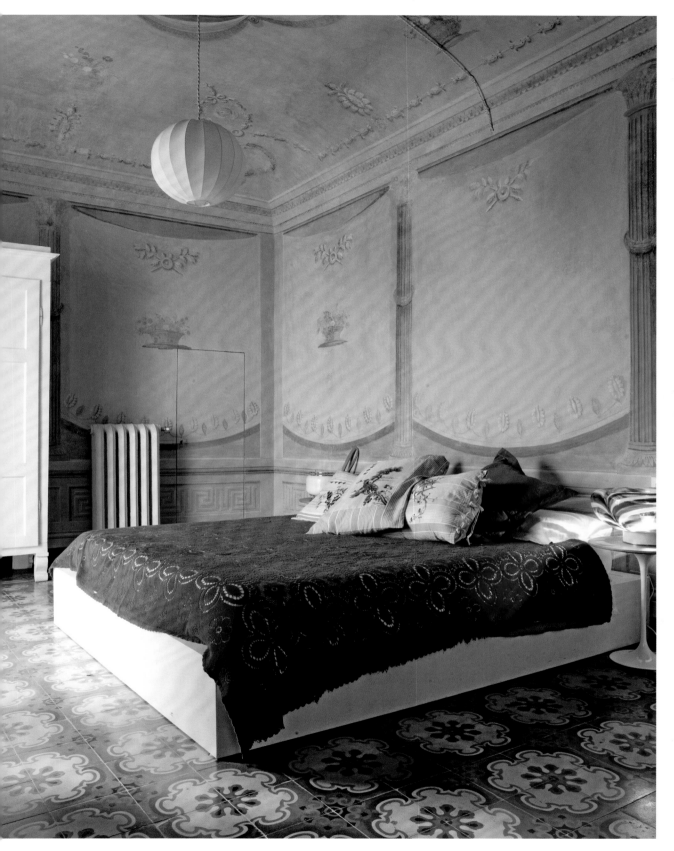

PROVENCE

France

OWNERS
Michelle & Yves Halard

OCCUPATION
Decorators

PROPERTY
Weekend house
600 sqm / 6,450 sq ft
2 floors; 10 rooms; 6 bathrooms

YEAR
Building: 18th-century hunting lodge
Remodelling: 1999

INTERIOR DESIGNERS
Michelle & Yves Halard, Paris

FURNITURE
Vintage garden chairs; Louis XVI side
chairs from Château de Versailles;
Aubusson carpets; Christian Bérard rug;
mixed vintage and fleamarket furniture
and toys combined with objects
of Halard's own design

PHOTOGRAPHER
François Halard, Trunk Archive, New York
www.trunkarchive.com

PRODUCER
Carolina Irving, New York

STYLE
The superabundance reflects a generosity
of spirit. Vivid splashes of colour are another
Michelle and Yves Halard signature.

Die Überfülle zeugt von einem großzügigen
Geist. Lebhafte Farbtupfen sind ein weiteres
Markenzeichen von Michelle and Yves
Halard.

Cette profusion reflète un esprit généreux.
Les touches de couleurs vives sont une
autre caractéristique du style de Michelle
et Yves Halard.

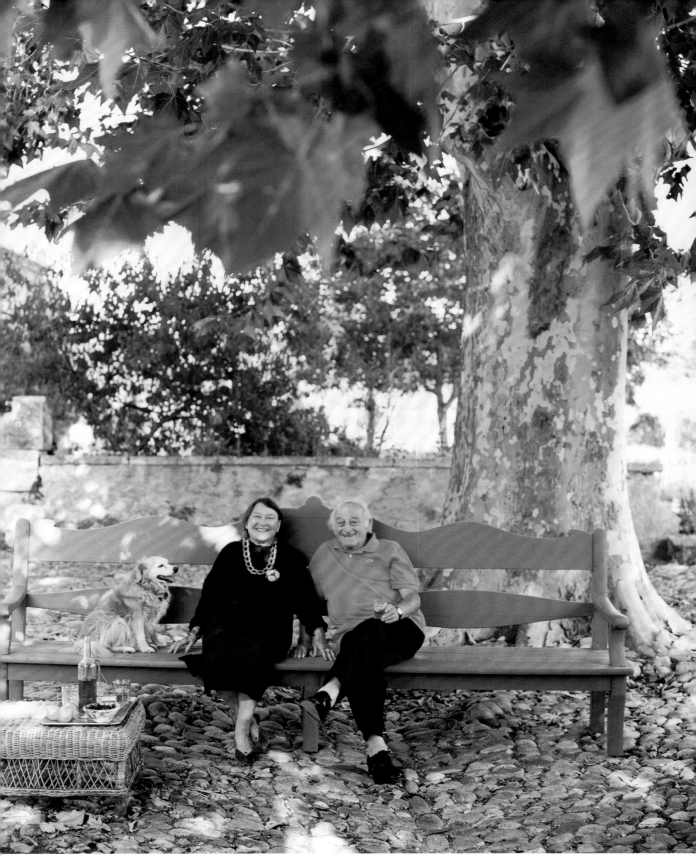

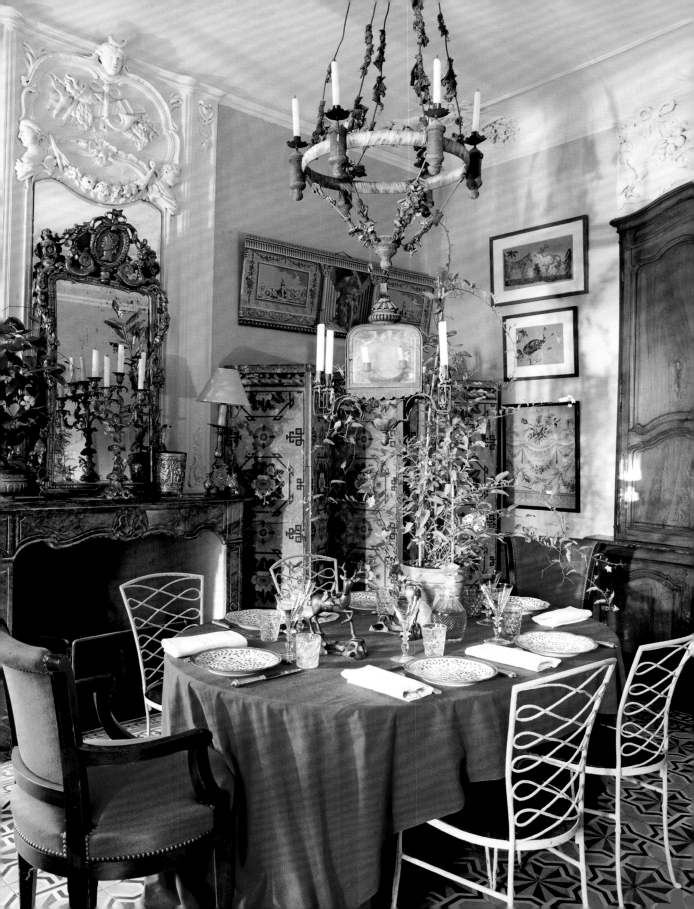

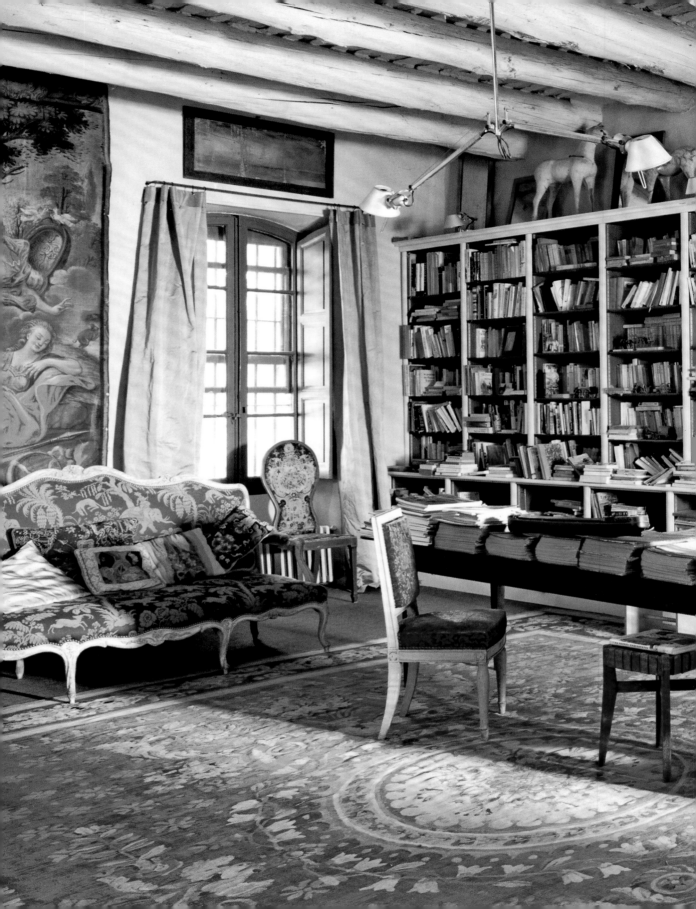

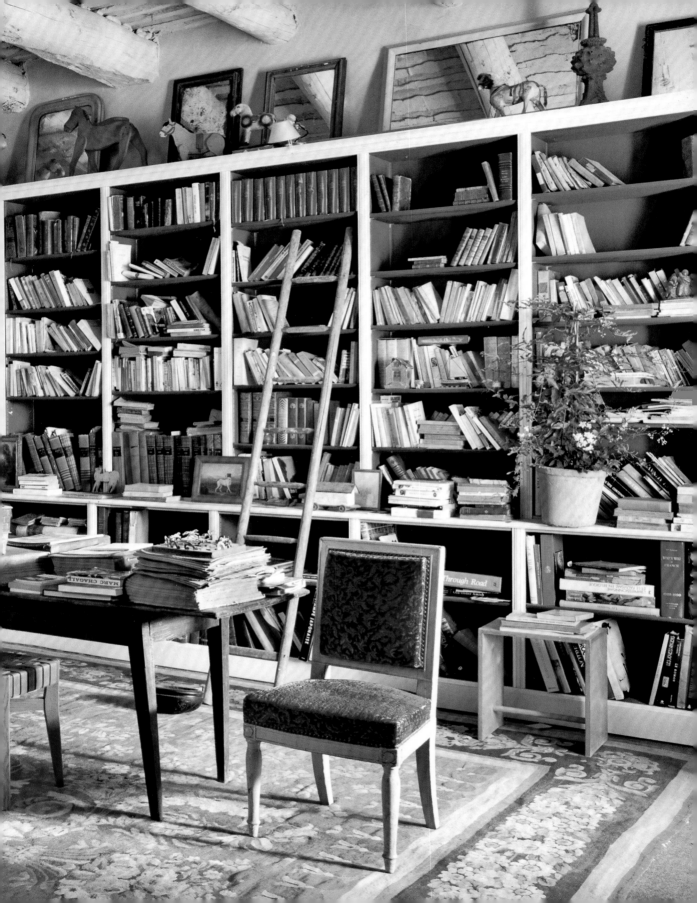

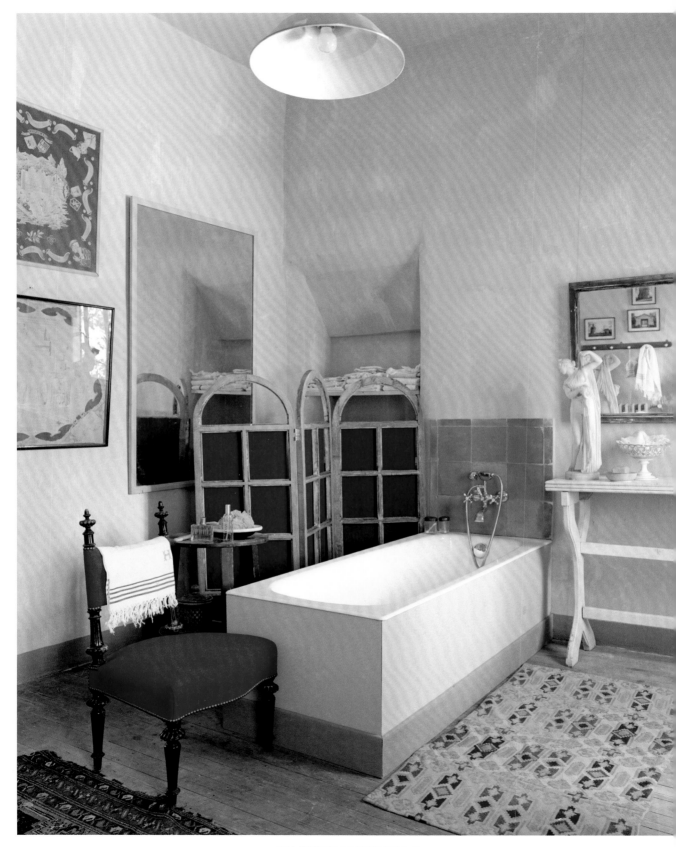

"We buy things we find adorable. They are not rare, they are poetic."

»Wir kaufen Dinge, die wir bezaubernd finden. Sie sind nicht selten, sie sind poetisch.«

« Nous achetons des choses que nous trouvons adorables. Elles ne sont pas rares, elles sont poétiques. »

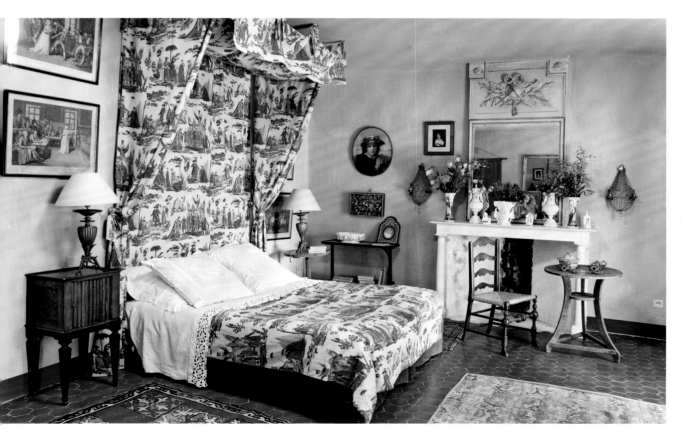

SÃO PAULO
Sumaré, Brazil

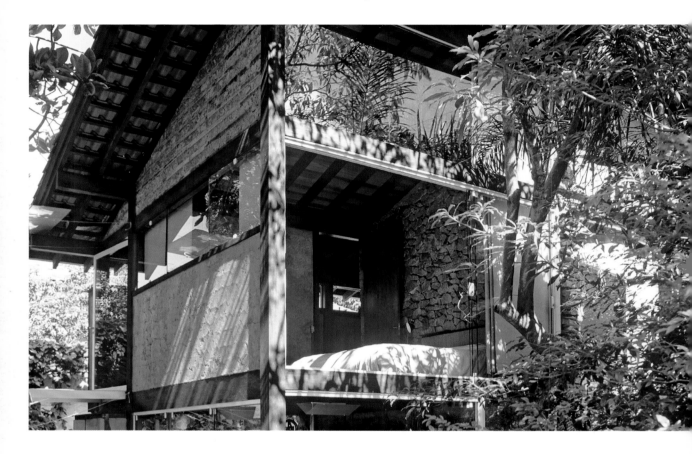

OWNERS
Samira Leal & Rafic Farah

OCCUPATION
Designer / Architect

PROPERTY
House
250 sqm / 2,700 sq ft
2 floors; 4 rooms; 1 bathroom

YEAR
Building: 1999
Remodelling: 2002

ARCHITECT
Rafic Farah, São Paulo
São Paulo Arquitetura / São Paulo Criação
www.raficfarah.com.br

INTERIOR DESIGNER
Samira Leal Farah, São Paulo
São Paulo Arquitetura / São Paulo Criação
www.raficfarah.com.br

ART
Adriana Alves; Dudi Maia Rosa; Guto
Lacaz; Verena Matzen; Isabelle Tuchband

FURNITURE
Furniture by architect designers:
Lina Bo Bardi, Paulo Mendes da Rocha,
Sergio Rodrigues; country-style benches
from Brazil; native Indian benches

PHOTOGRAPHER
Agi Simões, Zapaimages, Zurich
www.zapaimages.com

STYLE
All places in the house must offer something
for the eye and for the body. There should
be a constant re-arrangement.

Alle Räume in diesem Haus müssen etwas
für das Auge und den Körper bieten. Es
sollte eine ständige Neuanordnung geben.

Chaque coin de la maison doit offrir
quelque chose pour le regard et le corps.
Le réaménagement doit être constant.

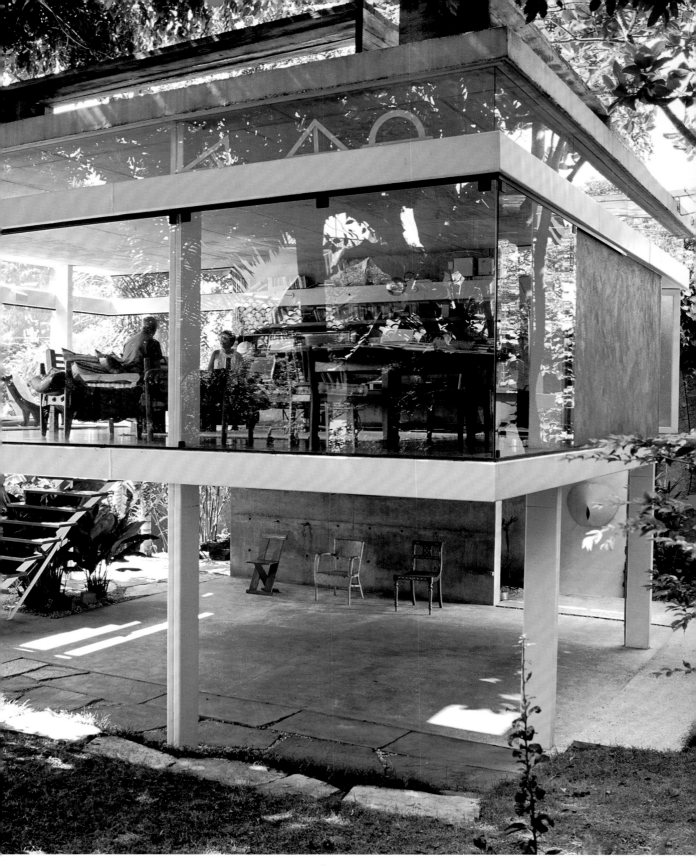

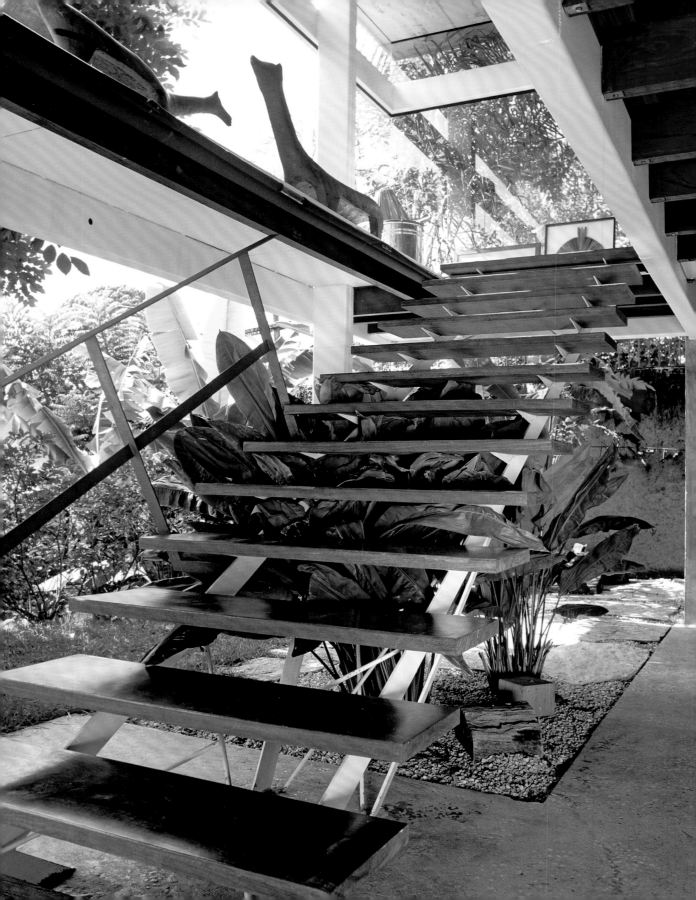

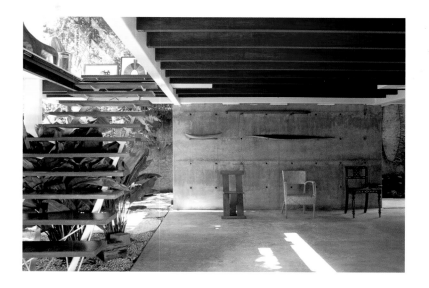

"... believe that an architect ... hould listen to a lot of ... usic while drawing."

»... Meiner Ansicht nach sollte ... n Architekt beim Zeichnen ... el Musik hören.«

« ... e trouve qu'un architecte ... evrait écouter beaucoup de ... usique pendant qu'il dessine. »

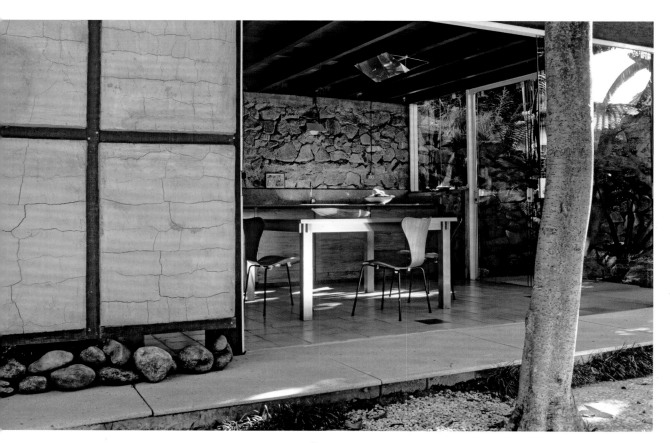

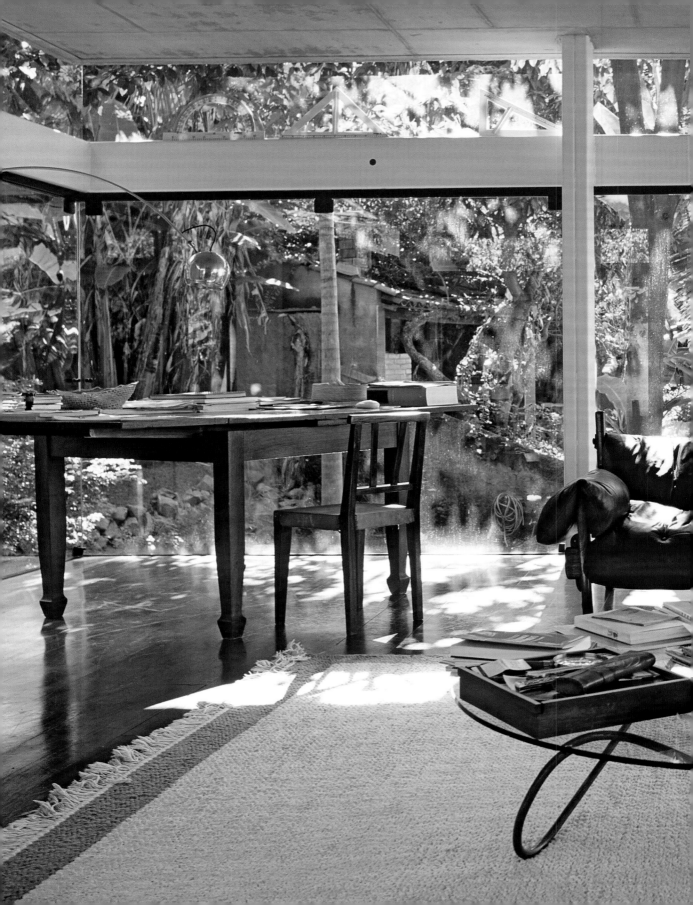

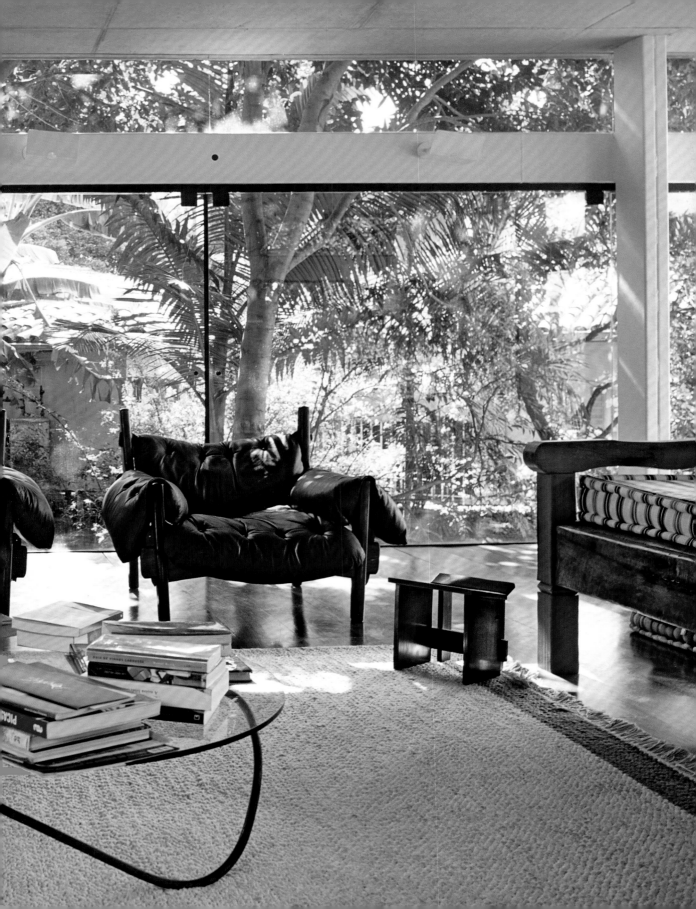

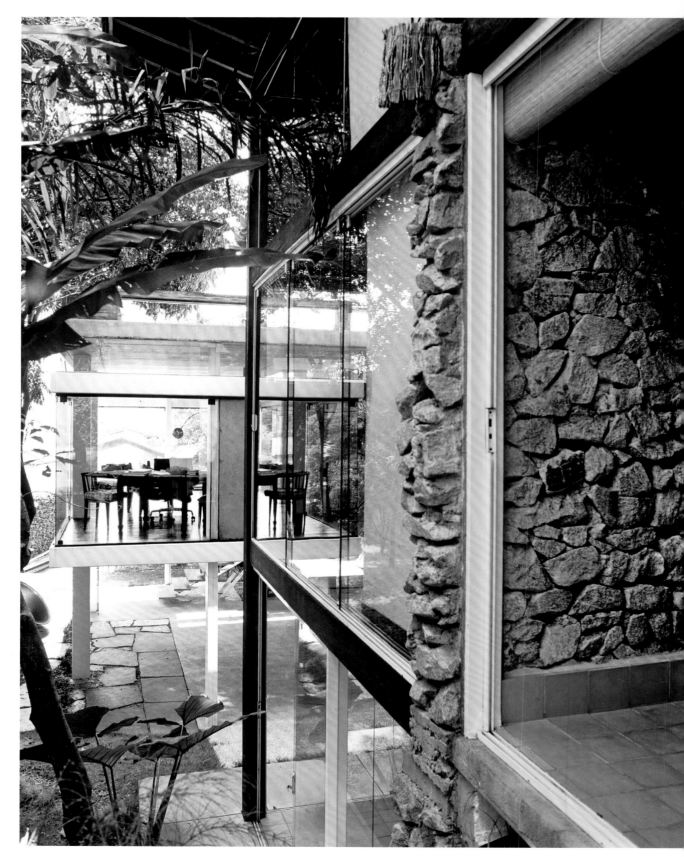

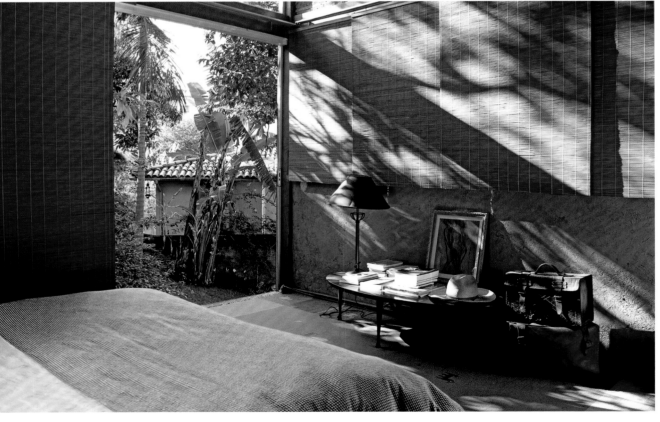

SÃO PAULO

Itaim, Brazil

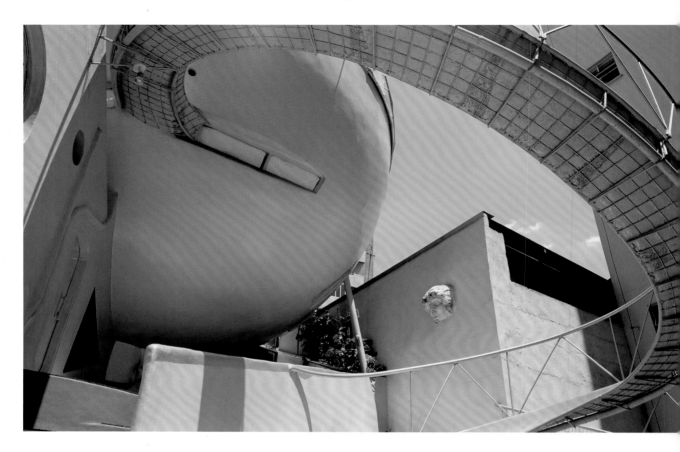

OWNER
Eduardo Longo

OCCUPATION
Architect

PROPERTY
Experimental modular
apartment prototype "Casa Bola"
100 sqm / 1,075 sq ft
3 floors; 3 rooms; 4 bathrooms

YEAR
Building: 1974–1979

ARCHITECT & INTERIOR DESIGNER
Eduardo Longo, São Paulo
www.eduardolongo.com

FURNITURE
All furniture designed and built-in
by the architect, except the bar stools

PHOTOGRAPHER
Reto Guntli, Zapaimages, Zurich
www.zapaimages.com

STYLE
Space capsule, submarine, hippie tree-house
the myths of the Pop era have survived in
Casa Bola.

Raumkapsel, U-Boot, Hippie-Baumhaus:
In der Casa Bola haben die Wohnmythen d
Pop-Ära überlebt.

Capsule spatiale, sous-marin, cabane de
hippie dans les arbres : Casa Bola réunit
tous les mythes de l'ère Pop.

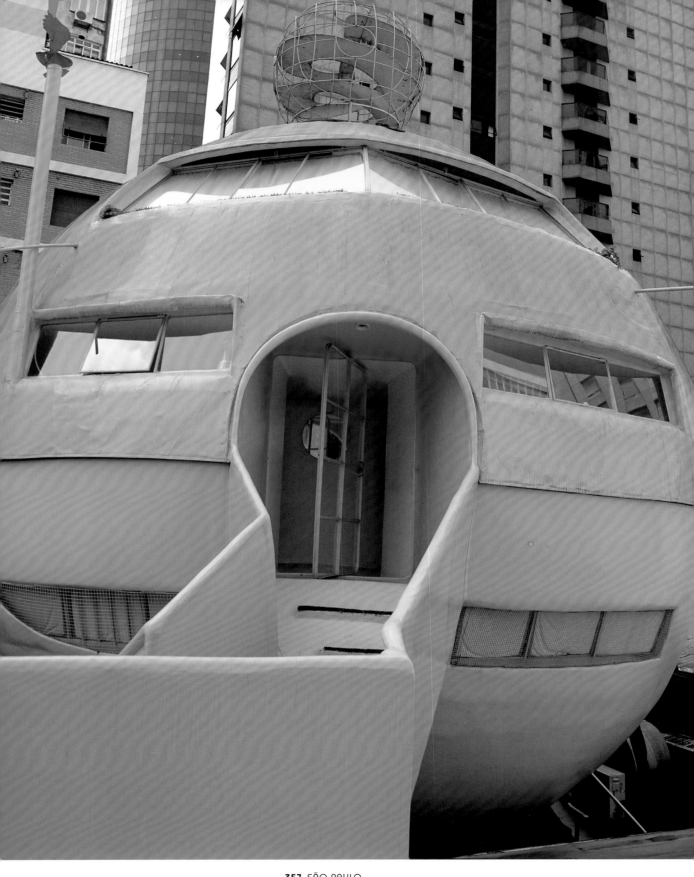

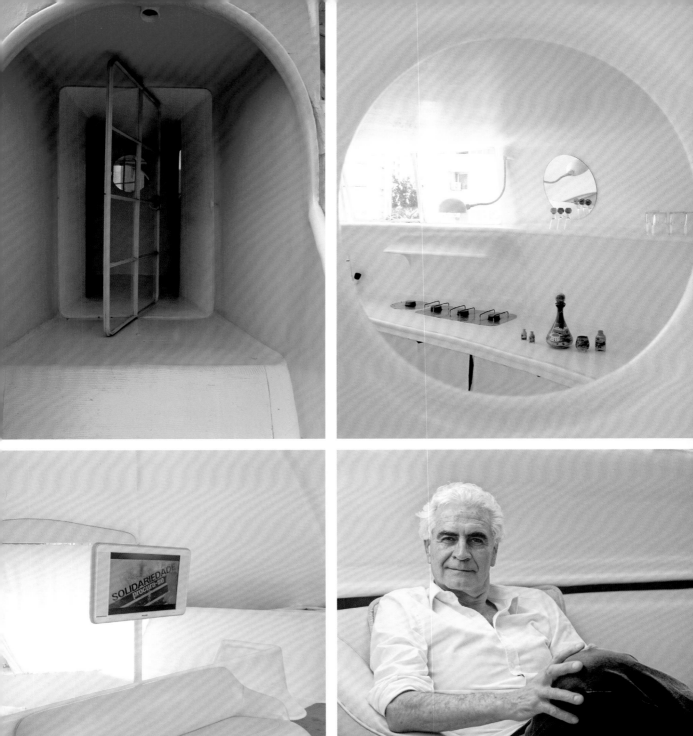

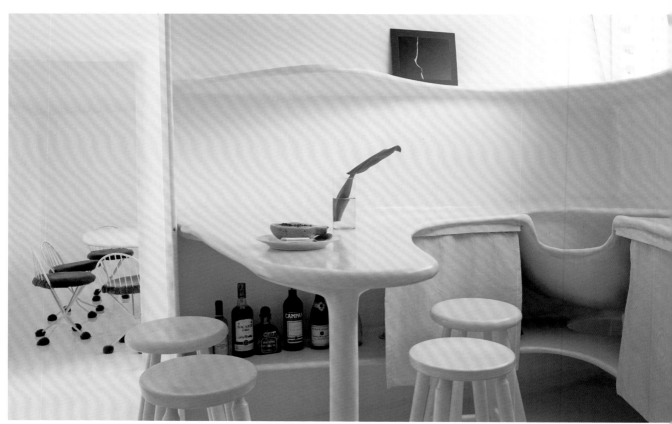

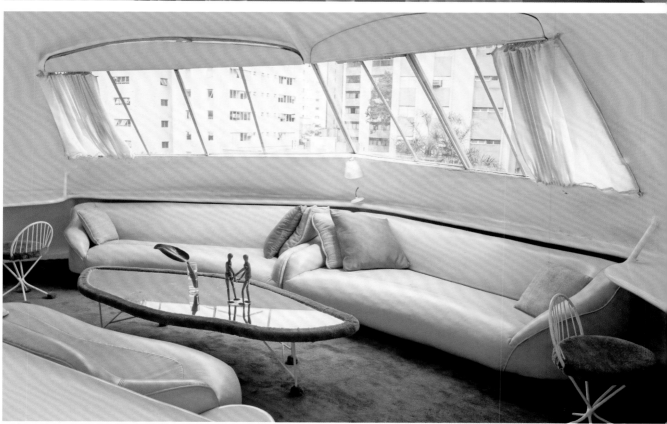

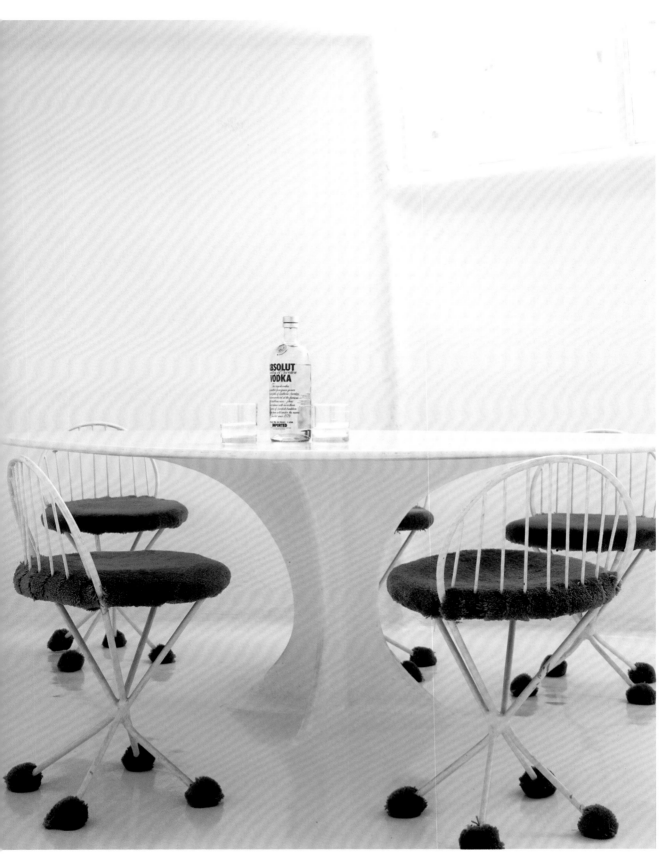

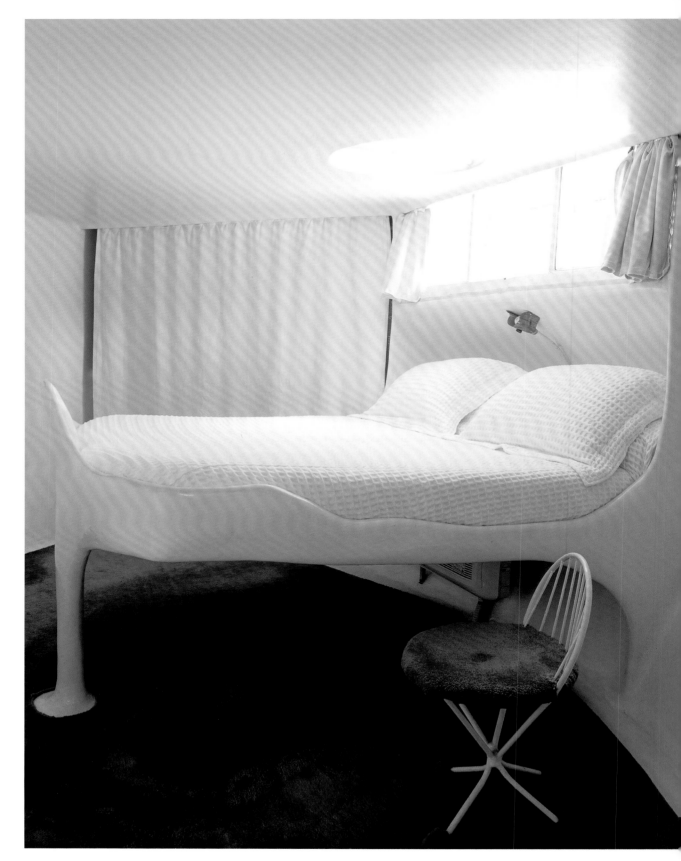

"Less, sometimes,
can be more."

»Weniger kann manchmal
mehr sein.«

« Parfois, le moins
fait le plus. »

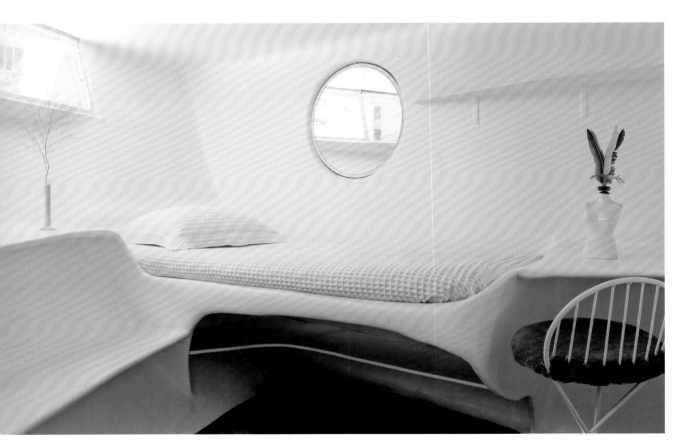

SHANGHAI

China

OWNER
Frank Visser

OCCUPATION
Stylist, art director

PROPERTY
Apartment
120 sqm / 1,300 sq ft
2 floors; 4 rooms; 2 bathrooms

YEAR
Building: 1930
Remodelling: 2006

**INTERIOR DESIGNER
& PHOTO STYLIST**
Frank Visser, ijm, Amsterdam
www.ijm.nl

FURNITURE
Chinese Art Deco furniture; pieces from
Ikea and street market stalls; coloured
plastic things from the supermarket

PHOTOGRAPHER
Mirjam Bleeker, Amsterdam
www.mirjambleeker.nl

STYLE
The apartment was previously furnished with
rather ugly and heavy pieces. Many of them
I gave away, the rest I covered with fabrics or
painted. Instead of the dark blue, black and
red you always see as typical Chinese, I chose
the lighter, pale pastel colours of Chinese
fruits, nylon raincoats, Shanghai city taxis and
advertisement signs.

Das Apartment war vorher mit ziemlich
hässlichen und schweren Stücken möbliert.
Viele davon habe ich verschenkt, den Rest
habe ich mit Stoffen überzogen oder ange-
strichen. Statt für Dunkelblau, Schwarz und
Rot – die Farben, die als typisch chinesisch
gelten – entschied ich mich für die helle-
ren, blassen Pastelltöne von chinesischen
Früchten, Nylon-Regenmänteln, Stadttaxis
aus Shanghai und Reklameschildern.

Autrefois, l'appartement était meublé avec
des pièces lourdes et assez laides. J'en ai
offert beaucoup, j'ai tapissé le reste avec des
tissus ou je les ai repeintes. Au lieu du bleu
nuit et du rouge qu'on considère typique-
ment chinois, j'ai opté pour des tons pastels
plus légers, les couleurs des fruits chinois, des
imperméables en nylon, des taxis de Shangai
et des affiches publicitaires.

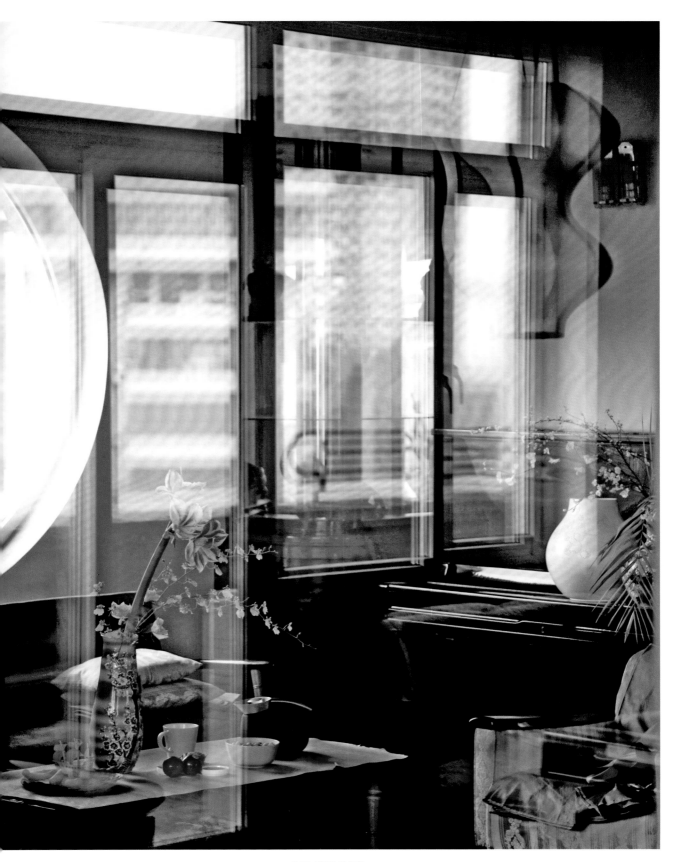

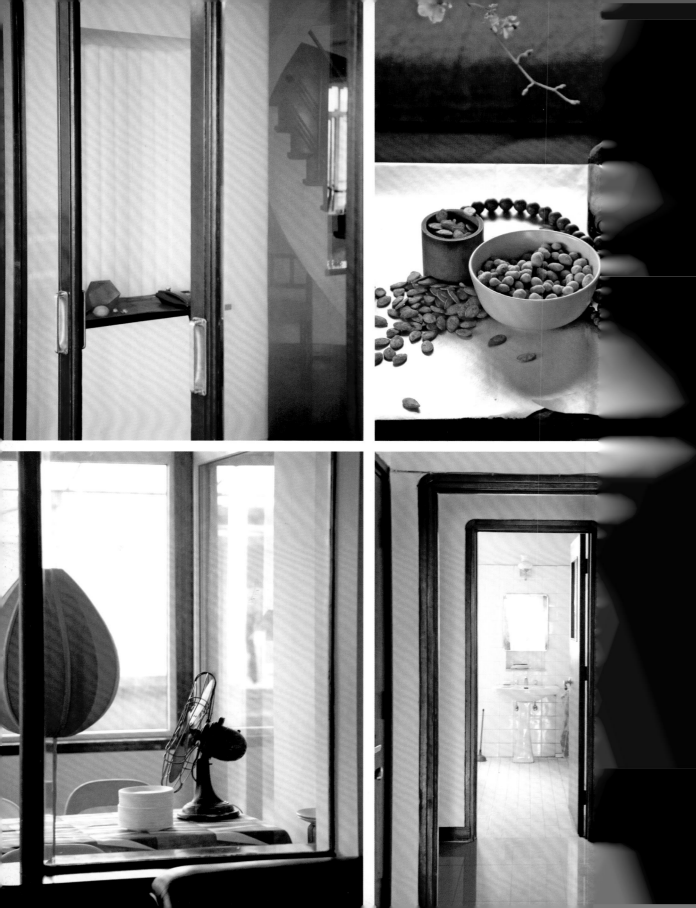

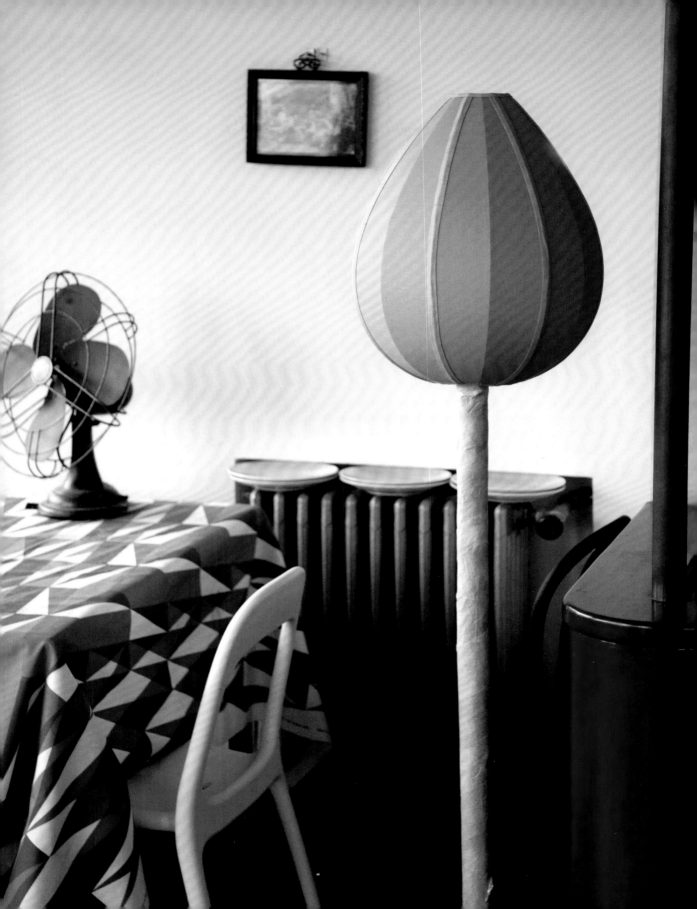

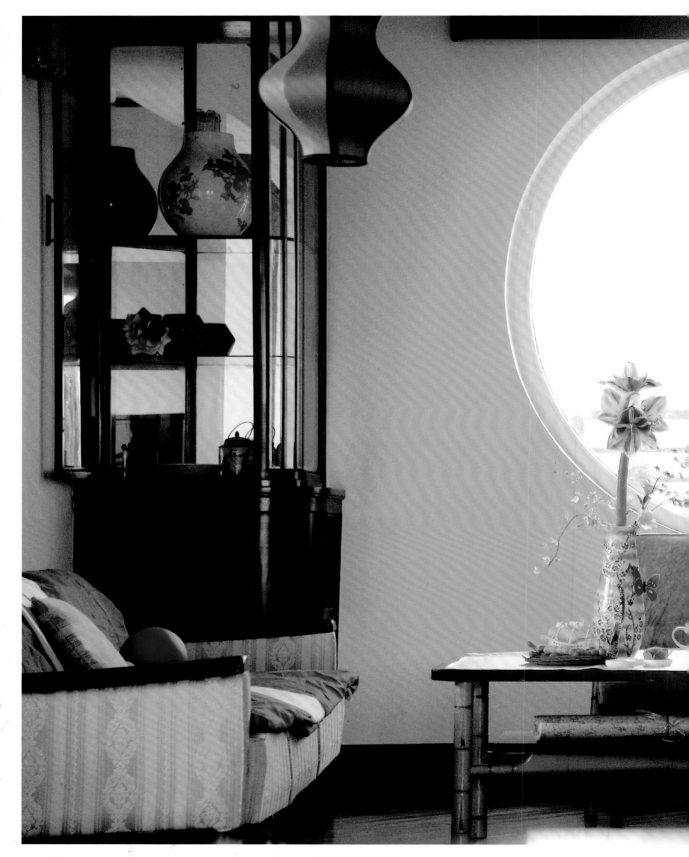

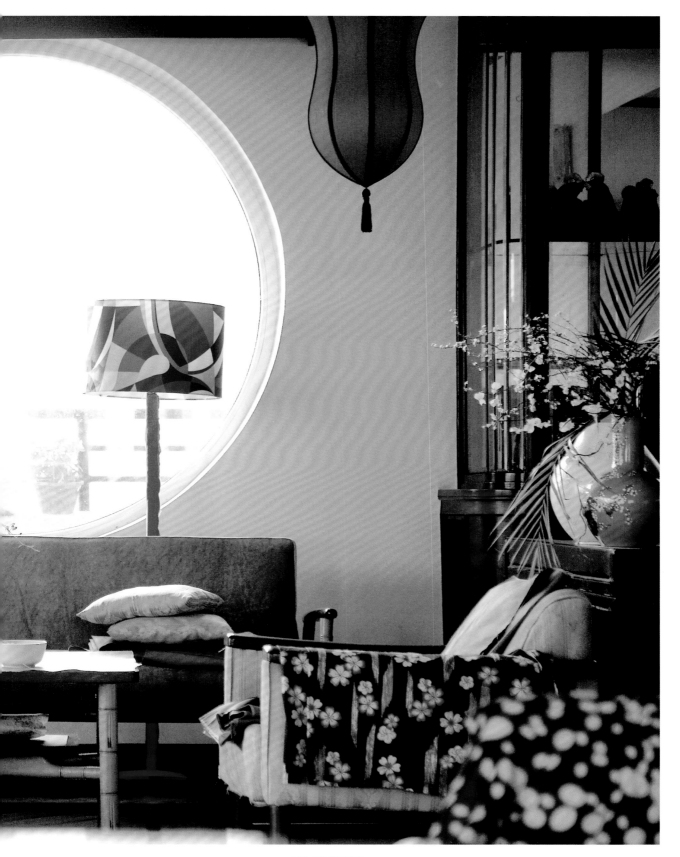

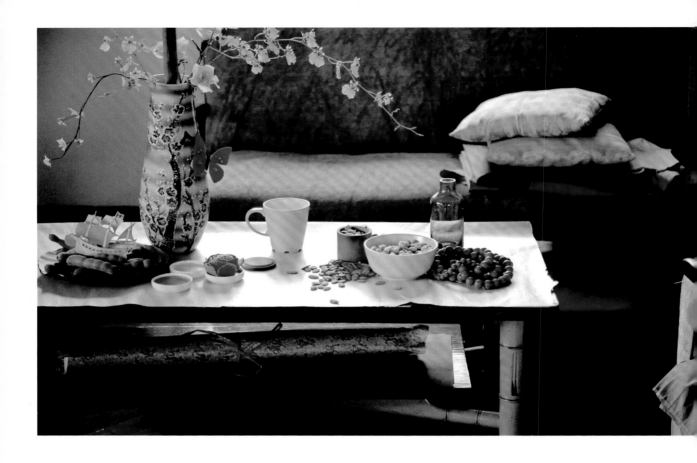

"A casual use of colour
emphasises (or denies)
the architecture
of the place."

»Ein unbefangener Einsatz von Farbe
unterstreicht (oder verleugnet)
die Architektur des Hauses.«

« Le recours aux couleurs peut
mettre en valeur (ou écraser)
l'architecture d'un lieu. »

TOKYO

Japan

OWNERS
Midori & Narumi Hayashi

OCCUPATION
Designers

PROPERTY
House
58 sqm / 624 sq ft
2 floors; 2 rooms; 1 bathroom

YEAR
Building: 2003

ARCHITECT
Andrea Hikone
A-H-ARCHITECTS, Tokyo
www.a-h-architects.com

FURNITURE
IQ lights; a mixture of old Japanese, Chinese and modern furniture

PHOTOGRAPHER
Lorenzo Nencioni, Vega MG, Milan
www.lorenzonencioni.com

STYLE
Retro style. The goal was to create a house that could be the neutral background for a lot of colourful things in different styles, that keep changing. It is a very small site but the windows and shutters can be opened completely, which makes the house feel like an outside terrace in the summer.

Retro Style. Das Ziel bestand darin, ein Hau zu schaffen, das als neutraler Hintergrund dienen kann für viele farbige Dinge in verschiedenen Stilen, die ständig ausgetausch werden können. Es ist ein sehr kleines Grundstück, aber man kann die Fenster und Läden ganz öffnen, sodass das Haus im Sommer einer Außenterrasse gleicht.

Style rétro. L'objectif était de créer une mai son servant de fond neutre à un tas d'objet colorés de styles différents et changeant sans cesse. L'espace est très petit, mais les fenêtres et les volets s'ouvrent complète-ment, ce qui donne l'impression d'être sur une terrasse en été.

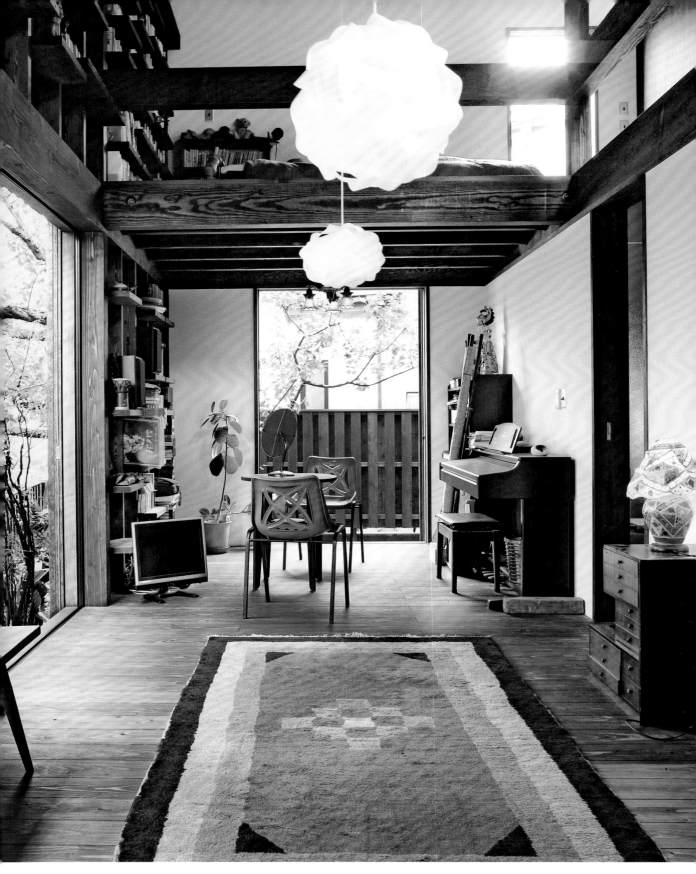

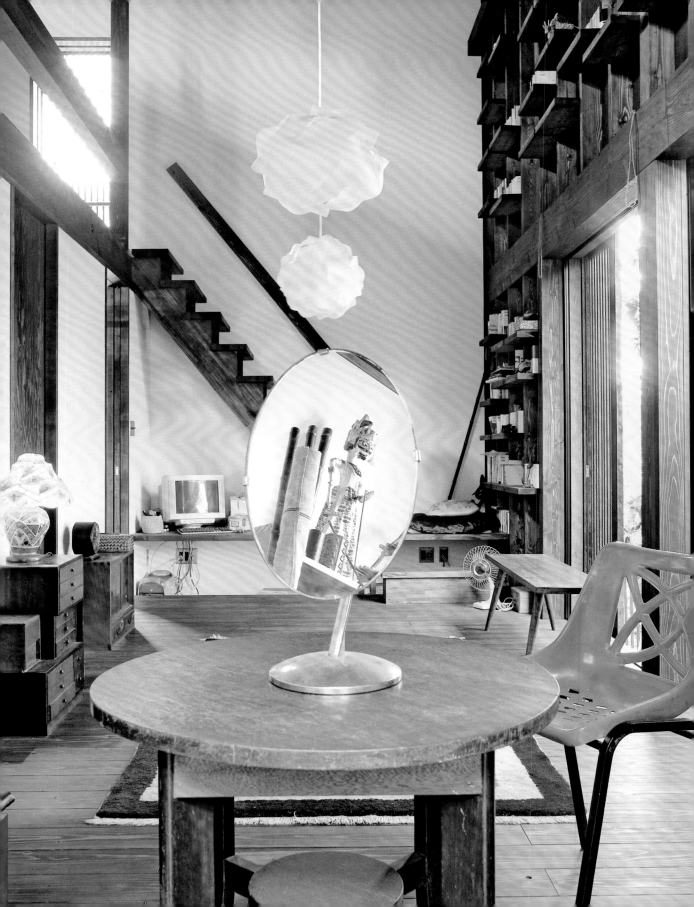

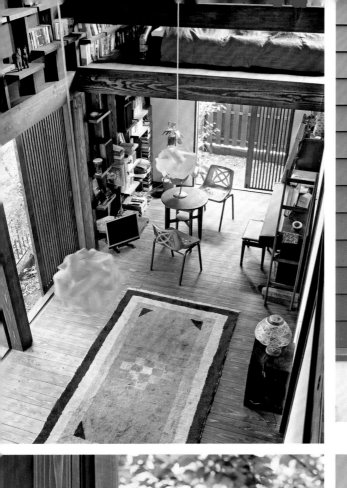

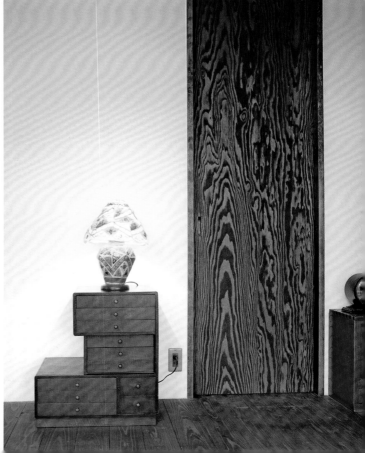

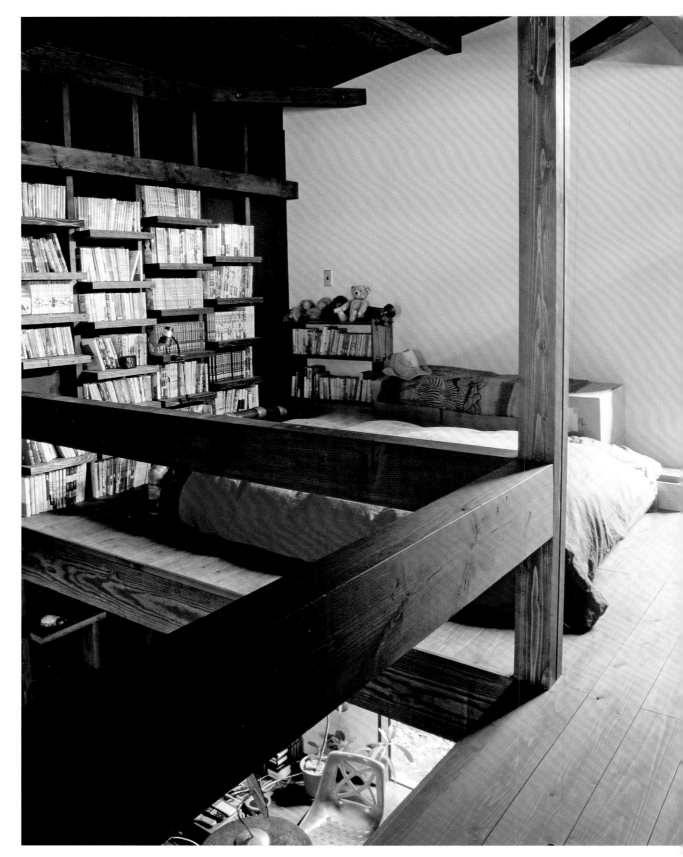

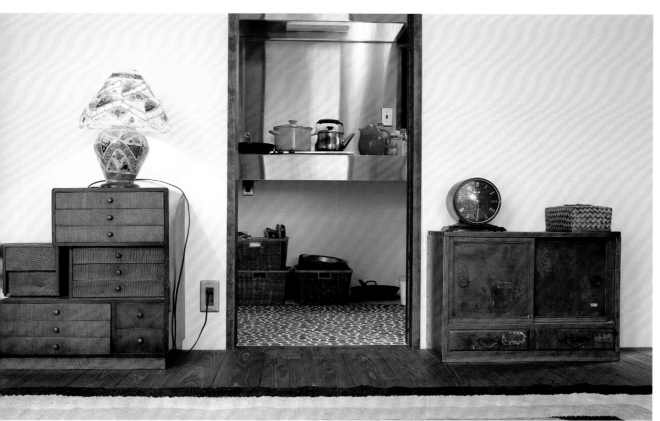

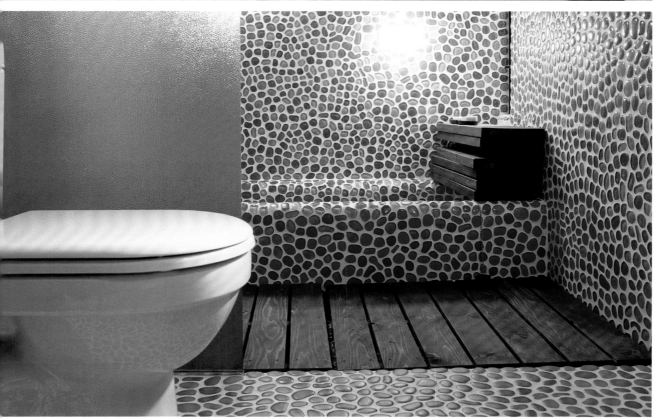

VICTORIA
Central Highlands, Australia

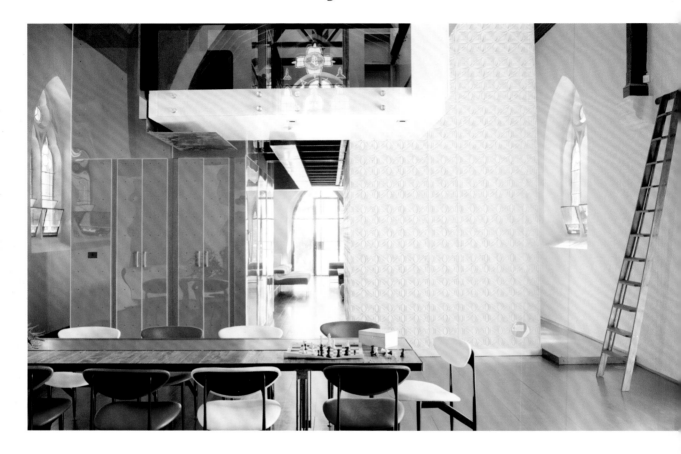

OWNERS
A family from Melbourne

PROPERTY
Converted church
200 sqm / 2,150 sq ft
1 floor + mezzanine; open floor
plan with 3 rooms; 2 bathrooms

YEAR
Building: 1864
Remodelling: 2005

ARCHITECT
Tim O'Sullivan, Multiplicity, Melbourne
www.multiplicity.com.au

INTERIOR DESIGNER
Sioux Clark, Multiplicity, Melbourne
www.multiplicity.com.au

LANDSCAPE ARTIST
Mel Ogden, Daylesford, Victoria
www.melogden.com

ART
The landscape was commissioned as an
artwork by sculptor Mel Ogden. Concrete
poem cast into the new step to the former
church entry by Patrick Jones

FURNITURE
Patrizia Urquiola "Lowland" & "Fjord" low
seats, Moroso; Grant Featherston "Scape"
dining chairs; custom-made steel dining
table, coffee study tables, bookshelves,
Multiplicity; Tim Made acrylic lights

PHOTOGRAPHER
Lisa Cohen, Melbourne
www.lisacohenphotography.com

STYLE
The conversion of the church into a resider
did not destroy the integrity of the original
building. Effectively it is a structure within a
structure, not touching any of the external
walls and thereby maintaining the sense of
drama and proportion of the church buildir

Bei der Umwandlung der Kirche in ein
Wohnhaus wurde die Integrität des ur-
sprünglichen Gebäudes nicht zerstört. Im
Grunde ist es ein Haus im Haus, das die
äußeren Mauern nicht berührt. So bleiben
die Dramatik und die Proportionen des
Kirchengebäudes bewahrt.

La transformation de l'église en résidence r
pas détruit l'intégrité du bâtiment. C'est un
structure dans la structure, laissant intactes
les façades, ce qui permet de conserver le
côté théâtral et les proportions du bâtimen

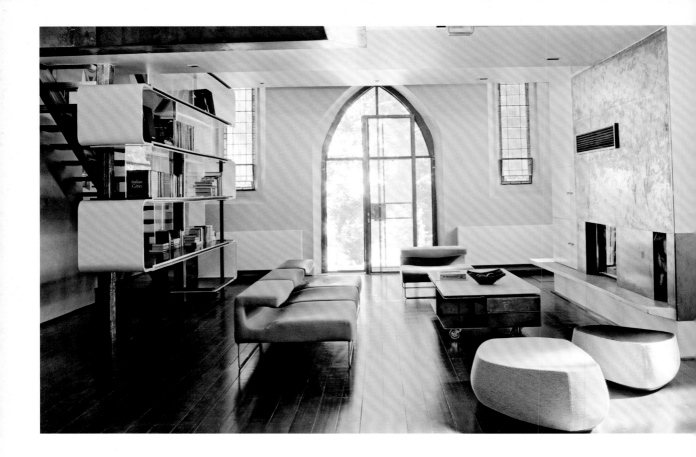

"The use of modern materials, such as steel and acrylic, complements and enhances the church building."

»Durch die Verwendung moderner Materialien wie Stahl und Acryl wird das Kirchengebäude ergänzt und visuell hervorgehoben.«

«L'utilisation de matériaux modernes comme acier et acrylique respecte l'église et met le bâtiment en valeur.»

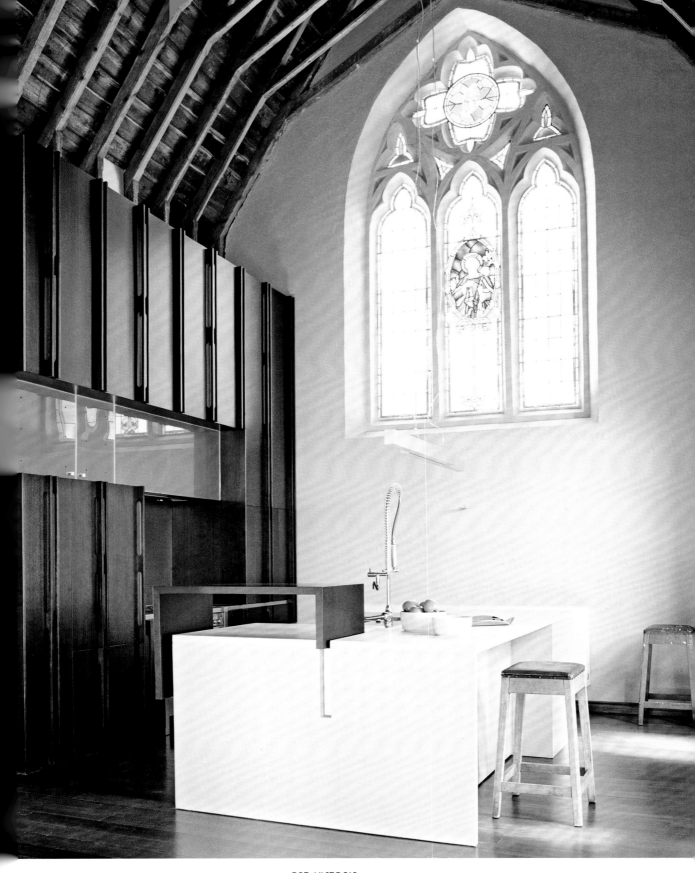

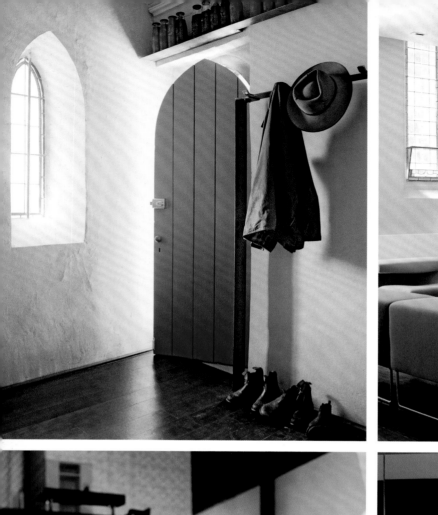
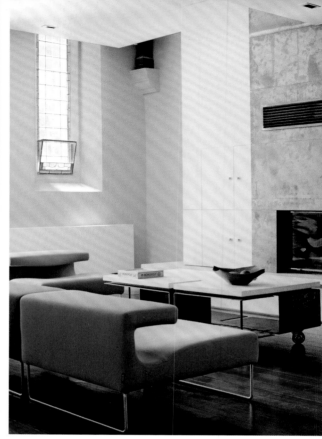
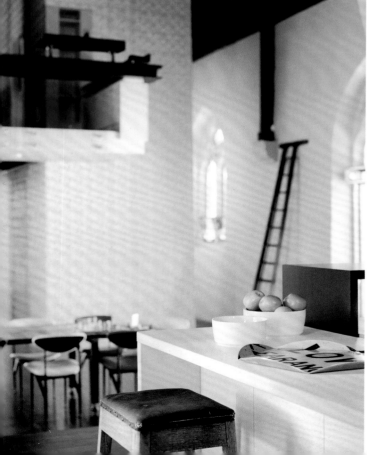
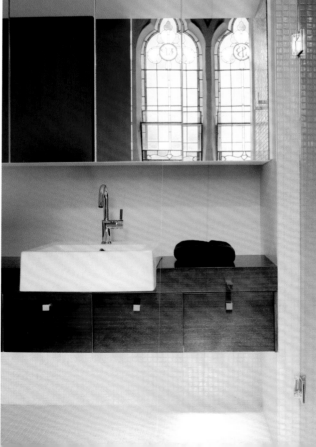

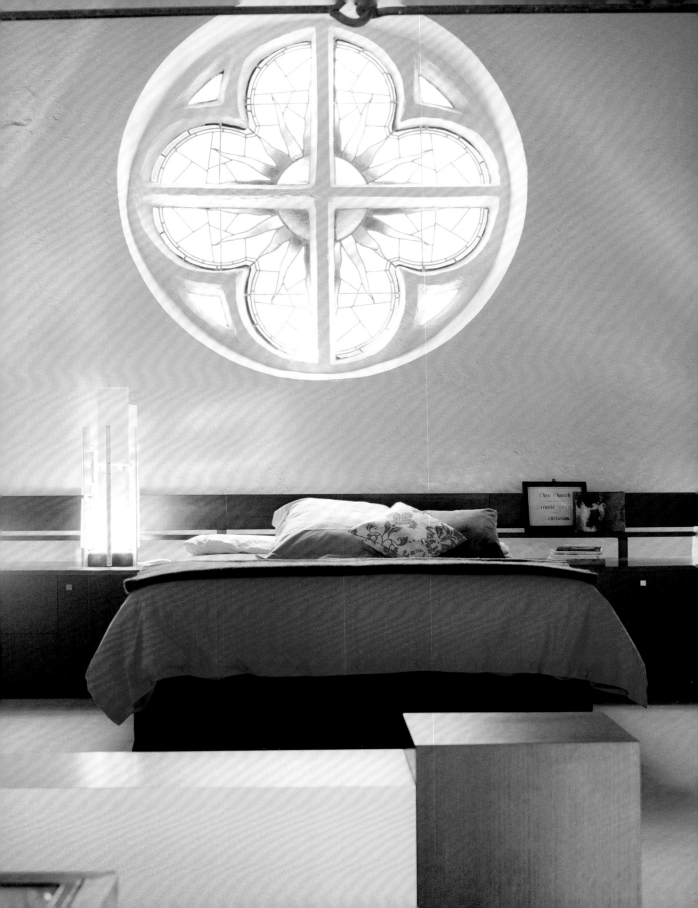

VIECHTACH

Bavaria, Germany

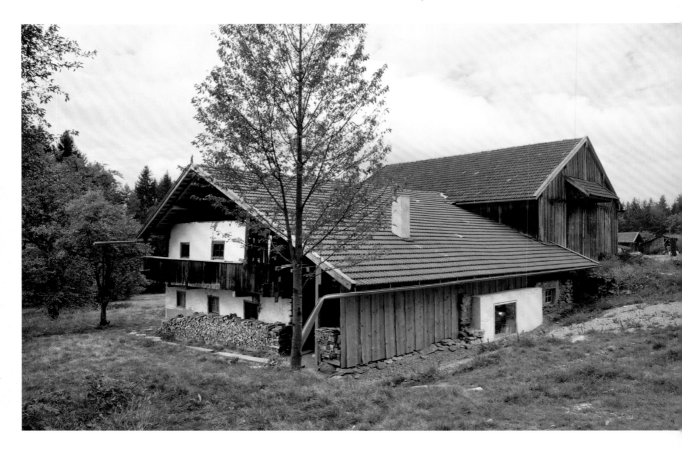

OWNERS
Jutta Görlich & Peter Haimerl

OCCUPATION
Artist / Architect

PROPERTY
Farmhouse
120 sqm / 1,300 sq ft
2 floors; 8 rooms; 1 bathroom

YEAR
Building: 1840
Remodelling: 2008

ARCHITECTS & INTERIOR DESIGNERS
Jutta Görlich & Peter Haimerl, Munich
www.peterhaimerl.com

ART
The vistas are the artwork

FURNITURE
All furniture is made out of recycled
materials from the house

PHOTOGRAPHER
Christian Kain, Munich / Paris
www.christiankain.com

STYLE
The concept envisages preserving what
exists, in however ruinous a state it may be,
and not intervening in the structure of the
old farmhouse. The rooms in the old build-
ing remain as they are. Cubes of concrete
have been placed in a few of the main ones,
and life is now lived in these.

Das Konzept sieht vor, den Bestand, wie
ruinös auch immer er sein mag, zu wahren
und in die Struktur des alten Bauernhauses
nicht einzugreifen. Die Räume des Altbaus
bleiben, wie sie sind. In einigen wenigen
zentralen Räumen wurden Betonkuben plat-
ziert, in denen das neue Leben stattfindet.

Le concept était de préserver ce qui existait
quel que soit son état de ruine, et de ne pas
toucher à la structure de la vieille ferme. Les
pièces du bâtiment ancien sont restées telles
quelles. Des cubes en béton ont été placés
dans quelques-unes des pièces principales,
où l'on vit désormais.

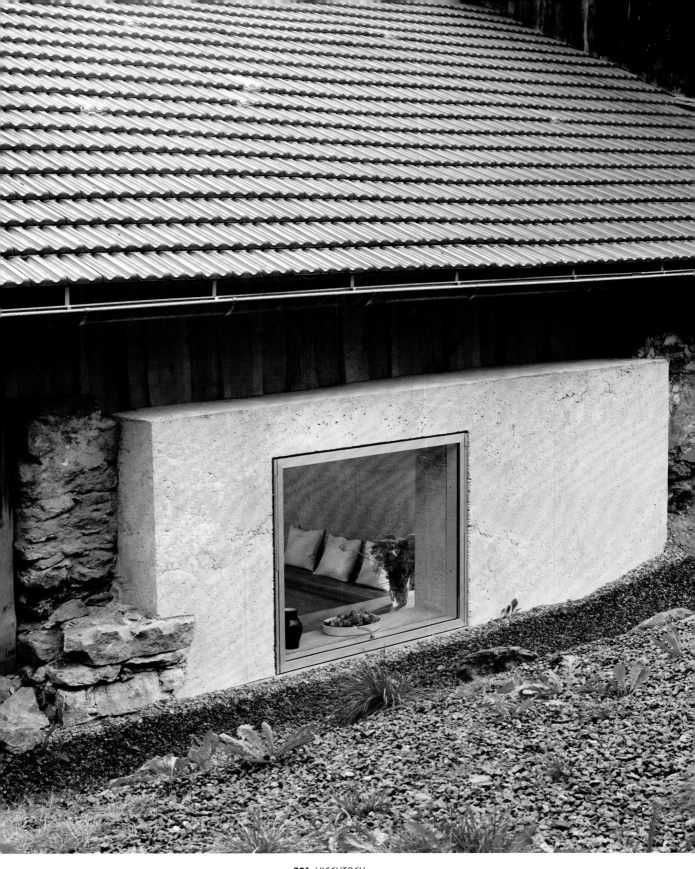

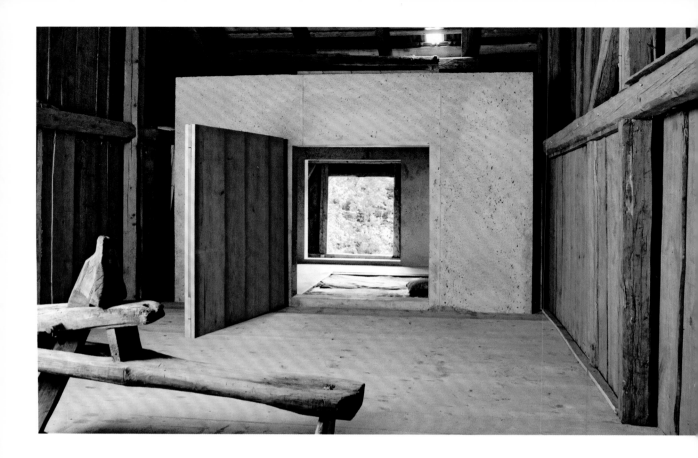

"Comfort comes after respect for a house's character. Only the bare necessities, and then as rough as possible."

»Komfort kommt nach dem Respekt für die Eigenart eines Hauses. Nur das Nötigste und das so roh wie möglich.«

« Le confort vient après le respect du caractère d'une maison. Rien que le strict nécessaire et le plus rudimentaire possible. »

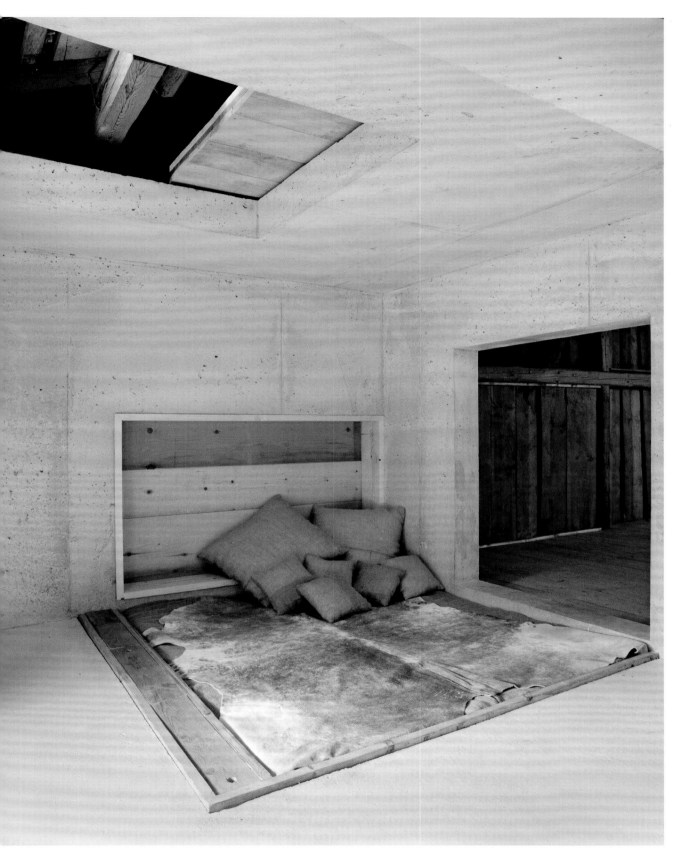

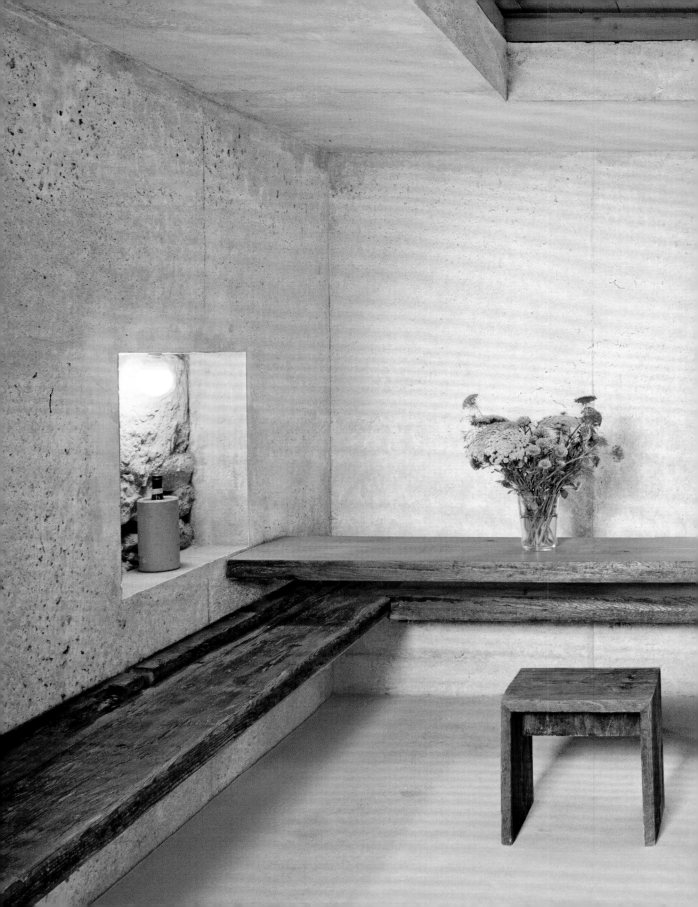

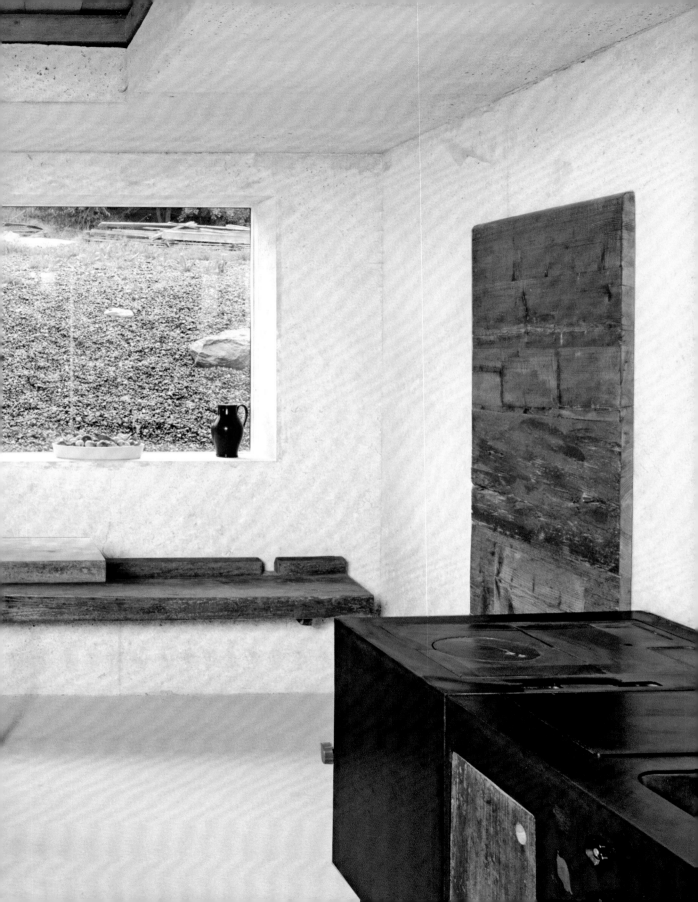

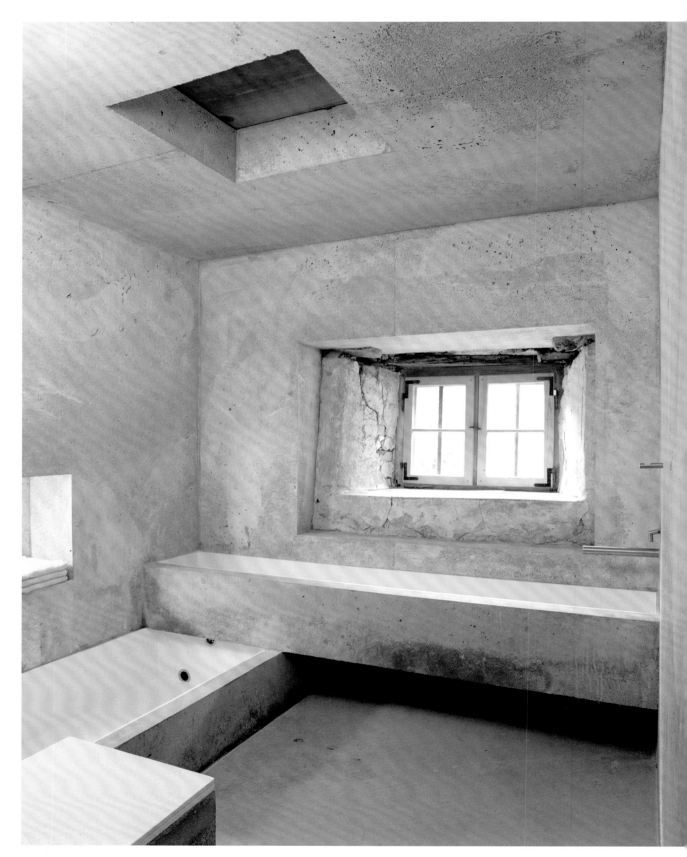

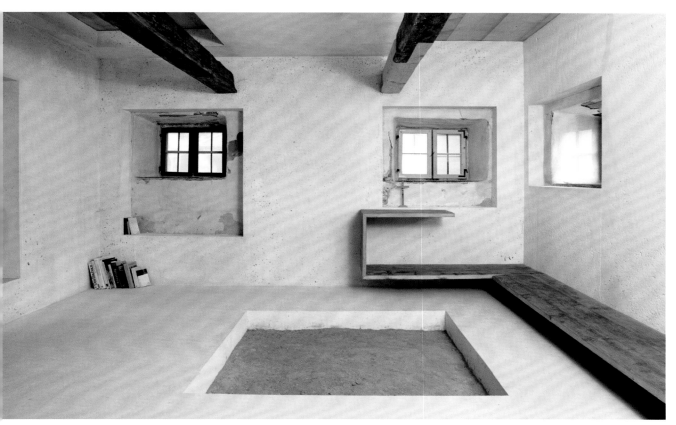

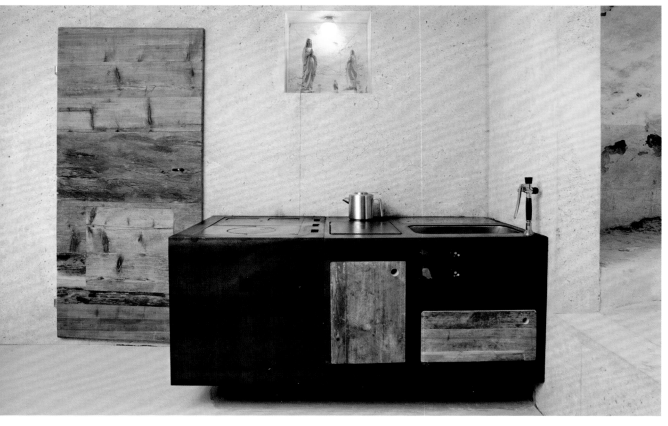

XI AN

China

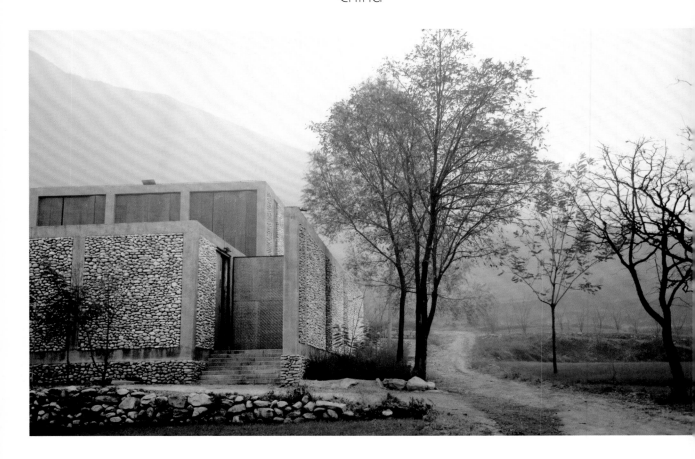

OWNER
Qingyun Ma

OCCUPATION
Architect

PROPERTY
Country house
400 sqm / 4,300 sq ft
3 floors; 6 rooms;
4 bedrooms; 3 bathrooms

YEAR
Building: 1998–2001

ARCHITECT & INTERIOR DESIGNER
Qingyun Ma
MADA s.p.a.m Architecture, Shanghai
www.madaspam.com

FURNITURE
Qingyun Ma designed most
of the furniture in the house

PHOTOGRAPHER
Mirjam Bleeker, Amsterdam
www.mirjambleeker.nl

PHOTO STYLIST
Frank Visser, ijm, Amsterdam
www.ijm.nl

STYLE
Most remarkable in this house are the ma-
terials used. The inside is completely lined
with bamboo. These relatively inexpensive
panels are common in Chinese building.
The yellow bamboo gives the interior the
warmth it needs in the cold climate.

Das Bemerkenswerteste an diesem Haus
sind die verwendeten Materialien. Das
Innere wurde vollständig mit preiswerten
Bambuspaneelen ausgekleidet, wie sie beim
chinesischen Hausbau weitverbreitet sind.
Der gelbe Bambus verleiht dem Interieur
die nötige Wärme, die man in diesem kalten
Klima braucht.

Le plus remarquable dans cette maison, ce
sont les matériaux utilisés. L'intérieur est en-
tièrement tapissé de panneaux de bambou,
qui sont bon marché et courants dans les
bâtiments chinois. Le bambou jaune apporte
aux intérieurs une chaleur bienvenue dans ce
climat froid.

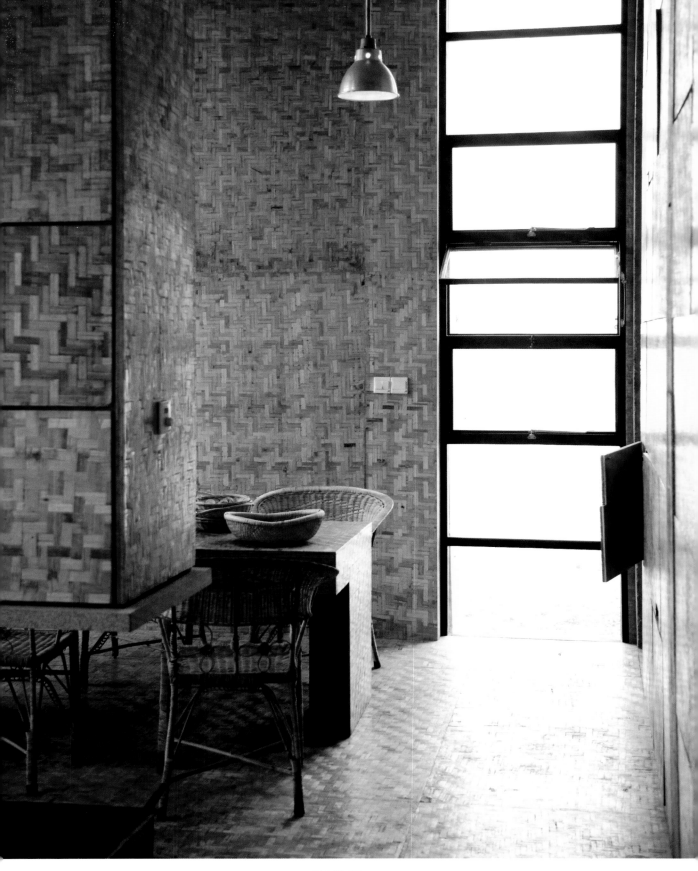

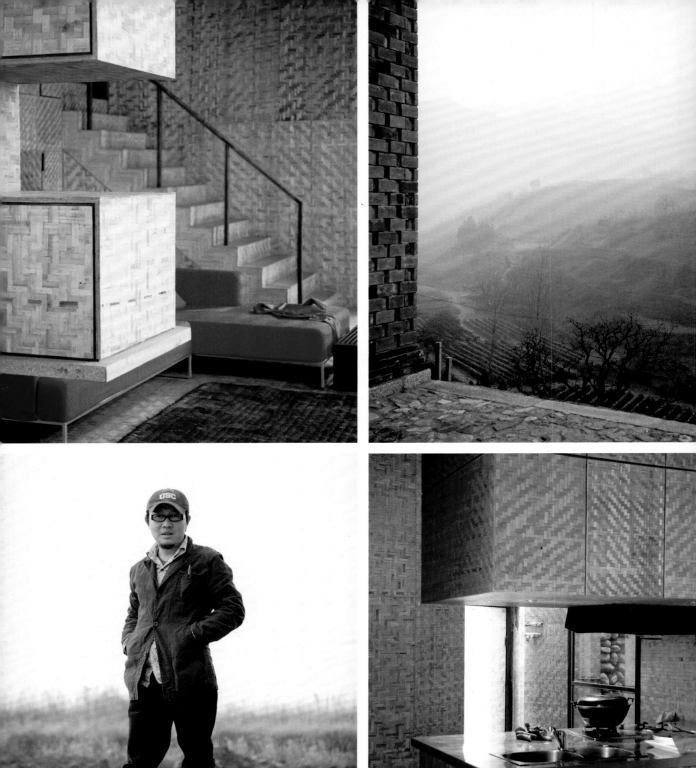

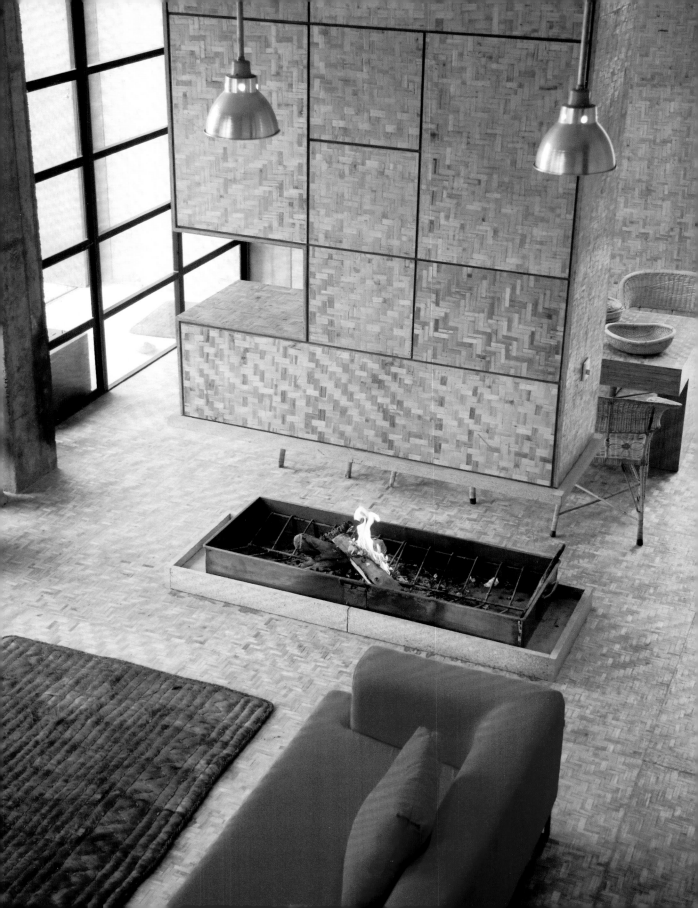

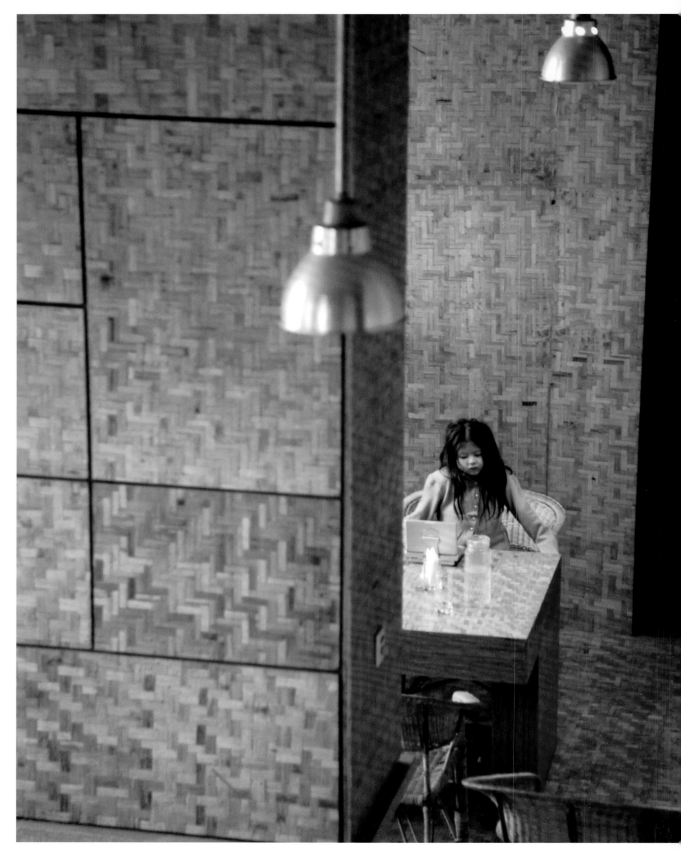

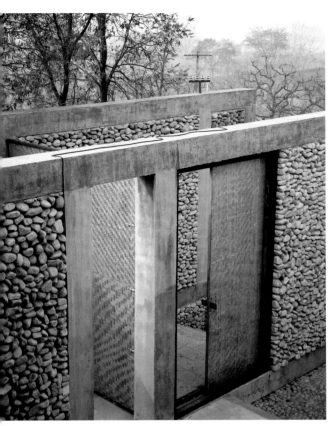

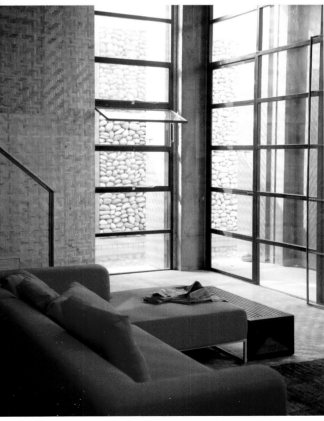
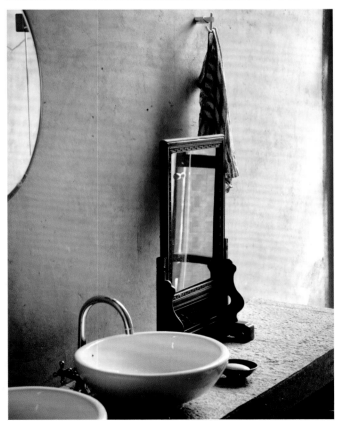

ZÜRICHSEE

Küsnacht, Switzerland

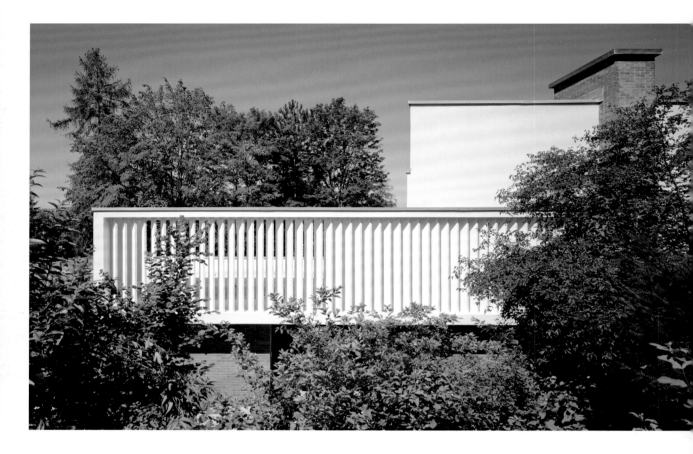

OWNERS
Melanie Grieder-Swarovski
& Damian Grieder

OCCUPATION
Artist / Art dealer

PROPERTY
Villa
550 sqm / 5,900 sq ft
4 floors; 15 rooms; 4 bathrooms

YEAR
Building: 1956 (Theodor Laubi)
Remodelling: 2006

ARCHITECTS
Gallery kitchen, office, built-in components
and overall concept, created and designed
by Andreas Fuhrimann & Gabrielle Hächler
Architekten, Zurich
www.afgh.ch

ART
Monica Bonvicini; Johannes Kahrs;
Daniel Pflumm; Gelitin; Lori Hersberger;
Gregor Hildebrandt; Michael Sailstorfer;
Christian Jankowski; Melli Ink; Horst P. Horst;
Sylvie Fleury; Erwin Wurm; Alighiero Boetti

FURNITURE
Florence Knoll; Isamu Noguchi; Charles &
Ray Eames; Verner Panton; Swiss vintage
pieces from the 1950s and 1960s

PHOTOGRAPHER
Oliver Heissner, Hamburg
www.oliverheissner.net

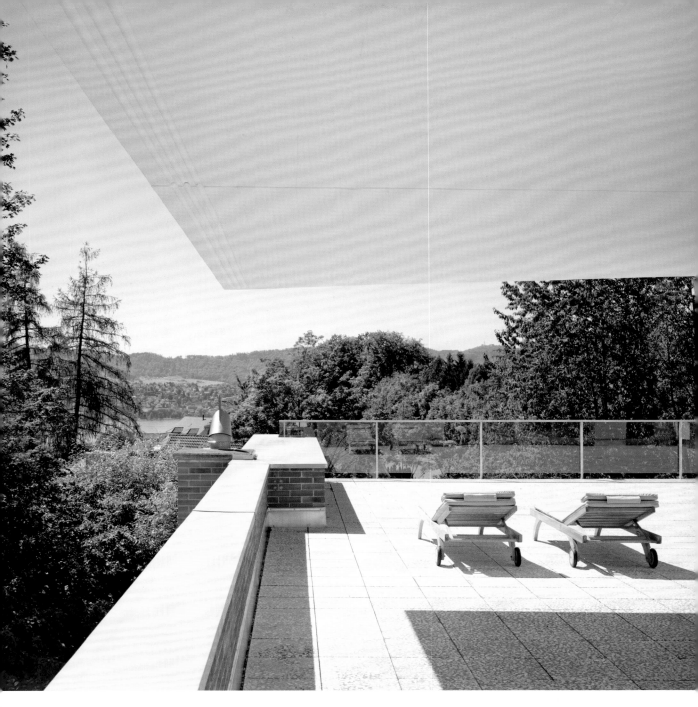

STYLE

We always love unique buildings and try to emphasise their distinct character. But we are also interested in a certain eclectic style and always mix old and historical design with contemporary art and design. The main floor is used as a gallery space to give artists a place to exhibit.

Wir lieben einzigartige Gebäude und versuchen, ihren eigenständigen Charakter zu betonen. Aber wir interessieren uns auch für einen gewissen eklektischen Stil und mischen stets Altes und Historisches mit zeitgenössischer Kunst und modernem Design. Das Untergeschoss wird als Galerie genutzt, in der Künstler ihre Arbeiten ausstellen können.

Nous aimons les bâtiments uniques en leur genre et essayons de respecter leur caractère distinct. Mais nous recherchons également un certain éclectisme et mélangeons toujours le design ancien et historique avec l'art et le design contemporains. Le rez-de-chaussée fait office de galerie pour les artistes qui souhaitent exposer leurs œuvres.

"We would rather offer
space to contemporary
artists who react
to the space's own
charisma and history."

»Wir möchten den Raum lieber
zeitgenössischen Künstlern anbieten,
die auf dessen Charisma und
Geschichte reagieren.«

« Nous préférons offrir de l'espace
à des artistes contemporains
qui sont sensibles au charme
et à l'histoire du lieu. »

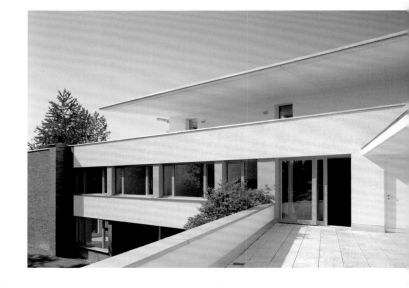

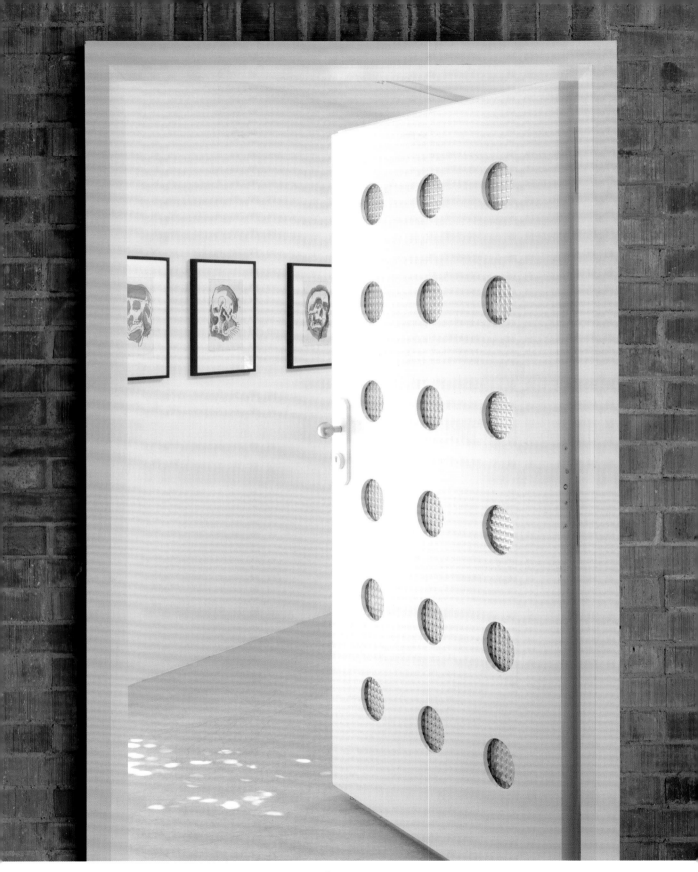

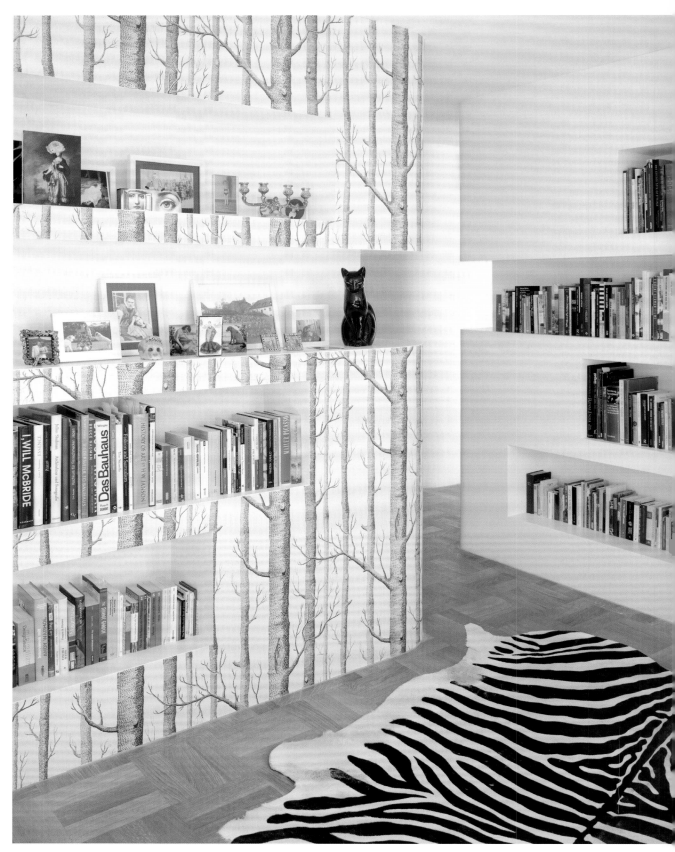

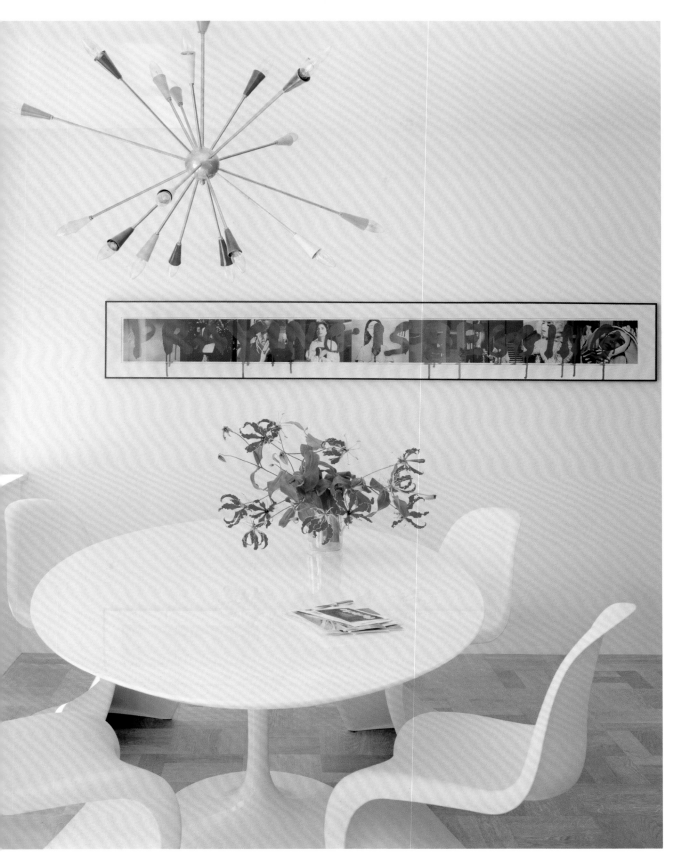

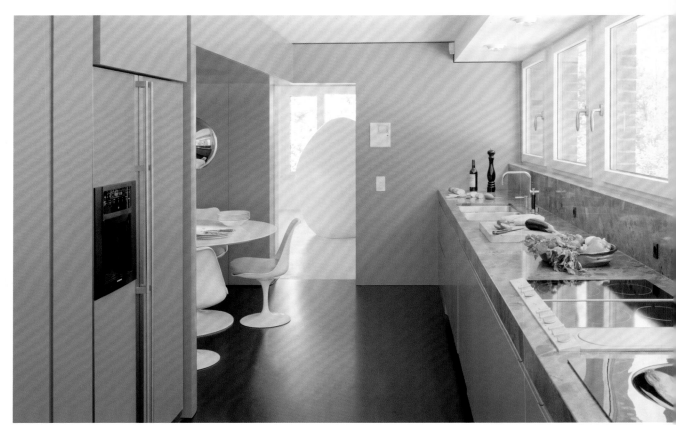

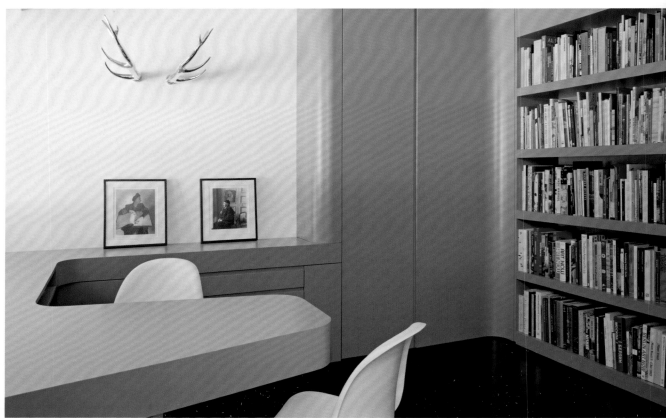

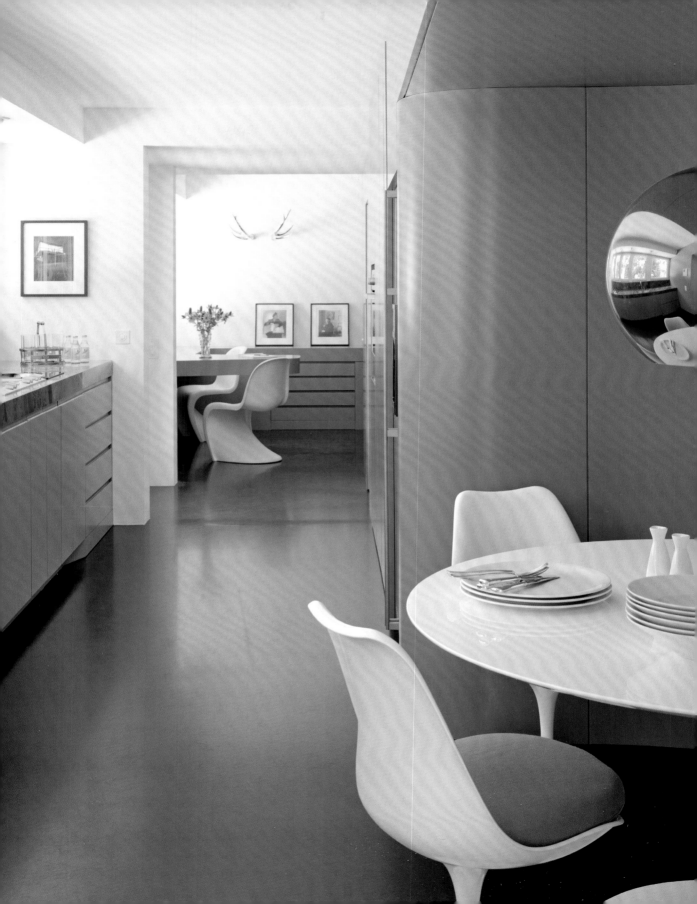

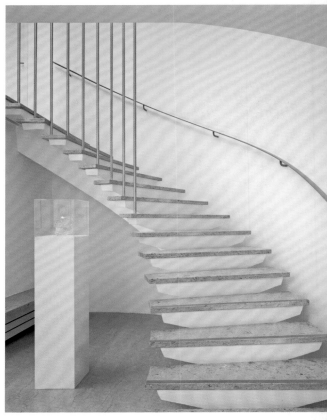

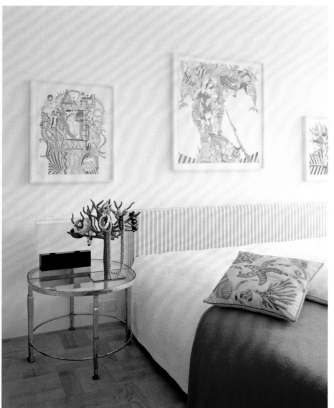

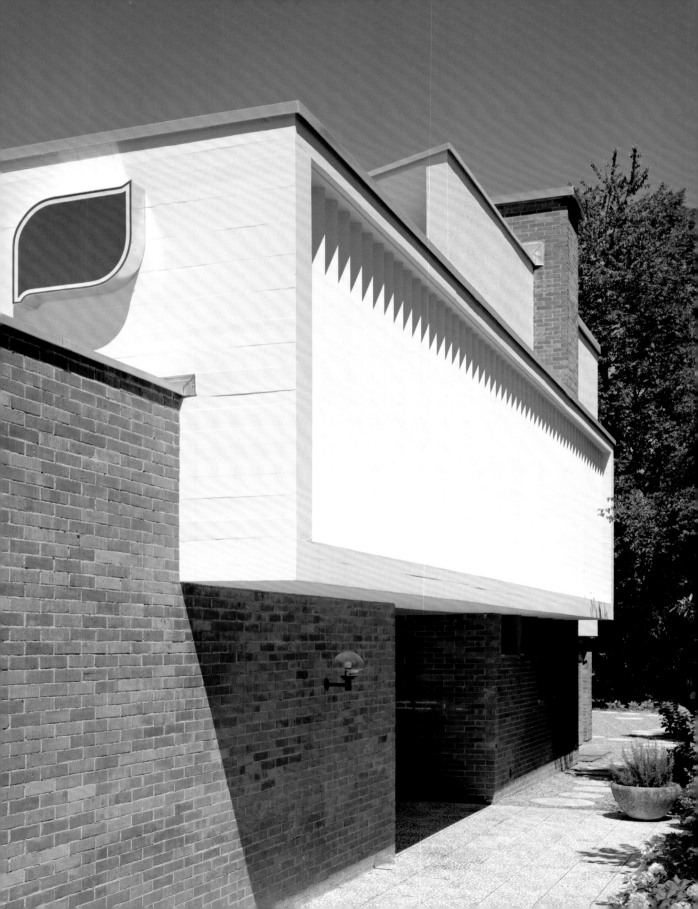

IMPRINT

© 2012 TASCHEN GmbH
Hohenzollernring 53, D-50672 Köln
www.taschen.com

To stay informed about upcoming TASCHEN titles, please
request our magazine at www.taschen.com/magazine or write
to TASCHEN, Hohenzollernring 53, D-50672 Cologne, Germany;
contact@taschen.com. We will be happy to send you a free copy
of our magazine, which is filled with information about all of our books.

COMPILED, EDITED & LAYOUT
Angelika Taschen, Berlin

DESIGN
Daniel Siciliano Bretas, Cologne

PROJECT MANAGER
Stephanie Paas, Cologne
Nina Schumacher, Cologne

PHOTO COORDINATOR
Sandra Rendgen, Berlin

LITHOGRAPH MANAGER
Thomas Grell, Cologne

ENGLISH TRANSLATION
Pauline Cumbers, Frankfurt am Main

FRENCH TRANSLATION
Philippe Safavi, Paris
Michelle Schreyer, Cologne (Foreword)

GERMAN TRANSLATION
Franca Fritz & Heinrich Koop, Straelen

PAGE 2
Sylvia Avontuur & Arie-Jan Laan, Amsterdam
Photo: Mirjam Bleeker, Amsterdam

PAGE 6
Amelia & Holden Shannon, Marfa
Photo: Michel Arnaud/GAP Interiors

Printed in Italy
ISBN 978-3-8365-1951-9